THE CAMBRIDGE COMPANION TO
Velázquez

The Cambridge Companion to Velázquez offers a synthetic overview of one of the greatest painters of Golden Age Spain and seventeenth-century Europe as a whole. With contributions from art historians and those working in other disciplines, this book offers fresh approaches to the vast literature on this artist. Velázquez's portraits of his patron, King Philip IV, and his wives are examined by two historians in an effort to reconstruct their reception and readings by contemporaries. Two historians of Golden Age Spanish literature provide an interdisciplinary account of the relationships between poetry, theater, and the visual arts at the Spanish court, as practiced by Velázquez, the poet Francisco de Quevedo, and the dramatist Calderón de la Barca. An expert on the history of Spanish music offers an unprecedented examination of how instruments "play" in Velázquez's compositions. Other essays guide the reader to an understanding of Velázquez's work – his training in his native Seville, reflections in his oeuvre of artistic currents from outside Spain, and how Velázquez's religious paintings may be understood within the religious context of Counter-Reformation Spain.

Suzanne L. Stratton-Pruitt is an independent scholar of Spanish Baroque art. A recipient of grants from the American Philosophical Society, the American Council of Learned Societies, and the Samuel H. Kress Foundation, she is the author of *The Immaculate Conception in Spanish Art,* which received an award for the best book on Spanish art published in English that year from the American Society for Art Historical Studies. In 1994, the Spanish government awarded Dr. Stratton-Pruitt the Lazo de Dama de la Orden de Isabel la Católica medal, in recognition of her work on behalf of the wider understanding of Spanish culture.

THE CAMBRIDGE COMPANION TO

Velázquez

Edited by

Suzanne L. Stratton-Pruitt

CAMBRIDGE
UNIVERSITY PRESS

PUBLISHED BY THE PRESS SYNDICATE OF THE UNIVERSITY OF CAMBRIDGE
The Pitt Building, Trumpington Street, Cambridge, United Kingdom

CAMBRIDGE UNIVERSITY PRESS
The Edinburgh Building, Cambridge CB2 2RU, UK
40 West 20th Street, New York, NY 10011–4211, USA
477 Williamstown Road, Port Melbourne, VIC 3207, Australia
Ruiz de Alarcón 13, 28014 Madrid, Spain
Dock House, The Waterfront, Cape Town 8001, South Africa

http://www.cambridge.org

First published 2002

Printed in the United Kingdom at the University Press, Cambridge

Typeface Fairfield Medium 10.5/13 pt. *System* QuarkXPress® [GH]

A catalogue record for this book is available from the British Library.

Library of Congress Cataloging-in-Publication Data

The Cambridge companion to Velázquez / [edited by] Suzanne L. Stratton-Pruitt.
 p. cm. – (Cambridge companion to the history of art)
 Includes bibliographical references and index.
 ISBN 0-521-66046-7 – ISBN 0-521-66940-5 (pbk.)
 1. Velázquez, Diego, 1599–1660 – Criticism and interpretation. 2. Arts,
Spanish – Spain – Madrid – 17th century. I. Stratton, Suzanne L. II. Cambridge
companions to the history of art.

ND813.V4C337 2002
759.6 – dc21 2001037495

ISBN 0 521 66046 7 hardback
ISBN 0 521 66940 5 paperback

Contents

List of Illustrations

Contributors

Jonathan Brown is Carroll and Milton Petrie Pofessor of Fine Arts, Institute of Fine Arts, New York University. Among his numerous books and articles on Spanish art are *Velázquez: Painter and Courtier* (1986); *Painting in Spain 1500–1700* (1998); and, with Carmen Garrido, *Velázquez: The Technique of Genius* (1998), all from Yale University Press. Among the honors bestowed on Dr. Brown for his considerable contributions to our understanding of Spanish art are the 1996 Gran Cruz de la Orden de Alfonso XII el Sabio and the 1997 Premio Elio Antonio Nebrija from the University of Salamanca.

Antonio Feros is Associate Professor of History, New York University. He is the author of *Kingship and Favoritism in the Spain of Philip III (1598–1621)* (Cambridge University Press, 2000), a study of the career of the duke of Lerma and the political history of the reign of Philip III of Spain. He has published several articles on royal favorites, power and propaganda, and patronage and clientelism in early modern Spain.

Margaret R. Greer is Professor of Spanish and Latin American Studies in the Department of Romance Studies at Duke University. Her most recent publications include *María de Zayas Tells Baroque Tales of Love and the Cruelty of Men* (University Park, Pennsylvania State University Press, 2000) and *Basta callar* (Ottawa, Dovehouse Editions, 2000). Dr. Greer is presently working on a study of the representation of hunters, beggars, and prostitutes in the literature, art, and law of early modern Spain.

Sara T. Nalle is Associate Professor of History at William Paterson University. Her publications include *Mad for God: Bartolomé Sánchez, the Secret Messiah of Cardenete* (University Press of Virginia, 2001); *God in La Mancha: Religious Reform and the People of Cuenca, 1500–1650* (Johns Hopkins University Press, 1992); and many articles on aspects of the religious and cultural history of early modern Spain.

Magdalena S. Sánchez is Associate Professor of History at Gettysburg College.

She published *The Empress, the Queen, and the Nun: Women and Power at the Court of Philip III of Spain* with the Johns Hopkins University Press, Baltimore, in 1998 and continues to work on the subject of women, power, and politics in early modern Spain.

Lía Schwartz, Distinguished Professor of Spanish and Comparative Literature and Chair of the Ph.D. program in Hispanic and Luso-Brazilian Literatures at the Graduate Center, City University of New York, has previously taught at outstanding universities in the United States and in Spain. Her expertise on the poet Francisco de Quevedo has resulted in seven books devoted to studies of his work, and she has also written many articles on other Spanish Renaissance topics and genres. Dr. Schwartz serves on the boards of a number of journals of literature and philology and has served as president of the International Association of Hispanists since 1998.

Louise K. Stein is Professor in Musicology at the University of Michigan. Her research on early Hispanic music and baroque has resulted in numerous publications, including the prize-winning *Songs of Mortals, Dialogues of the Gods: Music and Theatre in Seventeenth-Century Spain* (Oxford, Clarendon Press, 1993). She has also served as artistic adviser for a recording of the first New World opera, *La púrpura de la rosa,* which won an award for its contribution to the study and performance of early music, and she is presently working on a recording of the first Spanish opera, *Celos aun del aire matan.*

Suzanne L. Stratton-Pruitt, editor of this volume, is the author of *The Immaculate Conception in Spanish Art,* published by Cambridge University Press in 1994. She has curated many exhibitions of Spanish art in all its variety, with the most recent, "Bartolomé Esteban Murillo, Paintings from American Collections" on view at the Kimbell Art Museum in Fort Worth and at the Los Angeles County Museum of Art in 2002. Dr. Stratton is also the editor of a forthcoming volume on Velázquez's *Las Meninas* in the Cambridge University Press series *Masterpieces of Western Painting.*

Zahira Véliz trained as an art historian and conservator of paintings at Oberlin College and received her Ph.D. at the Courtauld Institute, London. Since 1990 she has worked in London and in Spain, lecturing and writing on technical aspects of sixteenth- and seventeenth-century Spanish painting and drawing. Since 1995 Dr. Véliz has served as the curator of a private collection of seventeenth-century Spanish paintings, drawings, and manuscripts. She is currently writing a monograph on Velázquez for Phaidon Press. Her doctoral dissertation on Alonso Cano is being published by the University of Granada, Spain.

Alexander Vergara is a specialist in Flemish and Spanish seventeenth-century painting and is the author of *Rubens and His Spanish Patrons* (Cambridge University Press, 1999). He has taught at the University of California, San Diego, and in the Department of Art and Archeology at Columbia University. Dr. Vergara is now a curator at the Museo del Prado, Madrid.

I Introduction

A Brief History of the Literature on Velázquez

Suzanne L. Stratton-Pruitt

Diego de Velázquez's first biographer was his father-in-law, the painter and art theorist Francisco Pacheco, whose *Arte de la pintura* was published posthumously in Seville in 1649.[1] Besides singing the praises of the young artist, Pacheco's account provides much useful information about Velázquez's youth and training in Seville, his move to the court in Madrid, and his first trip to Italy.

Another writer who knew the artist was the painter Jusepe Martínez, who devoted several paragraphs to Velázquez in the *Discursos practicables del nobilísimo arte de la pintura,* a treatise that he compiled in the 1670s. It should be noted, however, that Martínez's manuscript was not published until 1852.[2]

A third painter and theorist, Antonio Palomino, born five years before Velázquez died, has also left us an account of the artist's career. His three-volume work *El museo pictórico y escala óptica* was printed in Madrid in two parts, in 1715 and 1724.[3] Volume 3, the *Parnaso español,* includes the first published biographies of Spanish artists from the fifteenth to the eighteenth centuries; the life of Velázquez is by far the longest and most detailed. Although Palomino relied heavily on Pacheco's account of the early decades of Velázquez's life, he also had the opportunity to interview several eyewitnesses to his later career, such as the painter Juan Carreño de Miranda. Moreover, Palomino had access to a manuscript on Velázquez, a biography now lost, by one of the artist's pupils, Juan de Alfaro (1643–80), and he took the scholarly step of corroborating the memories of his informants with information in documents in the royal archives.[4] Since the publication of Palomino's book, the chronology of Velázquez's life and career has been fleshed out, but little changed, by later research.

Diego Rodríguez de Silva Velázquez, son of Juan Rodríguez de Silva and Jerónima Velázquez, was baptized in the church of San Pedro in Seville on

6 June 1599. On 1 December 1610 he was formally apprenticed to Francisco Pacheco; on 14 March 1617 he received his license to practice the art of painting; and on 23 April 1618 he married Pacheco's daughter, Juana. Between 1617 and 1623 Velázquez was active in Seville as a painter of genre subjects, religious works, and portraits. In 1623 he won an appointment to the court in Madrid as *pintor del rey* – painter to the young king, Philip IV. From then until 1629 he remained at the court, painting, among other subjects, portraits of Philip IV and his minister, the Count-Duke of Olivares.[5] During 1629–1630 Velázquez traveled in Italy, a journey whose impact on his art is analyzed by Jonathan Brown in an essay in this volume.

In 1631 Velázquez returned to Madrid to begin a busy decade, during which he would create a number of paintings to adorn the royal palaces. These include equestrian portraits of the royal family; portraits of the king, his brother, and his heir at the hunt; portraits of the court jesters; and one of his great masterpieces, *The Surrender of Breda*. In 1636 Velázquez was promoted to the position of Assistant in the Wardrobe, which was added to his previous appointments as *ujier de cámera* (Usher of the Bedchamber) on 7 March 1627 and as *pintor de cámara* (awarded sometime during 1627–28). During the 1630s and 1640s he painted mostly portraits, with the outstanding exceptions of the *Coronation of the Virgin* and his single painting of a female nude, the *"Rokeby" Venus*. Between 1648 and 1651 the painter was again in Italy, where the king had sent him to buy works of art for the royal collections. While in Rome, Velázquez painted a number of portraits, including his remarkable likenesses of Pope Innocent X and one of his own studio assistant Juan de Pareja. After his return to Madrid, he was appointed in 1652 to the prestigious position of *aposentador mayor de palacio*, a job whose duties kept him busy for the rest of his life with many tasks besides painting – decorating the royal palaces, arranging for court ceremonies, staging masques and festivals – and increasing his reliance on assistants to meet the demand for royal portraits. In spite of these obligations, Velázquez created, around 1656, two of his most impressive works, *The Fable of Arachne (Las Hilanderas – "The Spinners")* and *The Ladies in Waiting (Las Meninas)*.

In 1658 the king nominated Velázquez for a knighthood in the order of Santiago. The resulting inquiry into the artist's genealogy found that he did not have the requisite nobility, a lack that required not one papal dispensation, but two. These were acquired through the king's intervention, and Velázquez was finally granted his much desired knighthood on 28 November 1659. In 1660 he traveled with the king to the Isle of Pheasants at the border between France and Spain, where Philip IV gave his daughter María Teresa in marriage to Louis XIV of France. A month later, Velázquez fell ill. He died in Madrid on 31 July 1660 and was buried in the habit of the Order of Santiago.

Velázquez did not leave behind a "school" of painters trained to continue

his style. In fact, not long after his death, art at the Spanish court took a turn toward a high Baroque manner influenced by the earlier examples of Peter Paul Rubens and Anthony van Dyck, both amply represented in the royal collections. Their bravura compositions and brushwork had profound impact on the work of such late seventeenth-century Spanish court painters as Francisco Rizi, Francisco de Herrera the Younger, and Claudio Coello. Another infusion of Baroque energy at court came in 1692, when the king, Charles I, brought Luca Giordano from Italy to paint the vast fresco decorations on the vaults of the monastery/palace at El Escorial.

When Charles I died in 1700, the long rule of the Spanish Habsburgs ended, and a new king, Philip V, was chosen from the French royal family. Philip and his Bourbon successors introduced to Spain their "French" taste, a courtly style of costume, etiquette, and taste in art more attuned to their sensibilities than Habsburg austerity. The style of the court portraits created by Velázquez, which continued formal iconographic traditions established in the Renaissance by Titian, no longer suited the crowned heads of Spain, who now preferred lighter, brighter, more informal likenesses in the rococo manner.

In 1761, in the midst of decorating the new Royal Palace in Madrid, the Bourbons brought in the Bohemian painter Anton Raphael Mengs to oversee the work. Mengs also served as director of the Royal Academy of Fine Arts of Saint Ferdinand in Madrid and used his influence to foster the new neoclassical style championed by the Spanish King Charles III, who had underwritten the excavations at Pompeii, Paestum, and Herculaneum and had paid for the publication of the engravings after the Roman decorations found there.

These artistic developments in eighteenth-century Madrid explain why Velázquez's name is almost completely absent from Spanish art criticism and commentary in the decades following Palomino's publication of the painter's biography. Nor did it help Velázquez's reputation that several of his most important pictures were destroyed when the Alcázar (the royal palace) of Madrid burned in 1734. Except for some appreciative comments on Velázquez's art by Mengs himself (although he was unmoved from his own neoclassical course and thought that Velázquez should have done more to "improve" on what he saw), the great master of Spanish Golden Age painting attracted little interest. Although Juan Agustín Ceán Bermúdez accorded Velázquez prominent treatment in his *Diccionario histórico* of Spanish artists in 1800, the biography he provided essentially repeated what Palomino had written decades before.[6] In the intervening seventy-five years, no one had thought to search the archives for additional information about Diego de Velázquez – and much had been forgotten.[7]

In the early nineteenth century, however, the painter's popular and critical fortunes soared with the greater exposure of Spanish painting abroad,

especially in France and England. The turbulence of the War of Independence, begun in 1808, followed some years later by the suppression of the monastic orders in Spain, caused the removal of great numbers of Spanish paintings from private palaces, family chapels, churches, and monasteries. These found their way through an increasingly active art market to public and private collections outside of Spain, culminating with the 1838 opening of King Louis Philippe's *Galerie Espagnole* in the Louvre, where artists and art lovers could study Spanish painting firsthand. More important to the enhancement of Velázquez's reputation, however, was the opening of the Museo del Prado in 1819. For the first time, the rich collections that had been gathered by the Spanish Habsburgs since the reign of Charles I (Emperor Charles V of the Holy Roman Empire) and expanded by the Bourbon kings were placed on public view. Among the stars of the collection were the paintings that Velázquez had created for Philip IV, which had never left the royal palaces of Madrid and its environs. Following the excitement of Edouard Manet, Henri Regnault, and other painters over their discovery of Velázquez's subtle compositions and brilliant painting style was a new curiosity to find out more about the painter's life and works.

During the second half of the nineteenth century, Spanish scholars searched the archives for more information about Velázquez. Among the most diligent of these were Manuel Zarco del Valle and Gregorio Cruzada Villaamil, whose discoveries were published in the 1870s.[8] The work of Cruzada Vallaamil was especially important; his *Anales de la vida y las obras de Diego de Silva Velázquez, escritos con ayuda de nuevos documentos* (Madrid, 1885) is the basis on which much modern scholarship has relied. Since the turn of the nineteenth century, work in the archives has continued to be fruitful, turning up, for example, the inventory of Velázquez's possessions at the time of his death[9] or the body of documents related to the decoration of the Hall of Realms of the Buen Retiro Palace, in which he played a substantial role.[10] Additional information will undoubtedly continue to come to light, but we probably already know most of the facts relevant to Velázquez's life and work. That is, we know the facts. Contemporary observers note Velázquez's "phlegmatic" character but say little else about what kind of individual he was. Much more important to Pacheco, for example, is Velázquez's estimation in the king's eyes: "The liberality and affability with which Velázquez is treated by such a great Monarch is unbelievable. He has a workshop in the King's gallery, to which His Majesty has the key, and where he has a chair, so that he can watch Velázquez paint at leisure, nearly every day."[11] This sort of anecdote says more about Philip IV than about Velázquez, but the most fastidious research has yet to discover any cache of personal letters that might reveal to us more of the painter's feelings and personality, though the trajectory of his career at the court suggests a highly ambitious social agenda.[12]

The renewed interest in the artist's life brought with it a desire to identify his works. Pacheco had discussed Velázquez's earliest paintings, those created in Seville, emphasizing the *bodegones* (kitchen and tavern scenes) for their verisimilitude, painted "from life" in the manner of Caravaggio. Palomino had cited also many of Velázquez's canvases in the course of recounting his life, and although Ceán Bermúdez had not improved on Palomino's biography, he deserves credit for having been the first writer to atttempt to compile an authoritative list of Velázquez's works, listing 51 pictures.

Since Velázquez was rediscovered by both his fellow Spaniards and by artists and critics abroad at about the same time in the nineteenth century, it is not surprising that some of the earliest studies of his life and work were produced by an Englishman and an American. William Stirling-Maxwell's *Annals of the Artists of Spain* (1848)[13] and his *Velázquez and His Works* (1855) were followed by Philadelphia native Charles B. Curtis's *Velázquez and Murillo: A Descriptive and Historical Catalogue* (New York, 1883). Cruzada Villaamil,[14] Sterling-Maxwell, and Curtis each attempted to compile a definitive list, or "catalogue raisonné," of Velázquez's paintings." In an appendix to his 1848 study of Spanish art, Stirling-Maxwell listed 226 works by Velázquez. Cruzada Villaamil listed 240 paintings but did not consider all of those to be by the artist's hand. Curtis was most generous, attributing 274 paintings to Velázquez. Both Stirling-Maxwell and Curtis gathered masses of engravings after paintings thought to be by the artist and depended on them for the compilation of their catalogue entries. A later critic called Stirling-Maxwell's 1848 book "a delightful work, in which, however, the bibliographical element is perhaps stronger than the art criticism."[15] In a dramatic turnaround, the Spanish artist and critic Aureliano de Beruete y Moret, in 1898,[16] accepted only 83 works as authentically by Velázquez. Beruete's response to the methods of his predecessors, though severely reductive, is an understandable reaction to outdated methodology and the nineteenth-century tendency to attribute even very questionable pictures to revered masters. August L. Mayer returned to the expansionist vision of the artist's oeuvre in his catalogue of 1936,[17] in which he accepted 164 paintings as authentic and published a total of 610 works: his book is useful primarily as a guide to shop work and followers of Velázquez. Today, scholars accept an oeuvre that numbers about 125 paintings; the catalogue raisonné generally relied on is by José López-Rey, first published in 1963 and recently in a new edition.[18]

Although a catalogue raisonné is a basic reference for questions of attribution, dating, condition, and provenance,[19] Velázquez's life and career have also been the subjects of many monographic studies, most without catalogues. The changing interpretations of Velázquez's art over time serve as guides to evolving tastes and values – even when they fail to help us understand his art better. In the hands of nineteenth-century writ-

ers and critics, for example, Velázquez became both the ultimate realist and the first impressionist. Both ideas built upon long-standing notions about the artist.

For Pacheco, Velázquez's early *bodegones* and portraits had epitomized "the true imitation of nature." Likewise, over two hundred years later, for an anonymous critic writing about the exhibition of Spanish art at the New Gallery in London in 1896, Velázquez's "uncompromising naturalism" was the salient characteristic of his work: "The naturalism of Velázquez as here so completely illustrated, stands by itself; it is not the smiling, sympathetic naturalism which Murillo later on developed, or the naturalism of the great Dutchmen, consciously exaggerating the grotesque side of their subject from the point of view of the humourist; it is something simpler, more purely objective, more truthful than all this."[20] Although for some nineteenth-century artists, Velázquez was the "painter of painters," Beruete, himself an artist, criticized Velázquez for never working without a model. In turn, a contemporary critic decried Beruete's statement that, "The poverty of his imagination did not allow him to give free rein to his fancy," by asserting: "The opinion that a painter's imagination is most clearly exhibited by the portrayal of the unseen is too vulgar to need refuting, and assuredly Velasquez had so fine a sense of his art that he need not waste his ingenuity in the contriving of curious subjects. Nor is it becoming to charge the painter with a trammelled fancy, whose sincere vision and miraculous accomplishment revealed to the world a new art."[21] Beruete was not the only writer to interpret Velázquez's work as realistic and thus as the harbinger of modernity in painting. Indeed, this was the standard interpretation of his achievement in the books of Stirling-Maxwell and Paul Lefort (1888)[22] and by Carl Justi in his magisterial *Velazquez und sein Jahrhundert* ("Velázquez and his Times"), first published in 1888.[23]

By the close of the century, Velázquez was additionally annointed the father of impressionism, particularly in R. A. M. Stevenson's *Velázquez,* published in London in 1895.[24] Stevenson was a Scottish painter who had studied in Paris with the academic artist and influential teacher Carolus-Duran. Stevenson's small book on Velázquez was more an appraisal of Velázquez's painterly technique than a biography, and his critical evaluation was seen through the lens of his own artistic training and interests. He admired the "apparent artlessness" of Velázquez's technique. He identified Velázquez's crowning achievement as "unity of impression" and so considered Velázquez the first impressionist. While this conclusion is completely ahistorical, it must be granted that Stevenson captured Velázquez's technique beautifully in words. About a portrait of the Infanta Margarita, he wrote: "every inch of the dress is painted by Velazquez with a running slippery touch which appears careless near at hand, but which at the focus gives colour, pattern, sparkle, and underlying form with the utmost preci-

sion and completeness."[25] Justi, Stevenson, and Beruete were joined in their conception of the artist by Sir Walter Armstrong, director of the National Gallery of Ireland, who asserted in *Velázquez: A Study of his Life and Art* (1897) that "impressionism was first fully made manifest in the work of a portrait painter, Velázquez."[26] After having been largely ignored for decades following his death, Velázquez had become the artistic man of the hour. Reviewing the four books mentioned above, a critic wrote: "After two centuries of neglect, Velazquez now occupies a position which is, we should imagine, without parallel in the history of art. He is no longer an old master, he has become a living influence on modern painting; it is as if he had recently opened a studio."[27] Another writer went so far as to title an article "Velázquez and his Modern Followers."[28] However, the novelty of impressionism faded with the development of fauvism, cubism, and other artistic movements of the early twentieth century, and, for a while, production of books about Velázquez slowed.[29]

But to see Velázquez as the great champion of naturalism (as opposed, we may assume, to the idealized classicism of Guido Reni, or to the frothy rococo elegance of Watteau or Boucher) is to overlook the artfulness of his art. The view of Velázquez as a realist, or a naturalist, or even an impressionist, is misleadingly reductive, for regarding him as a mere copyist of nature ignores the intellectual wherewithal that he brought to his work. Nineteenth-century impressionists might have needed little beyond bringing their paints, brushes, and an easel outdoors, but it behooved a seventeenth-century court painter to be a learned man. In his biography of Velázquez, Palomino emphasized the artist's education beyond the preparation of a support or the grinding of pigments:

He practiced the lessons to be found in the various authors who have written distinguished precepts on painting. In Albrecht Dürer he sought the proportions of the human body, anatomy in Andreas Daniele Barbaro, geometry in Euclid, arithmetic in Moya, architecture in Vitruvius and Vignola, as well as in other authors from all of whom he skillfully selected with the diligence of a bee all that was most useful and perfect for his own use and for the benefit of posterity. . . . Velázquez was also well acquainted and friendly with poets and orators, for it was from such minds that he gained much with which to embellish his compositions.[30]

When the inventory of Velázquez's book collection was published in 1925, scholars slowly began to recognize that, in Jonathan Brown's words, "Velázquez had used his eyes to read as well as to study nature. Thus, his art could be connected to several branches of Renaissance learning."[31] This revised vision of Velázquez's art is taken up by the historian José Antonio Maravall in his consideration of Velázquez's position in the history of ideas.[32] Maravall asks that we place Velázquez in the age of Galileo, Descartes, Pascal, Leibnitz, Locke, and Newton and that we bear in mind that Velázquez was not the "genial inculto" suggested by partisans of the

painter's adept capture of reality, but rather a cultivated and well-read man in a period when painting was understood to be a "science."

This "new" Velázquez, a painter whose depth was largely unsuspected by his nineteenth-century admirers, has inspired considerable research into the meaning of Velázquez's works. This is particularly the case for his enigmatic "history paintings" such as *Los Borrachos*[33] and *The Fable of Arachne (Las Hilanderas).*[34] Even more striking are the interpretations of his group portrait *Las Meninas*, which are so numerous that they have inspired the compilation of bibliographies dedicated to this one painting.[35] *Las Meninas* has as well attracted the attentions of philosophers such as José Ortega y Gasset[36] and Michel Foucault.[37] The latter's 1966 interpretation of *Las Meninas* as a classical representation has spawned a number of articles influenced by linguistics and structuralism.

Traditional art historians have produced a plethora of books and articles situating Velázquez's work within the context of his time, particularly at the court of Madrid. Justi's 1888 monograph stands as the noble ancestor of monographs about the artist that discuss the many duties he performed for the king of Spain other than painting. Those tasks, through which Velázquez sought to enhance his prestige at court, have frustrated some writers such as Beruete, who suggested that if Velázquez had never entered the royal palace, "his production would not have been so restricted." However, there is a fascination with royalty even today that makes Velázquez's proximity to Philip IV of Spain a matter of keen curiosity. In a review of Beruete's book, an anonymous critic scolded him for even suggesting that Velázquez's career might have unfolded more fruitfully without the demands of being Painter to the King: "The author of 'Philip IV,' of 'Pope Innocent,' of 'las Meniñas' did not die with the consciousness of an undelivered message. He was no Keats perished with talent unfulfilled. The offices he held at Court, while they sensibly increased his dignity, did not diminish his work by a single stroke of the brush."[38] The critic, who tellingly entitled his review "Velasquez the Courtier," then goes on at length to tell the story of Velázquez's career at court without ever discussing the paintings, upon which it had been Beruete's intention to focus his reader's attention.

Velázquez's steady climb in status at the Madrid court, the special attention the painter to Philip IV was accorded on his travels in Italy, and his difficult, ultimately successful campaign to be received into the Order of Santiago – all this makes for an entertaining biography. However, Velázquez's career as a courtier who was more than a painter has deeper implications. Ortega y Gasset suggested that what mattered most to Velázquez was not artistic, but social, distinction. Ortega held that owing to the circumstances of Velázquez's birth and training, "in the deepest recesses of his soul he obeyed this imperative: 'Strain every nerve to become a nobleman.'"[39] In a monograph on Velázquez for a general audi-

ence published in 1969, another author has noted that, at the turn of the nineteenth century,

the biographical or autobiographical associations of Velázquez's pictures were virtually ignored – or rather, deliberately set aside. These were the heady days of the rediscovery of Velázquez's true stature as a painter; there was no time to spare for petty details of seventeenth-century history . . . the labours of such critics as Karl Justi, whose encyclopaedic study of Velázquez had appeared in 1888, seemed tedious and irrelevant.[40]

He goes on to insist that Velázquez did not "see himself simply as a painter and portraitist, but also as an architect, decorator and stage-manager of royal progresses and pageants. These were his official duties during a successful career at court that lasted for nearly forty years."[41]

This approach to Velázquez reached its apogee in Jonathan Brown's *Velázquez: Painter and Courtier* (New Haven and London, 1986). Brown chronicled Velázquez's career with special emphasis on the various tasks undertaken for the court outside of painting, demonstrating that analysis of the decorative programs Velázquez created for the royal palaces, and of his choice of works of art purchased for the king in Italy, have much to teach us about patronage in seventeenth-century Spain and the use of art to create a compelling iconography of monarchy.

More recently, impelled by the fourth centenary of Velázquez's birth in 1598, renewed attention has been paid to Velázquez's formative years in Seville. The catalogues of two recent exhibitions in Edinburgh (*Velázquez in Seville*, 1996) and in Seville (*Velázquez y Sevilla*, 1999) included essays about the painter's years before his life at the Madrid court.[42] These studies place the young Velázquez in the context of a cosmopolitan city with a cultivated elite that fostered and supported a lively intellectual and artistic life. Recent scholarship has enhanced our understanding of the complex milieu of the visual arts in which Velázquez's young talent was nurtured, as well as the cerebral aspects of his training under Pacheco. When Velázquez arrived in Madrid, he brought with him the best artistic education available in contemporary Spain (outside of Madrid), as well as an originality, an inventiveness, encouraged by the varied art market of Seville, where collectors commissioned and purchased not only religious subjects and portraits but the still radically new *bodegones* created by a young native painter.

Recent Velázquez research has, as well, paid considerable attention to Velázquez's technique, not only how he was taught to paint as a youth in Pacheco's shop but how he actually painted during his years at court. Modern science has enabled us to see Velázquez's paintings as they were never before seen. Conservators and conservation scientists, together with art historians, have used techniques unimaginable to earlier generations – microscopy, microchemical analysis, radiography, and infrared reflectogra-

phy among them – to plumb the secrets of the painter's magic.[43] Such technical analysis is obviously of great importance to the curators and conservators who are responsible for preserving Velázquez's paintings. However, technical analysis also reveals exactly how the artist painted: that is, how he adapted his media (supports, pigments, and binders) and the basic techniques learned by every painter-apprentice, to serve his pictorial vision. Technical analysis has revealed how Velázquez, using the same elements at the disposal of even the most ordinary of seventeenth-century painters, transformed their material nature into works of genius, achieving what Stevenson eloquently called "a running slippery touch which appears careless near at hand, but which at the focus gives colour, pattern, sparkle, and underlying form with the utmost precision and completeness."[44]

<p style="text-align:center">✳ ✳ ✳</p>

The *Cambridge Companion to Velázquez* offers the reader nine further essays on Velázquez. The first three of these, by Zahira Véliz, Jonathan Brown, and Alexander Vergara, focus on traditional art-historical concerns about the painter's training and the influences – especially those from Italy and northern Europe – on his works. The next two, by Antonio Feros and Magdalena S. Sánchez, both historians of early modern Spain, focus on Velázquez's work as a portraitist. Dr. Feros's piece explores contemporary belief in the actual effect of a portrait of the monarch upon the viewer, and Dr. Sánchez brings our attention, for the first time, to the female members of the Habsburg dynasty whose portraits Velázquez painted.

Although Velázquez painted relatively few religious subjects as compared to other Spanish artists of his time, he did paint some. The article by historian Sara T. Nalle offers a brief analysis of the religious tenor of Velázquez's time and of the issues of concern to Spanish churchmen and their parishioners during most of the seventeenth century.

The final three essays examine other aspects of the cultural life of the court that Velázquez served so brilliantly. In his service to the king he was joined by a number of other original and talented men of the era, including the poets Luis de Góngora and Francisco de Quevedo, whose contributions are presented by Lía Schwartz, and the court playwright Calderón de la Barca, whose work is discussed by Margaret R. Greer. The role of music at court and, especially, in Velázquez's paintings, is the subject of a pioneering article by Louise K. Stein. Each of these essays brings completely new light to bear on Velázquez. It is our hope that these new and innovative additions to the literature on Velázquez will increase not only our readers' understanding of the artist's work but their delight in it as well.

2 Becoming an Artist in Seventeenth-Century Spain

Zahira Véliz

To understand how an artist was trained, it is necessary to follow two paths of enquiry. On the one hand, the practical conditions of his life, and the skills required by his art must be studied to see how he learned to manipulate materials so that they would be an ally, and not an adversary, to his creative expression. This kind of research is aided by modern analytical techniques that have made it possible to identify with scientific certainty the pigments and media employed by artists of the past and, also, to glimpse aspects of the artist's process hidden below the surface of the finished work. The other path of study is less well marked as it progresses toward an understanding of the role of art at a given moment in a given culture. Without this, knowledge of artists' training stands in isolation. The goals of artistic production provide an essential context for understanding the mode of artistic training prevalent at a given time and place.

Learning to paint in early seventeenth-century Seville was a process that occurred in a unique social context whose characteristics differ strongly from those that have been analysed through the study of contemporary Italian or Netherlandish centres. Seville in the early seventeenth century was a dynamic metropolis whose impending economic decline was not yet sharply felt, and the city could fairly claim to be both a great European city and the capital of the Spanish Indies. The traditional guild system under the control of civil authority was still the official structure within which artists were trained and were required to work. At the same time, in intellectual circles there existed a passionate interest in the visual arts in which modern, humanist ideas about literature blended with Italian sixteenth-century artistic theory. Perhaps most important, these aspects were all coloured by the consciousness of the inspired purpose of artists in a post-Tridentine catholic culture. The proceedings of the Council of Trent (1545–63) established the all-embracing

strategy of the Catholic Church in response to the division of western Christianity by the rise of Protestantism. Many of the edicts combined rebuttal of Protestant assertions and also provisions to correct from within the established Church the many ills that had long beset it. The purpose of visual art to instruct the mind and elevate the spirit was outlined in the Council's *Decree on the Invocation, Veneration, and Relics of Saints, and on Sacred Images* and the act of artistic creation was interpreted almost as a form of religious worship.[1] Officially, clarity of message and decorum in representation became the touchstones of artistic merit. Bishops were made responsible for guarding the standards of artistic production and for policing the content of all images on public view in their dioceses. The coexistence of the rigid traditional structures of guild and church, alongside the innovative notions about artistic creation circulating in Seville's intellectual elite, set up an exciting tension. In this atmosphere, an intelligent, gifted young apprentice could acquire not only the time-honoured technical knowledge and valuable professional contacts imparted by the apprenticeship system, but if he were fortunate enough to find himself in the studio of a learned, enlightened master, he could also come to appreciate the subtle attraction of the philosophical dimension of painting.

To study how painting was practised and taught in Seville is to come quickly face to face with the artist and art theoretician, Francisco Pacheco (1564–1644).[2] Pacheco was among the most successful painters of his generation in Seville,[3] and the master to whom Velázquez was apprenticed in 1611 at the usual age of twelve years. Pacheco seemed never to lack prestigious ecclesiastic, monastic, or private commissions. Prominent in the guild, he was Inspector of Images for the Bishop, and, later, he fulfilled a similar office for the Holy Inquisition. He enjoyed the esteem and friendship of eminent humanists and theologians and the artistic patronage of Don Fernando Enríquez Afán de Ribera, Third Duke of Alcalá (1583–1637). The learned climate of Pacheco's studio was rare at a time when most artists could barely read, let alone collate, Italian art theory and current theological argument, as he did in his treatise *Arte de la pintura*.[4] Pacheco trained two young apprentices who were destined to rise to the apex of their profession – Alonso Cano and Diego Velázquez. Athough their mature pictorial styles appear to owe little to the master, closer study of their relationship reveals a common concern for the representation of reality with decorum, however varied were their modes of expression. The intellectual and moral rigour with which Pacheco engaged the art of painting is recorded in *El arte de la pintura*, a compilation of many years of observations and experience brought together with extensive quotations from authoritative writers of antiquity as well as the recent past. Pacheco certainly had firsthand knowledge of the influential artistic ideas of figures such as Benito Arias Montano, Philip II's librarian at the Escorial (Fig. 1),

and Pablo de Céspedes (a fellow Andalusian artist and theoretician who had spent time in Rome), as both were his friends. The citations in the *Arte* reveal that Pacheco had read nearly all that could be known at the time about the theory and practice of art, and his frequent references to Paleotti's *Discorso intorno le immagini sacre e profane*,[5] keep constantly before the reader the sense of divine purpose in the making and the uses of art. The *Arte* has become an invaluable work for understanding the theoretical parameters within which the art of painting was taught and practised in Pacheco's studio. It would be wrong to infer that the attitudes and techniques recorded in the *Arte* are typical for Spanish artists generally. On the contrary, they represent the views of a cultured man who was also a painter – by no means an ordinary occurrence at this time when the majority of practising artists had at best a rudimentary education. While most artists who rose to prominence in important cities or at the Habsburg court were probably literate, there were exceptions, such as the sophisticated and successful artist Antonio de Pereda, who reputedly was unable to sign his own name.[6] To understand the forces at work in a young artist's formation it is useful to look both at traditional practice centred on the guilds, and the theoretical concerns evident in the *Arte*. Pacheco's studio is of specific interest because Velázquez was trained and educated there. However, it is important to bear in mind that Pacheco's *milieu* was exceptional in early seventeenth-century Spain, where most practising artists lived in a state of economic uncertainty and cultural limitation more extreme than that of their contemporaries elsewhere in Europe.[7]

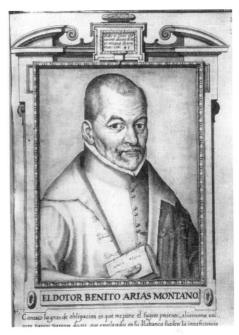

1. Francisco Pacheco, *Benito Arias Montano*, drawing (Madrid, Museo Lázaro Galdiano).

To characterise Pacheco as one of the great men of learning of his age would be to overstate the case. Nevertheless, he is a very convincing example of the erudite artist he undoubtedly aspired to be. His friendships with the leading theologians, ecclesiastics, and writers of his day made him one of a very few practising artists around 1600 in Spain who could carry on the *ut pictura poesis* debate in an informed manner. Pacheco's combined interests of literary and artistic theory are everywhere evident in his writings. The community of scholars, artists, writers, theologians, and statesmen whose ideas and accomplishments he admired is recorded in the

drawings and inscriptions he made for his *Libro de descripción de verdaderos retratos de ilustres y memorables varones*[8] (Fig. 1). The omnipresence of the Church both as client, arbiter of taste, and censor; the tension produced by the medieval guild system having to accommodate the "erudite painter"; the daily awareness of Europe beyond the frontiers and America beyond the sea: all these combined in the heady cultural climate of Seville, of which Pacheco was both product and contributor, and in which Velázquez learned how to paint.

Conditions of Apprenticeship

Velázquez's career began conventionally enough when his father placed him as apprentice for five years under contract to Francisco Pacheco.[9] The apprentice's life was that of a servant working in the master's studio, at first undertaking menial tasks, then slowly, as his competence grew, aiding the master in making art. The apprentice lived in the house of the master, by whom he was also fed and clothed. The master was obliged to teach his apprentice everything pertaining to the art of painting, "hiding nothing from him."[10] It is easy to imagine that in such a system, abuses might have been common, and this is borne out by many clauses in apprenticeship contracts prohibiting the master from imposing scullery work or beating the boy. At the end of the apprenticeship, the young artist would undergo an examination by guild officials to determine his proficiency, or mastery of theoretical and practical aspects of his art. Municipal guilds were governed by standards expressed in specific civil regulations known as *Ordenanzas municipales*. In turn, the guilds examined and licensed apprentices who wished to qualify as masters and so be entitled to contract for artistic commissions and to train apprentices. This system, while guaranteeing high technical quality in the work of guild members, encouraged a conservative, protectionist climate for artistic production. Recent study has shown that most apprentices in Seville came from lower-class families.[11] The art of painting was still considered a craft, and the unpredictable nature of demand may have lessened its popularity as a profession. Nevertheless, a great many workshops managed well enough on meagre profits from decorative painting and the production of cheap, repetitive devotional images.

The apprentice lived on intimate terms with the master's family, and so it is unsurprising that a promising youth might find himself engaged to marry the master's daughter or niece. This happened to Velázquez, who, upon qualifying as a master painter, promptly married Doña Juana Pacheco, his teacher's daughter. Family loyalties thus established also played a part in the organisation of large decorative programmes. It was usual for a single well-established master to contract huge projects that

might include not only the paintings for an altarpiece but also its architecture and sculpture and their polychromy. In these instances the specialised work would be subcontracted to other masters. The success of this practice depended on the "general contractor" belonging to a reliable network of specialists who were both accomplished and efficient. Such arrangements were often shaped by family ties, with the father-in-law or uncle subcontracting to his son, nephew, son-in-law, and so forth. The reliability and efficiency of the various masters involved on a large project influenced the scale of profit to be expected by all when the finished work – whether a single painting or an entire altarpiece – was valued by the official appraisers. According to law, both client and executor of a commission would name independent appraisers to arrive at a fair value for the work. In practice this system did not always run smoothly and often there was recourse to legal action.

It is a characteristic of the collaborative enterprise of painting in Seville during Velázquez's youth that distinct personalities are sometimes discernible in the large commissions of a major studio, such as that of Pacheco or Juan del Castillo. Often in such works a number of different hands can be distinguished, although it has not always been possible to identify these with specific assistants. Pacheco's *Christ Attended by Angels* (Fig. 2) or the Montesión altarpiece of 1636 contracted by Juan del Castillo (Seville, Museo de Bellas Artes) are examples of large works based on a unified design but executed by various different hands.

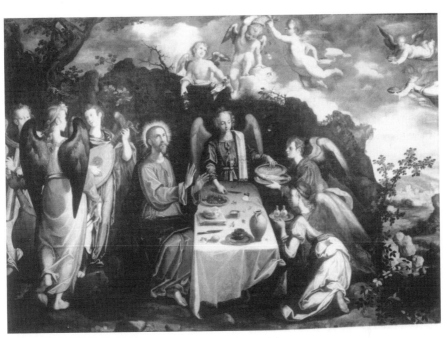

2. Francisco Pacheco, *Christ Attended by Angels*, 1616 (Castres, Musée Goya).

In the first stages of apprenticeship the pupil was taught the basic skills involved in preparing paint and varnishes so that he could quickly become useful by undertaking the many menial tasks of preparation while he gained familiarity with the materials of his profession. He would be set drawing exercises to begin training the hand and eye. Pacheco favoured a methodical didactic approach in which initially the beginner would draw only contours, until he could accurately draw the single features of the human face, and, proceeding from parts to the whole, the human body in a variety of poses and lights. The apprentice would do all this by copying, time and again, from his master's prints or drawings, or perhaps from a handbook or a drawing manual with models of eyes, mouths, noses, hands, feet and figures, designed to help the beginner acquire skill (Fig. 3). Later, the pupil, still copying, would work from plaster casts, or, occasionally from fragments of antique sculpture. In the stages of learning described by Pacheco, acquiring proficiency in drawing precedes colouring with paint. Many apprentices were only expected to advance thus far, and it was only for the gifted or the very hardworking few to master creative invention.

As elsewhere in Europe, drawing was the medium through which the artist's inventions were transferred from the imagination to visible form. In Spain, at least in the early part of this period, in order to develop this faculty, an apprentice would copy extensively after prints or drawings from the master's collection. In contrast to the practices established in Italy, for example, at Bologna with the Carracci, there is no evidence to suggest that drawing from life was practised regularly, nor was it considered in Spain as a principal source of new ideas. This may seem less surprising if we recall the recommendation of the treatise writer José García Hidalgo to the young artist that the female figure should be taken from anatomical drawings, because thus "they will know how to [draw such things] and they will be able to make the arm of an Angel, or a leg, or a woman, for the painter must be ignorant of nothing in nature, for which reason statues are used, from which such things should be studied without risking the natural danger we incur with the feminine sex; and this is how I have studied and learned [. . .]"[12] The particular emphasis with which Pacheco describes Velázquez's practice of drawing from nature gives the impression that this was exceptional.

I myself keep to nature for all things; and if it were possible, I would work with nature always before me, not only for the heads, nudes, hands and feet, but also for the draperies of silks and other fabric, and this is the best thing to do [. . .] thus works Jusepe de Ribera, since his figures and heads, alone amongst all the great paintings of the Duke of Alcalá, appear to be living, and everything else, merely painted, even if hanging next to a Guido [Reni]; and in the work of my son-in-law, who follows this same way, the same difference can be seen since he, too, always works from the life.[13]

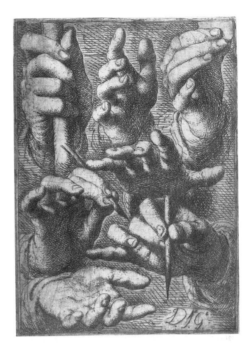

3. José García Hidalgo, *Studies of Hands,* etching from *Principios para estudiar el nobilísimo y real arte de pintura,* published Madrid, 1693 (Madrid, Biblioteca Real, Patrimonio Real).

By and large, however, relatively little life drawing was practised in Spain during the years of Velázquez's apprenticeship. Later, there were occasional informal life-drawing sessions in artists' studios in Madrid ca. 1650, but properly instituted academies of art did not appear until much later in Seville, Valencia, and Madrid.[14]

It has been long recognised that the place of drawing differed in Spain from its role in Italy. While in both cultures drawing was the medium of artistic invention, in Spain, drawing was taught not so much as a means of enabling the young artist to study nature, and to improve upon what he found, but more as a technical skill necessary to the creation of new visual statements formulated from a recognised vocabulary. This vocabulary was made up of images and iconography authorised by convention, and by the new, all-important *desiderata* of decorum and narrative clarity. It was a vocabulary limited by post-Tridentine codes and the censorship of the Inquisition, and assimilated through copying prints, drawings, paintings, and sculpture by recognised masters of the past.

Material Considerations

The master undertaking a large commission was ultimately responsible for the quality of the whole, including the component parts that he may have contracted out to his usual collaborators. For this reason good materials

and knowledge of their properties as well as sound technique were essential to his success, and the principal art treatises written in Spain during the seventeenth and early eighteenth centuries included major sections concerning these practical aspects.[15] Naturally artists learned not from treatises but from their masters by example and by practical instruction in the workshop and studio. Yet the information set down in writing, if analysed critically, is invaluable as a standard against which to compare and test observations drawn from authentic surviving paintings.

The inventory made in 1638 of the contents of the studio of the royal painter Vicente Carducho gives an idea of what materials and resources were to be found in the well-equipped studio of a court artist.[16] Carducho owned several thousand prints and drawings, and dozens of small-scale figures made of plaster, paste, wax, and so on. Some of these at least were likely to have been used in the course of composing his pictures. For example, small figures were sometimes arranged in tableaux and artificially illuminated so that the fall of light and shadow could be studied. Practical equipment included several hundred brushes, engraving tools, straight-edge rulers, squares, a burnisher for gilding, an enormous variety of pigments including lead-tin yellow, artificial copper blue, red earth, yellow lake, azurite, various grades of carmine, malachite, verdaccio, verdigris, smalt, ultramarine, and white lead. Studio furniture included trunks, storage cabinets, boxes, stools, benches, a large table, two palettes, and five easels. Knowledge of the varied mineral and organic pigments available and their behaviour in different media would be gained firsthand by the apprentice as he assisted the master in the early years of his contract in grinding the pigments to a fine powder and mixing them with linseed oil or egg yolk (for tempera) to the exact consistency required by the work that the master was painting. Equally, the young artist would learn the selection and preparation of canvas for painting by the application of earth pigments ground in linseed oil, and even how to make brushes, selecting hairs of various animals such as boar, squirrel, cat, and mongoose for brushes of varying qualities. The emphasis on quality of craftsmanship in the *Ordenanzas* (civil regulations governing guild practice) suggests that high standards were not always met; perhaps expensive pigments were adulterated with inferior grades, or detrimental shortcuts were taken in the time-consuming preparation of canvas or wood panel for painting. The importance of sound knowledge of the selection and preparation of colours and media derived from technical perhaps even more than from aesthetic concerns at this period. It is probable that in Pacheco's workshop little was left to chance when it was time to paint, the composition having been thoroughly worked out in finished drawings, of which many survive as examples of Pacheco's methodical approach to creative invention. In this way of working the potential of paint to create texture and expressive

handling would tend to be overlooked, whereas its properties of colour and density were exploited to the full.

Practical Skills

Pictures painted by Velázquez in the years 1617–23 are consistent in technique and materials with the methods he would have learned in Pacheco's studio. These paintings have been studied in detail and provide the only sound body of technical knowledge available about painting methods in early seventeenth-century Seville. When paintings by other artists – Pacheco foremost among them – can be studied, a more critical characterisation of the painting methods of the period will become possible. Linen canvas was the principal support for paintings, although panels were still occasionally used. The stretched canvas was made ready for painting by applying a sizing layer followed by a preparation of earth pigments ground in linseed oil. The ground or preparation layer provides an even surface for the application of paint, while preventing absorption of the medium by the canvas. By the seventeenth century artists everywhere had begun to exploit the optical possibilities of coloured or toned grounds. However, Pacheco is specific in his recommendation of a particular material:

The best and smoothest priming is the clay used here in Sevilla, which is ground to a powder and tempered on the stone slab with linseed oil. . . . This is the best priming, and the one I would always use without further modifications, because I see my six canvases in the cloister of the Mercedarians conserved without having cracked nor shown any sign of flaking since the year 1600 when they were begun.[17]

This heterogeneous mixture of clay, iron oxide, and silica, is probably the principal component of the dull brown grounds found without exception in Velázquez's Sevillian paintings. Apparently the same ground appears in most contemporary Sevillian paintings, although hetereogeneous preparations of this kind were by no means exclusive to Seville. The drab earth tone of the canvas preparation or ground could be exploited in various ways with the available pigments for achieving characteristic colour effects. The use of a dark red or brown ground lends itself to the efficient depiction of strongly contrasting light and shadow. The depth of the shadow is quickly achieved by either using the ground itself as the shadow, or by darkening it further with a transparent glaze. The light tones must have sufficient opacity to cover completely the dark ground. With this method the artist can achieve a broad range of cool half-tones and warm highlights by varying the thickness of the paint applied over the ground. In rigorously modelled compositions, dark shadows in high contrast with well-defined highlights heighten the plasticity of the forms, producing the

style of tenebrism. Velázquez's early paintings are all based on this kind of technique, which he must have learned from Pacheco, but which the younger man adapted to the naturalism so evident in his work at this time.

It is intriguing to imagine the young Velázquez face to face with his canvas, stretched and prepared an even dull brown – what was the next step? There is reason to believe that as apprentice and young master, still influenced by Pacheco, Velázquez worked from fully resolved drawings, although none of these is known today. Certainly this was the method advocated by Pacheco, who wrote,

> Cartoons for pictures to be painted in oil are rarely made the same size, so the figures or histories must be drawn onto the [. . .] canvases [. . .] from a small preparatory drawing by eye or by using a grid [. . .]. The only difference in drawing onto the various surfaces to be painted is in the kind of crayon (ocreón) that is used. [. . .] From an appropriate distance . . . block out all of the figure or history, stepping back to look at it often, and erasing and redrawing until it agrees with the design. The sure and good grace of the entire work lies in the proper delineation of the figure or history, because it is certain that all the difficulty of painting consists in achieving the contours. After the entire picture is well-proportioned and outlined, the various figures are refined using smaller points . . . thus . . . all the details to be painted are perfected.[18]

He then advises that before beginning to paint, "everything to be painted has been drawn correctly with accurate profiles".

Although the quest for preparatory drawings, or even the presence of underdrawing on the brown earth-coloured ground is frustrating in Velázquez's Seville paintings, Pacheco's own drawings can give an idea of the small preparatory drawings with "accurate profiles". The finished drawings of St. John the Evangelist (Fig. 4), and St. Jerome (Alcubierre collection, Madrid) are typical of Pacheco's composition drawings, in which exact contours are given relief with white highlights and ink wash shadows. The analysis of the form into precise areas of light and dark would have made such drawings instructive to pupils. Drawings of this kind were probably kept both for copying by apprentices and as compositional references. For example, St. Jerome, dated to 1605, was used again for an altarpiece in 1610–13. St. John the Evangelist, with an autograph date of 1632, is closely related to Velázquez's painting of this subject of ca. 1619–20 (Fig. 5). There is yet another drawing attributed to Pacheco of St. John on Patmos (Uffizi), which is closely related to a panel by Pacheco, Velázquez's painting of this subject in the National Gallery, London, and the British Museum drawing. Recycling compositions of sound iconography must have been inevitable in the intimate milieu of Pacheco and Velázquez in Seville. Without any drawings firmly attributed to Velázquez for this period, it is difficult to say if Pacheco influenced Velázquez, or if the teacher took inspiration from his gifted pupil. The kinship of these draw-

ings with Velázquez's painting does in any event show similarities in the structure of drapery folds, organisation of light and shadow, and emphasis on contours that are consistent with Velázquez's early painting method.

Recent technical study of some of Velázquez's early paintings has made it possible to describe the characteristic process he used to pass the image from a finished drawing onto the painting surface. Pacheco's belief of the supreme importance of accurate, analytical drawing as the foundation of good art is evident in the method of his pupil. Before beginning to paint, Velázquez "drew" with a pointed, rather stiff small brush that produced a thin graphic line that stood in relief to the preparation layer (Fig. 6).[19] Pacheco's instructions suggest that a preliminary sketch in chalk or charcoal may have guided the brush drawing. The principal contours were carefully described with the pointed

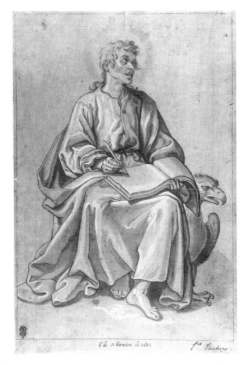

4. Francisco Pacheco, *Saint John the Evangelist,* drawing (London, Trustees of the British Museum).

brush and sometimes, in areas such as hands or ears, an even finer line is evident, which might have been made by a sharpened chalk or white lead drawing point. Although these fine graphic strokes continue to be seen from time to time in radiographs of paintings by Velázquez dating from the later 1620s, they become increasingly infrequent, suggesting that Velázquez's method had outgrown the laborious methods learned in his apprenticeship.

Close observation shows that Velázquez's early works were built up from discrete, carefully studied parts to make the whole. This impression accords well with Pacheco's accounts of Velázquez making finished drawings from life, as well as the view that generally cartoons were not used, but rather small finished drawings.[20] The carefully observed contours and artificial lighting of the painted compositions produced a charged stasis common to figures and objects studied intently from nature. However, the compositions of Pacheco and the young Velázquez seem slightly disjointed, and, while the assured contours and accuracy of line do much to convince the eye that the compositional subjects occupy a unified space, the treatment of colour, perspective, and light betray to the viewer the artist's effort and study. The absence of rigorous perspective in Andalusian pictorial art at this time has been observed.[21] Perhaps this is a technical failing influ-

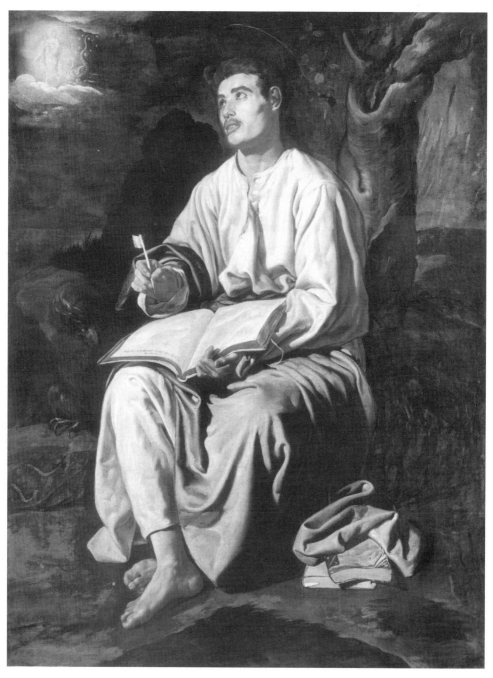

5. Diego Velázquez, *Saint John the Evangelist on Patmos,* 1619–20 (London, Trustees of the National Gallery, purchased with the aid of the Pilgrim Trust and the National Art Collections Fund, 1956).

6. Detail of Figure 5, showing brown ground and also part of a fine line of the brushed "under-drawing."

enced by the general reliance on prints as compositional sources. The dissatisfaction of Alonso Cano at not being taught correct drawing in Pacheco's studio is recorded by one of Cano's biographers, who writes, "Cano left this master [Pacheco], and retiring to his father's house, he gave himself virtuously to the hard work of studying symmetry, anatomy and the variety of movements which nature has designed for the human body".[22] The same biographer relates that Cano, at the age of twenty-four, turned down an important commission for the Mercedarian convent in Seville because he was aware that he lacked the knowledge of perspective the painting would require.

The painting method used by Velázquez and Pacheco at this period presupposes that the principal elements of the composition are correctly placed on the canvas before painting and that the application of paint can be undertaken almost object by object, filling in, and giving volume to the delineated shapes. The brushwork in paintings by Pacheco and his circle is controlled and steady, well suited to following carefully drawn contours.

The optical impact of this painting technique depends upon having a smooth, opaque paint mixture capable of maintaining its solid brightness when laid over a dark ground. One might expect these opaque paints to have been stiff and thick, yet Velázquez in his early works seems to have achieved the opacity required for painting over his flat brown grounds without making his paint stiff, which would have made it more difficult to manipulate with the delicate touch evident in even the earliest paintings. This skill suggests that the lessons learned in Pacheco's studio while mixing paints for the master gave the young artist a thorough understanding of the technical potential of the linseed oil medium. Pigments of an unexpectedly limited range were mixed with the oil to achieve the tonalities typical of Velázquez's early paintings: smalt, red ochre, yellow ochre, charcoal black, bone black, vegetable black, and lead white predominated the palette of the Seville years. Lead-tin yellow, red lake, azurite, and vermilion were also used, but far less frequently and usually in small quantities.[23] If this list of pigments is compared with those mentioned by Pacheco for

use in oil for painting on canvas or panel: white lead, orpiment, lead-tin yellow, verdigris, malachite, lamp black, bone black, azurite (*azul de Santo Domingo*), yellow lake (*ancorca*), carmine, vermilion, ochre, smalt, umber,[24] it becomes evident that although a wide range of native and imported pigments were available to artists in Spain, Velázquez seems intentionally to have limited his palette to inexpensive, abundantly available colours. This is most certainly a departure from his master's practice, especially in the period around 1600. Pacheco's own paintings are designed to be painted in brilliant, enamel-like oil colours, where the quality of pigments and smooth application are more important than the more subtle optical effects that can be achieved with a reduced palette.

The guild regulations required a master painter to show knowledge and competence in other specialisms, such as the painting of large canvases in a water-based medium similar in technique to modern stage painting (*sargas*) or the application of colour to carved sculpture. Pacheco was considered a fine practitioner of the latter and is known to have polychromed many works by the Sevillian sculptor Juan Martínez Montañés. In order to qualify as a master, as Velázquez did in 1617, he would have passed examination in these techniques as well, and from their variety he undoubtedly acquired more complete understanding of the behaviour and manipulation of paint, which served him well in later stages of his career.

Educating the Eye

Artists evolved from apprentice to master with constant recourse to printed images as compositional sources, and reliance on prints did not end with qualifying to become a master. The authority ascribed to the prints was great, and close observation reveals that scores of Spanish master artists based their compositions, sometimes with remarkable sophistication, on engravings.[25] Pacheco often refers to printed images in his treatise, and the following passage about devising new compositions, is typical.

With the memory enriched, and the imagination fully stocked with the worthy forms trained by imitation, the artist's creativity (*ingenio*) may move ahead [. . .] and, when he is asked to make a history, he will retire to compose it, having many things by worthy men before him, both prints and drawings, and [taking inspiration] from these various things by different artists, he can create a pleasing whole.[26]

According to Pacheco, the most highly accomplished master had so well developed his creative faculties that he could design new compositions from his own imagination. How often this really happened is open to question, since Pacheco, as well as many other successful masters, resorted to quotation from prints throughout their careers.[27] This opens the question

of how far the issue of "borrowing" really concerned the artists of Pacheco's generation and those they trained. In a post-Tridentine atmosphere pervaded by normative trends, qualities such as originality and fresh creative invention could be seen as slightly maverick. With reference to conventional images, an artist could design an "authorised version" of a subject based on existing sources whose iconographical clarity and decorum assured the worth of a new painting or sculpture. Images made from borrowings and reinterpretations opened the door to a sophisticated play of cross-referencing images with their prototypes in which both the artist and knowledgeable members of his audience could participate. In this artistic idiom it became useful to the artist to be familiar with as many models as possible. For an artist trained in Seville, especially one as favourably connected as the young Velázquez, the selection of models for study was surprisingly broad: Pacheco's own collection contained celebrated drawings and many albums of prints; that of the Duke of Alcalá was most admired for paintings and ancient sculpture.

Traditionally scholars have assumed that Velázquez had at least limited access – through his close relationship with Pacheco – to the "cultivated elite" of Seville in the first decades of the seventeenth century. The intellectual interests of collectors such as the Duke of Alcalá, Rodrigo Caro, and the Duke of Medina Sidonia, embraced both antique sculpture, modern painting, art theory and perhaps surprisingly, a lively interest in scientific research into optics and visual perception, horticulture and botany, and military fortification.[28] There existed in the first years of the seventeenth century an extraordinarily varied intellectual society in Seville at the centre of which the figure of Francisco Pacheco was often to be found. Pacheco seems to have sustained long friendships with many of the key scientific, literary, artistic, and religious figures of the day. It is logical to conclude that the breadth of the teacher's interests influenced Velázquez and other pupils as they matured under Pacheco's tutelage.

From looking at the youthful paintings of Velázquez alongside works by his teacher it becomes immediately clear that the pupil very quickly assimilated the lessons the master had to offer. By grafting the acute study of nature onto the artistic and intellectual practices learned from Pacheco, Velázquez synthesised a personal visual language and in so doing mounted a quiet revolution in the way both artist and viewer were to engage with the elusive realities of nature, perception, and truth. There is no doubt that Velázquez studied models from life with a vital directness foreign to the earnest, even pedantic, method followed by Pacheco. Whatever the immediate motivation may have been, it is clear that Velázquez broke with local tradition in so assiduously drawing and painting from life. Recent studies have discussed the relationship of Velázquez's artistic methods with major trends in thinking of the period.[29]

Theory, Style, and Meaning

One of the instances in which the text of Pacheco's treatise *Arte de la pintura* appears to disagree with observation is in the hierarchy of the genres of painting. The treatise contains passages that support the traditional ranking of history painting at the top and still-life, portraiture, and *bodegones* painting as genres less worthy of a great master. However, in an effort to place his son-in-law in the best light, Pacheco elsewhere writes as an apologist for portraiture, at pains to validate the genre in which Velázquez excelled by creating for it an honorable pedigree leading back to great artists of the past such as Dürer and Leonardo.[30]

The rank and file of artists probably took the pragmatic approach and would paint almost anything they were commissioned to do, as long as they would incur neither the guild's disapproval nor the suspicion of the Inquisition, so Pacheco's ranking of the genres belonged more to the realm of theory than to that of practice. However, the fact remains that by the time Velázquez completed his training, artists of great ability had turned their hand to still-life painting, and established the basis for the exceptionally rich tradition that would flourish in Spain throughout the century. Inventive imagination (*invención e ingenio*) no longer dwelt only in the reverent world of history painting or that of great religious subjects. The skill, the genius, the art of a painter – these could now be as quickly recognised in the depiction of a water jug or the study of a street urchin's face. The ability to paint these "low subjects" with expressive art was not easy to assess by guild examination but clearly met with the important approval of certain connoisseurs close to the king. Perhaps a connection might be found between the breakdown of the guild system during the seventeenth century and the relaxation of many strictures – about genre hierarchy, technical processes, subject matter – tied to the austere spirit of the early Counter-Reformation. Philip IV's interest in contemporary artists, his keen collecting of Italian and Flemish paintings, the courtly interest in portraiture, must inevitably have broadened notions of decorum and acceptable subject matter, at least in the sophisticated orbits around the Planet king.

An anecdote recorded by Pacheco in the *Arte* springs to mind as one considers the intense, emphatic presence of the jugs in the *Waterseller* (Fig. 7) by Velázquez, a work that marks the end of his period of learning and heralds the sophistication of his subsequent career at court. According to Pacheco, the artist Pablo de Céspedes painted a celebrated *Last Supper* (Fig. 8) that

he had in his house, and those who came to see it admired a certain glass vessel painted there, without attending to the artful ingenuity of the rest, and seeing that everyone's eyes went to that trifle, he became infuriated and called to his servant: "[. . .] erase this jar and take it away from here! Is it possible that no one looks at the head and hands into which I have put all my study and care, rather they indulge in this impertinence!"[31]

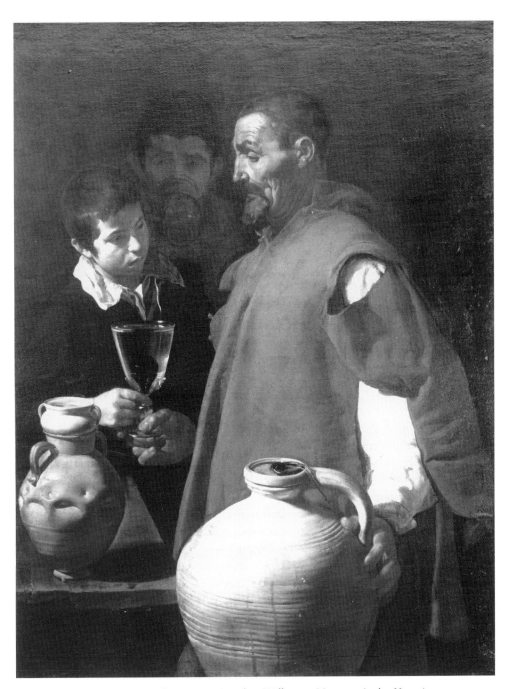

7. Diego Velázquez, *The Waterseller*, ca. 1620 (London, Wellington Museum, Apsley House).

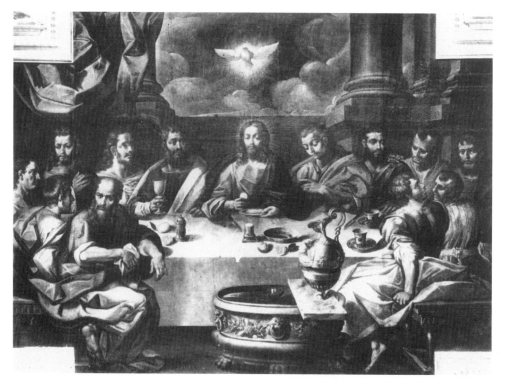

8. Pablo de Céspedes, *The Last Supper*, 1595 (Córdoba, Cathedral).

It is tempting to see in the *Waterseller* a young man's discreet rejection of the specific notions of orthodoxy and decorum propounded by his teacher in favour of a powerful new aesthetic based on the primacy of intensely observed reality.

Although Velázquez, and other apprentices of his generation, may have begun their training in the orthodox spirit counselled by Paleotti, intelligent, informed young men could not have resisted the powerful attractions of new knowledge, new ideas, and new aesthetics. The relationship between literature and the visual arts is usually a close one, and similar trends often influence both. For example, the intellectual attraction of science and discovery can make itself felt in both words or pictures. In Velázquez's youth scientific interest in the study of optics soon opened the way for literary works such as *Los anteojos de mejor vista*, a story in which a magic spyglass enables its owner to see the true nature of people beneath their outer appearance and which cannot have failed to appeal to portraitists. In literature, a taste for wit and the agility of mind able to express a complex idea in an apparently unelaborated, easy phrase was especially valued by those writers of the *Conceptista* school. The perfection of a phrase by endless revision was seen as outmoded and overworked; simi-

larly, the apparently spontaneous, inspired paint stroke came to be more highly valued than the carefully studied approach advocated by Pacheco and others of his generation.[32]

Inevitably all gifted pupils leave their teachers behind. It is to Pacheco's credit, as he himself was aware, that Velázquez's extraordinary abilities were developed not only by nature but also by his own brilliance as a teacher.

3 Velázquez and Italy

Jonathan Brown

For a non-Italian painter of the seventeenth century, a trip to Italy was considered desirable if not obligatory. By 1600, Italian artistic culture had acquired unrivaled prestige, which meant that its precepts and practices had to be mastered by any painter aspiring to achieve fame and fortune. The virtues of Italian painting had been proclaimed by the artistic theorists of Italy and validated by princely collectors, who competed with each other to acquire the best works by the most renowned painters. The Italianization of western European painting is so widely recognized as to require no further discussion. However, the parallel phenomenon, what might be called the naturalization of Italian painting in other parts of Europe, is now only beginning to be considered.

As every student of the period knows, the ideas and practices of Italian art were considerably transformed as they spread northward and westward across the subcontinent. Yet this process varied from place to place and even from painter to painter. Indeed, it is only through case-by-case studies that it is possible to understand these processes. None is more fascinating or dramatic than that of Diego Velázquez, whose encounter with the art of Italy is surely one of the most singular in the history of seventeenth-century art.

The subject of Velázquez and Italy seems to grow richer as the years go by. At first glance, this phenomenon is difficult to explain because the number of paintings definitely ascribable to one or the other of his two trips to Italy has remained stable. However, the documentation has been steadily increasing, although virtually all the newly published material concerns the second trip of 1649–50, the so-called mission to Italy, during which Velázquez sought to purchase objects for the royal collection.[1] (As a matter of fact, for a brief moment there appeared to be evidence of a third trip, which supposedly occurred in 1637, although it has now proved that

the documents in question refer to a homonym of the Spanish painter.)[2] By contrast, knowledge of the first trip has expanded at a much slower pace. It may seem perverse, then, or at least ill advised, to limit the present discussion to the first sojourn. Yet this is not entirely arbitrary, because it was during the first trip that Velázquez experienced the full impact of Italian, and specifically central Italian, art. By utilizing the Geertzian technique of "thick description," I hope to provide a densely textured account of the encounter between a highly perceptive non-Italian painter with Italian conventions of pictorial representation. Obviously this account cannot be paradigmatic – Velázquez is too unusual an artist – but perhaps it can offer a way of understanding how a painter born and bred within a powerful regional tradition confronted the exemplary art of Italy.

On or about 1 July 1629, Diego Velázquez left Madrid en route to Italy. The motive for the trip, as described by the Parmese ambassador, Flavio Atti, was to perfect his art.[3] By January 1632, he had returned to Madrid, having spent approximately sixteen months making his tour of the principal cities. This relatively short *Wanderjahre* is unusual, and possibly unique, in the history of sevententh-century art, as was Velázquez's response to the visual culture of Italy.

In some respects, the events of the trip are known, thanks to the brief account of Francisco Pacheco, the artist's father-in-law, published in his treatise *Arte de la pintura*.[4] There is also a certain amount of information to be gleaned from the letters of introduction written by the ambassadors of Parma, Venice, and Tuscany as Velázquez was about to commence his voyage.[5] Unfortunately, the artist does not seem to have kept a journal or even written to Madrid during his absence, which leaves us in the dark about what interests us most, his interactions with the artists and patrons of Italy. Nor do Italian observers seem to have noticed his brief passage in their midst. However, he did execute four paintings during his stay in Rome, which provide some idea of how he grappled with what he saw and, presumably, what he heard and read.

It seems reasonable to say that the impetus to go to Italy was provided by Peter Paul Rubens, who was at the Spanish court for several months from 1628 to 1629. Pacheco informs us that Philip IV, Velázquez's patron, had promised several times to send the painter to Italy. On 28 June 1629, less than two months after Rubens had left the court, he granted the permission. It is often and plausibly assumed that the experience of seeing Rubens at work and listening to him speak of the art of painting convinced the king that his protégé needed to experience the artistic culture of Italy in order, as Flavio Atti had said, to perfect his art.

The ambassadors' letters and other documentation set the stage for Velázquez's sojourn. As they make clear, this was not to be an ordinary artistic pilgrimage. In the first instance, the letters to the Italian courts were written at the bequest of Gaspar de Guzmán, Count-Duke of

Olivares, the royal favorite. Velázquez would be traveling under royal protection and as a person who enjoyed the favor of the king. As the Tuscan ambassador noted, "egli, come dico, e favorito dal Re e dal Conte, et oltre all'essere uscier di Camera, pratica molto adentro in Corte. . . ."[6]

Velázquez's status was reinforced by the generosity of the king, who granted him a purse of 400 silver ducats to support his travels in addition to his normal salary. This allowance was supplemented by a grant of 200 gold ducats from the count-duke. The count-duke also arranged for the painter's transportation. He was to travel in the party of the famous Genoese general, Ambrogio Spinola, which included the marquis of Santa Cruz, the duke of Lerma, and Abbe Scaglia, the Savoyard ambassador known to us by the portraits of Van Dyck. They left Madrid by coach and made their way to Barcelona, whence they embarked to Genoa on 10 August 1629.

Velázquez's trip southward is recounted by Pacheco. Although the itinerary is more or less predictable (except for the decision to bypass Florence), the hospitality offered to the royal painter was exceptional. At the first stop, Venice, he was welcomed by the Spanish ambassador, Cristóbal de Benavente, who invited him to dine with him and provided a bodyguard while he visited the artistic sites.

Next was Ferrara, where his host was Cardinal Giulio Sacchetti, who had probably known Velázquez while serving as nuncio in Madrid from 1624 to 1626. Although Cardinal Sacchetti invited Velázquez to eat at his table, the painter excused himself so as not to appear presumptuous. However, on the evening before his departure, he spent three hours in conversation with Sacchetti and undoubtedly heard the cardinal's well-honed views on artistic matters. From there, Velázquez proceeded to Cento, where he stopped but briefly. (It is assumed he made contact with Guercino.) And then, in a dash for Rome, he passed quickly through Bologna, not even pausing long enough to present his letters to Cardinals Ludovisi and Spada.

Pacheco mentions that Velázquez spent a year in Rome, which would suggest that he arrived in September or October. Once again, the red carpet was rolled out for his arrival, this time by Cardinal Francesco Barberini. Like Cardinal Sacchetti, Barberini had known Velázquez in Madrid, although their encounter in 1626 had not been successful from the painter's point of view.[7] According to the cardinal's secretary, Cassiano dal Pozzo, his portrait of Barberini had been rejected as too "melancholy and severe" and was replaced by another executed by Juan van der Hamen y León. Nevertheless, Barberini was generous with Velázquez when he arrived in Rome and invited him to occupy rooms in the Belvedere. Velázquez lived in what is now Sala 2 in the Museo Gregoriano Etrusco, decorated with Federico Zuccaro's fresco of *Moses and Aaron before the Pharoah*. Velázquez soon found this location too remote and isolated and

moved to the center, perhaps to a house in the Via Paolina near the Spanish Embassy, a house that would become the permanent residence of Nicolas Poussin.[8] Before leaving the Vatican, he obtained assurances that he could visit the frescoes of Raphael and Michelangelo whenever he wished.

At this point, Pacheco's narrative jumps forward to the summer of 1630, when Velázquez, with the intervention of the Spanish ambassador, moved to quarters in the Villa Medici. This narrative leap carries us clear across Velázquez's experiences in the promised land of European painting and was motivated by Pacheco's purpose of showing his son-in-law keeping the company of prelates and noblemen. Thus we learn that when Velázquez fell ill during the summer, his care was supervised and subsidized by the ambassador, the well-known patron and collector, Manuel de Fonseca y Zúñiga, Count of Monterrey and brother-in-law of Olivares.

Velázquez left Rome in the autumn, traveling to Naples, the port of embarkation for the journey home. One more encounter with the high-born awaited him, the king's sister, Mary of Hungary, then en route to Austria to marry the emperor Ferdinand III. If Velázquez met Jusepe de Ribera, which he almost certainly did, Pacheco fails to mention it.

Velázquez's production during his time in Italy is almost incredibly small – four paintings done in Rome have survived and perhaps one done in Naples, if the portrait of Mary of Hungary (Madrid, Museo del Prado) is assigned to this period and not to 1628–29, as has been suggested.[9] Although the latter is limited in scope and ambition, and thus will be omitted from discussion, the four paintings executed in Rome are milestones in the artist's career. Two of these are history paintings, the so-called "Tunic of Joseph" (Fig. 9) and the Forge of Vulcan (Fig. 10).

The most efficient way to assess the impact of Italian art on these paintings is to look at another famous painting, Los Borrachos (Fig. 11), completed shortly before Velázquez's departure for Italy.[10] Los Borrachos may be considered a triumph of imagination over technique. The invention is unforgettable, as the painter juxtaposes the group of ruddy rustics, flushed with drink, to the marmoreal Bacchus, who turns away from the merry company, as if looking for the cue that will terminate the encounter. However, Velázquez clearly has difficulty with the composition. The group of six peasants are crammed into a space too small to accommodate their bodies, leading to the arbitrary truncation of the four figures at the rear. A notional background, comprised of rolling hills and a patch of sky (now turned gray with the discoloring of the smalt) is wedged behind the foreground, almost as an afterthought.

By contrast, the Tunic of Joseph is a fully, almost ostentatiously Italianate picture.[11] The technical analysis of Carmen Garrido indicates that the execution of the painting preceded the Forge of Vulcan, principally because it has a reddish ground that was routinely employed by the artist

9. Diego Velázquez, *Joseph's Coat Brought to Jacob* *("Tunic of Joseph")*, 1630 (El Escorial, copyright Patrimonio Nacional).

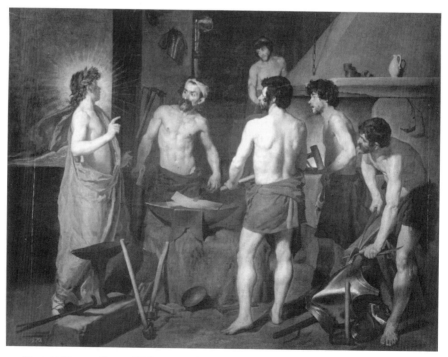

10. Diego Velázquez, *Forge of Vulcan*, 1630 (Madrid, Museo del Prado).

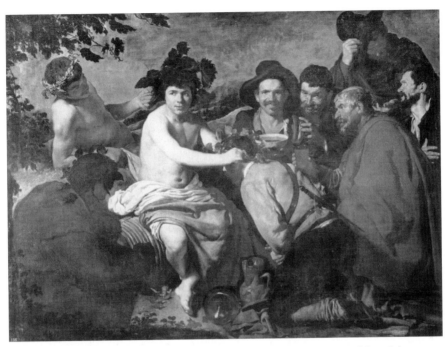

11. Diego Velázquez, *Feast of Bacchus ("Los Borrachos")*, 1629 (Madrid, Museo del Prado).

during his first Madrid period but never used again after the execution of this work.[12] The *Tunic of Joseph* systematically solves the problems of *Los Borrachos*. The space between the figures, established by a perspective grid, is ample, and no one is cut off at the shoulders or waist. A marked influence of classicizing figure drawing is readily observable in the chiseled, half-naked forms of the two brothers at the left, and gestures and expressions are carefully calculated to communicate the emotional impact of the revelation of Benjamin's supposed death. The illumination of the scene is notably more subtle, ranging from the highlights on the left to the transparent shadow that envelopes the two figures in the middleground. Velázquez has proved to be a quick study; within a short period of time, he has mastered the canons and conventions of the grand manner of Roman history painting, as well as the subtleties of Venetian *colore*, without surrendering his individuality. While the picture is Italianate, it is difficult to detect the predominant influence of any given Italian painter of the time.

In the *Forge of Vulcan*, Velázquez is no longer merely content to rehearse these lessons.[13] Although the dramatic composition and the figure style are attributable to Italian sources, the predominant brown tonality and the sharp-eyed realism of the inanimate objects harken back to ingrained practices of Spanish naturalism. Perhaps the most intriguing aspect is the method of elaboration, as revealed in a radiograph.[14] Changes in composition, some as important as the position of Vulcan's head, others as small as the alteration of the contours of the bodies of the Cyclops,

are easily seen. Most surprising is the enlargement of the lateral dimensions of the canvas, which were widened by the addition of narrow strips of cloth on either side, probably the result of the desire to "deepen" the illusion of space. This "paint-as-you-go" method becomes a standard procedure and is important because it suggests that Velázquez, however much he learned in Rome, was not convinced by the sovereignty of *disegno* in the realm of artistic practice.

Indeed, the other two paintings surely ascribable to the Roman stay of 1629–30 show the artist studying the work of northern painters and not Italians at all. These are the two small views of the gardens of the Villa Medici, where Velázquez lived for a while during the summer (Figs. 12 and 13). The debate over the dating of these sublime little pictures has now been resolved by the technical studies of Carmen Garrido, which leave no room to doubt that they were done in the first, not the second, of Velázquez's sojourns.[15]

The Villa Medici landscapes are on the cutting edge of a new development – plein-air landscape painting. The available evidence for the origins of this practice comes from Joachim Sandrart, who claimed that it was he

12. Diego Velázquez, *Gardens of Villa Medici*, 1629–30 (Madrid, Museo del Prado).

13. Diego Velázquez, *Gardens of Villa Medici*, 1629–30 (Madrid, Museo del Prado).

who was the first to do it, and that he soon persuaded Claude Lorrain to follow his example.[16] Apparently, Sandrart and Claude started to paint outdoors around 1630, exactly at the time Velázquez tried his hand, which suggests that he was in touch with the northerners when they began their experiments. None of the sketches mentioned by Sandrart have been identified, and thus the views of the Villa Medici seem to be the earliest-known examples of open-air landscape painting. Considering that Velázquez never painted pure landscape either before or after these works, they are all the more remarkable.

This, then, is the extent of Velázquez's production during the short time he was in Italy, and it is logically on these four pictures that the assessment of the impact of Italy usually centered. This, I believe, is a mistake, of which I myself am guilty. However, I like to think that the error is forgivable and derives from a simple fact – that the paintings done by Velázquez after his return to Spain are not overtly Italianate, with the possible exception of the *Temptation of St. Thomas Aquinas* (Orihuela, Museo Diocesano). Indeed, a few of them might even be described as anti-Italianate. Thus, rather than end the story of Velázquez and Italy in January 1631, let us push on into the decade and see what Velázquez made of his

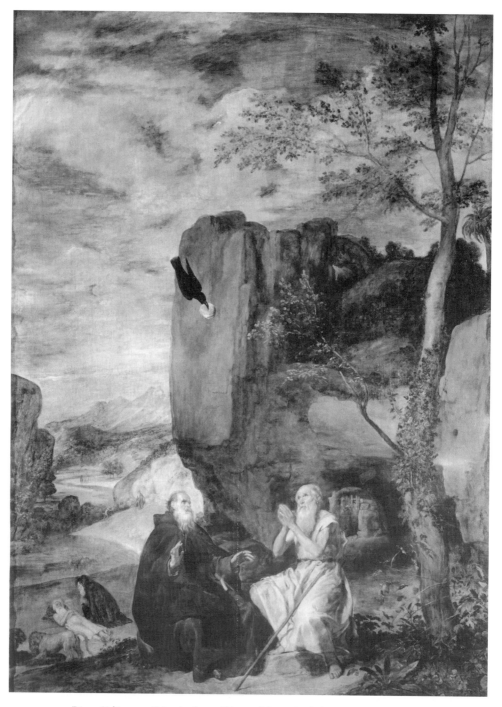

14. Diego Velázquez, *Saint Anthony Abbot and Saint Paul the Hermit*, 1633 (Madrid, Museo del Prado).

brief but intense encounter with Italian pictorial culture.

While the date of *Christ on the Cross* (Madrid, Museo del Prado) is not documented, evidence both circumstantial and technical indicates the early thirties. The composition faithfully obeys a formula used and defended by Pacheco, according to which Christ is secured to the cross with four nails, reducing the body to immobility so as not to distract the viewer with artifice.[17] Strong light strikes the figure, although the background is very dark, and there is no hint of a natural setting. This Hispanic formulation of the image, consciously adopted by Velázquez, and the slender, elongated proportions of the Christ, put a considerable distance between this work and Italian versions (for instance, Guido Reni's *Crucifixion* in Modena, of the late 1630s), although the

15. Radiograph of Figure 14.

accurate drawing and the careful modeling are not thinkable without the year in Rome. Reproductions of the painting disguise notable features of execution, which show Velázquez moving in a different direction.[18] For example, the dark background is by no means uniformly monochromatic. Rather there is a subtle interaction between the light brownish ground, comprised of lead white with organic black and iron oxide, and the superimposed dark tone, primarily comprised of azurite with smaller amounts of black, iron oxide, and calcite, mixed with abundant amounts of oil. The resulting mixture is applied unevenly, allowing patches of the ground to show through, modulating the darkish tonality. Another move of great delicacy is the application of a translucent stain to the flesh areas, which produces almost fugitive shadows on the surface.

The use of highly diluted colors applied freely over light grounds is consistent in the post-Italian works of the 1630s and at times almost attains the condition of watercolor. The thinning of the mixtures abets another of Velázquez's purposes, which is to suggest rather than delineate forms and patterns. The development is evident in the large altarpiece, *St. Anthony Abbot and St. Paul the Hermit*, executed for the Ermita de San Pablo in the Buen Retiro around 1633 (Fig. 14).[19] The radiograph (Fig. 15) is informative precisely because it is so difficult to read. Velázquez employs a very light ground, comprised mostly of finely ground lead white. The forms of the two saints can be partially discerned, but otherwise all we see are the marks of the palette knife used to apply the mixture. Over this ground, Velázquez paints with pigments heavily diluted in oil, which interact with

the ground to produce the range of cool green and blue colors. They are so thin as to be undetectable in the radiograph. Almost all these colors are comprised of the same pigments – azurite, smalt, lapiz lazuli – mixed with tiny and varying amounts of lead white, calcite, and iron oxide. This bold, inventive technique effectively dematerializes the solid volumes and compact masses characteristic of Italian painting of the period.

The narrative is cast in episodic form, with five installments, beginning in the distant background and concluding with the burial of St. Paul in the near left. This anachronistic procedure probably stems from early Netherlandish artists, specifically Joachim Patinir, whose *Landscape with St. Jerome* (Madrid, Museo del Prado), which employs this device, was one of several paintings by the master in the Spanish royal collection. (The greenish-blue tonality of Velázquez's painting also points in the direction of Patinir.) Another northern artist on Velázquez's mind was Albrecht Dürer, the author of the woodcut that has been identified as the source for the incident of the crow bringing food to the hermit and his guest.

The 1630s were Velázquez's most prolific decade, and this makes it impossible to review his production work by work in order to assess his posture toward Italian art. As a final example, I will choose one of his most radical pictures, *Pablo de Valladolid* (Fig. 16), which dates from the mid-thirties.[20] Once again, the radiograph shows the by-now characteristic use of diluted pigments applied to a ground comprised principally of lead white. Much more important, of course, is the definition of space, which so captivated and inspired Edouard Manet. By refusing to delineate the juncture of wall and floor, Velázquez goes some distance toward refuting geometry as an essential tool for creating the illusion of space. Only the shadow that falls to the right asserts the corporeality of the jester.

From this analysis, it might seem that, for Velázquez, the impact of Italian painting was a transitory episode in the development of his distinctive manner of painting. This is a doubtful proposition, but it must be said that Velázquez's negotiations with the pictorial culture of Italy produced an unusual result. Velázquez's response to Italian art is circumspect; there is a pronounced tension between resistance to and acceptance of the ideas and practices of Italian painting that is perhaps equaled only by Rembrandt (who of course had no firsthand experience of Italy). Unlike Rubens, whose painting might be called an extension of Italian art, or Poussin, who in effect became an Italian painter, Velázquez kept his distance.[21]

In order to understand this idiosyncratic response, we might begin by analyzing the circumstances of the 1629–30 trip. To reiterate a point made earlier, Velázquez was no ordinary artistic pilgrim. The sponsorship of the king guaranteed that he would travel in comfort and in the best of company. The royal sponsorship also relieved Velázquez of the need to work to meet his expenses. Sooner or later, foreign painters in Italy had to find either a patron or market, and this circumstance put them at the service

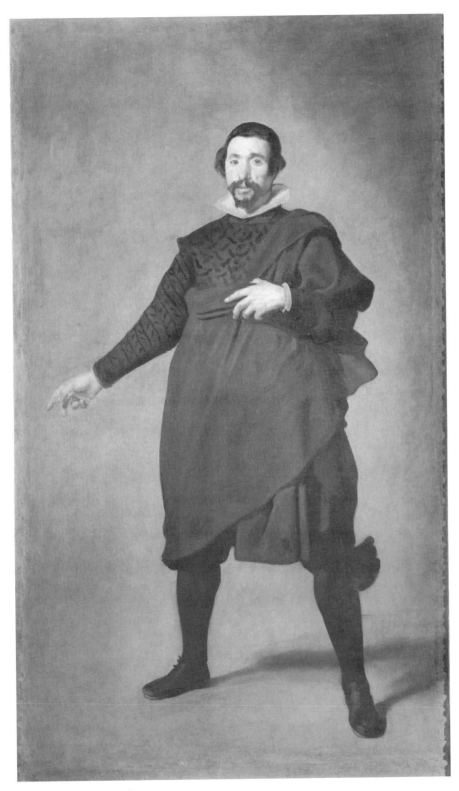

16. Diego de Velázquez, *Pablo de Valladolid*, 1634 (Madrid, Museo del Prado).

of local tastes and preferences. Velázquez, by contrast, was above the fray, as witnessed by the fact that he painted so few pictures during the year's stay in Rome. Furthermore, these pictures were painted for himself and were brought back to Madrid. He sold the two history paintings to the crown in 1634 and, presumably, although at an unknown time, the Villa Medici landscapes as well, which first appear in the 1666 inventory of the Madrid Alcázar.

A related factor is the duration of Velázquez's stay in Italy, which was remarkably brief. Rubens remained for seven years, van Dyck for four, Vouet for thirteen, Le Brun for three, Lastman for five, Honthorst for ten – these examples are chosen at random, but it is likely that a thorough study of the duration of Italian sojourns by foreign artists would corroborate the notion that Velázquez's was a lightning trip.

Then there is the factor of his age. Velázquez was in his thirtieth year when he set out for Italy and thus was a good deal older than the usual artistic pilgrims, who tended to make the journey upon the completion of their apprenticeships, when they were in their early twenties. Velázquez was well established in his career as court painter (this is the principal reason why he could not linger) and well experienced as a painter.

Let us now consider the various facets of that experience, beginning with Velázquez's early years in Seville. As we know, late in 1610 Velázquez, then eleven years old, was apprenticed to Francisco Pacheco, with whom he remained until he was licensed as a master in March 1617. In addition to technical competence, this apprenticeship provided an entry into the milieu of an authentic *pintor sabio*. It is sufficient to leaf through the pages of the *Arte de la pintura* (1649), where Pacheco has conveniently cited his sources in the margins, to see that he was widely read in Italian art theory and in the major works of ancient philosophy and medieval theology.[22] Some of the learning certainly rubbed off on Velázquez, although he wore it much more lightly than did his master. (By the way, this would be a debatable assumption to those who have attempted to interpret Velázquez's history and religious paintings as if they had been painted by Poussin or Rubens.) The point is that, from an early age, Velázquez became acquainted with Italian humanist writings on art.

Yet when we look at the paintings done by Velázquez in Seville, we appear to be in a different world. The Sevillian school was bound by a series of conventions exemplified by Pacheco's *Christ Attended by Angels*, signed and dated 1616 (Fig. 2) of which not even a precocious talent like Velázquez could break free. Without going into detail, it can be said that these conventions were determined in part by fidelity to the south-Netherlandish models preferred by a conservative clientele, which prized clarity of expression and orthodoxy of content above what might called artistry.[23] Velázquez's *Adoration of the Magi* of 1619 (Fig. 17) strains at these conventions but with only partial success. Despite the naturalism of the faces and

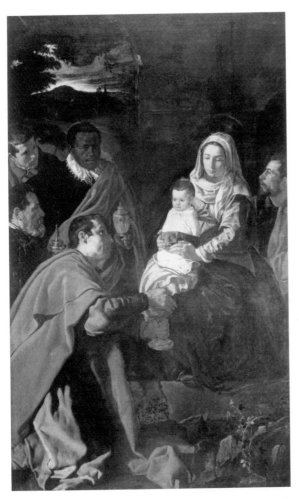

17. Diego Velázquez, *Adoration of the Magi*, 1619 (Madrid, Museo del Prado).

the bolder effects of light and shadow, the composition is unresolved, as the artist encounters many of the same problems that were to recur in *Los Borrachos*, particularly the uncertainty about the definition of space and the resultant difficulty in situating the figures convincingly within it.

With the permanent move to the court in 1623, Velázquez's knowledge of Italian painting acquired greater depth and resonance. Italian painting was certainly known in Seville, but the quantity, quality, and variety could not begin to compare with Madrid. The royal collection by this time had become the richest in Europe, with exceptional holdings of works by Titian and other Venetian masters of the sixteenth century.[24] Velázquez, in other words, had easier access to masterpieces of Italian painting than most of his counterparts outside Italy. In addition, works by contemporary Italian painters had begun to filter into Madrid during the 1620s, the most

important of which were the ones by Domenichino and Artemisia Gentileschi acquired by the count of Oñate for the king in 1626–27 (Domenichino, *Sacrifice of Isaac,* Madrid, Museo del Prado).[25]

Besides the presence of Italian paintings in Madrid during the 1620s, there were to be found important Italian patrons and connoisseurs. Cardinal Giulio Sacchetti, as we have seen, was one of these. Another was Giovanni Battista Crescenzi, scion of an important noble Roman family with a distinguished history of patronage, who arrived in 1617 and remained until his death in 1635, moving into ever higher positions of influence and control over matters artistic at court.[26] Nor can we forget the visit of Cardinal Francesco Barberini and Cassiano dal Pozzo in 1626, which brought two of the greatest patrons of the age into contact with Velázquez and other members of the court.

This rapid sketch of the Italian presence at the Spanish court is perhaps sufficient to suggest that, even before visiting Italy itself, Velázquez had had ample opportunity to become well acquainted with much Italian theory and much Italian painting. There were gaps in his education, of course. Roman painting of the sixteenth century immediately comes to mind, although this lacuna could be partly filled by the frescoes at the Escorial by Federico Zuccaro and Pellegrino Tibaldi. However, it must be said that originals by Raphael and Michelangelo were scarce despite the fact that there were copies of some of their works in the royal collection. And, of course, the important developments fostered by Carracci and Caravaggio were but little and imperfectly known. Still, when all is said and done, the world of Italian painting accessible to Velázquez was probably greater than that available to any other painter prior to his Italian trip.

Yet we must look long and hard for evidence that this contact with Italy made much of an impression on Velázquez. The body of Velázquez's work between 1623 and 1629 is fairly small and consists mostly of portraits. A major piece, unfortunately, is lost – the *Expulsion of the Moriscos by Philip III* – which was destroyed in the early eighteenth century. The portraits, however, are circumscribed by a venerable tradition of Spanish Habsburg portraiture, which is of northern origins and does not make the same demands on a painter as would a history painting.

Velázquez's specialization in portraiture and his deficiencies as a painter in the grand manner were noticed by his rivals at court, particularly Vicente Carducho, who was baptized in Florence as Vincenzo Carducci. Carducho, the artistic descendant of Federico Zuccaro via his older brother Bartolommeo Carducci, one of Zuccaro's assistants, had reason to be envious of Velázquez's meteoric rise at court and to be cognizant that his grasp of *disegno,* that cornerstone of Florentine art, was weak. Steven Orso has meticulously reconstructed how the rivalry developed during the 1620s, with Carducho, as the self-appointed guardian of Italianate history painting, watching with dismay as the young painter from Seville rose in

the king's favor despite his lack of qualifications in the highest sphere of art.[27] Here the tensions may be evoked by citing a brief reference made by Velázquez's friend, the Aragonese painter Jusepe Martínez: "But as envy does not know idleness, some critics tried to tarnish the good opinion of our Velázquez, daring to say that he only knew how to paint heads."[28]

Despite Carducho's obvious self-interest, he may have had a point, if we take as a benchmark another of the three history paintings done by Velázquez between 1623, when he was appointed *pintor real*, and 1629, the *Supper at Emmaus* (Fig. 18). (*Los Borrachos*, of course, is the first.) Velázquez is clearly attempting to inject movement and drama into the composition although his success is limited. Each figure seems to inhabit his own world, and again the definition of space and the placement of the figures within it is awkward.

It is not until the last of the pre-Italian history paintings, *Christ after the Flagellation Contemplated by the Christian Soul* (London, National Gallery), that Velázquez begins to show an Italianate approach to figure

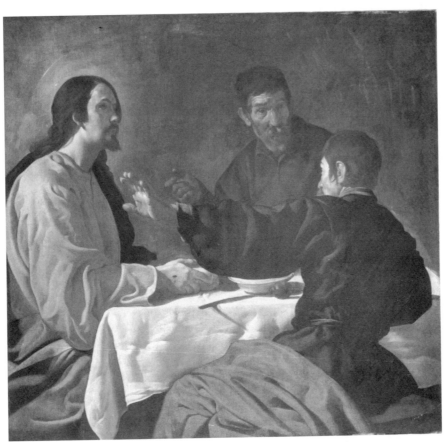

18. Diego Velázquez, *Supper at Emmaus*, ca. 1628–29 (New York, Metropolitan Museum of Art, Bequest of Benjamin Altman, 1913).

drawing. Nothing is known of the genesis of this work, and its dating has vacillated to just before, or during, or just after the journey to Italy.[29] The use of the reddish ground, typical of the Madrid period, points to the work having been done on the eve of Velázquez's departure. In this somewhat overlooked picture, we may be seeing the clearest evidence of Velázquez's encounter with Rubens, the encounter that finally launched the Spaniard toward Italy.

Italy was certainly a revelation, but it was a revelation that did not lead to conversion. Perhaps the stay was too brief, the contact with Italian patrons too tangential, or perhaps Velázquez, then thirty years old, was too set in his ways to change. Or it may be that his already considerable knowledge of Italian art and theory had advanced him farther along the learning curve than the usual artistic pilgrim to Italy, making him somewhat skeptical of the ideals and practices of Renaissance painting. Yet another possibility is that, having been schooled in a powerful local tradition that had different goals and methods, Velázquez was able to look at Italian classicism with an outsider's eye. I suspect that all these factors came into play and contributed to Velázquez's unusual response to Italian painting.

This response, albeit unusual, is not easy to define. There are post-1630 paintings that leave no doubt that Velázquez absorbed fundamental lessons from his study of the proponents of *disegno*, such as the *Coronation of the Virgin*, executed for the queen's chapel of the Madrid Alcázar around 1640 (Madrid, Museo del Prado), although there are astonishing bits of painting that are electrifying in their immediacy. And there are other works, especially his masterpiece, *Las Meninas* (Madrid, Museo del Prado), which subliminally acknowledge the grand manner of Italian history painting even while subverting it. However, it is clear that Velázquez found that the conventions of Roman classicism were too doctrinaire to help him accomplish what he had in mind, which was to propose that painting was an art of inference based on an understanding of the capacity of light and color to stimulate the eye and mind and to exploit their potential for capturing the changing aspects of appearances.

Thus, as has long been recognized, he turned to the Venetians of the sixteenth century, who, apart from their intrinsic qualities, had been elevated to a rank of superior prestige at the Spanish court, thanks to the patronage of Charles V and his successors.[30] The quotation from Titian's *Rape of Europa*, a jewel of the royal collection, which occurs in the *Fable of Arachne* (Madrid, Museo del Prado), testifies to Velázquez's profound admiration for the Venetian master. One of the most far-reaching consequences of the first Italian trip is also one of the most curious – that it allowed Velázquez to gain a profound understanding of a painter whose works he had lived with for six years.

Yet, just as he was determined to deconstruct the classicists, so he deconstructed the colorists. The mature technique of Velázquez departs

from the late works of Titian and, perhaps even more important, the paintings of Tintoretto, which were executed with greater spontaneity and *sprezzatura*.[31] In extending this line of approach, Velázquez was prepared to take greater risks, to leave more to the working of the eye than to the manipulations of the brush by drastically reducing the visual data supplied to the viewer.

In the end, Velázquez's relationship with Italian painting was as much a debate as a dialogue. Both sides agreed that there was a common premise – the canons and conventions of Italian Renaissance painting. Velázquez, however, detected what he believed were flaws in the argument, and these he determined to exploit in the hope of changing the ways in which painting mediated between the mind and sensory experience.

4 Velázquez and the North

Alexander Vergara

The artistic culture of the Spain that Velázquez lived and worked in, whether the cultured elite of Seville or the court in Madrid, was defined to a large degree by ideas received from abroad. From formal vocabularies to narrative systems, from the content of works of art to the professional concerns and horizons of painters, Spanish artists – like their peers in most areas of Europe – were dependent on ideas coming to them from the artistic centers of the continent. If one were to write about an Italian artist such as Michelangelo, it would be less important to learn of his relationship to artistic and cultural forces from outside his native Tuscany or the Rome where he worked. However, the ideas received from abroad are key to understanding the art of painters in seventeenth-century Spain.

Together with Italy, the region of Europe with the richest artistic tradition during the late Medieval and Early Modern period was an area roughly equivalent to what is now Belgium, the southern part of the Netherlands, and southern Germany. At the time the region was vaguely referred to by Spanish writers as "the North" or the Netherlands, Flanders, or Germany. The close relations between the region and the Iberian Peninsula made the art that was produced there especially close and relevant to Spanish artists and patrons.

Since the thirteenth century, Spain had strong economic ties to the Netherlands. Spain's primarily agrarian economy provided the Flemish textile industry with much of its wool, and with other products such as wine, salt, spices, and eventually also with exotic goods from the colonies. The more urbanized Netherlands provided the Iberian Peninsula with manufactured goods and luxury items from Ghent or Bruges, Brussels or Antwerp. In this city, Spaniards made up the largest community of foreign merchants in the sixteenth century. Through them, and also through the growing number of northerners setting commercial offices in the port

cities of southern Andalusia, especially in Seville, which had become a major center for international trade since the conquest of America, a wealth of Netherlandish art and artists found their way into Spain.

The ties between Spain and the Netherlands were also dynastic. The Castilian and Burgundian crowns had joined in 1497 with the marriage of Joanna of Castile, daughter of Ferdinand and Isabella, to Philip the Handsome, son of the Emperor Maximilian of Habsburg and of Mary of Burgundy, thus sealing the political destinies of both parts of Europe under the aegis of the Habsburg empire. The evolution of political events would put the Netherlands (the entire region until the end of the sixteenth century, and the Southern Netherlands until the early eighteenth century) under the control of the Spanish crown.

Numerous members of the Spanish royal family traveled and served in the North. Philip II (1555–98), for example, made two trips to the Lowlands, one in 1549–51 and the second from 1555 to 1559, and Spanish officials and noblemen occupied leading posts in the administration and the military in the Brussels court. Some of them became collectors and returned to Spain with paintings by local artists and a taste for Flemish painting. By the late fifteenth century, many of the most important works of art that could be seen in Spain were of Netherlandish origin. Flemish artists such as the sculptor Gil de Siloe and the painter Juan de Flandes worked as court artists to Queen Isabella in the final years of the fifteenth and the beginning of the sixteenth centuries, and in Andalusia painters such as Alejo Fernández and later Ferdinand Sturm (known locally as Hernando de Esturmio) and Pieter Kempeneer (or Pedro de Campaña) contributed a strong Flemish flavor to painting well into the second half of the sixteenth century. By the time of Velázquez's birth in 1599, much of the best art that could be seen in his native Seville was either by Netherlandish painters or strongly influenced by the Netherlandish style.

From the fifteenth century, two artistic idioms, one from Italy and one from the North, had become the respected points of reference for painters throughout Europe. The Italian Renaissance, which had originated in central Italy, found its model in ancient Greece and Rome and aimed at creating an idealized vision of the world according to the canons of beauty and proportion defined by the ancients. The artists of the Netherlands had created a more intimate and less monumental art, one that was less preoccupied with creating a sense of harmony and order and more concerned with the expression of feeling and with a realistic rendition of surfaces and detail – an emphasis that was made possible by the technique of oil painting, which was developed first in the Netherlands.

When Velázquez came onto the artistic scene, the history of art was still seen as defined by these two artistic models. But an important novelty had developed. A sense of opposition had grown between them, with the Italian Renaissance becoming gradually identified by artists and patrons as

the newer style and the Northern as the more old-fashioned one. An often quoted statement attributed to Michelangelo (admittedly a biased witness) is representative of learned opinions during the sixteenth century. According to Francesco da Holanda, Michelangelo once stated that

> Flemish painting . . . will . . . appeal to women, . . . and also to monks and nuns and to certain noblemen who have no sense of true harmony. In Flanders they paint with a view to external exactness. They paint stuffs and masonry, the green grass of the fields, the shadow of trees, and rivers and bridges, which they call landscapes. . . . And all this, though it pleases some persons, is done without reason or art, without symmetry or proportion, without skillful choice or boldness and finally without substance or vigor. Nevertheless there are countries where they paint worse than in Flanders. And I do not speak so ill of Flemish painting because it is all bad but because it attempts to do so many things well (each one of which would suffice for greatness) that it does none well.[1]

Just as telling as Michelangelo's statement is an omission in the book *Lives of the Artists* by the painter and writer Giorgio Vasari, which is the most influential text on the art of the Renaissance that has ever been written. Vasari did not mention a single Northern artist in the first edition of his text in 1550 and in the 1568 edition added only a few disparaging remarks about his Northern colleagues.

Netherlandish authors, of course, answered their Italian counterparts with their own interpretation of the history of painting, but it would be the Italians who would find their version gradually shared by the rest of Europe. There can be no clearer example of this than the situation in the North itself, where artists became increasingly italianized both in their art, which increasingly followed Italian models, and in their general culture, as witnessed by the growing number of Netherlandish painters who traveled to Italy and who changed the spelling of their names to Latin and Italian.

The contrasts between the two artistic styles, Italian and northern, can be overemphasized. In fact, Italian Renaissance art owed much to the North.[2] Netherlandish artists were sought out by Italian collectors, and they provided their southern counterparts with important technical innovations such as the use of oil painting; with numerous individual motives and models; and with novel ideas for the development of different genres – portraiture is a case in point, since it is probable that Italians adapted from the Netherlands the custom of painting figures in a three-quarter view instead of in strict profile. However, during the Renaissance there was a growing sense that the Italian example was now the one to follow.

By the time of Velázquez's birth, Spain had accepted the hegemony of the artistic culture of the Italian Renaissance, and the biases expressed by Michelangelo and Vasari were echoed by local writers. The Hieronymite Fray José de Sigüenza is exemplary when, in his *Historia de la orden de San Jerónimo* (published between 1595 and 1605), he writes of artists from Flanders and Germany in the following terms: "if they placed as much care in

knowing the art as they do in those colors and execution of details, they would have competed with the Italians, of whom they are always distant."[3] Later on in the century the Florence-born painter Vicente Carducho (1578–1638), who was also one of the most important art-theorists of seventeenth-century Spain, wrote in his book *Diálogos de la pintura* (published in Madrid in 1633) that Flemish painters "have progressed, because of the close contact with the things from Italy, attempting to imitate them in drawing and grandeur."[4] The idea that the positive qualities of Flemish painting derive from the study of Italian art is typical of the period.

The Sevillian painter Francisco Pacheco (1564–1644) is especially revealing of the artistic culture to which Velázquez belonged, because he was his teacher and also his father-in-law. Pacheco is the author of what is perhaps the most important art treatise written in seventeenth-century Spain, the *Arte de la pintura*. Pacheco worked on this text throughout his life, finishing it by 1638. In several passages he refers to Netherlandish art, showing the same bias that we have seen in the other cases. The invention of oil painting, attributed to Jan van Eyck, causes him to say: ". . . the illustrious Italy, admired, turned its head to see and follow his steps growing with the milk it received in Flanders from the breast of this ingenious artifice." This is one of the highest praises that the art of Flanders will receive in seventeenth-century Spain. With Pacheco's critique of the art of Pieter Kempeneer we come closer to Velázquez, since Kempeneer was the leading painter in Seville during his stay there between 1537 and 1563, when he returned to his native Brussels. Pacheco considers Kempeneer a painter of merit, if excessively "Flemish": "He lacked this Italian manner, our Maese Pedro Campaña, who having spent twenty years in Italy, and having been a follower of Raphael of Urbino, could not dispose of the dry Flemish mode." This "Flemish mode" has been previously described by the author by saying, "when a painting is dry and without strength or courage, we say it is Flemish."[5]

Other similar examples of the prevailing attitude could be given, but the point is already clear. When Velázquez began painting, there remained the idea of a Northern painting as a model quite separate from the Italian, but the latter had prevailed. The pervading prejudice saw Flemish painting as concentrating erroneously on color and details and lacking in drawing and the correct treatment of the human figure, harmony, and proportion. It was an artistic language that had lost some of its appeal in Spain like elsewhere in Europe. Velázquez's relationship with the North needs to be understood in light of this historical situation. The dominance of Italian art is clearly reflected in the artistic language of his paintings. In the broadest of terms, his can be considered an Italianate art, where the canon and the actions of the painted figures are inspired by the examples of antiquity and of Renaissance Italy. His two trips to Italy in 1629–30 and 1648–51 are also revealing of an Italianate artistic culture: when he decided to study the art from the art of the past, or when he was sent by

his king to purchase art, he traveled to Rome, Florence and Venice, rather than to the North.

However, the traditional strengths of Netherlandish art, its remarkable level of quality and wealth of talent, had consequences of fundamental importance for Velázquez. First, Early Netherlandish painting remained a force to be reckoned with in Spain, where some of the most famous works by artists such as van Eyck, Roger van der Weyden, and Hieronymous Bosch could be found. Second, northern cities such as Antwerp were veritable powerhouses of the industry of painting during the late sixteenth- and early seventeenth-century, cradle and home to large numbers of exceptionally talented artists. Northern painting, whether by the early masters or by the more "italianized" contemporary painters, remained a powerful source of inspiration throughout Europe, and very especially in Spain.

The presence of Flemish art in Seville in the sixteenth century had an effect on Velázquez before his departure for Madrid in 1623.[6] There are two types of pictures from the Seville period that show traces of a Netherlandish influence. The first is portrait painting. Pieter Kempeneer had been noted for his portraits of distinguished Sevillians, and Pacheco admired their verisimilitude in his treatise. The intense immediacy and uncompromising realism of Velázquez's portraits of the Seville period find their most obvious and influential local precedent in the work of this Fleming.

Traces of Northern art are also found in a second group of Velázquez's early works. These are genre scenes called *bodegones* (Fig. 19), which show figures in domestic settings, with food and drink. Sometimes they include in the background a religious scene, which adds a religious and moralizing message to the picture. In these compositions, Velázquez followed the example of two sixteenth-century Netherlandish artists, Pieter Aertsen (1508/9–1575), who worked in Amsterdam and Antwerp, and Joachim Beuckelaer (ca. 1533–1573/4) (Fig. 20). Works by these artists existed in Seville collections and had become popular through the prints made by Jacob Matham. Reproductive prints such as these were imported by the thousands into Seville. They served to introduce local audiences to northern genre scenes and were used by local artists as models for their own compositions. Velázquez's *bodegones* show that he had access to them and used them as models. In his pictures, like in those by Aertsen and Beuckelaer, the scenes are composed in a horizontal format with a kitchen or market scene in the foreground and a small-scale biblical episode in the distance. The similarities between Velázquez's works and his Flemish sources center on the organizational principle of relegating a key part of the subject to the background. As has often been noted, background elements would remain important in Velázquez's art, reappearing in such masterpieces as the *Fable of Arachne* and *Las Meninas,* where the tapestry and mirror on the back walls show images that are key to the meaning of the works. The differences are also worth stressing, because they demonstrate Velázquez's characteristic independence in approaching his models. The Spaniard's

19. Diego Velázquez, *Kitchen Scene with Christ in the House of Martha and Mary*, 1618 (London, National Gallery).

20. Joachim Beuckelaer, *Christ in the House of Martha and Mary*, ca. 1565 (Madrid, Museo del Prado).

works are compositionally simpler than the paintings of Aertsen and Beuckelaer, with fewer figures and objects. The two areas of the image, foreground and background, are more obviously connected than in his models, which serves to clarify the exemplar nature of the religious scene in the back. Color and light are another difference between Velázquez and his sources: the Spaniard's pictures are conspicuously darker than his Flemish models, and the contrast between light and dark areas is more abrupt.

Even after his move to the court in Madrid in 1623, Velázquez occasionally used northern images as sources for his compositions. In the court he also encountered new artistic models of northern origin through the international scope of royal collecting and patronage.[7] Late in 1632 or in early 1633, Velázquez was commissioned to paint a large canvas destined to one of the hermitages that were built in the gardens of the king's summer palace, the Buen Retiro, on the outskirts of Madrid. In the foreground of the *Saint Anthony Abbot and Saint Paul the Hermit* (Fig. 14) a bird brings food to the two figures. In the background are several scenes from the story of Saint Anthony's search for Saint Paul and his later burial. Several aspects of this composition are interesting to us. The prominent rocky formation that forms the backdrop to the two seated saints appears to derive from the work of the Flemish landscape specialist Joachim Patinir (ca. 1480–1524). Patinir's works were collected by the royal family in the sixteenth century, and Velázquez encountered his work in the royal collection. The disposition of the two saints and the bird that delivers their food also have a northern source. As has long been acknowledged, these figures, and especially the bird, take inspiration from Albert Dürer's woodcut *Saint Anthony Abbot and Saint Paul the Hermit* (Fig. 21). Dürer's print had already been used by Kempeneer in a picture of the same subject of 1546 (now in the church of San Isidoro in Seville), which Velázquez undoubtedly knew and probably admired as a youth, given Kempeneer's prestige in Seville. This example of Velázquez turning to a northern work known to him years earlier shows how the rich past of Netherlandish art constituted a reservoir of images he could draw from.

A few other paintings by Velázquez may be based on Netherlandish or German sources, among them the *Christ and the Christian Soul*, painted in the early 1630s (London, National Gallery), and the *The Crowning of the Virgin* painted in the 1640s for the queen's oratory in the palace in Madrid (Museo del Prado). In general, however, Velázquez made limited use of direct quotations from paintings by others. When he did so, he integrated his models into a highly personal idiom. The *Saint Anthony Abbot and Saint Paul the Hermit* allows a rare glimpse of the sources and ideas that fed into Velázquez's art, especially of his sources of northern origin.

Velázquez's encounter with the art from the North upon his arrival in Madrid stemmed both from his exposure to a wealth of northern painting in Madrid collections and from the requirements of his earliest commissions. When Velázquez entered the service of the monarchy in August of 1623 he was hired as a portrait painter, with his main task to produce portraits of

members of the royal family (Fig. 22).
Velázquez's elegantly understated repre-
sentations of Philip IV and his family typi-
cally show the figure in full length or
three-quarter length, turned slightly to one
side, and accompanied only by a small
number of elements such as a table or a
chair. These portraits followed a tradition
of portraiture that had already been estab-
lished at the court in Madrid, a tradition
with an important northern component.[8]
Among Velázquez's most distinguished
predecessors as court painter to the
Monarchy was Antonis Mor (ca. 1516/
20–ca. 1576), a portrait specialist from
Utrecht who was in contact with the Hab-
sburg court from 1549 and became court
painter to king Philip II in 1554. During
the 1550s Mor had been among the cre-
ators of a type of state portrait that the
Spanish Monarchs would adopt as their
favorite image well into the seventeenth
century (Fig. 23). Mor's definitive image of
the Spanish Habsburgs derived in part on
the example of his former teacher, Jan van

21. Albrecht Dürer, *Saint Anthony Abbot and Saint
Paul the Hermit,* woodcut, 1503–4 (New York,
Metropolitan Museum of Art, Harris Brisbane
Dick Fund, 1931 [31.58.2]).

Scorel, and in part on the portraits of the Habsburgs by Titian, who had in
turn relied on German precedents. Mor's portraits, like Velázquez's, show fig-
ures in full length or three-quarter-length, in three-quarter view, accompa-
nied by a few elements such as a table or chair, curtains, a sword or a baton,
gloves, a hat, a scarf or a fan if the sitter is a woman, and devoid of the type
of allegorical elements that sometimes appear in Renaissance portraiture.
The sitters exude an air of aristocratic distance and self-confidence and are
set against dark, neutral grounds that enhance their presence.

Continuity is a fundamental ingredient of court portraiture, because
the message carried by the image includes an assertion of the right to rule
by right of descent. The years that Mor spent as a portraitist for the Span-
ish monarchy made him a reference for all future court portraiture in
Spain, because his images had become the images of the monarchy's
immediate past. Moro's style was kept alive in the Spanish court in the late
sixteenth and early seventeenth centuries by his follower Alonso Sánchez
Coello (1531/32–1588) – who studied with Mor in Brussels – and by other
portrait specialists up until Velázquez's time. The similarities between
Mor's paintings and those by Velázquez reflect the conscious decision of
the latter to insert his works into the tradition of royal portraiture to which
the northern artist had contributed so much.

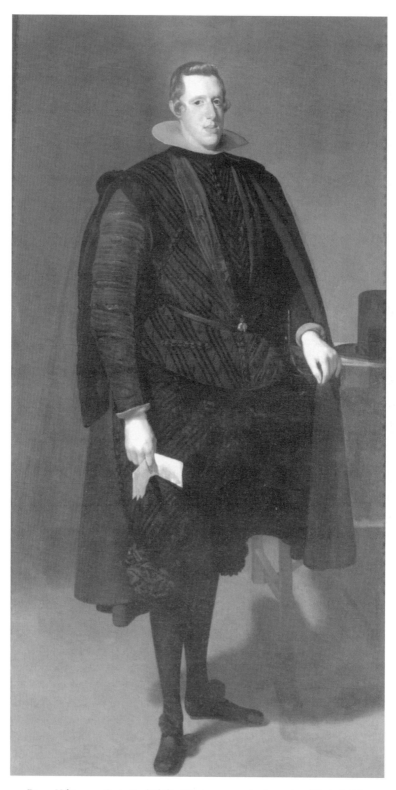

22. Diego Velázquez, *Portrait of Philip IV*, 1624, retouched ca. 1627 (Madrid, Museo del Prado).

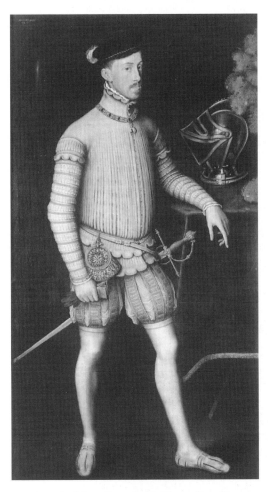

23. Antonis Mor, *Portrait of Maximilian II,* 1550
(Madrid, Museo del Prado).

In addition to the similarities, there are also significant differences
between the portraits of Mor and Velázquez, differences that are typical of
Velázquez's independence vis-à-vis his artistic sources. In his portraits we
find less attention lavished on the description of surfaces and textures, and
the forms are treated by the Spanish artist in a more pictorial fashion, with
the brushstrokes occasionally remaining conspicuously unblended on the
surface of the canvas (this is true even in Velázquez's early court portraits
of the 1620s and is more evident thereafter). The portraits by the Spanish
artist are also more naturalistic and three-dimensional, and in them we are
made less aware of the geometric pattern of the design. Velázquez's back-
grounds are slightly lighter than Mor's, and in them the artist gives some
indication of the existence of a floor and a wall, either by means of a line
that separates the two areas, or through a difference in tone (this way of

treating the background may actually owe something to Mor, since the backgrounds of Velázquez's portraits, even if more defined than those by the painter from Utrecht, are less so than what can be found in most other portraits of the period in Spain).

The relationship between Velázquez and Mor that has been described is typical of Velázquez's relationship with the North. Velázquez was interested in Mor not because Mor was a Netherlandish painter, but because he had worked for the Spanish monarchy. However, this does not mean that Mor's northern origin was not a factor. The wealth of artistic talent stemming from the Netherlands made for an important presence of artists of that origin throughout Europe on purely statistical grounds. Also, the fact that the Spanish monarchy had strong ties to that area, as was explained earlier, facilitated the import of artists of that origin, such as Mor into Spain.

Velázquez's work as court portraitist also brought him into contact with the Flemish painter Anthony van Dyck (1599–1641), one of the great portraitists of all times, author of pictures that have contributed to the very definition of sophistication and elegance. Velázquez's exact contemporary, van Dyck was also the most distinguished heir in the seventeenth century of the tradition of Netherlandish portrait specialists. Van Dyck's work must have been known to Velázquez not long after 1628, when the Fleming painted a portrait of the Infanta Isabella Clara Eugenia, governor of the Spanish Netherlands, copies of which were surely sent to Madrid to her nephew, King Philip IV. During the years when van Dyck worked for the courts of Brussels, from 1627 or 1628 until 1632, and later in London, for the court of Charles I of England, additional works by and after him also arrived in Spain. Like Velázquez's portraits, van Dyck's depend on earlier models, which are revitalized in his hands, and modified along lines quite opposite from the Spanish painter. Instead of the latter's understated elegance, van Dyck's portraits are flamboyant and theatrical. The differences between the two painters are apparent in two portraits of King Philip IV and his brother, the Cardinal Infante Ferdinand. In 1634, van Dyck painted a portrait of the cardinal infante after his entry in Brussels as the new governor general of the Spanish Netherlands (Fig. 24). The portrait shows the sitter dressed in a brilliant red velvet outfit embroidered with gold, with a baton, a sword, and the red sash of commander of the Habsburg forces, set against a brocaded curtain. The portrait must have been executed with the intention of being sent to Spain, for it is recorded in the royal collection in Madrid in 1636. And there Velázquez appears to have taken note of it. A portrait of the king that Velázquez painted in 1644 is clearly an answer to van Dyck's image (Fig. 25). Velázquez portrayed the king during a campaign in the town of Fraga. That he was working on an image of the ruler as military commander wearing the outfit when the king asked to be painted in (the one he had actually used during a review of the troops at Fraga) seems to have ignited in Velázquez the memory of van Dyck's portrait. The similarities between the two pictures are apparent in the cos-

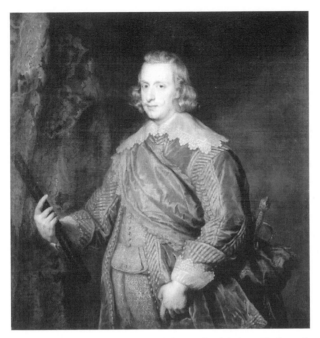

24. Anthony Van Dyck, *Portrait of the Cardinal Infante Ferdinand,* 1634 (Madrid, Museo del Prado).

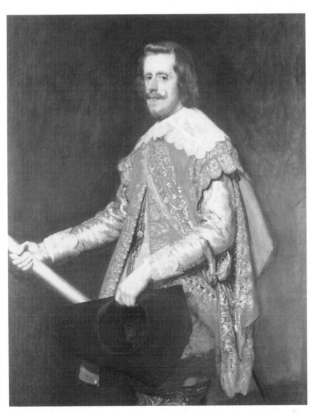

25. Diego Velázquez, *Portrait of King Philip IV of Spain,* 1644 (Copyright The Frick Collection, New York).

tumes of the sitters, the compositions and poses, and the displays of baton and sword. The differences are also notable. In van Dyck's painting the sash and curtain enhance the richness of the overall image. Velázquez simplifies the setting, leaving the outfit as the only sign of the king's wealth. Velázquez is also more naturalistic in how he poses the figure. In van Dyck's painting the disposition of the hands of the cardinal infante create the impression that the sitter is acting out his role as commander, wielding the baton in a demonstrative gesture. In Velázquez's image we are convinced not through rhetoric but by the natural ease of the sitter.

Other individual models that appeared in Velázquez's horizon with his move to Madrid had an effect on his work. Among Netherlandish artists from the past, Jan van Eyck (active from 1422 to 1441) had acquired the greatest status by Velázquez's time. Van Eyck was among the most famous artists in Europe in the fifteenth century, and he was credited by Vasari, and after him by Pacheco and others, with the invention of oil painting – erroneously, as we now know. His fame also derived from his position as court

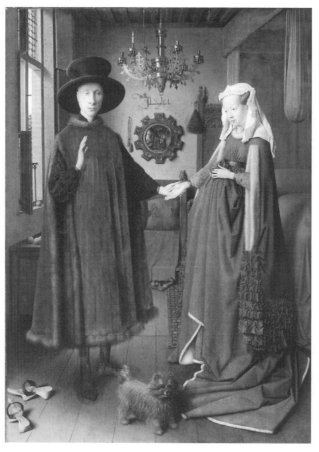

26. Jan Van Eyck, *The Arnolfini Portrait*, 1434 (London, National Gallery).

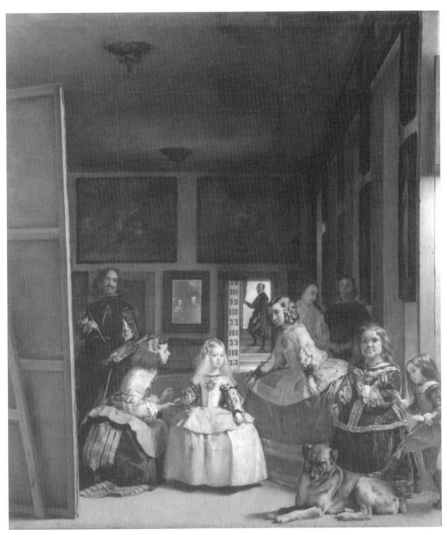

27. Diego Velázquez, *Las Meninas,* ca. 1656 (Madrid, Museo del Prado).

painter of Philip the Good of Burgundy in Bruges, which made him a model
as an artist who had acquired an elevated social status. Van Eyck's art was
represented in Madrid by one of his most famous works, the *Arnolfini Por-
trait* (Fig. 26), which belonged to the Spanish royal collection from the six-
teenth century and hung in the royal palace in Madrid during Velázquez's
time. Van Eyck's fame, and the striking quality of his work, its meticulous
exactness and vivid portrayal of the sitters, appear to have caught the atten-
tion of Velázquez, for he was inspired by him when making his most famous
work, *Las Meninas* (Fig. 27).[9] The most obvious similarity between the two
pictures is the role played by the mirrors that hang on the wall at the back
of the painted spaces. In both cases, this device serves to bring into the
experience of viewing the picture an awareness of the area that lies between

the canvas and the onlooker. The similarities of other elements that exist in both paintings – the placement of the dog, the light entering through lateral windows – has made scholars speak of Velázquez's work as a transformation of the *Arnolfini Portrait,* where the artist has depicted a space equivalent to that in front of the Arnolfini couple. We will never know if Velázquez was so specifically focused on van Eyck's picture when he conceived of *Las Meninas,* but the similarities between the two works are sufficient for us to believe that he did have that picture in mind. The intrinsic qualities of van Eyck's's panel, and his historical stature, would have made him a natural target of Velázquez's interest.

If van Eyck was the most famous Flemish painter from the past, among contemporaries no one surpassed the reputation of Peter Paul Rubens (1577–1640). Velázquez and Rubens shared in Philip IV their main patron, and they met during Rubens's extended stay in Madrid in 1628–29.[10] Rubens and his art were extremely influential for Velázquez, in spite of the fact that the pictorial vocabulary of the two masters is quite different. As we will see, Velázquez's relationship to Rubens is characteristic of the way in which the Spanish artist related to his models, integrating his sources into his very personal aesthetic.

As a Fleming, and as painter to the court of the Spanish Netherlands in Brussels from 1609, Rubens was a subject and a servant of the Spanish monarchy, a fact that facilitated the collecting of his paintings in Madrid. By the time when Velázquez became court painter in Madrid in 1623, some works by Rubens could already be seen in the royal collection. In the following years the continued arrival of his art in Madrid, and especially Rubens's personal presence in the Spanish capital, would have a determining effect on the art and the career of Velázquez.

The key moment for the relationship between the two artists is Rubens's second trip to Spain of 1628–29 – Rubens had been in Spain once before, in 1603. When Rubens arrived in Madrid in mid-October of 1628, he brought with him a spectacular set of eight large mythological paintings. He was also preceded by the fame that resulted from his large decorative project in Paris for the palace of the Queen Mother of France, Maria de' Medici, and also by the arrival in Madrid only a few weeks before him of some tapestries that he had designed to decorate a convent in Madrid, the Descalzas Reales.

A measure of the impact that the presence of Rubens in Madrid had on Velázquez – who was twenty-two years his junior – can be drawn from a commission for a portrait that the Fleming received from the king. One of Velázquez's main jobs as court painter, as we have seen, was to paint portraits of the king. In 1626 he had done a monumental equestrian portrait of Philip IV (now lost), which hung in one of the main ceremonial rooms in the royal palace. Shortly after Rubens's arrival in Madrid, the Fleming received from the king a commission to paint another equestrian

portrait of himself (which has also been lost; there is a copy of this picture in the Uffizi), which, upon completion, was installed in the place previously occupied by the Vélazquez. Given this act of patronage, one would expect a reaction of jealousy from Velázquez towards Rubens. But the evidence that we have points to the contrary. Velázquez's father-in-law Pacheco wrote with great admiration of the Flemish artist, and with pride of his pupil's proximity to him. "He communicated little with painters," Pacheco writes of Rubens's stay at the Spanish court; "He only established a friendship with my son-in-law . . . and he greatly favored his works for their modesty, and together they went to see the Escorial."[11]

At the time when Velázquez and Rubens met in Spain, Rubens had obtained such high status that the relationship between the two was bound to be one of admiration of the younger artist for the man who was one of the stars of the artistic courts of Europe. Velázquez probably shared his studio in the northern section of the royal palace with Rubens, and he must have been greatly impressed to see the master at work. During his nine-month stay in Madrid, Rubens made portraits of all the members of the royal family and of several other sitters; he copied many paintings from the royal collection, all of them by Titian; he enlarged and partially repainted an *Adoration of the Magi* by his own hand that the king had owned for some years; and he painted two large religious pictures for private patrons. His total production during his stay in Madrid is hard to establish with precision, but it probably exceeded thirty pictures. And these were not small sketches, but rather finished paintings, many of them large compositions. This number means that Rubens painted in less than nine months about one-fourth of Velázquez's total output for his entire lifetime. The fascination caused by Rubens must have stemmed not only from his remarkable productivity but also by his spectacular talent. Since his arrival in Madrid, Velázquez had become familiar with the work of some of Europe's greatest artists, but his experience of a painter at work remained limited. Having Rubens nearby priming his canvases, sketching in his compositions, and applying his paints, must have been an irresistible demonstration of talent.

At first sight, the art of Rubens and Velázquez appear significantly different, the first characterized by its rhetorical gestures, ebullient energy, and wealth of color, the second by its quiet, understated mood, its deceiving ease, and its restrained color range. But upon closer look we can discern some lessons learned by Velázquez from his elder colleague. One of the most intriguing aspects of the relationship between the two artists is technique. Our knowledge of the methods used by artists remains incomplete, due to the intrinsic difficulty of understanding what is to a large degree an intuitive activity. But a close look at the paintings, and recent studies of materials and techniques, allow us an approximation to this aspect of Velázquez's art. From the early stages of his career, it appears that his choice of pigments was influenced by practices that were typical

of the art of the North, such as his preference for calcite over Italian gesso, and the way in which he achieved green tones by combining yellow and blue rather than using a green pigment. This may imply that some aspects of artistic practice in Spain, such as the techniques used by painters, lagged behind changes in style in their change from a northern to an Italian model. Paradoxically, the effect that Rubens appears to have had on Velázquez from the time of his visit to Spain in 1628–29 was to encourage him to move closer to Italian models. The change that can be seen in Velázquez's painting technique in the direction of lighter grounds, a freer technique and more transparent paint layers can probably be credited in part to his witnessing Rubens at work in Madrid. In one of the copies after Titian that Rubens painted in 1628–29, the *Rape of Europa*, the preparation layer (or ground) was applied on the canvas with curving strokes, as can be seen by the marks left beneath the outmost paint layers. This same technique is characteristic of Velázquez beginning shortly after this time, as shown by X-rays of his paintings.[12] The change in Velázquez from dark to light grounds around this same time may also owe something to the example of Rubens's characteristic luminosity. The result of the light color of the ground and the manner in which it is applied was a shimmering effect that adds vibrancy to the finished picture, a feature typical of Rubens's work, and also of Velázquez from this time onwards. The exact extent of Rubens's influence over Velázquez in these changes, or even whether it was his art that he used as a model, remain uncertain. The technique of Velázquez is sometimes closer to Titian than to Rubens, in areas such as the blending of the different tones used to paint the flesh. But even in this case Rubens was a factor, because his careful study of the Venetian master probably induced Velázquez to use him as a model. Rubens's fame, and his proximity to Velázquez during his stay in Madrid, suggest that he indeed had an important effect on Velázquez's general sensibility, contributing to his turn towards a lighter, more sketchy manner of painting.

Rubens was a model for Velázquez not only in the technique that he used for painting, but also in his general approach to his art. According to the artistic culture of the time, paintings that dealt with subjects from history, religion, or mythology had a higher status than other subjects, such as portraiture, because of their intellectual and exemplary nature. Rubens's visit to Madrid coincided with the moment when Velázquez was intent to become more of a history painter, and it contributed to encourage this turn in his career.[13] The date of Velázquez's first history painting *The Feast of Bacchus* (Museo del Prado) is uncertain, but it may have been painted exactly at the time when Rubens was in Madrid. This suggests that, together with the artistic culture of the time and the environment at the court, Rubens was a factor in inspiring Velázquez to try his brushes at his first history painting. The Flemish painter was probably also instru-

mental in encouraging Velázquez to travel to Italy, where he went in June of 1629, little over a month after Rubens's departure from Madrid. In contact with the art of antiquity and the Renaissance, Velázquez would culminate his artistic training. Rubens had made him – and his patron the king – aware of his need to master the grand manner of history painting, with its narrative emphasis and its language of rhetorical expressions and gestures.

The impression that the presence of Rubens in Madrid had on Velázquez, and his influence over him, emanated not only from his art but also from his personality and standing. Since 1627 Rubens had been involved in diplomatic conversations with representatives of the English king seeking a peace between England and Spain, and his arrival in Madrid had been prompted by the need to explain to the king the state of affairs. Rubens's conversations with the monarch and his ministers on matters of politics, and the distinguished manner in which he carried himself among such company, were an example that made Velázquez and his royal patron see beyond the prejudice generally associated with the lowly social status of artists. Writers on the arts in Spain, from Pacheco onwards, used Rubens as a model of the recognition that a painter could achieve not only as a result of his talent but also of his social merits. Rubens's presence in Madrid had brought to Velázquez an example of what he himself strived to be, and a model to imitate: a court painter who had achieved aristocratic status.

There are two paintings by Rubens and Velázquez where we can see a pictorial manifestation of Rubens's elevated status, and of the influence of this status over Velázquez. When Rubens was in Madrid he enlarged an *Adoration of the Magi* (Fig. 28) that he had originally executed in 1609. In the enlarged section of the picture, to the right of the composition, the painter included his self-portrait. He is shown dressed in a crimson jacket and riding on a white horse, facing away from the viewer and turning back to look at the child Christ, with a chain around his neck and a sword on his side. The king owned the painting and he must have asked the painter to add his portrait. This was an unusual sign of the favor shown by the king towards Rubens. A measure of how rare this was can be obtained from another occasion when the prince of Wales asked the painter for his portrait, to which the painter answered, ". . . to me it did not seem fitting to send my portrait to a prince of such rank."[14] The way Rubens portrayed himself is also important. He does not appear as a painter, but rather as a gentleman who displays two elements that were understood at the time as signs of the favor shown to him by his royal patrons: the golden chain and the sword.

Rubens's self-portrait cannot have failed to impress Velázquez, and indeed there may be an echo of it in the inclusion of his own self-image in *Las Meninas*. The portrait in the *Adoration* is the most obvious precedent

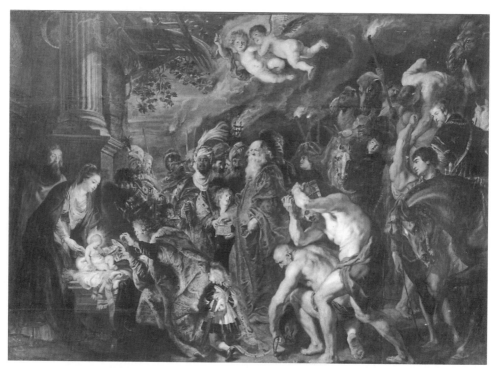

28. Peter Paul Rubens, *Adoration of the Magi,* 1609 and 1628–29 (Madrid, Museo del Prado).

for this painting because it was probably the only picture present in the royal collection to include a self-portrait of an artist, and certainly the only one where this inclusion had taken place in the presence of the king and of Velázquez. Like in the painting by Rubens, by including his portrait in *Las Meninas,* Velázquez was making a case for his elevated status, since he showed himself painting in the company of royalty.

With Rubens we end this survey of the relationship of Velázquez with the art of Northern Europe. The relationship between these two painters exemplifies in several ways the nature of Velázquez's relationship to that artistic tradition. Rubens's art serves to underscore the Italianate character of the arts of Europe at the time. His is an Italianate art in the subjects that he paints and in his figure types, the goals of his career, his artistic culture, and his taste. In spite of this overarching fact, Rubens's Flemish origin was a factor in making him known to Velázquez for two reasons. As a result of the traditional importance of the industry of art in that area, cities such as Antwerp, where Rubens had his workshop, continued to produce a prodigious amount of artistic talent, which was exported throughout Europe. The political connections between Spain and the Netherlands facilitated access to the art and artists of that origin. In the case of Rubens, his main patroness, the governor of the Spanish Netherlands,

Isabella Clara Eugenia, was the aunt of the Spanish king Philip IV, who became Rubens's greatest collector. Isabella was instrumental in making Rubens and his paintings known and collected in Spain.

When studying the relationship of Velázquez to the North, in the end one is struck by the stubborn independence of the artist. Again here the relationship with Rubens is illuminating. In spite of the Fleming's fame and overflowing talent, which as we have seen had a profound effect on Velázquez during the time the two shared in Madrid, our painter remained a very different artist, secure in his own artistic idiom. A comparison with a contemporary is illuminating. Van Dyck, who like Velázquez was one of the most successful and talented artists of the time, grew up in the shadow of Rubens and learned to paint from an early age in the artistic language that Rubens had created. For Velázquez, Rubens, like the rest of his sources, was not such a dominating influence but rather a source of ideas that nurtured a highly personal talent.

5 "Sacred and Terrifying Gazes"

Languages and Images of Power in Early Modern Spain

Antonio Feros

The Politics of Representation

In 1640 Diego de Saavedra y Fajardo, one of the most influential seventeenth-century Spanish writers, made a remarkably explicit reference to the effect that images of kings had upon their subjects as he recalled his own experience of viewing a royal portrait by Velázquez. In it Philip IV appeared "full of grace, august in his countenance . . . [and] I was overcome with such respect, [that] I knelt down and lowered my eyes."[1] The importance of the king's representation within a monarchy like Spain's, composed of a number of territories where the king was an "absent" ruler, is also evident in royal ceremonies celebrated in kingdoms distant from the monarchy's political center. In 1621, for example, the elites of the viceroyalty of Peru took oaths of loyalty to the new monarch, Philip IV, in a ceremony replete with symbols of obedience, loyalty, and adoration for the king. In the absence of the monarch himself, a portrait of Philip, framed in gold and "seated" on a throne beneath a canopy, presided over the ceremony.[2]

In this essay I do not seek to evaluate whether Saavedra y Fajardo and the Lima elites believed that the image of the king was the king or whether in the presence of the king or his image they truly experienced the intensity of feeling that their accounts suggest. Certainly, in Spain, as in the rest of early modern Europe, royal images were perceived as something more than simple representations of the monarch. Within Catholic tradition, an image of the king not only represented the king but "was" the king, just as the Holy Sacrament "was" the body of Christ rather than its representation.[3] The reactions of Saavedra y Fajardo and his contemporaries in Lima demonstrated that in the seventeenth-century Spanish empire the images of monarchs, like other images perceived as sacred, were imbued with a

symbolic force regardless of their aesthetic characteristics, qualities, and content. What mattered was the subject of the image, not its quality or technical characteristics.

And yet the ceremony in Lima and Saavedra's experience with Velázquez's portrait of Philip IV do call our attention to important questions concerning discourses of domination and political legitimization developed by the Spanish monarchs in the sixteenth and seventeenth centuries. As they beheld these and other portraits, the subjects of Philip IV not only privileged an image but also recognized a series of ideas, discourses, and symbols that, as a whole, offered a certain vision of the monarch and his power. In other words, as inhabitants of a monarchical world, Saavedra and his contemporaries were prepared to go beyond the plain literal sense of images and to experience and analyze these images within specific ideological and discursive contexts.

Before turning to an analysis of the dimensions and vocabulary of the discourses of power in early modern Spain, it is important to recall that the Spanish rulers themselves sought to propagate royal images and symbols throughout the entire monarchy and that this process of propagation was very much centralized.[4] Images and representations of the monarch were indeed present in all corners of the empire, part of an attempt to encourage all the monarch's subjects "to idolize the king's omnipotence in all orders of everyday life . . . to live in fascinated astonishment."[5]

The intensity and efforts the Crown and its servants dedicated to design and propagate royal images confirm that the consolidation of royal power in early modern Spain also depended upon the ruler's capacity to demonstrate that his power – and thus the monarchical system itself – was not socially created but divinely ordered. In early modern Spain, as in the Balinese court described by Clifford Geertz, "the driving aim of higher politics was to construct a state by constructing a king . . . [and] a king was constructed by constructing a god."[6] The stability of a political system and of the power and authority of rulers, in Pierre Bourdieu's words, is best sustained when it "is perceived not as arbitrary, i.e. as one possible order among others, but as a self-evident and natural order."[7] Such an understanding of power and political authority required that the monarch himself be viewed as the architect of his own image, because the power of royal images and discourses was directly linked to their recognition as legitimate by the king's subjects.[8]

It is important to note, however, that royal discourses and images were not monolithic and that, indeed, in the early modern period there coexisted various views on how the monarchy should be ruled. A review of work on the early modern Spanish monarchy reveals that we have an increasingly sophisticated understanding of the discourses, ideologies, and images that the Spanish monarchs used to legitimate their power and authority. Indeed, recent scholarship provides detailed discussion of the

initiatives, models, objects, ceremonies, gestures, and portraits that, it is argued, served to establish the dimensions of the Spanish monarchs' power over their subjects. Consequently, the most prominent impression that we have is of the Spanish Habsburg dynasty as one capable of imposing its dominion through images and ideologies that actually persuaded its subjects to obey. The Spanish Habsburgs' ability to create powerful political discourses and images, we are told, permitted them to maintain their empire more or less intact for almost three hundred years.

Although the abundance of studies on the monarchy's initiatives is generally salutary, given previous inattention to these questions, such scholarship has presented a somehow distorted picture of the Spanish monarchy by insisting upon the monarchy's ideological hegemony. Within the sixteenth- and seventeenth-century Spanish monarchy there was a greater degree of disagreements and opposition than has been recognized. We know increasingly more about the numerous contemporary texts that criticized the actions of monarchs and the many more that criticized the actions of royal favorites; and we can now turn to the many satirical poems that present a dark view of the court and courtiers by ridiculing the images and ideas used by monarchs and their ministers in the attempt to legitimate their power.[9]

The existence of political disagreements and conflicts, however, did not preclude the creation in seventeenth-century Spain of what David Kertzer has called "a widely shared ideology of legitimacy,"[10] comprised of doctrines that, to our modern eyes, could be seen as paradoxical. Such ideology includes a defense of the monarchs' capacity for independent action as well as a belief in a theocratic concept of kingship in which the monarch "was seen as sanctified, ruling as a surrogate of God on earth."[11] Yet it also limits the exercise of this power and obligates the king to respect the jurisdiction and role of other members of the body politic. As Janet Coleman has noted,

the office of kingship, being divinely instituted, had as its purpose the furthering of the divine will; hence the monarch was not to rule by absolute whim. . . . In Roman terms his was a tutorial role to his people, which in itself limited his freedom of action, as it required that he protect certain of their rights which were not necessarily derived as concessions from him.[12]

Ceremonies of power, the propagation of the king's image, and the praises offered in the theater therefore served not only the interests of the monarchy but also those of the political and social elites that controlled the institutions of government and retained important territorial jurisdictions. Thus, while the propagation of an image of the king as a "Catholic monarch" gave his policies a certain legitimacy, it also allowed the church and the Inquisition to retain power and influence. Presenting the monarch as a "public official" whose duty was to defend the commonwealth gave

him legitimation to design and implement dynastic policies but also allowed other institutions such as the Councils to express and exercise an active role in the process of defining the monarchy's policies, sometimes against the monarch's will. The ceremonialization of political life, particularly in those kingdoms from which the monarch was absent, permitted the propagation of a powerful and "sacralized" image of the king but also acknowledged the political elites' right to claim that the king was created to protect the commonwealth and the rights of the other members of the body politic. Many of the subjects of the Spanish monarch interpreted discourses and images that described the monarch as God's representative on earth, not as proof of the sacred nature of majesty but rather as proof that the king's legitimacy was based on his ability to protect the Church and his kingdoms. As Fray Aguilar de Terrones asserted in a funeral sermon for Philip II, "the King is a man" like any other; what differentiates him from other mortals, what makes him closer to God, is not his power and authority but his competence to defend religion and administer justice.[13]

How these contrasting views of kingship affected the creation of the king's image is the subject of this essay. Readers cannot expect to find here the proof that the Spanish Habsburgs promoted the construction of just one public royal image, or that public representations of the king and his power had the same meaning for every member of the body politic. Equally important, readers should not expect a study of Velázquez's views on political discourses and public images of the Spanish rulers. As *pintor del rey"* Velázquez was, indeed, an important actor in the construction of his master's public image, but in doing so he was influenced by the existence of, first, fully developed patterns of pictorial royal representation, and, second, a political ideology that established limits to how the king could be represented. The aim in the following sections is to reconstruct royal discourses and images in sixteenth- and seventeenth-century Spain in order to contextualize Velázquez's work as *pintor del rey* – his portraits of Philip III, Philip IV, and his favorite and chief minister, the count-duke of Olivares, as well as his works and designs for that paradigm of royal propaganda, the *"Salón de los Reinos"* (The Hall of the Realms) in the Palace of the Buen Retiro, built in Madrid by Philip IV in the 1630s.[14]

A Distant King: The Politics of the Royal Body

In his second letter (30 October 1520) to the Emperor Charles V, Hernán Cortés, in reporting the conquest of Mexico, carefully recorded the ceremonies and rituals of the Mexicas and their emperor Montezuma. "All the chiefs who entered his house went barefoot," Cortés wrote, "and those he called before him came with their heads bowed and their bodies in a humble posture, and when they spoke to him they did not look him in the face;

this was because they held him great respect and reverence." Beyond the boundaries of the palace such respect and reverence for their emperor was even more pronounced. "When Montezuma left the palace, which was not often," Cortés reported, "all those who went with him and those whom he met in the streets turned away their faces so that in no manner should they look at him; and all others prostrated themselves until he had passed." The respect and reverence with which the Mexicas beheld their lord stood in contrast to the behavior of Cortés's men toward their captain: a difference that, according to Cortés, was noted by members of the Mexica nobility. "[C]ertain of those chiefs reproved the Spaniards saying that when they spoke to me they did so openly without hiding their faces, which seemed to them disrespectful and lacking in modesty."[15]

The references of Cortés to the particular behavior of the Mexica and of the Spanish toward their superiors illustrate how political power was conceived in Spain at the beginning of the early modern period. Cortés described Montezuma as a ruler venerated by his servants and beheld as divine and sacred, whose subjects displayed absolute respect at times motivated by fear. In early sixteenth-century Spanish political culture, such gestures and behavior had a clear meaning: the political system of the Mexicas was based on the absolute power of a monarch who was publicly imagined to be a godlike man. More important, for Cortés's contemporaries these characteristics were associated with the political systems of "primitive peoples," who lived without rights, subjugated by an emperor who governed by his will and for his interests alone.

In contrast to the Mexica's "primitive servility," early sixteenth-century Spanish subjects understood the power of their rulers to be based on radically different principles. First, the Spanish prince was regarded as an individual with qualities and virtues that justified his elevated status but that did not transform his fundamentally human nature or his power. For sixteenth-century Spaniards, to use the language reserved for God to describe the monarch was a political aberration, if not a heresy. God alone was untouchable, invisible, an all-powerful being whom one could beg for help but whom no one could counsel or criticize, correct or resist. On the contrary, within the early sixteenth-century political paradigm, the monarch was recognized as open to the criticism, pleas, and counsel of his subjects. More important, according to the dominant political ideology, the monarch had to govern in collaboration with his ministers and the representatives of the kingdom, and, consequently, the monarch needed to be public, accessible to his subjects, and to the community of which he was an integral part.[16]

While such an understanding of monarchical authority was dominant at the beginning of the sixteenth century, less than a century later this authority had been dramatically reconfigured. Beginning in the 1580s, the Spanish monarch was described with language similar to that used by Cortés to describe Montezuma: a detached, inaccessible, untouchable, and almost invisible monarch, God's representative on earth whose sacred gaze was

terrifying. Although earlier scholarship has attributed this development to the "personality" of Philip II, recent work has shown it to be part of a concerted strategy to reinforce royal power sustained by both Philip II and his successors. Their primary goal was to consolidate royal authority and to transform the person of the monarch into a central and fundamental symbol of power without having to appeal to absolutist principles.

Although during the reign of Philip II some political theorists insisted on the need to "sacralize" not only the image of the king but his "body" as well, it was in the first decades of the seventeenth century when these ideas gained currency and resonance. The central element in these attempts to sacralize the king's body was not, as in other early modern monarchies, an emphasis upon the monarch's healing powers but his transformation into an untouchable, inaccessible, and "invisible" monarch.[17] Juan Fernández de Medrano provided the reason why the king should become inaccessible and invisible to a majority of his subjects: "[I]f great men are seen often they are less revered," he wrote, drawing his argument from Giovanni Botero's *Ragion di stato*.[18] While Medrano had recourse to many historical examples to support his claims, and indeed he settled on Emperor Tiberius, other authors preferred models and precepts taken from Christian doctrine and traditions, including the doctrine of the Holy Sacrament. Diego de Guzmán, Queen Margaret's biographer during the reign of Philip III, for example, suggested that the Holy Sacrament should not be displayed all day and visible to everyone at all times. Such exhibition, he feared, would result in a loss of "the respect, reverence, and love due to Him." Guzmán reminded his readers of God's commands: "Those who see me will die, our Lord said. In this way God imposed respect and fear among men." According to Guzmán, a monarch, God's representative on earth, should behave similarly, limiting his public exposure and prohibiting his subjects from attempting to see him apart from established, and increasingly exceptional, public ceremonies.[19]

The sacralization of the king's body and the steps taken to reduce the accessibility of the monarchy in practice deeply affected public perceptions of royal majesty in the seventeenth century.[20] Royal panegyrists claimed in the 1610s and 1620s that Philip II, like Christ himself, had performed miracles and that his status as God's representative made him godlike.[21] These special virtues imbued the *natural person* of the king with an aura that affected those who surrounded him in dramatic ways, often recalling passages from the Book of Exodus, where communication with God is forbidden to all "for fear that the Lord may break out against them."[22] Standing before Philip, his ministers and servants trembled and lost their composure. "With the first glimpse," Baltasar Porreño explained, "brave men who had faced thousands of dangers trembled in his presence and no one beheld him without being moved."[23]

This sacralized vision of the Spanish monarch acquired public dimensions in seventeenth-century theater. Indeed, in the first decades of the

seventeenth century, in works such as Lope de Vega's *El arte nuevo de hacer comedias* (1609),[24] the Spanish translation of Philip Sidney's *Defense of Poesie* (1616),[25] and the Spanish translation of Aristotle's *Poetics* by Juan Pablo Mártir Rizo (1623),[26] theorists of poetics began to assert that poetry, and more particularly drama, should serve to promote the sacred image of the monarch. It was Lope de Vega who most aptly addressed the role of the poet in relation to royal power. In a poem written in 1605 to celebrate the birth of Prince Philip, the future Philip IV, Lope writes:

> Quien duda que naciendo humanos Príncipes
> Será justo alabarlos con los versos?
> [Pues] los reyes son Dioses de la tierra.[27]

> [Who may doubt that the birth of Princes
> Should be celebrated with verse?
> [For] Kings are gods on earth.]

Lope de Vega and other authors sought to adapt the theater to the doctrines and images of royal power that prevailed during the reign of Philip II and his successors. It was not important, contemporaries argued, whether the playwrights drew their models of monarchy from history. Rather, the duty of the playwright was "to introduce persons and represent them according to the customs of our times," and this included the representation of monarchs as inaccessible, untouchable, irresistible, almost invisible and possessing a divine aura.[28]

In accordance with contemporary political discourse and poetic theory, seventeenth-century playwrights presented monarchs to their subjects not in terms of the symbols and instruments of power, but rather by reference to their divine aura and the strength of their person. To mention just a few examples, in Lope de Vega's *Valor, fortuna y lealtad,* the peasant Sancho asks: "¿No es hombre la majestad?' Yes, responds his colleague Mendo, "Pero es hombre endiosado: / un rey es Dios en la tierra." ["Is not His Majesty a man?" Yes, But a godly man: / a king is God on earth."][29] Similarly, Sancho Ortiz, a character in Lope's *La Estrella de Sevilla,* explains to King Sancho that he is moved by his presence because to see the king is to see "an image of God."[30] In *El Rey Don Pedro en Madrid y el infanzón de Illescas,* Don Tello trembles before the presence of the monarch; the ruler is indeed a man, but his greatness as God's representative on earth, transforms him into a deity.[31]

The efforts to sacralize the person of the monarch continued throughout the reign of Philip IV and, significantly, came to encompass all that the monarch touched: his possessions and personal effects came to be regarded as imbued with the "semi-divine substance that emanated from majesty."[32] It was precisely this idea of the extension of the king's essence to those objects and persons he blessed that allowed the royal favorites to present themselves as their masters' shadows, friends, and public

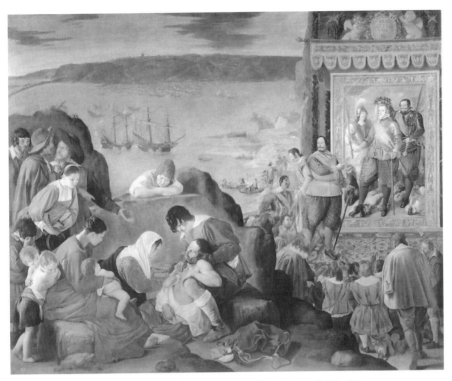

29. Juan Bautista Maino, *Recapture of Bahia*, 1635 (Madrid, Museo del Prado).

"images." As one seventeenth-century writer explained, favorites had to be perceived and accepted as "real incarnations of the prince," whom they represented in the ruling of the monarchy.[33] This perception affected the way many painters depicted royal favorites like the duke of Lerma, Philip III's favorite between 1598 and 1621, and the count-duke of Olivares, Philip IV's favorite between 1621 and 1643. This was the case in the *Recapture of Bahia* (1635) by Juan Bautista Maino, in which Olivares appears as Philip IV's twin image (Fig. 29), or in the title page of the Count of La Roca's *El Fernando* (1632), depicting Olivares as Atlas and Hercules, duplicating similar images employed to represent kings (Fig. 30).

A Catholic King: The Politics of Religion

This "political deification of temporal rulers," to use Stuart Clark's words,[34] appeared to its promoters and opponents as central to the future of the political system. To supporters, the deification of the king and the acceptance of a monarchial authority derived from "supernatural qualities and powers" made it possible to eliminate alternative political discourses that attributed royal power to a "social contract" or based it upon "popular sovereignty."[35] To opponents like the English Jesuit Robert Parsons, who spent

30. Title page representing Olivares as Atlas and Hercules from *El Fernando, o Sevilla restaurada . . .* by Juan Antonio de Vera y Figueroa, Count of La Roca, Milan, 1632 (Madrid, Biblioteca Nacional).

part of his life in Spain, and the Catalan Franciscan Joan de Pineda, the deification of the rulers seriously endangered the freedom and rights of the kingdoms and the various members of the body politic. Pineda, for example, in a book published in 1594, recalls that the Egyptians "called their rulers gods . . . a practice followed today by an increasing number of writers who use divine names to address their king."[36] His knowledge of the political situation in Philip II's Spain made him believe that the use of "sacred" names to authorize the ruler, resulted not from the political writers' desire to flatter kings but was a clear attempt to increase royal power in order to destroy "the liberty of the kingdoms."[37] Despite Pineda's and others' criticism, the attempts to transform the Spanish king into a powerful godlike man gained momentum in the last years of Philip II's reign with the development of a "Catholic" perspective on royal majesty – one that presented the Spanish Habsburgs as the only defenders of the Catholic faith. Such a perception took shape during the reign of Philip II, for whom the most fundamental feature of ideology and politics, both

31. Hans Liefrinck and Hieronymus Wierix, *Christ and Philip II*, 1568 (Bibliothèque Royale Albert I^er, Brussels).

domestic and international, was the idea "that the Catholic King was always . . . to the right of the Priest" and thus stood as the defender of the Catholic faith.[38]

Thus, for example, in a print by Hans Liefrinck and Hieronymus Wierix, entitled *Christ and Philip II* (Fig. 31), the "realistic" rendering of Philip II does not preclude the display of "similarities" with the image of Christ. The symbolical dimensions of this image are further manifest in the accompanying text, which includes biblical references to the divine origin of royal power and the duty of absolute obedience to kings. Indeed, by the last decades of the sixteenth century, the Spanish Habsburgs were forcefully promoting the belief that the king was God's representative on earth and that his power and authority were divine. This principle was expressed, for example, by Fray Alonso de Cabrera in a sermon preached in honor of the late king Philip II:

The eminent power that the king has derives from God and is communicated by Him. . . . Those who resist and rebel against the king, resist God and destroy God's established order. The king's subjects have to obey their master who occupies the

place of God on earth. This is the order that will last in the world until the second coming of Christ when He will recover for himself the whole *potestas* and administration of this His realm.[39]

Others also represented the Spanish Habsburgs as members of a race of kings selected by God to rule over men. In the *Annunciation* (ca. 1605), for example, Juan Pantoja de la Cruz, a painter at the courts of Philip II and Philip III, offered an image of Queen Margaret (1598–1611) as the Virgin Mary, even as the queen herself was pregnant with the future Philip IV (Fig. 32).

This ideology became temporally controversial in the last years of Philip II's reign and throughout the 1610s. Although official propaganda continued to insist that the Spanish monarch was the greatest, if not the only, defender of the true faith, an important political debate arose dominated by two discourses. One advocated a "contractual" and Catholic view of government that emphasized the duties, rather than the powers, of the king. Its proponents defended an ascendant theory of political power, claiming that even if God had created power, the authority necessary to exercise it rested in the people who transfer their sovereignty to the king. This definition of sovereignty as "popular" produced a vision of the monarchy as a system in which the king was conceived as a "public official" who had to rule in collaboration with his counselors, themselves beheld as representatives of the commonwealth and defenders of its rights.

Yet in the last decades of the sixteenth century, in Spain as elsewhere in Europe, the theory known as *ragion di stato* (reason of state) began to exert an increasing influence on political debates and governmental practices. Its promoters, as Bartolomé Clavero has noted,[40] did not entirely dismiss the more traditional views outlined earlier but rather tried to address explicitly the monarch's "specific needs and concrete interests." These authors were less interested than the "contractual" writers in debating the origins of political power and the duties of the various members of the body politic, including the monarch. Rather, their central concern was to delineate the steps necessary "to preserve the king as a head of the state at all costs." Although none of these authors denied that it was in the best interests of the monarch to respect the rights of his subjects, all believed that "if the preservation of a political order was at stake, then rules of justice or constitutional proprieties had to give way."[41]

Although both groups of writers believed that the Spanish monarch should be a staunch defender of the "true faith" during the first decades of the seventeenth century, they disagreed on many other questions, including the practical consequences of this vision of the prince as *Defensor Fidei*. Writers who supported more traditional views of the political order agreed with Cicero that truth and honesty were the principal elements of successful human activity;[42] consequently, they defined political virtue, in general,

32. Juan Pantoja de la Cruz, *Annunciation*, ca. 1605 (Vienna, Kunsthistorisches Museum).

and prudence, in particular, as the monarch's capacity to distinguish good from evil and to follow just and honest policies.[43] The practical corollary of these principles – usually defined as the "real reason of state" or the "Catholic reason of state" – was that a prudent ruler had to defend Christian principles, the Catholic church, and Catholics everywhere at all costs and regardless of the consequences for his kingdoms and himself.[44]

Although the proponents of reason of state theories also believed that prudence was the most important virtue a ruler should possess, they applied their own definition to the term. To these writers prudence meant not the ability to distinguish good from evil but rather the capacity to distinguish what was "useful" from what was "harmful."[45] Accordingly, they emphasized that the king should take into consideration his "interests" when deciding what plan to follow and what causes to defend.[46] This interpretation implied continual assessment of the monarchy's strategic inter-

ests, of the strength of its enemy, and of the political consequences of the king's actions. Decisive action against rebels and heretics would depend on a given set of circumstances, and at times political prudence dictated a policy that early modern Spaniards defined as *política de medios:* compromise with the kingdom's enemies (regardless of their faith and the fate of Catholics living in their territories) when an aggressive policy could result in defeat or, even worse, the spread of conflict within the Spanish realms. While the Church had to be defended and so did Catholics within and without the territories controlled by the Spanish crown, the conservation of royal power had to become the king's highest priority. These views can be found, for example, in Botero's *Ragion di stato,* in which he discusses political prudence with emphasis on the importance of timing and opportunity, but without a single reference to religious or political orthodoxies.[47]

These were the ideas that dominated official discourse during the reign of Philip III. During this period both the monarch and his favorite, Francisco de Sandoval y Rojas, Duke of Lerma, sought to end the conflicts in the Low Countries, to sign peace agreements with other polities, like England, considered "heretical," and to evade the emergence of new conflicts. At the same time, Philip III and Lerma asserted the role of the Spanish monarch as the defender of Christianity and, more generally, of Europe, against its common enemy: the Ottoman empire and its allies. Thus, they sought to avoid what had come to be regarded as the disastrous overexpansionist politics of Philip II that, it was argued, had led the monarchy into an unprecedented crisis.[48]

The mounting criticism of a policy of appeasement with "heretic" rulers, a strategy that many contemporaries of Philip III beheld as a policy of hesitation and weakness,[49] together with the beginning of the Thirty Years War (1618), the end of the truce with Holland (1621), and the increasing conflicts with France, reinforced the belief that the Spanish monarchy was the last bastion of Catholic orthodoxy and that this orthodoxy formed the basis for the monarchy's reputation and even its raison d'être. Indeed, it was during the reign of Philip IV that the king and his chief minister, the Count-Duke of Olivares, reasserted the need to "re-Catholicize" the image, policies, and ideological foundations of the monarchy. This quest to recover the Catholic essence of the monarch's authority was manifest in the emergence of a shared discourse enunciated by writers from opposing ideological positions. Thus, the anonymous author of a pamphlet published in 1638 defended reason of state principles and the absolute political preeminence of the king within the monarchy as well as the centrality of religion:

Divine Faith provides the stability and strength of empires, such that as Faith grows, empires grow, and as Faith recedes, empires collapse. . . . Where Faith flourishes there is a sacred civility and where it is lacking good government crumbles, because the order of things is not disturbed when religion is made the ends and the means of the Empire; indeed the force of the Empire is best used to further the practice of religion.[50]

A similar argument was advanced by Fray Marcos Salmerón, one of the most ardent defenders of a traditional political ideology on the grounds that there was indeed only one reason of state: "the Catholic [one] . . . in which God and his law is privileged above all other [notions] of political utility."[51]

It was after 1619 and, especially, during the reign of Philip IV that the Crown organized campaigns of propaganda to advertise that, after a period of deviation and paralysis, the Spanish monarchy was again leading the struggle against the enemies of Christianity (Turks), and those battling against Catholicism and Spain's legitimate authority upon territories that were viewed as inalienable parts of the monarchy (the Low Countries, the Americas, various polities in Italy, and Portugal). This renewed insistence on the Catholic credentials of the monarchy and the Spanish ruler strongly influenced the iconographic motives in the royal representations during this period. The image of the king as *Defensor Fidei*, for example, was used

33. Engraving depicting Philip II as the defender of the faith, from Luis Cabrera de Córdoba's *Felipe Segundo Rey de España*, Madrid, 1619 (Madrid, Biblioteca Nacional).

to identify Philip II, who became the model for Philip IV's and Olivares's views on royal majesty, in the frontispiece of the first part of Philip II's biography published by Cabrera de Córdoba in 1619 (Fig. 33).[52] Velázquez himself participated as *pintor del rey* in this promotion of Philip IV as the only true Catholic king. His first public accomplishment, for example, was winning a competition sponsored by Philip IV to celebrate the expulsion of the Moriscos (converted Muslims living in Spain) from the Iberian peninsula (1609–14), a deed heralded by the official propaganda as the final act of the sacred reconquest of the Iberian peninsula from the Islamic "invaders," and the only of Philip III's decisions acclaimed as truly royal and Catholic by Philip IV and his government.[53] These ideological motives figured prominently in the iconographic programs included in the "Hall of the Realms" in the Palace of the Buen Retiro in Madrid, a hall that Velázquez helped to design as well as to decorate by painting some of its most well-known pictures. The "Hall of the Realms," magnificently studied by Jonathan Brown and Sir John Elliott, housed paintings celebrating the Habsburg dynasty, the power of the royal favorite, and representations celebrating the Spanish monarchy's victories during the 1620s and 1630s against its enemies in Europe (England, the Dutch Republic, France, German protestant princes, and Savoy), including the depiction of the rendition of Breda in the Low Countries by Velázquez himself.[54]

A Virtuous King: The Politics of Portraiture

As both Saavedra y Fajardo's recollection of his experience with Philip IV's portrait and the ceremony in Lima reveal, however, it was the royal portrait that played a crucial role in the propagation of the official conceptualization of the qualities and power of the monarch. There is no doubt that during the early modern period royal portraits were viewed as the most important means of monarchical propaganda, because it was believed that, first, the "message" enclosed in the royal portraits was easily understood by the rulers' subjects, and, second, because royal portraits seemed to be imbued with the same "sacredness and untouchableness" of the king's person. Royal portraits are also central in modern analyses of royal representation, if only because, in Jonathan Brown's words, they allow us to penetrate into the monarchs's "aspirations, ideals, pretensions . . . and self-concepts."[55] At the same time, through royal portraits modern scholars can study the contributions of painters like Velázquez made to the creation of the king's image without making references to the ideologies of the painter's contemporaries. It is important, however, to distinguish our "sight perspective" from the one that Philip IV's subjects had. In our own times, when we see one of Velázquez's portraits of Philip IV, our interest usually centers on the "artistic" contribution of Velázquez. In contrast, during the seventeenth century when someone observed a royal portrait

his or her attention centered upon the sitter, his power and authority. It is of course true that some painters were better than others in translating into canvas the monarchs' views regarding their public representation, but even a painter such as Velázquez was constrained by ideas, models, and concepts (political and pictorial) developed during previous decades and accepted by his master as the models to be followed.

A fundamental peculiarity of Spanish Habsburg royal portraits, from the time of Philip II until the death of Philip IV (almost one hundred years of royal portraiture), is the extreme simplicity of presentation manifest in the absence of explicit regal symbols and in the "realistic" rendering of the king's facial and physical features. As Jonathan Brown has observed of Velázquez's portraits of Philip IV, in "not a single work does [the king] display an attribute which could not have been worn by a high-ranking nobleman."[56] And yet, it was one of these portraits that provoked such a deep reaction from Diego Saavedra y Fajardo. Understanding such reactions and, more important, the longevity and stability of this particular model of the court portrait, demands an analysis that goes beyond the portrait's surface and its ostensibly simple and realistic images, to the more profound nature of the allegories and symbols it contains.[57]

The supremacy of the "individual virtues" of each monarch over the "symbols" of power and the degree to which court portraits were intended to emphasize the "person" of the king rather than the symbols of the king's "office" was established by Erasmus of Rotterdam in *The Education of a Christian Prince*, a book written to provide a political education for Prince Charles, the future emperor, which, in turn, also provided a basis for the education of his successors. In *The Education*, Erasmus presented a vision of the monarch as one who served and defended the community. A stable and happy kingdom could only be created by a monarch with the capacity to inspire the love, respect, and obedience of his subjects. The king's inner virtues, not the symbols of power and authority, were what made a truly good king. "If all that makes a king is a chain, a scepter, robes of royal purple, and a train of attendants," Erasmus wrote, "what after all is to prevent the actors in a drama who come on the stage decked with all the pomp of state from being regarded as real kings?" On the contrary, he explained, "a prince's prestige, his greatness, his regal dignity must not be established and preserved by noisy displays of privileged rank but by wisdom, integrity, and right action."[58]

The Spanish Habsburgs sought to cultivate this Erasmian iconographic model of the ideal monarch,[59] privileging a pictorial representation that focused upon the person of the ruler and not the symbols of power. Essential to this model was the portrayal of the king as an individual who embodied the virtues of a good ruler, virtues that would help him to serve as "model" for his subjects in all the kingdoms.[60] In visual terms, this paradigm of majesty required the court painter to reproduce the king's facial and physical features with as much realism as possible, as was the case in Spain. Yet, as Julián Gállego has argued, the ostensibly forthright simplicity of these images belies an

allegorical and symbolic program of great proportions, in which "realism" is a subtle reference to "the deeper and secret dimensions of idealism."[61]

Such understanding of the representation of royal majesty was not unique to painters working in the Spanish courts. In early modern Europe, the "court portrait was characterized by an interplay between personality and general propriety, protecting the ruler both from realistic portrayal as an individual and from depersonalized depiction as a type." The resulting images were intended to show "the ruler as a figure who existed at once on a real and an ideal plane . . . to portray the prince's person in a recognizable form, but to invest him with a supra-personal aura."[62] In Spain, the construction of this "supra-personal aura" was based upon a certain understanding of royal beauty, marked by the idealization of the physical characteristics of the Habsburgs themselves: "long faces, fallen noses, prognathic jaws, large lips"[63] (Fig. 34). In a book published in 1575, Juan Huarte de San Juan attempted to glorify the physical features of the Spanish Habsburgs by proposing that kings, in contrast to common mortals, have their various humors in ideal balance and, thus, their constitution

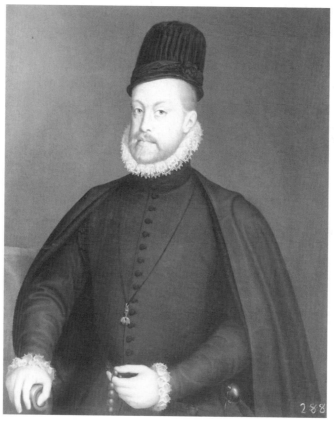

34. Sofonisba Anguisciola, *Portrait of Philip II,* 1580s (Madrid, Museo del Prado).

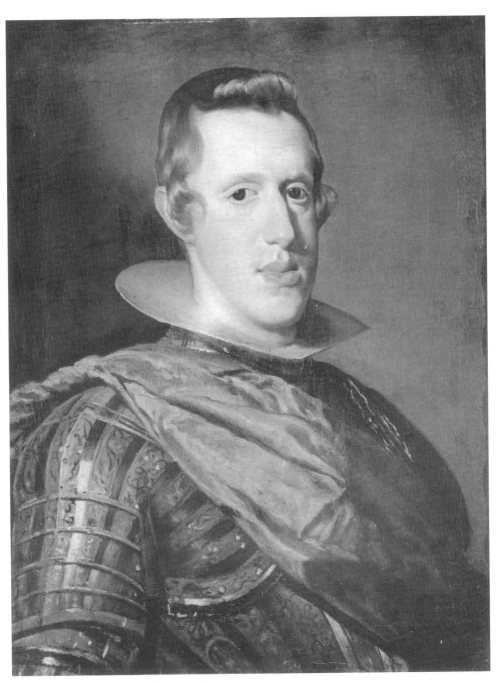

35. Diego Velázquez, *Portrait of Philip IV*, ca. 1625–28 (Madrid, Museo del Prado).

achieves "supreme perfection." Their exterior appearance reflected special interior qualities: perfect beauty of the face (to attract the love of his subjects), blond hair (the middle of two extremes, black and white), and medium height. Making his adulatory intentions even clearer, Huarte attributed such qualities only to the Spanish Habsburgs and three other figures: Adam (the first human created in God's image), King David (God's favorite monarch), and Jesus (the son of God).[64]

In addition, art historians who study early modern Spanish court portraiture, especially portraits from the last years of Philip II's reign, have noted what seems an important feature in some of the king's portraits. Fernando Checa Cremades, for example, recently argued that some of the portraits of Philip II show clear "traces of hieraticism, dignity and distance."[65] While scholars have associated this model of representation with Philip II, the portraits of his descendants exhibit similar features.[66] The work of Velázquez as portraitist of Philip IV confirms this analysis. We know, for example, that Philip IV himself actively participated in defining the final "aesthetical" characteristics of his portraits, especially in those painted by Velázquez – a total of eight portraits between 1623 and 1655, all certified by the king himself, sometimes after asking Velázquez to make certain changes that would make the royal facial features more "realistic."[67] Velázquez's rendering of Philip IV (Fig. 35), indeed, followed models ("artistic" and "political") already well established and did not change substantially in his thirty years of service as court painter, not even after the artist's trip to Italy (1629–31), which resulted in certain changes in technique evident in other work but not in his royal portraits.[68]

It is precisely the stability of the Spanish model of royal portrait and that it lacked any symbol that would depict the Spanish king as an absolute and all-powerful ruler that gave enormous authority to this form of royal representation. Velázquez, as previous *pintores del rey*, depicted the Spanish Habsburgs as virtuous, paternalistic, and benevolent rulers, thus helping to create among the king's subjects a "habitus" of seeing the royal image in assigned ways, as the one beheld by Saavedra y Fajardo in front of Velázquez's portrait of Philip IV.[69]

6 Court Women in the Spain of Velázquez

Magdalena S. Sánchez

Diego de Velázquez was not simply a court painter but also a skillful courtier. From student in Francisco Pacheco's studio to his appointment as court painter to Philip IV (r. 1621–65), followed by his rise through palace offices until he won the much coveted appointment as Aposentador Mayor de Palacio, his career shows his ability to win royal attention and favor and all the benefits that accompanied that favor. Velázquez seems to have been determined to move beyond the narrow confines of the artistic world of Seville and to succeed in the slippery and perilous world of the Spanish court.

His victory was hard-won; rival court painters resented his rapid rise and belittled his artistic skills.[1] Yet Velázquez plainly knew how to survive and prosper at court, how to prevail over detractors and maneuver through or around courtly intrigues, both major and minor. He became a court painter in his early twenties and from then until his death almost forty years later, in 1660, he remained the king's favorite painter, responsible for official portraits of the royal family and rewarded with prestigious and profitable court offices. Despite his close association with Gaspar de Guzmán, Count-Duke of Olivares, Velázquez managed to survive Olivares's fall from grace and banishment from court in 1643. Velázquez served Philip IV during the reigns of two queens, and through Spain's involvement in the Thirty Years War, the revolt of Portugal, and the revolt of Catalonia. He knew the royal court not simply as a workman occasionally invited inside to execute a portrait, but very much as a participant or, as we might say, a "player."

His paintings, accordingly, offer a peculiarly privileged perspective on life at the Spanish royal court of the seventeenth century. He painted the royal family and their attendants in the privacy of the royal palace (the Real Alcázar) as they wished to be seen in their lifetime and by posterity.

Indeed, Velázquez was largely in charge of creating the officially sanctioned royal image. Nevertheless, paintings such as *Las Meninas* and *Baltasar Carlos in the Riding School* invite the viewer to step behind the facade of royal portraiture to glimpse some of the intricate personal and political relationships of the court. In *Las Meninas* (Fig. 27), for example, the central and highlighted figure is that of the Infanta Margarita (1651–73), carefully and rather formally posed, but around and behind her – half-hidden in shadow, reflected in a mirror, receding through a doorway – appears a crowded, active concourse of characters, including Philip IV and his second wife, Mariana of Austria (1634–96). The painting gives the viewer a remarkably intimate glimpse of palace life but also hints somewhat mysteriously at unknowable personal and political courtly dynamics.

In a similar fashion, *Baltasar Carlos in the Riding School* shows Philip IV and his first queen, Isabel of Bourbon (1603–44), standing on a balcony in the background, observing Baltasar Carlos, the heir to the throne, solemnly seated on his prancing horse as the Count-Duke of Olivares is handed Baltasar Carlos's lance. Like *Las Meninas*, *Baltasar Carlos in the Riding School* illustrates crucial elements of the power structure at the Spanish court, in this case Olivares's responsibility for the training of Baltasar Carlos, as well as the king and queen's recognition and sanction of Olivares's status at court and his ability to groom a future king. Both paintings imply that the queen's presence was necessary to ratify the message Velázquez wished to convey: in *Las Meninas*, the idea of royal recognition and acceptance of the elevated social status of the artist, and in *Baltasar Carlos in the Riding School*, the monarchs' shared approval of the Count-Duke of Olivares's power. Thus the paintings indirectly confirm the queen's important role in presiding over and even shaping the political and social culture of the Spanish court.

This court, the focal point of Velázquez's personal and professional life, was a complex and fascinating world, peopled by powerful men – but also women. Indeed, Velázquez's paintings remind us that women were central to palace life, that they often accompanied the king in private and public moments, and that they were integral to his public image and private needs. But to appreciate the position and role of women in the culture of the royal court, we need first to understand the geography of that court. The physical space of the court extended beyond just the offices and meeting rooms officially devoted to government business. The private apartments of the royal family were on the main floor of the royal palace in Madrid, the Real Alcázar, directly above the meeting rooms for the royal councils.[2] A passageway connected the Real Alcázar to the royal convent of the Encarnación, completed in 1616. The royal family visited numerous churches and convents in Madrid (and in Toledo and Valladolid, when the court resided there), and went for brief or lengthy stays to royal country residences. In many respects, the Spanish court extended to all these locations outside the Real Alcázar, because the king moved from one to

another of these different places and took ministers, servants, ambassadors, and family members with him.

In this fluid, peripatetic world of the Spanish court, the monarch interacted regularly with many women. Principal among them were his wife and her attendants, relatives ranging from daughters to aunts and grandmothers, nuns, *beatas* (or holy women), and other pious women. Mistresses, too, had frequent contact with some Spanish kings. Philip II (r. 1556–98), for example, was known to have had several mistresses throughout his lifetime, and perhaps even several illegitimate children.[3] There is no evidence that Philip III (r. 1598–1621) ever had a mistress, but his son, Philip IV, was famous for his numerous love affairs, which continued throughout his two marriages.[4] While these mistresses might have influenced Spanish kings, they never gained official, recognized status as did the mistresses of early modern French kings. Their influence is therefore hard to document.[5]

As John Elliott has shown in his study of the early modern Spanish court, Spanish kings were private individuals who deliberately limited their contact with the outside world and who hid behind an elaborate court ceremonial designed to impress and awe the viewer with the king's unapproachable magnificence and to minimize the ruler's exposure to the people he ruled.[6] In public, Spanish royalty appeared formal and theatrical, as actors on a stage or as figures posed on a Velázquez canvas. Spanish monarchs increasingly turned inward and isolated themselves from personal contact with the world outside the court. Philip II, overwhelmed with the management of his huge empire, often left Madrid to retreat to the Escorial, where he would work night and day away from the oppressive daily burden of audiences, ambassadors, and conciliar meetings.[7] Philip III regularly left the court to go hunting or to spend time at one of his many residences around Madrid. Moreover, Philip III and his son, Philip IV, relied heavily on their first ministers, or *privados*, Francisco Gómez de Sandoval y Rojas, first Duke of Lerma, and Gaspar de Guzmán, Count-Duke of Olivares, respectively. In an effort to monopolize the monarch's attention and protect their power over him, both Lerma and Olivares took pains to control and limit access to the king. Such efforts reinforced a court ceremonial that gave primacy to royal privacy.

Although increasingly isolated from courtiers, ministers, and the populace, however, Spanish kings had no desire to isolate themselves from their female relatives, and usually not from their wives, to whom they were often also related by blood.[8] In addition, the personal piety of Spanish monarchs – their concern with their own salvation as well as their fear that their own sins would bring misfortune to the Spanish kingdoms – persuaded them on many occasions to seek the advice not only of theologians but also of religious visionaries, many of them women. In this way, the pious practices and concerns of Spanish kings indirectly accorded greater visibility and influence to women known for their spirituality. Velázquez

would certainly have known and interacted at the Spanish court with Philip IV's two successive queens, the king's female relatives, and the noblewomen serving in the royal household, and he no doubt would have heard of many of the *beatas* who acquired popular followings. By looking at the different women the kings saw frequently, in some cases daily, we can gain a better understanding of the social context, the daily routine, and the political dynamics of the royal court during the time of Velázquez.

The king's female kin – sisters, daughters, aunts, grandmothers, cousins – had numerous roles to fill, some personal, others in a more official capacity. They certainly often acted as unofficial counselors. In theory, these kinswomen were loyal to and sympathized with the king and could advise him in a disinterested fashion, providing a friendly ear and a consoling presence in times of personal or political crisis.[9] Given the intrigues and machinations at early modern courts, monarchs needed reliable gauges of political policies and public opinion; royal women served just this purpose. Another and perhaps more crucial function of these women was to give the monarch a measure of relief and distraction from the anxieties and stress of official business, by providing him with personal affection and companionship. In fact, female relatives often accompanied the kings on their recreational outings. Spanish royal women liked to hunt, and even when illness or pregnancy prevented them from taking part in the hunt, they often watched from nearby carriages, as seen in Velázquez's *Philip IV Hunting Wild Boar* (Fig. 36).[10]

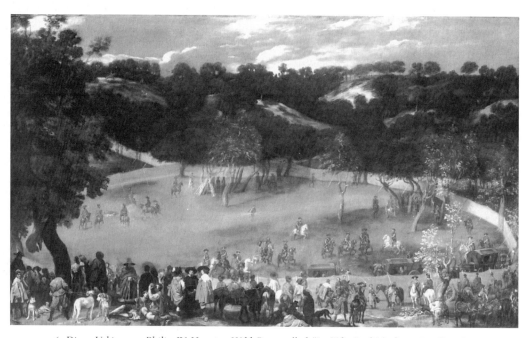

36. Diego Velázquez, *Philip IV Hunting Wild Boar,* called *"La Tela Real,"* before 1643 (London, National Gallery).

One well-documented example of such companionship is the great comfort Philip II derived from the company of his two daughters, Catalina Micaela (Fig. 37) and Isabel Clara Eugenia (Fig. 38). As young girls, they sometimes played alongside their mother in his company while Philip wrote letters and saw to official business.[11] When he was away from court, he wrote to them regularly. That these letters, still preserved, are in the monarch's own handwriting testifies to the fact that rather than regarding them simply as an obligatory correspondence, he took pleasure in writing to his daughters; it was not a task to be delegated to a secretary. When Catalina Micaela married the Duke of Savoy in 1585 and went to Italy, Philip missed her greatly and wrote her frequently; his letters to her are filled with affection and tenderness and reveal how much he missed her company. In these letters, the monarch sent news of the royal family and of developments in Spain, such as the construction of the Escorial.[12] In a letter of 17 June 1585, Philip wrote Catalina Micaela that he was unsure who loved her more, he himself or her husband.[13] In another letter, written in August 1585, he told her that he "enjoyed her letters so much."[14] He continued to miss her; in a letter of 14 June 1588, he noted that the previous day marked the third anniversary of her departure and that his memory of the occasion filled him with sorrow and loneliness.[15] It was no coincidence that his other beloved daughter, Isabel Clara Eugenia, a year older than Catalina Micaela, did not marry and leave Spain until after Philip II's death. Even then, the king had arranged for her to marry his nephew, Archduke Albert, who had arrived at the Spanish court in 1570, had grown up there in the company

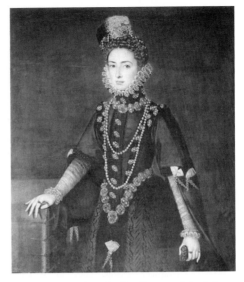

37. Alonso Sánchez Coello, *Portrait of the Infanta Catalina Micaela*, ca. 1584 (Madrid, Museo del Prado).

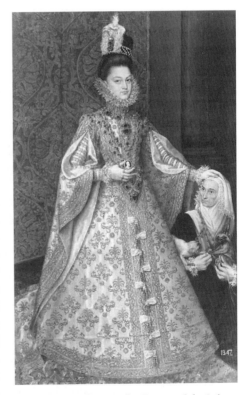

38. Alonso Sánchez Coello, *Portrait of the Infanta Isabel Clara Eugenia with Magdalena Ruiz*, ca. 1585–88 (Madrid, Museo del Prado).

of Philip's children, and had become one of the monarch's closest advisers from 1593 until Philip's death in 1598. In selecting Albert as his son-in-law, Philip chose someone to whom he felt very close and whom he had come to regard and love as a son.[16] Philip's two daughters exemplify the role that must have been filled by many female relatives of the king. They provided the personal, familial dimension of a monarch's life, something that would have been a particularly welcome and necessary contrast to the stresses of politics and power at the Spanish court.

Philip II also profited greatly from the company and friendship of his younger sister, Juana (1535–73). In 1552, Juana married the heir to the Portuguese throne, but her stay in Portugal was brief because in 1554 her husband died and she returned to Castile to serve as regent, a position she held until 1559. A dutiful daughter, Juana followed the instructions of her father, Charles V, and left Portugal for Castile only months after giving birth to a son, Sebastian. She left her infant son behind in the care of her mother-in-law, and although she surrounded herself with Portuguese attendants and corresponded with individuals at the Portuguese court, she never returned to see or care for her son. Instead, she remained in Castile, where she eventually converted her father's palace in Madrid to the royal convent of the Descalzas Reales. In Madrid she regularly visited her brother, Philip II, and became, as Henry Kamen writes, the "effective centre of Philip's family circle."[17] She developed close ties of friendship and affection with Philip's successive wives, Isabel of Valois and Anna of Austria, and even assisted at the birth of two of Anna's children.[18] She provided companionship for the monarch, who greatly missed her after she died in 1573.[19]

Philip II's other sister, Empress María (1528–1603), eventually filled the affectionate role in Philip's life that had been left vacant by Juana's death.[20] María had left Spain in 1551 to serve first as Queen of Bohemia and then as Holy Roman Empress until the death of her husband, the Emperor Maximilian II, in 1579. Three years later she returned to Madrid with her youngest daughter, Margaret of the Cross, who entered the royal convent of the Descalzas in Madrid as a cloistered Franciscan nun, while her mother the dowager empress lived the rest of her life in rooms in the convent, adjacent and easily accessible to the cloistered section. The empress ventured out of the convent regularly to visit Philip II, to accompany him to the Escorial and other royal residences, and to see the royal children. In turn, Philip II visited her frequently in the Descalzas and often took his children, Isabel Clara Eugenia, Catalina Micaela, and Prince Philip, to stay with her. In this way, Philip III, like his father, grew to have a very close, affectionate bond with the empress, and he clearly enjoyed her company both when he was prince and in the first few years of his reign, before her death.[21] In turn, Philip III's son, later Philip IV, also stayed as a young child at the Descalzas and spent time with his great

aunt, Margaret of the Cross. After the death of his mother, Margaret of Austria, in 1611, when the prince was only six years old, Margaret of the Cross served as surrogate mother to the young Prince Philip.

Thus, the female relatives of the monarch, especially the unmarried or widowed, could provide him with affection and comfort, as well as the companionship of trusted individuals who tended to share the king's concerns and his point of view. In these women, monarchs had ready advisers and even confidantes, people with his best interests in mind, from whom he could expect to receive disinterested views and counsel. This was certainly the role played by Empress María, for example, when she advised Philip III not to change ministers so often and not to allow Magdalena de Guzmán, an associate of the Duke of Lerma, to exercise so much influence at the court. On this occasion, the empress justified her freedom in expressing her opinion by telling the king that her affection for him and her familial relation to him compelled her to speak out.[22] Royal women could take advantage of both their physical proximity and emotional ties to monarchs to voice their concerns and even press their own interests.

Royal women had at least one other important role, moreover. They often served as diplomatic instruments, useful in establishing or promoting the monarchy's alliances with other countries. Early modern kings or emperors assumed that their daughters would marry into other prominent lines and further the dynastic interests of their natal families. Velázquez, in fact, painted portraits of Philip IV's daughter, the infanta María Teresa, to send to foreign courts to display her to prospective suitors.[23] This diplomatic and political function of marriage usually took precedence over any consideration of affection or even compatibility between the betrothed couple. It often took precedence even over the monarch's own personal inclinations: having arranged the politically advantageous marriage of his daughter, Catalina Micaela, to the duke of Savoy, Philip II desperately missed her for the rest of his life. In most cases, the princesses left their country to marry at a very young age and never returned. Widowhood was one of the few contingencies that allowed women to return from their marital exile to the land of their birth. Empress María, for example, returned to Spain only after the death of her husband, Maximilian II – almost thirty years after leaving as a young bride. On the other hand, Philip III's daughter Anne of Austria, who left Spain in 1615 at the age of fourteen to marry Louis XIII of France, did not return even after the death of Louis in 1643. Instead, she served as regent for her young son, Louis XIV, and died, still in France, of breast cancer in 1666.[24]

Royal women who went as queens to a foreign country faced a particularly difficult task, caught as they were between competing expectations. On the one hand, their male relatives expected them to ensure that their husbands were favorably disposed toward the interests of their original royal family. Their new husbands, on the other hand, naturally sought to

acculturate them to their new homeland and tried to sever their ties with their paternal family. The Habsburgs, certainly, assumed that their married daughters would negotiate for Habsburg needs and interests and act as informal ambassadors and even on occasion as spies. When Philip III's daughter Anne married the king of France, Louis XIII, for example, Philip plainly expected her to protect Spanish and Catholic interests. He particularly wanted her to fight against heresy in France and to ensure that her husband did not provide aid to any rebellions against Spain.[25] In such ways, royal women functioned as diplomatic representatives of their male relatives, and many tried to influence political policy in their adopted homelands, as well.

The several queens of the Spanish kings, Philip II, Philip III, and Philip IV, provide us with telling examples of the many roles that might be involved in royal marriages. Several of these marriages clearly represented diplomatic alliances aimed at bringing about peace or at least more favorable relations between Spain and the queens' native countries. Philip II's marriage to Mary Tudor in 1554, for instance, was patently intended to lessen Anglo-Spanish tension after the religious and political turmoil that accompanied Henry VIII's break from Rome twenty years earlier. More often than not, however, the Spanish Habsburgs sought marriages for their daughters and nieces that would strengthen the Habsburg dynasty and ensure that no part of the Habsburg territorial inheritance was alienated. The range of suitable matches for royalty in this period was limited, moreover, since the requirements for a suitable match were various and possibly even conflicting. Ideally, kings wanted unions that would produce heirs, solidify diplomatic alliances, or strengthen dynastic holdings – and if possible, accomplish several of these goals. Another complicating concern in post-Reformation matchmaking was religion. At a time of religious tensions and hostilities, the Spanish Habsburgs preferred to ally themselves with those whose religious orthodoxy they could trust, and this often meant their own Catholic relatives.[26]

During Velázquez's lifetime, three women served as queen of Spain: Margaret of Austria (1584–1611), the only wife of Philip III; Isabel of Bourbon, the first wife of Philip IV; and Mariana of Austria, Philip IV's second wife and regent for their son Charles II from 1665 to 1675. Margaret of Austria (Fig. 39) was from the Styrian branch of the Austrian Habsburgs. The daughter of a Bavarian Wittelsbach princess (who herself had Habsburg blood) and an Austrian Habsburg archduke, she lived in Spain from 1599 until her death in 1611.[27] Isabel of Bourbon (Fig. 40), daughter of Henry IV of France and of Marie de Medicis, went to Spain in 1615 as part of a joint-marriage treaty negotiated between France and Spain, by the terms of which Isabel became the wife of the Spanish heir to the throne, Prince Philip (later Philip IV), and Philip's sister, Anne, went to France to marry the future Louis XIII.[28] Philip IV's second wife, Mariana of Austria

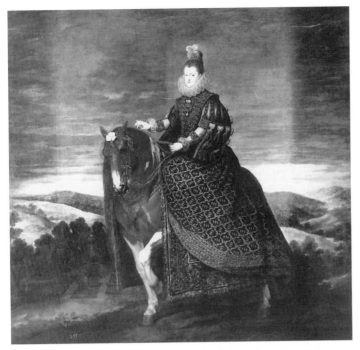

39. Diego de Velázquez and others, *Queen Margaret of Austria on Horseback,* ca. 1628–35 (Madrid, Museo del Prado).

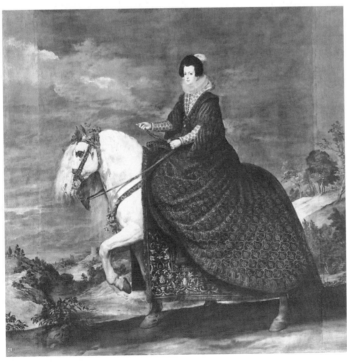

40. Diego de Velázquez and others, *Queen Isabel of Bourbon on Horseback,* ca. 1628–35 (Madrid, Museo del Prado).

(Fig. 41), was also his niece, the daughter of Philip IV's sister María and the Holy Roman Emperor, Ferdinand III. She married her uncle Philip in 1649, five years after he had been widowed by the death of Isabel of Bourbon; the marriage of Mariana and Philip lasted until his death in 1665.

For a modern audience, one of the most striking and probably distasteful aspects of these politically arranged marriages was the very young age at which the women were often wed. Margaret of Austria was barely fifteen when she married Philip III; Isabel was twelve when she married Philip IV; and Mariana was fifteen when she became Philip IV's second wife. As young as the three women were, their ages were fairly typical for royal brides in the sixteenth and seventeenth centuries.[29] Isabel, who of the three queens married the youngest, did not assume full marital duties for several years; as young as she was, her husband Philip IV was even younger – only ten years old at the time of their marriage in 1615 – and the marriage was not consummated until 1619, when he was fourteen and a half and she was seventeen.[30]

The circumstances surrounding the marriages of all three of these very young queens provide a glimpse of the pragmatic rather than personal motives leading to such royal unions. Margaret and Mariana were each blood relatives of their husbands, Philip III and Philip IV, respectively. Margaret was her husband's second cousin (by no means a particularly close degree of consanguinity relative to many other Habsburg marriages) and Mariana was her husband's niece. Neither Margaret nor Mariana was a first choice as a royal spouse. Margaret's older sister was originally selected to marry Philip III, but when her death prevented this match, Margaret was chosen to fill her place as Philip's bride, even though Margaret is said to have had plans to become a nun.[31] Regardless of what her personal wishes might have been, however, she was deemed eligible to marry Philip because of her pious nature, her Habsburg lineage, and the apparent likelihood that she would be able to bear children.[32] Mariana of Austria, in turn, was first nominated to be the bride of Philip IV's son and heir, Prince Baltasar Carlos, but his premature death in 1646 forestalled this plan. So, in need of another heir, Philip IV decided to marry her himself, although she was not only related to him, but was also twenty-nine years his junior. When she married Philip IV, Mariana was only four years older than his daughter, María Teresa.

Clearly Mariana's marriage to Philip IV was negotiated for almost the sole purpose of producing an heir to the throne. In letters he wrote to the Countess of Paredes de Nava, formerly lady-in-waiting to Isabel of Bourbon but by the time he was writing a cloistered Carmelite nun, Philip IV claimed that he had not wanted to marry a second time but had done so for the greater good of the Spanish kingdoms.[33] His marriage to his young niece was, he further asserted, a "sacrifice" made completely against his own personal inclinations. His description of his young wife is also

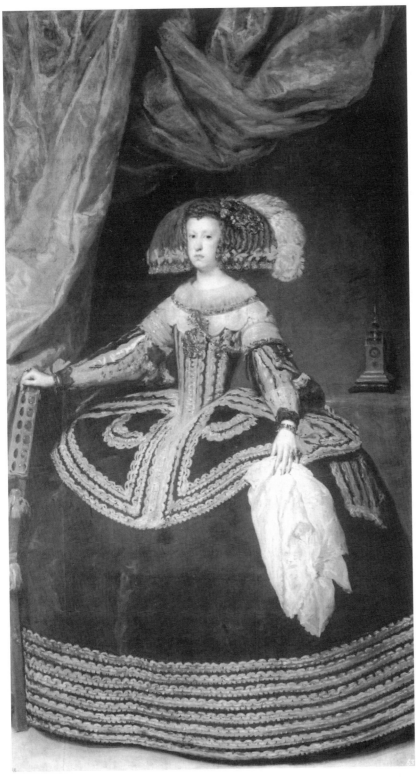

41. Diego de Velázquez, *Queen Mariana of Austria*, ca. 1652–53 (Madrid, Museo del Prado).

notable: he referred to her as a "girl" (*niña*).[34] But, Philip explained, God repaid the king's "sacrifice" when in 1656 the young queen gave birth to a son and heir. Suddenly, Philip described his wife as a soulmate [*tal compañia*] "whose affection I would be unable to deserve even if I were to live a thousand years."[35]

Philip's more loving description of his wife after she produced an heir illustrates how royal women often gained greater affection from (and probably greater leverage with) their husbands when they gave birth to a son. By producing at least one male heir, a royal woman had fulfilled her most important responsibility and duty. A son not only helped secure the inheritance of the royal family but also promised stability and continuity for the entire kingdom; he brought a queen greater esteem not only from her husband but also from the populace. Philip III's affection for his wife, Margaret of Austria, seemed to grow with the years, as she gave him eight children, four of them sons.[36] The birth and baptism of Isabel of Bourbon's son, Baltasar Carlos, in 1629, was greeted with elaborate festivities, precisely because up to that point Philip IV had lacked a male heir.[37] For Isabel personally, the birth of this son was crucial; her husband was romantically involved with an actress, María Inés de Calderón ("La Calderona"), who gave birth to Philip's illegitimate son, Don Juan, the same year that Baltasar Carlos was born. Isabel must have realized that to win favor and attention from her husband, she needed to give him an heir. Early in his reign, a court observer noted that Philip "greatly loves the queen . . . visits her . . . often, shows her great love and esteem, [and] speaks words of love to her."[38] Philip IV certainly grew to be very devoted to and indeed to love Isabel. A little over a month after her death, he wrote to the cloistered nun, Sor María de Agreda, that he was still experiencing the most extreme pain and sorrow imaginable because of his wife's death, that he had greatly loved her, and that her death was the greatest defeat of his life.[39]

The lives of queens in the age of Velázquez were not always easy, and Spanish queens were no exception. Separated at a very young age from their families, they arrived at the Spanish court with only their attendants and a confessor. Several, at least, were not even fluent in Castilian; this was certainly the case with Margaret of Austria and Isabel of Bourbon. Nevertheless, following the practice of most early modern European monarchs, Philip III and Philip IV soon sent home most of the servants who had accompanied their queens to Spain from their native countries.[40] The women then received new households with Spanish attendants, to help ensure that the queens' attendants were loyal to Spain rather than to a foreign country. With her new Spanish retinue, the queen would also, it was hoped, learn to accommodate herself more easily to Spanish customs and practices. Moreover, the queen's household was a center for patronage, with offices there awarded to recompense the loyal service of Spanish

nobles. For ministers such as the Duke of Lerma and the Count-Duke of Olivares, whose power was heavily dependent on extensive patronage networks staffed by loyal relatives, the queen's household provided a particularly useful site for extending power and controlling access to the king.[41] The Duke of Lerma tried to fill all the major positions of Margaret of Austria's household with his own relatives or with others he thought loyal and sympathetic to him. His uncle, Juan de Borja, was appointed the queen's *mayordomo mayor,* for example, while Lerma's wife, Catalina de la Cerda, became the queen's *camarera mayor,* an office that required her to sleep in the queen's room except when Philip made conjugal visits to Margaret (in which case the *camarera mayor* slept in a room adjacent to the queen's bedroom). When the sympathies of his own wife seemed to be inclining toward the queen rather than toward him, Lerma replaced her with his sister, Catalina de Sandoval, Countess of Lemos. Lerma placed his close associate and confidante, Magdalena de Guzmán, Marquesa del Valle, in the position of governess to Philip's and Margaret's eldest daughter, Anne. When the Marquesa del Valle became too powerful, however, going so far as to grant her own audiences, and when she began to rely more on the queen than on Lerma himself, the worried *privado* had her not only dismissed from court but also arrested.[42]

When it came to Margaret's Jesuit confessor, the Bavarian Richard Haller, the Duke of Lerma was less successful. Soon after Margaret's arrival in Spain, Lerma sought to remove Haller from his position as the queen's confessor and replace him with Mateo de Burgos, a Franciscan friar; ostensibly this proposed switch was intended to conform to the Spanish royal custom of having a Franciscan serve as the queen's confessor. Clearly, however, Lerma realized that Haller's strong influence with the queen was potentially a threat to his own power, and to secure that power, Lerma meant to bring the queen under his own control. Yet despite her youth, Margaret was able to persuade Philip III that she should be allowed to keep Haller as her confessor.[43] Among other things, she pointed out that she was uncomfortable speaking Castilian and argued that she needed a German-speaking confessor. Remaining in his position as her confessor, Haller became one of Margaret of Austria's closest friends and confidants and, just as Lerma had feared, Haller and the queen did in fact work together to limit Lerma's power.[44]

In a way similar to his use of the Marquesa del Valle, the Duke of Lerma placed in the queen's household Pedro de Franqueza, who was completely dependent on Lerma for his place at court. Franqueza was appointed secretary to Margaret of Austria in the hope that he would be able to monitor her actions and correspondence. Franqueza was also a principal member of the Junta de Desempeño, a committee set up in 1603 to investigate the financial solvency of the Spanish monarchy.[45] In an ironic twist, Franqueza was later arrested on charges of misappropriating

funds from the royal treasury and eventually found guilty of the charges. The queen played a central role in the discrediting of the Junta de Desempeño and of Franqueza, and although her concerns were well founded, she no doubt was also reacting strongly against Lerma's attempt to surround her with his "creatures" (*hechuras*), as they were called in the seventeenth century, and thereby circumscribe her activities.[46]

Since offices in the household of the king, the queen, and the royal children were a principal means both of cementing the *privado*'s power and of rewarding loyal followers, upon gaining power, the Count-Duke of Olivares quickly began to replace Lerma's family members and supporters who held palace offices. Olivares proceeded with caution, however, because he wished to distance himself from the practices of the previous Lerma regime, whose members had been dismissed, indicted, and even executed for corruption.[47] In the long run, Olivares employed patronage as a political tool much more infrequently than did the Duke of Lerma.[48] Nevertheless, the Count-Duke ensured that relatives and supporters received important court offices, along with nobles he wished to win over.[49] As John Elliott has shown in his biography of Olivares, "The effect of these various court appointments was to give Don Gaspar a power-base at the point where power was won or lost – in the palace itself."[50] Unlike the Duke of Lerma, Olivares did not maneuver immediately to place his wife in the queen's household; whereas Olivares became the king's favorite in 1621, his wife did not enter the service of Isabel of Bourbon until 1627. The Countess of Olivares then entered the queen's service at the highest level – as *camarera mayor*. Even then, Olivares claimed that he and his wife did not welcome such an appointment and that he had agreed to it only to distract his wife after the recent death of their only daughter.[51] In providing this justification, Olivares was no doubt trying to defend himself from his critics, who would argue that the *privado* had engineered his wife's appointment in order to augment his power at the court and in so doing was following in the steps of the discredited Duke of Lerma. Clearly Olivares profited from having his wife occupy the highest female office in the queen's household; in that position she closely supervised the queen's activities.[52]

The Countess of Olivares was a very pious woman, given to an austere devotion that did not allow for much gaiety.[53] In this sobriety, her attitudes clashed with those of Isabel of Bourbon, who loved the theater and other forms of court entertainment. The young queen certainly had many other reasons to dislike the influence of the count-duke and his wife at the court; Isabel's resentment was also connected to Olivares's failure in the early part of Philip IV's reign to curb the king's frequent evening escapes from the palace to party and enjoy the company of his current mistress.[54] Isabel believed, as did many observers, that Olivares actually encouraged the monarch's pursuits, which included romantic trysts. The queen was

also angered at Olivares's unwillingness to allow the creation of a separate household for her son and Philip IV's heir, Baltasar Carlos.[55] There was, moreover, little love between the Count-Duke of Olivares and Isabel's ladies-in-waiting, who were, as R. A. Stradling has noted, the "wives, daughters or place-women of the put-upon court nobility."[56] These palace women regularly voiced their families' complaints against the Olivares regime; and when in 1630 Olivares became frustrated at criticism emanating from the court, he urged Philip IV not to heed the complaints of "the women of the palace who listen to everything."[57] Nevertheless, criticism of Olivares grew increasingly strong as the monarchy's financial and military fortunes worsened with its involvement in the Thirty Years War (1618–48). Numerous factors thus fueled the queen's resentment toward the *privado* and eventually emboldened her to urge Philip IV to dismiss the count-duke and govern alone.

Palace office was not the sole means through which women outside the royal family could gain access to and influence with Spanish kings. Philip II, Philip III, and Philip IV were known to value highly the opinion of exceptionally pious women, or *beatas*. Early in his reign, for example, Philip III met with Beatriz Ramírez de Mendoza, Countess of Castellar, a *beata* who had extensive contact with the court in Madrid. At this lengthy meeting between monarch and *beata*, the countess commented freely on court politics, on the queen's unhappiness at court, and on Philip III's excessive and unhealthy reliance on the Duke of Lerma. The countess urged Philip to pay greater heed to his wife (as opposed to Lerma) in considering decisions of state, because of Margaret's strong virtue and her love for the monarch. Philip spent so much time with the countess and took her advice seriously precisely because of her reputation for sanctity.[58] In a similar fashion, Philip IV corresponded for fourteen years with the Countess of Paredes de Nava, one of Isabel's favorite ladies-in-waiting, who after Isabel's death went on to become a cloistered nun.[59] Philip wrote to the countess about his late wife, Isabel, and asked the countess for advice about matters dealing with the personnel of the late queen's household. He also told her about his new wife, Mariana de Austria and the royal children, and went so far as to promise and in fact send the countess portraits of Queen Mariana and of the Spanish princesses María Teresa and Margarita, all painted by Velázquez.[60]

The Countess of Paredes de Nava's move from a life at court to the confines of a cloistered convent illustrates just how intimately a number of convents were connected to the Spanish court, a link that scholars have long overlooked. Spanish queens and kings visited convents on a daily basis to hear mass or to meet with nuns. Philip II's sister Juana even founded a convent, the Descalzas Reales in Madrid, which became a royal monastery receiving royal patronage and support. Margaret of the Cross, youngest daughter of Empress María and Emperor Maximilian II, entered

the Descalzas Reales as a cloistered nun in 1585 and remained there until her death almost fifty years later. Rudolf II, Holy Roman Emperor from 1576 until 1612, sent his illegitimate daughter, Ana Dorotea, to become a cloistered nun in that same convent. Returning to Spain from Central Europe after the Emperor Maximilian's death, the dowager Empress María spent the last twenty years of her life (1582–1603) in the Descalzas convent, living in rooms adjacent and connected to the cloistered section of the convent and participating in all the daily routine of the convent's religious life; nonetheless, she still left the convent regularly to visit her brother, Philip II, and his children. Hans Khevenhüller, the Holy Roman Emperor's ambassador at the Spanish court from 1573 until 1606, made a daily visit to the Descalzas, where he attended Empress María and discussed political matters with her; sometimes he even met there with Philip II and Philip III. The latter's queen, Margaret of Austria, patronized several convents and even took it upon herself, in particular, to reform the convent of Santa Isabel in Madrid, placing it under royal patronage. She later founded the royal convent of the Encarnación in Madrid, connected by a direct passageway to the Real Alcázar so that the royal family could pass easily and privately to the convent to take part in religious devotions and confer with the nuns. Philip II and Philip III, when they had to leave Madrid for an extended period, usually left their children and sometimes even their wives at the Descalzas Reales to stay with Empress María and Margaret of the Cross.

This frequent and intimate involvement with religious institutions is not surprising in Spanish royalty; after all, Philip II's father Charles V had retired to a monastery at Yuste, in Extremadura, after his abdication in 1556, and Philip II spent much of the last two decades of his life at the Escorial, which housed a monastery of Hieronymite monks. Spanish Habsburg women also left vivid proof of their devotion to convents and nuns; in widowhood or at their death, they were sometimes depicted wearing the robes of a cloistered Franciscan nun (Fig. 42).[61]

This affinity of Spanish royalty for conventual life seems to have communicated itself to a fair number of those around them. One example of this has already been noted: Isabel of Bourbon's lady-in-waiting, the Countess of Paredes de Nava, left the court several years after Isabel's death to become a cloistered Carmelite nun. Sequestration in a convent did not necessarily imply a complete withdrawal from worldly concerns, however. In her letters to Philip IV, the countess, who had been widowed at age thirty-three, regularly requested favors for various of her relatives, especially her children. Aristocratic wives were expected to see to the advancement of their children and to negotiate favorable marriages for them; as a widow the countess assumed even greater responsibility for their well-being. Although cloistered in the Carmelite convent of San José in Malagón (Ciudad Real), as a widow she was expected to take on the role

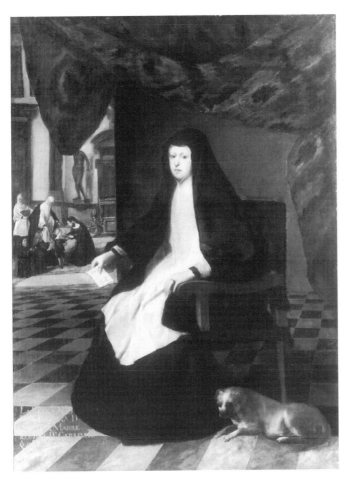

42. Juan B. Martínez del Mazo, *Queen Mariana of Spain in Mourning,*
1666 (London, National Gallery).

of mother and father.[62] The Countess of Paredes de Nava was by no means
the only noblewoman who chose to cloister herself. Three court ladies
who accompanied the Habsburg archduchess Margaret of the Cross from
Prague to Madrid in 1582 joined the royal convent of the Descalzas with
her, where they continued to serve as her companions and attendants.
Convents could also provide women with some protection from court
intrigue. After being implicated in a court conspiracy opposed to the Duke
of Lerma in 1603, for example, the Countess of Castellar retreated to a
monastery and took religious vows almost overnight.[63] A similar tactical
retreat, perhaps, was that of Philip IV's most notorious mistress, María
Inés Calderón ("La Calderona"), who retired to a monastery shortly after
giving birth to Philip's illegitimate son, Don Juan de Austria.[64]

Even more revealing than Philip IV's correspondence with the Count-
ess of Paredes de Nava is his lengthy and detailed correspondence with

Sor María de Agreda (1602–65), a cloistered nun in a convent in Aragon, who became one of the king's principal advisers and confidantes during the last few decades of his life.[65] Philip first met Sor María when he was on his way to lead an army to the border of Aragon and Catalonia. The nun was already renowned for her trances and for her claims of having been transported bodily to such faraway places as New Mexico – there were even reports that the Indians had seen her preaching in New Spain.[66] Philip IV was no doubt aware of Sor María's reputation when he decided to stop at the monastery at Agreda. After meeting her, he requested that she write him regularly to give him advice on numerous matters, stipulating that she keep the content of his letters confidential. Sor María seems to have ignored this injunction, however, going so far (on the instructions of her confessor) as to make copies of the king's letters.[67] She corresponded not only with Philip, moreover, but also occasionally with Queen Isabel of Bourbon and with influential court ministers such as Don Luis de Haro and the Duke of Híjar.[68] She seems to have been well aware of Philip IV's weakness for women, sometimes pointedly referring in her letters to King David, known for keeping a harem.[69] While she clearly tried to provide the king with spiritual counsel, she also commented on and asked for information on many political and military matters, as well. She urged the monarch to bring peace to the Spanish kingdoms, she asked him to tell her about the outcome of battles, and she even urged Philip not to rely on any single favorite (*privado*).[70] In a letter of 13 October 1643, she indirectly counseled Philip to remove the Countess of Olivares from the court, because popular sentiment held that though Philip had already dismissed her husband, the Count-Duke of Olivares was still well represented and even protected at the court by his wife.[71] Philip IV subsequently dismissed the Countess of Olivares from court. Whether Sor María exercised a formative political influence on Philip IV remains a matter for scholarly debate, but it is clear enough that the monarch found it important to stay in touch with her, solicit her opinion, and seek her approval.[72] Perhaps, as Consolación Baranda has argued, the monarch used Sor María for both otherwordly and pragmatic purposes.[73] He could appear brighter with the reflected glow of her well-known piety and spirituality, and through her prayers he could hope to gain divine favor and guidance. In Baranda's estimation, Philip was aware of and concerned about the imminent political and financial ruin of his monarchy and felt in need of such providential assistance. The historian R. A. Stradling, in his masterful, comprehensive study of Philip IV, argues that the king was willing to use his association with the nun to gain more money from Aragon.[74] Stradling also asserts that Sor María might have been a crucial part of the faction that brought an end to the Count-Duke of Olivares's favored position (*privanza*).[75] Philip IV's correspondence with Sor María had, Stradling concludes, a "concrete political meaning – despite its spir-

itual (or psychological) medium of expression."[76] The extensive and frequent correspondence between the two suggests a relationship beyond mere friendship and mutual respect; the king's letters to the nun sometimes have a confessional tone, as if Philip were a penitent and Sor María his priest-confessor.[77] Nevertheless, although the correspondence between Philip and Sor María was certainly remarkable, in seeking the advice of a cloistered nun Philip was simply following what had become a time-honored tradition of Spanish royalty.

Religious devotion and a reputation for personal piety could actually give one political influence and even power with a Spanish monarch. Monarchs like Philip III and Philip IV were exceptionally pious and devout; both engaged in religious practices almost as rigorous and time consuming as those of their wives, and they respected piety in others. To emulate their monarchs, gain an aura of sanctity, and meet their concerns about attaining salvation, *privados* such as the Duke of Lerma patronized religious institutions and orders. Lerma, for example, founded several convents and monasteries and encouraged reforms of existing religious orders.[78] Olivares, whose religious devotions intensified greatly after the death of his only daughter in 1626, founded with his wife a Dominican convent.[79]

Seventeenth-century Spanish queens engaged in extensive and elaborate religious rituals on a daily basis. Margaret of Austria, in particular, was known as a devout, virtuous, and even saintly queen.[80] After hearing mass in her private oratory every morning, she went to at least one other mass at a church outside the royal palace. This second mass was usually in a convent of cloistered nuns, and the queen then tended to remain at the convent until late evening to eat, converse, and pray with the nuns. Margaret also dispensed charity regularly, and the bulk of her estate went to support the performance of pious deeds such as caring for the sick, freeing Christians who had been imprisoned by Muslims, and helping needy women and children. She also stipulated that 14,000 masses be said for the repose of her soul.[81]

In a similar fashion, Isabel of Bourbon had a reputation for piety. She, too, engaged in daily religious rituals, which included visits to convents and monasteries. Jacopo Arnolfini, ambassador from the Italian city-state Lucca, described her as a very pious woman who gave abundant alms, cared for the sick at hospitals, received the sacraments frequently, and prayed assiduously.[82] She took it upon herself to have a chapel constructed in honor of the Virgin of the Almudena, a favorite of the people of Madrid.[83] Immediately before she went into labor in 1623, Isabel had a final testament prepared, in which she made provision for the construction of a court church to replace one that had been destroyed by fire. She also left funds to found two hospitals: one for the care of destitute soldiers, the other for orphans.[84] When Philip IV went to Aragon from 1642 until

1644 and left Isabel as governor of Castile, the queen visited and prayed to the Virgin of Atocha every Tuesday.[85] These visits confirmed the popular notion of Isabel as a devout woman.

Historians sometimes assume that the piety of Spanish queens prevented them from exercising political influence, yet this assumption ignores the clear connection between religion and politics at the Spanish court, and the practical ramifications of the queens' pious activities. Because of the piety of Margaret of Austria and Isabel of Bourbon, their husbands regarded them with greater respect and valued their opinions more highly. In 1607, when Margaret of Austria, in conjunction with the king's confessor, ventured to criticize the activities of the Junta de Desempeño (the committee set up by the Duke of Lerma to investigate the monarchy's finances), she spoke with credibility and authority, and Philip III paid attention to her comments. When Isabel urged Philip IV in 1643 to govern without the Count-Duke of Olivares, her reputation for moral virtue and religious piety lent weight to her arguments. Mariana de Austria, Philip IV's second wife, who served as regent for their son Charles II, was also described as a very pious queen, although with less positive connotations. Italian ambassadors claimed that after Philip's death she neglected her duties as regent in favor of her religious devotions.[86] The queen-regent's religiosity also supposedly caused her to rely too heavily on her confessor, John Everard Nithard.[87] Mariana's case differed considerably from that of Margaret of Austria and of Isabel of Bourbon; because Mariana had formal powers and responsibilities as regent, her piety was thought to interfere with the proper execution of political duties.

Margaret of Austria and Isabel of Bourbon, on the other hand, grew to represent good government to the populace. In the popular imagination, they were connected with a style of government different from that of Philip III and Philip IV, a style that did not rely on a strong *privado* but instead was based on a monarch who himself retained the reins of power. Even the Venetian ambassador, Ottaviano Bon, noted in 1602 that Margaret of Austria would govern "in a manner different from that of the king" if only she could.[88] Diego de Guzmán, Philip III's royal almoner and Margaret of Austria's biographer, claimed that she was honest, in sharp contrast to the dishonesty everyone saw at the Spanish court.[89] The court preacher, Jerónimo de Florencia, who delivered a eulogy at Margaret's funeral, claimed that from her grave, the queen asked Philip III to provide "just laws" and "efficient government" and urged *privados* (Lerma) to help the powerless.[90] In an anonymous report written to determine whether she died a martyr for the faith, the author claimed that Margaret worked incessantly for the "fatherland *[patria]* and benefit of the kingdoms."[91] Likewise, when she served as regent of Castile in 1642 while Philip IV went to the Catalan-Aragonese border, Isabel of Bourbon was also thought to have served the kingdoms well and to have provided good government.[92]

Isabel was also believed to have played a principal role in Philip IV's dismissal of the Count-Duke of Olivares from the court. When Philip returned to the court after leading the army to the Aragonese border, Isabel supposedly spoke with him and urged him to govern alone. She was aided in this task by Philip's cousin, Margaret of Savoy, Duchess of Mantua. The latter had served as vicereine of Portugal from 1634 to 1640 and had witnessed and been humiliated by the revolt and secession of Portugal. The duchess blamed the Count-Duke of Olivares for giving her little respect while she served Philip IV in Portugal and believed that Olivares had deeply injured her reputation. She willingly worked with Isabel of Bourbon to counsel the monarch to dismiss his *privado*.[93] Popular rumor added several other women to the conspiracy. Ana de Guevara, the king's former nurse, who still resided in the royal household, also purportedly begged the monarch to see to the kingdom's best interest by dismissing the count-duke.[94] Likewise, Sor María de Agreda counseled the monarch to govern alone. Finally, some reports, which remain unsubstantiated, even claimed that Philip's sister, María of Hungary, asked her husband, Emperor Ferdinand III, to write Philip and urge him to dismiss the count-duke.[95] Though all these stories remain in the realm of court gossip, they still point to the fact that popular sentiment believed that devout women, especially the female relatives of a king, were more in tune with the needs of a kingdom than was any *privado* and that ultimately these women would use their influence with a monarch to unseat a royal favorite.

This essay has examined the numerous roles and expectations of the female relatives of Spanish monarchs in order to create a picture of the world of the Spanish court.[96] Women were present and visible at the courts of Philip II, Philip III, and Philip IV. Monarchs looked to them for companionship, affection, counsel, and more pragmatic concerns, such as cementing diplomatic alliances and producing heirs. Spanish kings readily assumed that their female relatives would occupy political positions and did not hesitate to appoint their sisters, cousins, daughters, and wives as governors or regents. Monarchs assumed that their female relatives would protect the interests of the dynasty; they could trust their female relatives as they could trust no one else. Growing up in the knowledge that someday they might well occupy a political post, and trained to think that political developments were family matters, Spanish royal women were political creatures. They (and their contemporaries, for that matter) did not see a clear distinction between the political and the private aspects of the Spanish court. Moreover, many of these women resided at the very locus of political decision making and were thus inevitably involved in the political and personal intrigues that characterized court politics. Even those relatives who lived in convents remained abreast of political developments, as did nuns, such as Sor María de Agreda, whose piety led them to become informal advisers to the monarch.

Privados, whose power rested on their ability to win and retain a monarch's trust, friendship, and attention, might try to loosen the cords tying kings to female relatives and religious women, but the bonds between Spanish kings and these women proved tenacious. Despite all their efforts, royal favorites were unable to monopolize the avenues of political expression. Royal women could rely on popular sentiment and could ally themselves with disaffected ministers, loyal confessors, or devoted servants to challenge the power of *privados.* In a world where the political and the domestic realms overlapped, women could find many ways to gain access to monarchs and voice their concerns. At the time of Velázquez, Spanish royal women were central to court life, and no picture of the court is complete without them. Velázquez himself was no doubt aware of this, especially as he painted portraits of many of these women and often depicted Philip IV's queens right alongside the monarch himself – reminders of the status, authority, and heritage of royal women of the seventeenth-century Spanish court.

7 Spanish Religious Life in the Age of Velázquez

Sara T. Nalle

The royal portraits and scenes from mythology produced by Velázquez while he lived in Madrid reveal scarcely a trace of the intensity of religious life in his day. Indeed, the artist appeared little interested in religious affairs, if religious commitment can be judged by the contents of his personal library and the paintings he chose to keep in his studio. Velázquez's move to the royal court in 1623 liberated him from the artistic future that waited for him in Seville, where the fashion ran to religious art. During his apprenticeship in that city, and on occasion for his patrons in Madrid, Velázquez produced religious paintings on standard themes such as the Immaculate Conception, the Adoration of the Magi, the Crucifixion, the Supper at Emmaus, and so on, but he did so on his own terms, using unconventional compositions, models, or colors from his palette. It is for art historians to decide what special meaning may be drawn from these paintings. The goal of this essay is to paint in words a portrait of the wider religious world in which Velázquez moved but which for the most part he chose not to render in his canvases.

The Institutional Foundation: The Spanish Church in the Seventeenth Century

The Spanish church in the seventeenth century was a growing enterprise, something that did not escape the notice of contemporaries. In an age of declining fortunes, high taxes, and military conscription, a career in the church was not a bad idea. For women, a cloistered life sometimes was the only honorable option when husbands were scarce. Without discounting the very real worldly motives that often were behind the choice of a religious vocation, there was also the tenor of the times: Spaniards felt closely

tied to the church triumphant – a militant, evangelizing organization at the top of its game. One could dream of martyrdom in the jungles of Paraguay or the Philippines, self-effacing meditation in a reformed convent, or, simply, the quiet life of the parish cura, tending to the spiritual needs of one's community, and for many these dreams came true.[1]

The Spanish church proudly traced its origins back to the days of ancient Rome. During the middle ages it survived Arian Visigoths and Muslim Arabs by converting the former and defying the latter. At the close of the fifteenth century, with the conquest of Granada, the expulsion of the Jews, and the discovery of the Americas, Spanish Catholics entered a period in which it seemed that anything was possible. The crises at the end of the reign of Philip II (1556–98) lessened expectations concerning Spain's messianic role on the world stage, but the institutional church's position in society remained strong, if not stronger than ever. At the opening of the seventeenth century, the church in its various branches was a ubiquitous institution: in Spain alone there were forty-eight bishoprics organized into nine metropolitan districts. There were innumerable religious orders, male and female, throughout the peninsula, although the most popular and numerous of these was, without doubt, the Franciscan in both its male, female, and tertiary branches. It is difficult to say with precision how many Spaniards belonged to the religious estate, but extrapolating from the very accurate 1591 census of Castile to include Aragon as well, circa 1600 there were approximately 40,600 secular clergy, 25,500 members of male religious orders, and 25,000 nuns in a total population of eight million, or about 1.2 religious persons per 100 inhabitants. Throughout the seventeenth century the religious estate grew while the total population declined, a circumstance that attracted contemporary comment but that could not be reversed. Even in the eighteenth century, after the population had recovered and grown to 9.3 million, in 1768, there were then 66,700 secular clergy, 55,500 male religious, and 27,700 female religious, or 1.6 religious for every 100 inhabitants.[2]

The seventeenth century was the high water mark of the Catholic Reformation.[3] The papacy's goal was to establish hierarchical, centralized control over the secular church. Rome was aided in this by the Spanish church's early interest in issues of pastoral reform, which predated the sessions at the Council of Trent (1545–63). Institutionally, much of the work of the Catholic Reformation was in place by the beginning of the seventeenth century. For example, twenty Tridentine seminaries were founded before 1600; only eight more were established in the course of the seventeenth century. The Roman rite, catechism, and calendar of saints officially had all replaced local traditions. In deference to the Spanish church, the ancient mozarabic rite observed at the Cathedral of Toledo was allowed to continue alongside the Roman rite. The papacy, again to please the monarchy, permitted the canonization in 1622 of several Spanish saints

who symbolized the evangelizing efforts of a revitalized church: Francis
Xavier, Ignatius Loyola, Teresa of Avila, and Isidore the Laborer (patron
saint of Madrid).[4] Together with these new saints, a series of cults
designed to reinforce doctrine and respect for the Holy Family gained pop-
ularity. Typical of these were the cults dedicated to the Immaculate Con-
ception, Sacred Heart, Name of Jesus, Holy Cross, Corpus Christi, Souls
in Purgatory, Joseph, Mary Magdalene, and the Infant Jesus.

The overall impact of the church's reform campaign appears to have
been mixed. In central areas of the country, where population and
resources were numerous, the catechizing and centralizing efforts of the
Spanish church were noticeable at all levels of society. In the archbish-
opric of Toledo and bishopric of Cuenca, two prosperous districts close to
Madrid, visitations of the dioceses were carried out on a regular basis.
Such inspections showed a generally well-educated, resident clergy pre-
siding over a materially robust infrastructure that included not only sturdy
temples but precious liturgical objects, vestments, expensive missals, and
other printed books. The population responded well to the church's cate-
chization efforts and adopted many of the new Tridentine cults.[5] On the
other hand, in remote, poverty-stricken mountainous regions such as Gali-
cia and Cantabria, where often Castilian was not the primary language of
the population, the Catholic Reformation had little success or was even an
outright failure. Episcopal inspectors complained about crumbling, poorly
furnished churches, ignorant clergy, and wayward parishioners. Indeed,
these regions would remain rich reservoirs of pre-Christian folk traditions
well into the twentieth century.[6]

Through history and by papal decree the church and faith were closely
allied to the royal crown. Under Ferdinand and Isabella the reconquest of
Spain was completed, and in gratitude the papacy granted the Spanish
monarchs the honorary title of "Catholic Kings" (in a parallel move, the
French monarchy won the title of "Most Christian"). More to the point,
the monarchy won exclusive rights of patronage in the newly created arch-
bishopric of Granada and the Americas. The *patronato real* was extended
under Charles V to include the entire empire, thereby making the king in
matters of religious appointments more powerful than the pope and, just
as important, than local interests. The monarchy used this power to
appoint prelates of Spanish origin who were usually well qualified for their
posts. Prominent exceptions were the appointments of the Habsburg
princes Albert (1594–98) and Ferdinand of Austria (1620–41, known as the
Cardenal-Infante) to the archbishopric of Toledo. Albert was a mere child
when appointed to the highest dignity in Spain, and Ferdinand made no
secret of his preference for the battlefields of Europe, where he spent his
career. The monarchy enjoyed other privileges as well: a 1478 papal bull
establishing the modern Inquisition gave the crown full administrative
control over the tribunals. In the seventeenth century there were sixteen

courts in Spain, two in Spanish-held Italian territories, and three in the New World. Other papal concessions confirmed the crown's right to collect income from the indulgence known as the Cruzada (originally established to fund crusades against the Moors), claim a portion of the income from all religious benefices, and receive special subsidies from the Spanish church. These rights and privileges made the monarchy as powerful as the pope inside the empire, a circumstance that inevitably led to conflict with the Holy See.

In the sixteenth century, relations with Rome had been tumultuous. The Spanish crown's control over a good part of Italy led at times to outright warfare between the crown and the papacy, itself a territorial power in the peninsula. Yet, the two needed one another to confront such common enemies as the Turks and Protestants, as well as to reform the church. In the seventeenth century, the crown was unable to ensure the election of a pro-Spanish pope, and relations continued to be hostile throughout the difficult years of the Thirty Years War, war with France, and the rebellions of Catalonia, Portugal, and Naples. However, Philip IV's religious attitude was such that despite provocations, relations were not allowed to deteriorate into outright warfare, as they had at times in the previous century.[7]

In Madrid, the life of the court evolved to reflect the Spanish king's enormous responsibilities as the head of the largest Christian empire in the world. The monarch, in effect, was the world's leading Catholic. This role, which had been alternately eschewed by Charles V and embraced by Philip II, fell heavily on the shoulders of the pleasure-loving though devout Philip III and Philip IV. Both avoided the austere monastic life at El Escorial, Philip II's preferred refuge. In his youth, Philip IV's amorous adventures were an open secret at court. As a penitent, though, he could be equally extravagant in his devotions, for example, kneeling in prayer before a human skull (his favorite memento mori!) (Fig. 43). Sometimes, on encountering a priest on his way to administer extreme unction, following Spanish custom Philip would drop everything and accompany the eucharist to the home of the dying patient.[8] Later in his reign, as the realm entered a state of near collapse in the 1640s, Philip gave up his worldly pleasures and entered into a long spiritual relationship with the celebrated nun Sor María de Jesús de Agreda, which would last until her death in 1665 (Philip died shortly after).[9]

In keeping with the king's role as first Catholic of the realm, liturgical pomp and circumstance at the court became highly elaborate. Traditionally, Spanish kings had been invested with few of the trappings of office and kingship that one might find further north in France or England. Medieval Spanish kings had no thaumaturgical powers, wore no crown, and enjoyed no elaborate ceremonies of investiture or burial. The Habsburgs remedied some of these deficiencies by bringing to Spain the etiquette of the Bur-

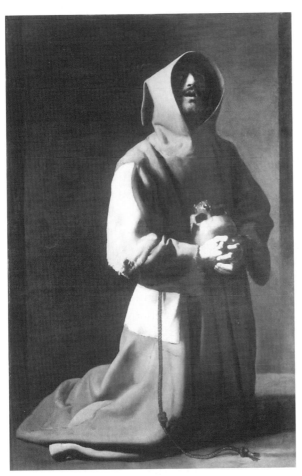

43. Francisco de Zurbarán, *Saint Francis in Meditation* (London, National Gallery).

gundian court, where Charles V had been raised. By the seventeenth century, court ceremonial had become highly formalized. The goal of some religious rituals was to put the monarch on display for all to see while minimizing the monarch's contact with his subjects. Long gone were the days when ordinary subjects could directly petition the king for his justice on his way to or from hearing mass, as would often happen to Charles V. Now, on the special occasions when the king had to leave the royal palace (the Alcázar) on the western limits of Madrid to attend services at the convent-church of St. Jerome, on the eastern side (behind the present-day Prado Museum), the entire court would form a lengthy procession, whose vanguard would reach San Jerónimo just as the rear was leaving the Alcázar. Other rituals, such as the protocol surrounding the seating arrangements in the Royal Chapel, literally isolated the monarch behind a curtain so that his daily devotions could not be observed and thereby turn into the subject

of ordinary gossip.[10] At Easter, Madrileños looked forward to the ceremony on Maundy Thursday, when their monarch came down to earth, so to speak, visited one of the city's parish churches and, in imitation of Christ, would wash the feet of a selected beggar.

Main Religious Trends

The all-consuming religious question for Spaniards in the first half of the seventeenth century was not the spread of Protestantism, the conversion of the Moriscos, or the merits of free will, which had been so forcefully posited at the end of the sixteenth century by the Jesuit Luis de Molina. It was the doctrine of the Immaculate Conception, immensely popular among the people, thanks to Franciscan and Jesuit preachers, but opposed with equal vigor by the Dominicans. In the fourteenth century, the Franciscan theologian Duns Scotus had declared the idea of the Immaculate Conception a "pious opinion." Marian supporters argued that for Jesus truly to be divine and free of the taint of original sin, his mother had to have been conceived without sin as well. Mary's status as Queen of Heaven, her supreme power to mediate between God and humankind, her spiritual motherhood, all depended on the teaching, which – inconveniently – had no basis in Scripture or the early Fathers of the Church. The Dominicans, who held most of the chairs of theology in the universities, made no secret of their opposition to the doctrine, which they regarded as patently misguided. Nonetheless, many Spaniards made the Immaculate Conception a point of national honor, and pursued it relentlessly. Prior to the seventeenth century, the papacy was forced to issue several directives with the intent of quelling the controversy or, at least, preventing violent arguments between the partisans from breaking out in public.[11]

The opening volley of the seventeenth century was delivered in 1613 in Seville, a city passionately committed to the cult of the Virgin. In the privacy of his convent, a Dominican dared to preach against the Immaculate Conception. Word got out and a public uproar ensued. To erase the stain on the Virgin's honor, Sevillanos held interminable cycles of masses, sermons, and processions for the next two years, and her image was painted and carved innumerable times. Velázquez, too, produced a painting of the *Inmaculada* during the years the controversy gripped the city (Fig. 44). Seizing the initiative, a group of enthusiasts armed with letters from the Archbishop of Seville traveled to Madrid to petition the crown to open an investigation. In a show of solidarity, it became the fashion for associations of all sorts to vow public allegiance to La Inmaculada. At first Philip III, influenced by his Dominican confessor, held back, but public demand won out, and the monarchy convened a Junta of Prelates to discuss the matter.

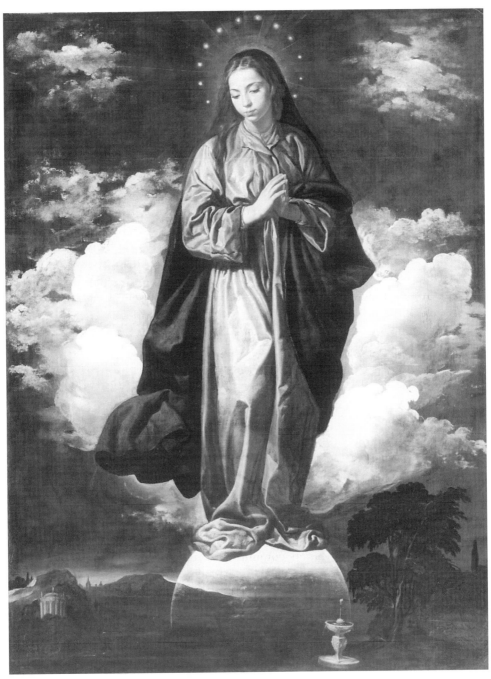

44. Diego Velázquez, *Virgin of the Immaculate Conception*, ca. 1619 (London, Trustees of the National Gallery. Acquired in 1974 with the assistance of the National Art Collections Fund).

The Junta recommended sending an embassy to Rome; in fact two embassies were needed to win from Gregory XV a bull in 1622 prohibiting the public or private defense of the Maculate position. Philip IV, devoted by nature to the Virgin, made winning formal recognition of the doctrine a matter of state policy. Another junta, the *Real Junta de la Inmaculada*, was formed for this purpose, but Urban VIII's dislike for the Spanish meant that no headway was made in Rome until after his death. Finally, in 1661 Alexander VII issued the bull *Sollicitudo omnium ecclesiarum*, which taught that the Virgin had indeed been conceived without original sin. With his country in virtual ruin, Philip IV perhaps could take comfort in this spiritual victory, which had taken forty years to win.[12]

Another religious controversy of the first part of the seventeenth century involved the question of who was to be Spain's patron saint. For centuries, the patron saint of Spain had been the apostle St. James, brother of Jesus, who according to tradition had preached in Spain and whose body was miraculously discovered in Galicia around 813. Within a short time, Santiago, as he is known in Spanish, was closely associated with the Reconquest. Santiago Matamoros (St. James the Moorslayer) typically was

45. Anonymous, *Santiago Matamoros.* Frontispiece of a pamphlet published by the Archbishop, Dean, and Cabildo of Santiago, *Memorial a Su Majestad . . .* (New York, The Hispanic Society of America. Pamphlet v. 20/9 in a bound volume on St. Teresa, *Articles with reference to her tutelage of Spain*).

preference in the seventeenth century was to put off holding the ceremony until the tribunal had accumulated a backlog of prisoners so that an impressive show of properly repentant heretics could be delivered to the public. A week before the auto would be held, street criers would announce the coming event, and workers would begin constructing a stage that included two facing bleacherlike structures, one for members of the Holy Office and other officials and the other for the prisoners. The night before the auto was to be held, members of the Inquisition's own Confraternity of St. Peter Martyr would march through town with the large green cross and other symbols of the Inquisition. The next morning, the representatives of the ecclesiastical and secular establishment would march in rank order to the public ground. The ideal was to have as many representatives possible of the church and city's population present to witness the auto. The prisoners marched according to the gravity of their penances – "reconciled," "condemned but saved," and "relaxed (condemned to death)" – which were advertised to the public by the type of sambenito worn. The line of prisoners was brought to the scene by the tribunal's corps of familiars. The auto proper consisted of a mass, sermon, and reading of sentences. Each prisoner received his sentence onstage, but those who were to be burned were handed over to the secular government for execution on the city's execution ground.

The auto-da-fé, which for most Spaniards meant the triumph of their faith and preservation of their society, came to symbolize in Protestant countries the most offensive aspects of Spanish Catholicism.[18] But the auto-da-fé was an exceptional event limited to those cities that housed Spain's sixteen tribunals of the Holy Office. More representative of the times were the holydays of Semana Santa and Corpus Christi, which were celebrated year in and year out in every community of the kingdoms. In modern Spain, the popularity of Semana Santa has far eclipsed that of Corpus Christi, but in the age of Velázquez, the two were of equal importance in the religious life of the country.

In cities and towns, Corpus Christi was the holyday in which the corporate community could affirm its allegiance to the eucharist, under attack abroad. Originally a minor feast day, by 1600 Corpus Christi celebrations had become a huge event all over Spain. Like many Spanish holydays, Corpus Christi was a complex melding of religious and profane elements. Central to the holyday was the triumphal procession of the eucharist through the community. The procession gathered together members of the local church, town council, and populace marching according to their social rank. However, as was typical of the baroque period, the festivities had elements of the bizarre as well. In Zaragoza, Toledo, and Valencia, patients from the cities' insane asylums would march with the confraternities. Across Spain the procession also included the *tarasca*, a large, articulated serpent made of wood and canvas designed to frighten children

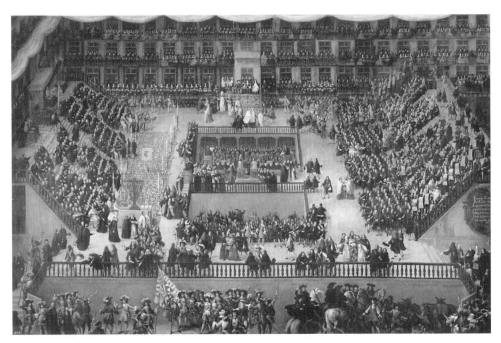

47. Francisco Rizi, *Auto-da-fé of 1680,* 1683 (Madrid, Museo del Prado).

since it affirmed the continuity of faith and redemptive value of submission to God's law, carried out by the Inquisition. But an execution, especially the burning alive of a heretic who refused to recognize his errors, was not the hoped-for outcome, because a death sentence signified the failure of the church to persuade a lapsed Catholic to return to the true religion. Although society had the right to defend itself from such heretics, who were considered to be in the devil's thrall, the auto-da-fé's goal was not retribution but salvation: the fewer who were lost along the way, the more successful the auto actually was.

Autos had always been important events in the local life of the cities where tribunals where located. While all autos followed a similar pattern, the exact sequence of rituals, seating arrangements, and props did not become completely fixed until the seventeenth century. The creation of a special tribunal for the city and court of Madrid in 1630 brought the Holy Office to the capital at a time when Spanish public life was particularly concerned with outward appearances and propaganda.[16] As a result, the two autos held in the city in 1632 and 1680 were extraordinarily lavish and well publicized via printed *relaciones.*[17] Important autos-da-fé were held in other cities as well: Barcelona (1627), Seville (1627, 1648), Cuenca (1654), Córdoba (1655), and Granada (1672).

The prime time for holding an auto-da-fé was between Easter and Corpus Christi, when the weather was good and the liturgical year was at its high point. Smaller autos could be held inside the local cathedral, but the

were the lawyers of the Cortes to take away Santiago's patronage, when it was Santiago who gave Spain to its kings? Quevedo reminded Philip

These Spains are booty [bienes castrenses], won in war by Santiago. . . . You, Sir, owe to him the kingdoms that, multiplied, you bind together; the advocates of the Cortes [owe him] the kingdom of which they are the tribunal; the temples for not being mosques; the cities for not being abomination; the republic and holy government for not being tyranny, its souls for not being Mohamodans or idolaters; lives for not being spent in slavery; damsels for not being tribute.[14]

In the end, the supporters of Santiago won the day, and Teresa never was accepted as the copatron of the nation, although many groups adopted her as their corporate patron.

Religious Life

Quevedo's statement concerning Santiago's patronage expressed something of the national religious spirit. Traditionally Christian Spaniards had defined themselves in opposition to the Jews and Muslims, and more recently, the Protestants, even though there were few enough of them on Iberian soil. In the seventeenth century, communities across the Hispanic world self-consciously expressed their Catholic identity through public allegiance to key aspects of doctrine. In part this was done by mounting ever more extravagant public celebrations, in particular, the annual holidays of Corpus Christi and Holy Week, and the occasional autos-da-fé held around the country by different tribunals of the Inquisition.

In the seventeenth century, where high drama was the watchword of the day, the spectacle of the auto-da-fé reigned supreme. Few public events could match the auto-da-fé for its combination of pageantry, symbolism, and real-life drama (Fig. 47). For, although the auto-da-fé was a meticulously scripted event, the outcome was never completely certain: at the last moment one of the condemned could renounce his heretical views, save his soul, and thereby bear witness to God's strength and mercy.

Today the image of the auto-da-fé serves as the ultimate statement of religious intolerance; it is difficult for the modern observer to comprehend the complexity of meanings that were bound up in the ceremony.[15] Few readers might imagine that the appropriate way to celebrate the king's arrival in a city, a royal wedding, or the opening of parliament was to hold an auto-da-fé. No monarch refused to attend one until Philip V, who was the first king of the new Bourbon dynasty and did not yet fully appreciate the religious sensibilities of his Spanish subjects. The purpose of the auto was to reintegrate heretics into society and heal the wound created by their rupturing of the body Catholic. From the point of view of orthodox Christians, the church, and the state, an auto-da-fé was a positive event,

46. Friar Juan de la Miserias, *Santa Teresa de Jesús*, 1562 (Seville, Convento de las Carmelitas. Photo Institut Amatller d'Art Hispànic, Barcelona).

depicted on horseback, wielding a sword and trampling the Moor underfoot (Fig. 45). In the seventeenth century, the followers of Santiago became embroiled in a dispute with the partisans of the newly canonized St. Teresa of Avila (Fig. 46), whose own followers felt that Teresa should be the national patron saint.

That Teresa – a woman, once denounced to the Inquisition for her mystical writings – should have been beatified within living memory itself was near miraculous, testimonial to the determined mettle of her followers and the amazing powers of her uncorrupted body.[13] A few years after her beatification in 1614, the advocate general for the Discalced Carmelites in Spain presented a brief to the Castilian parliament (Cortes) asking that Teresa be declared patron saint of Spain. The Cortes agreed and on 16 November 1617 so voted. The followers of Santiago were not pleased, and there ensued throughout the 1620s a lively debate in print over Teresa's suitability as the copatron of a warrior nation such as Spain.

Urban VIII's 1627 brief confirming the patronage of Teresa inspired Francisco de Quevedo, then one of Spain's most famous authors, to take up his pen in defense of Santiago. Quevedo happened to be a knight of the Order of Santiago, which was the most prestigious of the several crusading orders under the umbrella of the monarchy. (Velázquez did not gain entrance into the exclusive order until late in life, in 1659.) Quevedo protested to Philip IV, who was the titular head of the Order of Santiago, that the laws of Castile did not permit copatronage and that Christ had chosen Santiago to convert Spain, and for that reason he was patron. Who

and astonish country folk. These mock dragons, mounted on wheels, could reach thirty-six feet in length and were operated by one or two men hidden inside. The solemn spectacle of the city's clergy, religious, and local notables, decked out in full regalia, must have contrasted oddly with the antics of the mad "innocents," the dancing *tarasca,* and excited children.[19]

Corpus Christi could not be celebrated without the inclusion of one or two presentations of a uniquely Spanish form of sacred theater, the *auto sacramental.*[20] These presentations developed out of the medieval mystery plays known as *farsas* or *autos,* which were quite short in length. In the sixteenth century, the mystery plays were moved out of the churches into the patios. Such was their popularity that Spanish printers brought them out by the thousand, and authors became famous for their output. As professional theater developed in the late sixteenth century, it naturally included religious themes: lives of the saints, biblical histories, and eucharistic allegories. Each year, municipalities would contract with theater companies to present an auto during its Corpus celebrations. Custom dictated that these plays be written for the occasion, which meant that all of Spain's playwrights – Lope de Vega, Calderón de la Barca, Ruiz de Alarcón, Tirso de Molina, to mention only the more famous – found ready employment composing sacred theater. The public loved the productions equally for their spectacle – the costuming, set design, and stage tricks – and religious content, which was presented in verse and song. The acknowledged master of the auto sacramental was Calderón de la Barca, whose highly allegorical plays were admired for their theology and fine poetry.[21]

Corpus Christi, like all the important feast days of the year, was also the occasion for specially commissioned sermons. Communities would pay to bring in the best preacher available in the region, who was expected to fulfill the trinity of sacred oratory: to teach, entertain, and move or inspire, the last being the most important goal. For ordinary Sundays, the community might rely on its parish priest, who was now expected to undertake this weekly responsibility. Collections of printed sermons and manuals made the burden of weekly preaching easier to shoulder and kept local preachers in touch with current fashions. In the first half of the sixteenth century, leading preachers like Antonio de Guevara and Juan de Avila, influenced by Renaissance theories of rhetoric and style, had produced masterpieces on spiritual themes in clear, classical Castilian. However, the baroque preacher had other concerns to take into account: his was an audience addicted to theater and theatrical display. Thus, the sermon became a performance in which the church's moral and spiritual authority was vividly demonstrated. Looming over his audience on a high, ornately carved pulpit, with the polychrome statuary glinting in the candlelight, the orator could count on the temple's naturally dramatic ambience to increase the public's receptivity to his message. Some would employ props such as skulls to enhance the impact of their performance.

Contemporary taste called for the preacher to draw on emotion to inspire his audience to spiritual commitment. If he expected to bring tears of compassion to his listeners's eyes, then the preacher had to show similar feeling. Baroque audiences also expected a high level of verbal pyrotechnics: after all, this was the age of *culturanismo,* that is, a deliberately ornate and highly stylized use of language. If the preacher did not reach just the right balance of emotion and style with his public, laughter sometimes might be his reward, rather than praise. In their fiction, Golden Age authors frequently poked fun at preachers whose delight in worldly pleasures far outweighed their talent, learning, and pious demeanor.[22]

The most concentrated period of sermons came during Lent, when a preacher was expected to deliver forty new homilies, one for each day of the period. The intent was to prepare the community for its spiritual rebirth during Easter. During the final days leading up to Good Friday – Holy Week – communities would exhaust themselves in the penitential processions that accompanied the *pasos,* or religious floats. Wealthy confraternities in cities such as Seville, Valladolid, and Valencia commissioned masterpieces of polychrome sculpture to use in the processions.[23] As the pasos were carried or rolled through the city streets, the penitents, disguised in conical hats and long robes baring the back, would whip themselves until they bled. The pasos mirrored the agony of the penitents. These were executed with the utmost realism and attention to display of wealth. The members of the confraternities, hidden underneath their robes, could not receive personal recognition for the depth of their passion or pocketbooks, but the pasos could express these things for them. Foreign visitors remarked on the bloody, bruised Cristos (Fig. 48), the Virgins with wigs of real hair, and gowns encrusted with jewels, gold thread, and embroidery.

All of the religious activities described above relied on the presence of the confraternities (*cofradías, hermandades*), who served a myriad of purposes. The penitential confraternities mentioned above actually were a relatively recent addition to the landscape, having first become popular in the fifteenth and sixteenth centuries. Before their arrival, confraternities dedicated to charitable purposes such as succoring the poor and running hospitals and orphanages, were widely extended and continued their ministrations in the seventeenth century. In the sixteenth and seventeenth centuries, several new types of confraternities emerged from the changing religious environment. Some were dedicated to saving the souls in purgatory, others to promoting new cults such as the Name of Jesus, the Rosary, La Inmaculada, or St. Peter Martyr. Large cities supported a variety of confraternities, some of which could be exclusive according to gender, social rank, and purity of blood. Others, in a spirit of true Christian fraternity, recognized no distinctions whatever between brothers (women, if admitted, were always subordinate).[24]

48. Gregorio Fernández, *Dead Christ*, 1614 (Valladolid, National Museum of Sculpture. Photo Institut Amatller d'Art Hispànic, Barcelona).

A function of all confraternities was to bury the dead. At the high tide of their popularity in the sixteenth century, most testators requested at least one, and often two or three, brotherhoods to march in the funeral cortege. Members of a confraternity were entitled to certain exequies and memorial services that would be paid for by the organization. In the age of Velázquez, though, attitudes involving death and funeral rituals were changing rapidly. Although still holding a prominent role in funerals at the beginning of the century, by midcentury in the cities of Toledo and Cuenca fraternal organizations had given way to a different approach altogether.[25]

Death in the age of the Baroque was a staged affair in which the roles of the dying person, family, clergy, and community were rewritten to fit a new style of religiosity. In the words of one author, baroque death was "macabre, ever-present, moralizing, and enveloped in a great apparatus and ceremonies."[26] Our own age, which has banished all public reference to death and mourning, may find it difficult to understand the macabre taste of the time and to appreciate that the seventeenth century was even more morbid than the previous century. "Life is a dream," "true life begins with death," "the flesh is a temporary and flawed vessel for the soul" – these were some of the common themes of the day. The baroque obsession with death was the natural consequence of the church's incessant preaching on the twin themes of dying well in uncertain times and making provisions for those in already purgatory. It was helped along by several impor-

tant outbreaks of the plague and other epidemics in the first half of the century. Through disease, economic stagnation, and emigration, most cities in the interior of Spain, excepting Madrid and Seville, lost one-third to one-half of their population in a matter of two generations. Many villages were virtually abandoned.[27] In such conditions, how could one not be seized by an oppressive sense of earthly doom (Fig. 49).

The previous century had seen the apogee of an elaborate, corporate style of death, in which the testator arranged the details of his exequies, funeral cortege, and burial with a careful eye towards upholding his standing in the community. The funeral cortege of a well-to-do person typically included not only a confraternity or two but a selection of other community groups, for example, some of the town's poor or orphans (*niños de la doctrina*), and parish clergy. In the seventeenth century, the participation of community groups fell out dramatically, to be replaced by groups of friars (Franciscans, Dominicans, and Augustinians) and priests. Moreover, the deceased often chose to be buried in the habit of one of these religious orders (most typically, St. Francis) and even be laid to rest in the order's church. At the same time, the type and amount of suffrages (pious donations to the church) changed to focus on the quick passage of the deceased through the pains of purgatory. Death remained a public and even lavish event, but one from which the symbols of secular connections to the world had been banished.[28]

Although the religious life of the cities during the seventeenth century became ever more elaborate, it would be a mistake to assume that the religious life of the countryside remained unchanged. Even as traditional rogations, vigils, and pilgrimages continued as before, the religious landscape constantly underwent revision as Spaniards adopted new cults and discarded old ones. The impetus for change came from two sources: the church's doctrinal program and the need for ever more powerful heavenly advocates. In terms of community advocates, the seventeenth century witnessed the temporary success of Christocentric cults – temporary, because the cult of Mary continued to strengthen throughout the century and into the next while the Christocentric cults lagged behind. The growth of the cults of Mary and Jesus were accompanied by the "discovery" of new images, or, more typically in the seventeenth century, the images that already existed would demonstrate their strength by weeping, sweating, or bleeding. These miracles would be carefully noted down by the town notary and priest and publicized in print.[29]

The controversy in print over who was to be Spain's patron saint was lost on country folk, who evaluated the saints according to their ability to mitigate the malign forces of nature and disease. Neither Santiago or Teresa were particularly valued for these qualities. Thus in Ourense, Galicia, where one might expect Santiago to be a popular patron saint, children were not often named for him. The name "Teresa" was unknown in

49. Ignacio de Ries, *El arbol de la vida (The Tree of Life)* (Seville, Cathedral. Photo Institut Amatller d'Art Hispànic, Barcelona).

Ourense before Teresa's canonization in 1621; it was not until the end of the seventeenth century that children were named for the new saint with any regularity. By contrast, new saints with reputations for protecting against disease, for example, St. Roch and St. Julian, quickly became more popular as both personal and collective patrons when the faithful sought shelter from the century's horrible plagues.[30]

Heterodox Spain

Seventeenth-century Spain was a society organized for war – actual war, and the ongoing ideological war against heresy. Internally, the real danger to society posed by heresy was limited, since the campaign against Protestantism on Spanish soil had already been fought and won in the previous century. Nor, except for the odd convert,[31] was the majority population of Christians tempted to join the ranks of crypto Jews or Muslims. Socially the Conversos and Moriscos were far too marginal and despised for anyone to risk conversion to their ancestral religions. Yet, mindful of the inter-

national success of Protestantism, Spaniards continued to believe that constant vigilance against heresy at home was necessary for the protection of society and the honor of the faith. The networks of the Inquisition's familiars and commissioners remained in place, the edicts of grace and faith were read, and the harvest of Spain's unorthodox continued, although not at the same pace or with the same emphases as in previous years.[32]

The first controversy of the century was the ongoing problem of the Moriscos. One hundred years had passed since the crown had issued in 1502 the edict of conversion of all Muslims in Castile. A similar edict was promulgated for the Crown of Aragon in 1525. It was clear to all involved that nothing – neither missionary work, forced relocation, or inquisitorial persecution – was going to result in the assimilation of the minority. The problem was most pronounced in Aragon and Valencia, where large numbers of Moriscos lived in their own communities under the protection of seigneurial lords. Unlike the Jewish converts, who quickly became indistinguishable from other Christians, in 1526 Valencian and Aragonese Moriscos negotiated with the crown (at the price of conversion and a gift of 50,000 ducats) for the right to wear their traditional clothing, speak in Arabic, and practice their customs for the next forty years. In 1582, high-ranking members of the royal government decided on expulsion of the Moriscos as unassimilable, beginning with those in Valencia, but Philip II vacillated and the decision was tabled until the reign of Philip III (1598–1621), when international circumstances became favorable for expulsion. The Archbishop of Valencia, Juan de Ribera, for years had been convinced that the Moriscos would never become sincere Christians and since 1582 had advocated expulsion. Finally the old archbishop would get his wish: since the crown was at peace with France and the Netherlands, the ships and troops necessary to carry out the expulsion could be diverted to Spain. Philip III's favorite, the Duke of Lerma, reassured the monarch that the Aragonese and Valencian nobility would not mind the loss of their Morisco serfs if they were to receive their property as compensation together with other considerations. Thus on 22 September 1609 the order of expulsion was given, although most Moriscos did not leave until 1610. Some fled into the mountains and had to be recaptured by force: in the end, upwards of 272,000 (one-third of the population of Valencia and one-quarter of that of Aragon) were expelled to the general rejoicing of the Christian population.[33]

With the Moriscos' departure, the last vestiges of medieval Spain's religious pluralism were eliminated. Conversos of Spanish origin ceased to be a real concern of the Inquisition; in the 1620s the royal Junta de Reformación relaxed some of rules concerning purity of blood and ordered the destruction of libelous literature that imputed Jewish origins to prominent members of Spain's aristocracy. The Inquisitor General, Andrés Pacheco,

actually advocated eliminating the old purity-of-blood statutes on the grounds that the Conversos had long since assimilated and were as good Christians as anyone else. Ironically, though, the Inquisition's Converso-hunting days were not over; the autos-da-fé during Philip IV's reign featured many Portuguese *marranos*, largely merchants and bankers, who had entered the kingdom with the protection of the first minister, Count-Duke of Olivares.[34]

Hated as the Conversos and Moriscos were, Christians were drawn to them by their reputed skills in the magical arts, which enjoyed great popularity in the seventeenth century. Moriscos were thought to have inherited the Moors' skills in astrology, finding lost treasures, and concocting secret potions.[35] Hunting for treasure was harmless enough, except for the spells that were used in the process. In 1600, in a story that more properly belongs in a novel, the Morisco Don Antonio de la Fuente y Sandoval was accused of sorcery, enchantment, and conjuring devils. His accuser, a Converso, claimed that to locate hidden treasures in Madrid and its environs Antonio would employ special sheets of tin and paper. Once, when Antonio claimed to have located a treasure trove somewhere inside a cave near Getafe, he and his accomplices went there to bring it out. Antonio drew a circle in the cave floor near a spring and placed a magical mirror in front of himself. Holding in one hand a pot filled with a live coals and a candle in the other, Antonio began to pray silently and then threw into the live coals pellets made of amber, liquidambar, benzoin, and storax, all exotic-plant resins that would burst into flame and release incense. After a half hour, ingots of what appeared to be silver and gold fell out of the walls of the cave into the spring. Antonio persuaded his companions to leave for the night, since the treasure was more than they could carry, but when they came back in the morning, the treasure had disappeared.[36]

The Inquisition's archives are full of similar stories of marvelous or magical episodes, which to our modern taste seem almost fairy book–like or childish in their content. With the exception of witchcraft, historians have chosen to ignore this aspect of the age of Velázquez. Heresy makes more sense to the modern observer than the period's obsession with astrology and sorcery. The pope himself, Gregory XV, published in 1623 a bull criticizing the use of magic and charging the Inquisition to pursue more vigorously those who employed it.[37] In the seventeenth century, as had long been the case, consumers of the occult fell into two categories. First, there were the literate connoisseurs and sometime practitioners of astrology, cabalistic texts, and the *Key of Solomon*, a compendium of astrology, necromancy, and love-magic particularly popular in Spain. For these people, who were well aware of the prohibited nature of these texts, knowledge of the occult ranged from a dangerous pastime to a serious profession. Whatever the church said, pseudoscientific astrology remained popular with kings and prelates. The second group of "consumers" were

the traditional practitioners of *"hechicerías"* – village and neighborhood magicians. Male or female, illiterate or marginally literate, these individuals would solve lovers' quarrels for a fee, locate lost objects, cure impotence, and provide dubious medical treatments. As long as maleficium (the intent to cause harm through the devil's power) was not involved, religious authorities preferred to treat such cases with relative leniency, sometimes with a simple warning and instruction.[38]

Belief in real witches, though, was common enough, and it was only the judicial wisdom of the Inquisition that prevented the outbreak of witch crazes similar to those that occurred at this time in northern Europe. In 1526, the Suprema, the royal council of the Inquisition in Madrid, had agreed that witches and witchcraft were real but then established such strict conditions of proof that it was virtually impossible to convict anyone of the offense. In the famous incident of the witches of Zugurramurdi (in the Basque Country), the local inquisitors disregarded their instructions and proceeded to create their own witch craze. At the auto-da-fé held in Logroño, 7–8 November 1610, eleven witches were burned (six alive and five in effigy, having died before the auto). Another eighteen were reconciled. In the aftermath of the auto, the Suprema, which had been distracted by the expulsion of the Moriscos, realized its error and sent three inquisitors to investigate. One of them, Alonso Salazar y Frías, went to the trouble of interviewing over a thousand witnesses and came to the conclusion that the craze was the tragic result of human factors – excess publicity, fear, and rumors – and that it would disappear as soon as all speculation and publicity about witchcraft in the area ceased. Salazar y Frías was able to convince the Suprema of his position and in the Basque Country and Castile, there were no further panics (although witches occasionally were tried and penanced). In Cataluña, however, where royal officials claimed jurisdiction jointly with the Inquisition, witch hunters still could whip up the local population, and scores of witches were burned in the seventeenth century.[39]

In some cases, women who were tried for witchcraft or sorcery had begun their careers as spiritually gifted nuns or holy women (*beatas*). Known as *alumbradas* or *iluminadas,* these women claimed to receive visions and other divine gifts from God. Theologically, the alumbradas of the seventeenth century bore little, if anything, in common with the men and women tried under the rubric of *alumbradismo* between 1520 and 1540. Although they did not reach the sexual excesses of the alumbrados of Llerena during the 1570s, the Seville group of the 1620s claimed to be independent from ecclesiastical authority and to enjoy a state of impeccability. One hundred years before, a series of beatas had enjoyed the favor of powerful lords; now the Inquisition was determined to discredit women like Catalina de Jesús, whose followers in Seville numbered in the hundreds.

Although no one was burned, Madre Catalina was sentenced to six years of reclusion in a convent and her teachings silenced.[40]

* * *

In 1665, Philip IV died and his earthly remains were deposited in the mausoleum of his Habsburg ancestors at El Escorial. The throne was inherited by Charles II, whose deformed body and superstitious frame of mind, it is often said, matched the condition of his country. Childless even after a second marriage, with the connivance of his confessor Froylán and the Inquisitor General Rocaberti, the hapless king became convinced that someone had cast a spell on him, and the monarchy engaged a famous exorcist from northern Spain in the vain hope that the spell – blamed on the French – would be lifted. The one positive note in this story is the action of the Supreme Council of the Inquisition. As soon as the inquisitor general died, the council, which had never believed the rumors, began action to reverse the damage. The king's confessor, Froylán, was sent packing to a monastery, and a second exorcist sent by the Austrian Habsburgs was imprisoned.[41] Unfortunately, the case of Charles II's bewitchment has become emblematic of the time. Instead of remembering the rich and complex nature of Spanish religious life in the seventeenth century, we are left with the image of the last Habsburg king shivering in fear and exhaustion, waiting for a cure that never came.

8 Velázquez and Two Poets of the Baroque

Luis de Góngora and Francisco de Quevedo

Lía Schwartz

Art theory in Renaissance and Baroque Spain followed closely the development of Italian ideas, as discussed in treatises written since the fifteenth century in Florence. E. R. Curtius had recalled this relationship when studying a legal deposition "in defence of the nobility of painting", written in 1677 by the playwright Pedro Calderón de la Barca in support of some Madrid painters who were involved in a legal suit with the Crown's tax office.[1] In this document, Calderón defends the notion that painters were not artisans but the practitioners of a noble art. If painting was not counted among the seven liberal arts, argued Calderón, it was because painting "is the art of arts" that combines all the others. Like poetry, painting was conceived as an imitation and emulation of nature; the painter, as a cultivated artist, who needed to study geometry and perspective, rhetoric, dialectic, and music. Painters were also intelligent readers of poetry, of historical and mythographical works. What we know about Velázquez's life confirms his "erudition" – a requirement for poets of the Baroque – which informs many an aspect of his paintings.

In treatises of art painters were often compared to poets; in treatises on the art of poetry, poets were compared to painters.[2] Poets and painters frequently engaged in drawing analogies between the "sister" arts. The existence of traditional motifs on the interrelationship between *pictura* and *poesis* facilitated the comparisons. Well known since the Middle Ages were those that represented God as a painter – *Deus pictor* – or as an artificer – *Deus artifex*. The practice of description in poetry required the development of visual and pictorial imagery, thus the writer's quill could be compared to a painter's brush, drawing on the white page as if it were a canvas. Painters like Velázquez frequently alluded to literary motifs in their works; in turn writers like Quevedo, Góngora, Lope de Vega, and Calderón showed a real knowledge of pictorial devices and techniques,

whereas others were amateur painters, when painters did not also write poetry.[3]

The interrelationship between the sister arts was also cemented by friendships among artists who shared common spaces at court and in literary and artistic academies in Madrid and in other Spanish cities. A commonality of motifs in the works of three Baroque artists, Velázquez, Góngora, and Quevedo, who must have met at court in the 1620s, merely confirms the connections between the languages of art in seventeenth-century Spain. In the narrative that follows, the story of their intertwining lives precedes the discussion of the relations between *pictura* and *poesis* in the age of Velázquez.

<p style="text-align:center">✳ ✳ ✳</p>

Two poets and a painter in search of patronage at the Spanish court may well have crossed paths in Madrid in the decade of the 1620s. Velázquez's father-in-law, the poet and painter Francisco Pacheco, tells in his *Arte de la pintura* of two trips the still young artist took to the capital of the kingdom. "Wishing to see Escorial", says Pacheco, Velázquez left Seville in April 1622. He was back in the city on the Guadalquivir in January of 1623 but returned to Madrid in August, this time for good.[4] Madrid and the court would become the center of Velázquez's work and life, and from Madrid he would travel to Italy or to work on different artistic projects such as the refurbishing of El Escorial.

At court in Madrid, Velázquez could have met the famous humanist and satirist Francisco de Quevedo (1580–1645), who had been born in the city.[5] Quevedo left Madrid in 1613 and returned in 1618, having spent six years in Italy as secretary and confidant of the Duke of Osuna, Viceroy of Sicily (1613–16) and Naples (1616–19). Luis de Góngora (1561–1627), an Andalusian like Velázquez, settled in Madrid in 1617 and would mostly remain there until 1626, when he returned to Córdoba. A famous portrait painted by Velázquez in 1622 (Fig. 50) survives as evidence of the painter having met and talked to a fellow and famous Andalusian in Madrid.[6]

No written documents survived to tell about our men of letters getting together. Yet the existence of a handful of satires in which Quevedo and Góngora lampooned each other suggests that they must have met on unhappy occasions and that their mutual dislike was personal, going beyond aesthetic disagreements. The enmity of these great poets of the Spanish Baroque has even been recently construed in nationalistic terms, as the inevitable confrontation between an Andalusian and a Castilian.[7] The provincial poet who had come from Córdoba to visit the seat of monarchical power was bound to clash with his younger competitor, an experienced *madrileño* and a seasoned traveler in the rough seas of the Habsburg court.

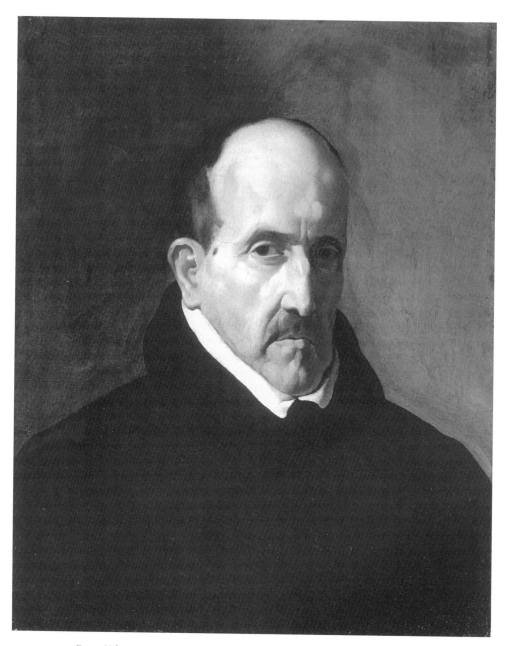

50. Diego Velázquez, *Portrait of Luis de Góngora y Argote,* 1622 (Courtesy, Museum of Fine Arts, Boston. Marie Antoinette Evans Fund).

To my knowledge, there is no proof that Quevedo met Velázquez either. In fact, the portrait of Quevedo that had been attributed traditionally to Velázquez is now considered to be the work of a follower.[8] However, it is unlikely that they missed each other at court. In any case, what Quevedo's poems undoubtedly tell us is that he admired Velázquez's art, that he was

acquainted with his work, and that he was even capable of appreciating his technical innovations, since he describes some features of the painter's syle in sixteen lines of the *silva* addressed "to the brush", *Al pincel,* to which we will return.

Quevedo was first and foremost a "madrileño". His parents had been in the household service of the kings of Spain. He was then familiar with life in the royal palace, with its architecture, and with the hierarchical structure of the Burgundian etiquette. Faithful to the city of his childhood and youth, Quevedo immortalized its squares, buildings, and monuments in many of his works.[9] Quevedo, who had studied with the Jesuits in Madrid and in Ocaña, attended the universities of Alcalá de Henares, where he graduated as "bachiller", and Valladolid. From 1613 to 1619 he lived in Italy as secretary to the Duke of Osuna, yet Madrid and the court were a permanent point of reference and return. In the third decade of the century Quevedo actually commuted between Madrid and his country manor, his *señorío,* of La Torre de Juan Abad, near Villanueva de los Infantes (La Mancha), a place to which he was banished when his patron fell in disgrace, was imprisoned in 1621, and prosecuted. Quevedo was well aware of the struggle to obtain positions and benefits from the king and his ministers; the manifold satirical portraits of courtiers and pretenders or aspirants to public office (*pretendientes*) that he bequeathed us confirm that.[10] Moreover, they also intimate how the nobleman Quevedo may have behaved in order to gain access to patronage and power.

Luis de Góngora was already a famous poet by 1620. His two major works in verse, the *Fable of Polyphemus and Galatea* and *Solitudes,* composed around 1612–13, were widely circulated at court, where he was well known from the turn of the century, as a creative and daring innovator of poetical discourse.[11] As early as 1600, thirty of Góngora's compositions had been published in collective anthologies; others circulated in manuscript. Quevedo had read them while still a student, and in the years that followed, he made many of them objects of poetical imitation or comic parody. Góngora, who was born in Córdoba, with the exception of the years he spent as a student in Salamanca, lived in Andalusia most of his life. He made ten trips to Madrid between 1585 and 1612. He also visited other cities in Spain, among them Valladolid, during the years between 1601 and 1606, when, at the request of the Duke of Lerma, Philip III ordered that the court be transferred there. Góngora and Quevedo were both in Valladolid in 1603, yet, to my knowledge, there is no historical evidence that they were in close contact there. Quevedo was certainly a keen reader of the satirical poems that Góngora composed about Valladolid, and he responded with parallel satiric compositions in defense of the old Castilian town or mainly to attack Góngora.[12] Quevedo had already acquired a reputation as a poet and deft satirist; thus when Pedro Espinosa, Góngora's fellow Andalusian, collected his well-known anthology *Flores de*

poetas ilustres, published in 1605, for which he selected thirty-seven poems by Góngora and even one poem by his friend Francisco Pacheco, he decided to include, among the work of other authors, eighteen compositions by Quevedo.[13] Góngora returned to the court in 1617, many years after it had moved back to Madrid. He lived in Madrid until 1626, attempting to obtain the favor of Philip III's favorite, the Duke of Lerma and of his protégé, Rodrigo Calderón, Marquis of Siete Iglesias. During the almost ten years Góngora spent as *pretendiente* at Court, in close vicinity to Quevedo, he wrote many a poem in praise of potential patrons, in which, like Quevedo, he flattered powerful noblemen while unmasking, in the opposite satirical register, their corruption and the obsequiousness of the train of sycophants that surrounded them.[14]

Several satirical poems attributed to Góngora also criticize his detractors and the enemies of the "new poetry" he had developed, among them Quevedo, who reciprocated with equivalent satires.[15] His rejection of Góngora's aesthetic program, which was admired and treated with reverence by many of his contemporaries, is also evident in the satirical texts he wrote against the *poetas cultos,* that is, Góngora's followers, whose obscurity he decries in *La culta latiniparla* and *Aguja de navegar cultos,* and in two Menippean satires, *Discurso de todos los diablos* and *La Fortuna con seso y la hora de todos.*[16]

Tradition has it that Góngora and Quevedo were declared enemies.[17] In a letter of 4 November 1625, Góngora, who was renting a house that was bought by Quevedo, tells that he was evicted by order of his new landlord. In a satirical poem that he wrote afterwards, Quevedo, on his part, does not hesitate to joke about Góngora's "obscure" poems, *Polifemo* and *Soledades.* Their complexity is synesthetically described as fetidness, thus, claims the satirist, the need to refresh the air in the house that Góngora inhabited by burning, as if they were incense, poems by the Renaissance poet Garcilaso. Quevedo even coins a neologism, the verb *desengongorar,* to indict Góngora's stilted Baroque syntax and his profuse use of Latinisms and ingenious conceits: "para perfumarla / y desengongorarla / de vapores tan crasos, / quemó como pastillas Garcilasos."[18] There is no question, however, that, aesthetic differences aside, Quevedo was an assiduous reader of Góngora and that his own poetry shows important intertextual relations with that of the former.

Personal enemies, or just competitors in the artistic arena, Quevedo and Góngora paradoxically shared similar misfortunes in that ominous year of 1621 that changed in many ways their lives as noblemen in need of patronage. Philip III died on 31 March 1621, precipitating the downfall of his principal minister, the Duke of Uceda, who was replaced by Baltasar de Zúñiga, Gaspar de Guzmán's uncle. After the political triumph of Olivares's faction, it became obvious that power now lay in the hands of a new

team of rulers, who took over the government of the monarchy, promising to effect radical reforms so as to correct the rampant corruption that had characterized the government of Philip III's favorites, Lerma and Uceda. Góngora reports on the death of Philip III, in a letter written to Francisco del Corral, dated 6 April 1621. Designated honorary chaplain to the king in 1617, Góngora was a witness of the events that took place a few hours after his death. Thus in his letter he is able to comment on Philip's last days, on his concerns and "scruples" for not having fulfilled his mission, but he also refers to the resolute actions taken by Olivares's group in order to gain immediate control of power after the king expired. Philip IV transferred Uceda's papers to Zúñiga, says Góngora, while changing the secretaries in charge of government and some members of his councils: "Everything is now don Baltasar de Zúñiga and the Count of Olivares." He concludes his letter with the following sentence: "Great changes are expected; I will be telling you about them."[19]

Quevedo, though in exile at La Torre, had, however, informants who provided him with many precise details of the process. In his well-known journalistic work *Grandes anales de quince días,* whose wide circulation is evident from the many manuscripts now extant, he describes the death of the king in words very similar to those of Góngora's letter. Next, Quevedo reports on the first two weeks of the new government, while appraising the changes that Olivares and his counselors are keen to effect.[20] Like Góngora, Quevedo had many reasons to feel uneasy about the change of government. Their protectors, the Marquis of Siete Iglesias, and the Duke of Lerma, and the Duke of Osuna, respectively, had lost their positions. Osuna was going to be tried; Quevedo was trying to disentangle himself from his close connections to the Viceroy of Naples, or at least, to clear his own case in light of the accusations brought forth by the Neapolitans who had denounced Osuna at court. It should not be surprising, therefore, that Quevedo hastened to pay homage to the Count of Olivares a few days after the death of Philip III, dedicating to him the manuscript of his political treatise *Política de Dios,* part I. During the decade of the 1620s Quevedo wrote other works in praise of the new favorite: his satiric epistle *Epístola satírica y censoria contra las costumbres presentes de los castellanos*; a play, *Cómo ha de ser el privado,* and other circumstantial poems in praise of the "new Seneca" that he claimed Olivares was or, as it appears from our perspective, in the attempt at repositioning himself at court.[21] Góngora also did not hesitate to try to get closer to the favorite. In a letter of 13 April 1621, he tells Francisco del Corral how Philip IV conferred on Olivares the title of Grandee of Spain: "Count of Olivares, put your hat on," Góngora claims that the king said "in a louder voice than he usually talked", thus bestowing upon his minister a privilege reserved for the royal family and the highest nobility.

Góngora is very specific about his "having been with Olivares at twelve thirty" in his room, and praises the king's decision, because "Olivares deserves the applause" he got.[22]

Góngora had a better chance of being accepted by Olivares and his faction than Quevedo, in spite of his former association with Rodrigo Calderón, the Marquis of Siete Iglesias, who was executed in October 1621. As an Andalusian, he must have felt closer to the new favorite. Góngora was also a famous poet by the time Olivares came to power, thus recognized as an important figure among the artists that gravitated towards the court. In several of the letters written during the year 1622, Góngora indicates that his petitions are being heard by the king and his ministers, among them his request for a pension. The count-duke had manifested an interest in him, as a person, and in his work. He encouraged Góngora to publish his poetry, while promising to help him obtain the concession of his nephew's "hábito".[23] Nevertheless, Góngora returned to Córdoba in 1626, feeling defeated and disillusioned with life as a courtier in Madrid.

In turn, Quevedo's attempt at building a positive relationship with the favorite was met with a measure of success after 1623, when he returned from exile to Madrid. Among the first proofs of his political "rehabilitation" at court is the invitation he received to accompany the king and his royal retinue to Andalusia. In 1624, Olivares organized this impressive trip that culminated in an epic hunt at Doñana, then property of the Duke of Medina Sidonia. Quevedo described the adventures that befell them in a comic letter addressed to the Marquis of Velada and San Román and dated 17 February 1624.[24] Góngora was not among the travelers, although Córdoba was one of the cities that they visited. Probably the newly appointed royal painter Velázquez did not participate either. Yet two of Francisco Pacheco's friends, Francisco de Rioja, Olivares's new librarian, and the Sevillian canon Juan de Fonseca y Figueroa, one of the earliest protectors of Velázquez at court, profited from the opportunity of staying in Seville between 1 March and 13 March, to visit Velázquez's father-in-law in the city.[25] It has been conjectured that, on that occasion, Quevedo may have sat for Pacheco, who included his portrait in his *Libro de retratos,* where Quevedo appears as *poeta laureatus.*[26]

Quevedo's early praise of Olivares as the politician who would restore Spain's fortunes, however, would slowly develop into mistrust. John H. Elliott has amply demonstrated that until 1634, even though he never became personally close to Olivares, Quevedo was well received at court. After that date, and in the years that followed, his developing friendship with don Antonio Juan Luis de la Cerda, Duke of Medinaceli, Quevedo joined a faction of the nobility that opposed Olivares's politics and became increasingly alienated from the seat of power. As is well known, Quevedo ended up attacking Olivares ferociously in his later satirical and doctrinal

works, although in 1639, the latter would order his imprisonment in the convent of San Marcos de León. Quevedo regained his freedom in 1643, in time to witness Olivares's own fall from power, but it is known that he returned home a broken man.

At the beginning of the 1620s, however, both poets had welcomed the ascent of the count-duke as a necessary and positive change for the Spanish monarchy. As recounted by Pacheco, Velázquez, who arrived at the court in 1622 hoping to find a position as official painter, enjoyed Olivares's and the king's protection from the start. After having painted a portrait of Philip IV, Velázquez was named royal painter in October 1623. He was to receive a monthly salary and also payment for individual paintings as he produced them. Until 1629, when he traveled to Italy, Velázquez lived in Madrid and became acquainted with the artistic life at court and in the city. This obviously included witnessing the development of Baroque drama in the works of Pedro Calderón de la Barca, whose *Amor, honor y poder* was performed in 1623. By living at court in Madrid, Velázquez must have heard of, and maybe even read, many of the literary works that circulated in manuscript or were published in those decades, when intense artistic productivity seemed to belie Spain's economic problems and its steady loss of power in the European theater, against the background of the gruesome Thirty Years War.

The Pen and the Brush

In his *Arte de la pintura*, Francisco Pacheco, quoting Plato and Aristotle on the status of drawing, defends the notion that painting is not a craft but should be numbered among the liberal arts.[27] To accept this conception required that the artist become also a reader and have a basic education in the humanities. Pacheco, a painter who also wrote poetry and was the editor of the poetical work of the Sevillian Fernando de Herrera, among others of his contemporaries, was very interested in classical scholarship and in the very issue of the creative process in poetry and in painting. As leader of a literary and artistic academy in Seville, which continued the one created by the sixteenth-century humanist Juan de Mal Lara, Pacheco was an influential voice among the writers that homologated poetry with painting.

Poetry and painting share in many features, one reads in several seventeenth-century treatises. They are both based upon the aesthetics of imitation; they both use fictions to create artistic texts; both are the product of imagination and craftmanship. In the work of theoreticians of painting, like Pacheco and Carducho, as well as in that of theoreticians of rhetoric and the art of wit, like Baltasar Gracián, one finds references to

the particular parallelism between the pictorial and the verbal arts.[28] Pacheco advises the painter to quote explicit motifs from other artistic compositions and to adapt them to a new one. Gracián also addresses the equivalent technique of verbal imitation by extolling the function of erudition in a literary text and by supporting the type of imitation called *contaminatio*, which consisted of weaving quotes from different sources and incorporating them into a new and meaningful text.

As regards painting, the presence of literary allusions and mythological motifs in pictorial compositions proves their interplay with verbal contexts. Even specific features of the discourses of wit that were in fashion in the seventeenth century, for instance, the creation of linguistic conceits built on interrelated metaphors, wordplays and other figures of speech, were translatable into pictorial devices. In Velázquez's compositions, for instance, the reference or allusion to another reality, based on analogies or oppositions, reminds the reader of Góngora's or Quevedo's technique for building figurative contexts, in which a wordplay is part of a metaphor or in which a metonymy and/or a wordplay generate another metaphor. Velázquez's treatment of space also seems comparable to the literary technique of embedding that Quevedo, for instance, deploys in his satire *Fortuna con seso y la hora de todos,* which encompasses, within a frame based on mythological narratives, forty satirical chapters. In at least twenty of its forty chapters, a specific social or moral type is unmasked, at times establishing subtle analogies or contrasts with the gods of Olympus who are represented in the frame. Thus it should not be surprising to find out that for seventeenth-century theoreticians, Baroque rhetoric manifested itself not only in verbal speech but also in pictorial techniques, so that if a poem could become a living picture, a painting could be considered a mute poem.[29]

The painter was often represented in poetic texts through the motif of *Deus artifex,* thus his brush could be said to be divine, as does Góngora in a sonnet written in imitation of epigrams of the *Greek Anthology,* where he describes the paintings that were exhibited in a gallery of Cardinal Don Fernando Niño de Guevara. The visitor here is another pilgrim who is exhorted to admire, speechless, the divine brush – "pincel divino" – with which they were painted.[30] Pictorial perfection could be also ciphered in the names of famous painters of Antiquity, Apelles (4th c. B.C.) or Timanthes (5th c. B.C.), a contemporary of Zeuxis, who, says Góngora, were defeated by the artist who had painted the room of fruits at the Alhambra:

> y su cuarto de las frutas,
> fresco, vistoso y notable,
> injuria de los pinceles
> de Apeles y de Timantes,
> donde tan bien las fingidas

imitan las naturales,
que no hay hombre a quien no burlen
ni pájaro a quien no engañen;[31]

The painter of the room had imitated nature with such superb skills
that birds and people took these artistic objects for real, claims Góngora,
alluding to the well-known anecdote about Parrhasius's *trompe-l'oeil*
painting, transmitted by Pliny.[32] The hyperbolic conceit, "injury to Apelles'
and Timanthes' brushes", far from being original, was a trite *topos* in sev-
enteenth-century poetry. Quevedo recreated it in a laudatory sonnet to a
famous calligrapher, Pedro Díaz de Morante (ca. 1565–1633), who had
drawn a portrait of Philip IV. Of his skilled pen, Quevedo also said that it
defeated Apelles' and Timanthes' brushes:

Bien con argucia rara y generosa
de rasgos, vence el único Morante
los pinceles de Apeles y Timante.[33]

In praise of El Greco's art, Góngora forges another conceit that extolls
the brush. In a sonnet written in imitation of the *Greek Anthology's* funer-
ary epigrams as an "inscription for the tomb of El Greco", the marble mon-
ument is metaphorically redescribed as a hard key that shut "the softest
brush, which conferred spirit and life to wood and canvas", the latter being
represented metonymically by the words *leño* and *lino*.[34]

Another set of encomiastic motifs in seventeenth-century poetry, which
were based upon corresponding analogies, turned the poet into a painter,
the printed page into a canvas, and his pen into a brush. In his satirical
romance on the loves of Pyramus and Thisbe, Góngora conflated, in a typ-
ical image, *voiced* poetry with *silent* drawing by means of a conceit. Thus
the pen is metaphorically seen as "a goose's brush" and the lovers' portraits
to be developed in the poem as "two beautiful drawings" that talk:

En el ínterim nos digan,
los mal formados rasguños
de los pinceles de un ganso,
sus dos hermosos dibujos.[35]

The same metaphorical relationship informs a conceit found in one of
the sonnets attributed to Góngora, where the brush is conferred the qual-
ity of *facundia,* "eloquence", and then applied metonymically to define the
poet-painter Juan de Jáuregui, author of the well-known mythological
poem *Orfeo,* published in 1624: "pluma valiente, si pincel facundo".[36] As
expected, similar conceits were devised by other seventeenth-century
Spanish poets. Gabriel Bocángel, for instance, who in a sonnet also dedi-
cated to Jáuregui, again by means of a semantic exchange of attributes,

says that Jáuregui's brush *describes,* while his pen *paints:* "pues describe el pincel, pinta la pluma."[37]

The connections between poetry and painting become particularly evident when appraising the vogue of *ekphrastic* or descriptive compositions in seventeenth-century Spanish and European literatures, which seemed to egregiously synthesize the visual and verbal arts. Descriptive or epideictic Spanish *silvas,* or epigrams, had their classical sources in the *Greek Anthology* and particularly in the collection of *Silvae* by the Roman poet Statius (40–96), which enjoyed a tremendous success during the Renaissance and the Baroque. Imitators of Statius and the *Greek Anthology* in Latin or in the vernacular languages of Europe helped expand their influence. Yet there is no question that the practice of descriptive poetry in Spain was also fostered by the ongoing dialogue between poets and painters. Thus many compositions by Góngora, as we have seen, by Quevedo and other Baroque poets, focused upon the verbal description of objects in the natural world, of gardens, statues, and other monuments. The motif of gardens was highly representative of Baroque thematics, since it allowed for exploration of the relationship between Nature and artifice, while becoming the favorite setting for mythological poems such as Góngora's *Polyphemus and Galatea,* where the description of landscape became fundamental.[38] Descriptions of paintings, drawings, and other "spacial" objects allowed a poet to compete with their creator, by trying to emulate the plastic artist with a verbal and temporal medium. It was thought at the time that rhetoric and wit could be then pressed into service to create an equivalent artistic object.

Quevedo bequeathed us an extensive collection of poems, *silvas,* and sonnets, dedicated to the art of *ekphrasis.* He described clocks (*silvas* 139, 140, 141) and Roman ruins (*silva* 137); he depicted country houses (*silvas* 202); a portrait of the Duke of Osuna painted by Guido Reni of Bologna (sonnet 215), another by Pedro Morante of Philip IV (sonnet 220).[39] One of his *silvas* (205), is addressed to the brush (*Al pincel*), which, by metonymy, represents the art of painting. Small in body, says Quevedo, the brush competes with Nature; it overrides the law of time and death, since painting immortalizes in its images the beauty and majesty of disappeared creatures, thus allowing the living to communicate with the dead.[40]

The poem can be thematically divided into three sections. The first is built around typical motifs and commonplaces. Art imitates nature, but the painter, *Deus artifex,* who creates a beautiful microcosm, often defeats it, as it defeats time, since a painting transcends mortality. In the middle section of his poem, Quevedo enumerates the names of excellent painters who were able to confer life, feeling, emotion to their compositions, thus transgressing the boundaries that separate inanimate from animate objects.[41] In the third section, the poet recalls the art of hieroglyphics to document the antiquity of paintings and also to praise religious images

and their important function in society. These last lines have been read in their relationship to Counter-Reformation ideology.[42]

A longer version of the second section of the poem, its catalogue of excellent painters, was published in the 1670 edition of Quevedo's *Las tres musas*. It included an encomium of Velázquez's art that evinces our poet's familiarity with his artistic production. It also shows that Quevedo was aware of some characteristic devices of Velázquez's technique. Thus, claims our poet, Velázquez, deft and ingenious painter, thanks to the brush, was able to animate beauty, to confer feeling to his figures by using his brush strokes (*las manchas distantes*).[43] Quevedo also refers in this section to another well-known device in some paintings of Velázquez, the mirror, which shows the reflection of a figure portrayed in the composition.[44] In *Venus and Cupid*, also called *The Rokeby Venus* (Fig. 51), a mythological painting by Velázquez, usually counted among his major works, the face of Venus is only visible in its reflection on the mirror that Cupid holds with both his hands. Thematically the picture has been characterized as the combination of two traditional motifs in sixteenth-century Venetian painting, the toilet of Venus and the reclining Venus. Pictures of female nudes, particularly reclining female figures, were very popular also, and well known by Velázquez.[45] However, what a reader of Quevedo finds interesting in this picture, is the fact that Venus's face *can only be seen* in the mirror. Although Velázquez's motivation may have been different, Quevedo

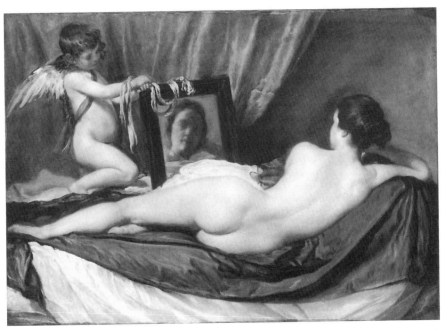

51. Diego Velázquez, *Venus and Cupid* (*"The Rokeby Venus"*), ca. 1649–51 (London, National Gallery).

thematizes a similar conceit in one of his love poems, written earlier than *Venus and Cupid* yet still functioning in parallel contexts. In sonnet 307, a lover who wants to draw/write a portrait of the beloved says that he can only offer her reflection in a mirror. The irradiating light of her face, claims the lover, blinds the poet-painter; admitting that his task is impossible, that he cannot depict her, he defers to his lady and her mirror, where she can be, at the same time, "model, painter, brush and copy" of herself.

> Conocí el imposible en el bosquejo;
> mas vuestro espejo a vuestra lumbre propia
> aseguró el acierto en su reflejo.[46]

The final conceit overturns a most reiterated one. A great work of art is often said to vanquish Nature, but in Quevedo's poem, feminine beauty has defeated art.

The Painter as Reader

It has been said that Velázquez's background as a student of Pacheco manifests itself in many aspects of his compositions. His years in Seville, his acquaintanceship with many an artist who attended his father-in-law's academy, probably fostered an interest in literature, history, and mythographic treatises, as well as in the aesthetic problems of representation and rhetoric, which were central to the thought of seventeenth-century artists. Palomino, for instance, had said that Velázquez applied himself to the study of letters since early on. He also mentions a series of works, treatises of anatomy, perspective, geometry, architecture, and art, that Velázquez studied or consulted to create his pictures. He also claims that he had been a friend of poets and orators and that he elicited from their works, many an 'ornament' for his paintings.[47] Velázquez's knowledge of classical and contemporary written sources, literary and encyclopedic, verbal and emblematic, becomes evident when the nonspecialist observer tries to reconstruct the narrative elements that are encoded in his paintings.[48] In fact, some of his compositions lend themselves to comparison with literary texts by Baroque writers on account of the presence of equivalent aesthetic effects.

Velázquez's representation of grotesque figures, for instance, cannot but be related to seventeenth-century satire in verse and in prose. Quevedo's *Sueños*, or *Visions*, structured according to the model of ancient and Renaissance Menippean satire, offer a catalogue of social and moral types, whose grotesque portraits are meant to draw attention to their flaws and vices. The presence of roguish types in literary satire also indicates

that some of its figures gravitate towards the literary context of Picaresque fiction, a literary genre that was highly successful and productive in seventeenth-century Europe. The relationship cannot be always established at the level of plot, but direct references to Picaresque characters or allusions to traditionalized Picaresque motifs indicate that these intertextual relations should not be overlooked by the contemporary reader.

To the nonspecialist, the figures represented in Velázquez's *bodegones*, or genre paintings, also seem to gravitate towards a common Spanish background of satiric and Picaresque types, placed in the usual interior settings – taverns, humble houses, popular streets, as those depicted in the earliest tavern scenes, *Three Musicians* (Fig. 61) and *Three Men at Table* or *Breakfast*. Usually related to the tradition of satirical paintings or *pitture ridicole*, these images of people eating or drinking could also acquire moral connotations, as the Picaresque stories to which they seem to allude. The old man in *Three Men at Table*, for instance, who is holding a turnip in his hand, has been related to the figure of the blind man in *Lazarillo de Tormes* (1554).[49] The literary allusion seems indisputable to any reader who recalls the famous episode in which Lázaro cheated the blind man by stealing the sausage he wanted to eat and replacing it with a cold turnip.

Intertextual relations with the Picaresque tradition and with satirical texts can be also detected in the painting *The Feast of Bacchus* (Fig. 11). The drunkards' faces and postures embody the effects of intoxication, usually included in moral interpretations of the figure of the god of wine to be found in mythographical treatises.[50] As subjects of grotesque representation, they were also developed in a *romance* by Quevedo entitled *The Drunkards*, without any concession to the ambiguous benefits of wine or to the figure of Bacchus himself, highly celebrated, for instance, in Anacreontic poetry in the late Renaissance.[51]

There is no question that to be familiar with the techniques and contexts of satire a painter like Velázquez did not have to read the work of Góngora, that of Quevedo, or of any other of their contemporaries. However, it is likely that he did so and that the copresence in literature and in art of certain motifs and themes that were in vogue in the seventeenth century reinforced their pertinence. Góngora's poetry, as well as the first poems by Quevedo published in anthologies, were known to Francisco Pacheco's friends in Seville. Quevedo's satires circulated at court in manuscript before they got into print, beginning in 1626, the date of publication of his Picaresque novel, *The Swindler*.[52]

In his *Visions*, five Menippean satires that Quevedo wrote between 1605 and 1621, he presents a satirist who as an authorial figure is invited to descend into hell or is taken by Death to her realm, to see how corrupted men are punished for their vices. One of Quevedo's classical models for building his third and fifth satirical visions, "The Vision of Hell" and "The

Vision of Death", was a satire by Lucian (115–200), a Greek-speaking Roman who authored a remarkable collection of satires, some written as dialogues, on literary and philosophic subjects.[53]

Lucian's *Menippus or the Descent into Hades,* presents Menippus going to the realm of the dead, in order to discover the right way to live. Below, he consults the seer Teiresias, who tells him to disregard philosophers; the ordinary way of living is best. Menippus also discovers that the rich and powerful are faring badly in Hades, thus he becomes convinced that only the man who is satisfied with a simple life can be truly happy.[54] In this satire Lucian imitated the model offered by the real Menippus of Gadara, who lived in the third century B.C., a Cynic philosopher whose works got lost but which survived indirectly through Lucian and Varro's *Saturae Menippeae.* Menippus of Gadara's *Nekya* (the descent into Hades), is a text written as a Cynic sermon to criticize wealth and power, a basic ideological tenet in Renaissance satire as well.

52. Diego Velázquez, *Menippus,* ca. 1636–40 (Madrid, Museo del Prado).

Among the paintings that Velázquez apparently intended for the Torre de la Parada in the decade of the 1630s are the full-length portraits of *Menippus* (Fig. 52) and *Aesop* (Fig. 53).[55] As Jonathan Brown has pointed out, there are no precedents for pairing these two figures. Velázquez may have conceived them as a response to Rubens's pictures of *Heraclitus* and *Democritus,* the crying and the laughing philosophers. The couple had become a *topos* in Renaissance literature, which ciphered two opposing views of life. Since no earlier image of Menippus seems to exist either, the figure of the "beggar-philosopher" can be said to be the product of Velázquez's invention. Aesop and Menippus may have been probably conceived as a couple of ancient philosophers, yet to a Renaissance reader, Aesop was first and

foremost recognized as the inventor of fable, while Menippus the Cynic was identified as the father of Menippean satire, a genre that allowed cultivated writers to expose what they considered the ills of their society, among them, greed and ambition, hypocrisy, lust or drunkenness. Velázquez's Menippus, dressed as a beggar, would symbolize the rejection of wordly values. As such it dialogues intertextually with a satirical romance (745) by Quevedo, in which Alexander the Great offers Diogenes the Cynic to satisfy all his needs and demands, yet Diogenes defends his poverty and freedom. Rejecting his help, he indicts Alexander for being a victim of his ambition and power.[56]

Antonio Palomino's *Museo pictórico y escala óptica* (1715–24) summarized pictorial theory in the Baroque almost a century later, demonstrating, as we said, how poetry and painting were considered sister arts in the time

53. Diego Velázquez, *Aesop,* ca. 1636–40 (Madrid, Museo del Prado).

of Velázquez.[57] If the poet had to learn to paint with words, the painter had to acquire a measure of erudition, in order to become truly *doctus*. Baroque rhetoric thrived upon the art of allusion. Writers wanted to redescribe men and the world by incorporating the discourse of other writers, modern and classical, so as to expand the realm of references that were appropriate for a given genre, for a given text. Moreover, their own discourse had to be built with conceits. The reader needed a high degree of imagination but also had to think logically in order to decode a text. Mythological narratives fulfilled the function of expanding the realm of relations that an author wanted to establish between his own discourse and ancient discourses. The sources he had to consult encompassed translations of Ovid's *Metamorphoses,* or other mythographic manuals that circulatated in his environment. In seventeenth-century Spain, Juan Pérez de Moya's *Filosofía secreta* (1585) became a basic reference work that writers

and artists would consult to recall mythological stories. As well, they turned to encyclopedias, or *polyantheae*, that summed up a wealth of references to historical, literary, and philosophical knowledge. The production of ingenious conceits depended upon erudition, and erudition was defined in seventeenth-century treatises of wit as a repository of transmitted information about exemplary figures and actions.[58]

Velázquez had in his library several translations of Ovid's *Metamorphoses*, in verse and prose, among them the very popular prose version by Jorge de Bustamante that Cervantes had also used, as well as Pérez de Moya's *Philosophia secreta*.[59] These were his sources for the mythological compositions that he created. As far as the allusive techniques that Velázquez develops to combine mythological motifs with the representation of other figures, they are comparable to the rhetorical devices that were used to build conceits in poetical texts.

What matters, however, when examining mythological references in poetry and painting is not only the identification of a narrative and its protagonists but the particular reading thereof that an author freely chooses to perform. There is a direct reference to the mythological story of Arachne in a passage of Góngora's *Solitudes*, for instance, that only stresses Velázquez's particular use of the story in his famous painting *The Fable of Arachne ("Las Hilanderas")*. In Góngora's poem Arachne is quoted as an *exemplum* of immodest arrogance punishable by the gods. With the same mistrust the subjects chosen by Arachne to weave her tapestry are rejected. Neither Jupiter's rape of Europa nor his dissolution into gold to conquer Danäe will be woven by Góngora's characters, for men are to be mistrusted by honest girls.[60]

The central representation of *The Fable of Arachne* by Velázquez (Fig. 54) is also focussed on the story of the mortal weaver who dared to compete with Minerva, as told by Ovid, in *Metamorphoses* VI, 1–145, yet it fulfills a different thematic function.[61] Velázquez has avoided representing the end of the story, that is, Arachne's transformation into a spider as punishment for her *hubris* in contesting with a goddess. But more important, Brown has shown how by choosing a discrete segment of the mythological narrative and by quoting Titian's *Rape of Europa*, which was in fact the subject chosen by the Ovidian Arachne for her own tapestry, Velázquez has pressed the story into service to transmit his "belief in the nobility and transcendental value of the art of painting". At the same time, by quoting a painting by Titian, Velázquez pays homage to an admired predecessor, while his representation of humble weavers who work at the tapestry workshop in the foreground suggests the gap that exists between their craft and authentic art. Originality in seventeenth-century poetry and art depended precisely upon the innovative re-creation of stock images, motifs, or stories, always informed by the artist's *ingenium*. Arachne's story, that in Pérez de Moya's moral interpretation was meant to warn against the vice

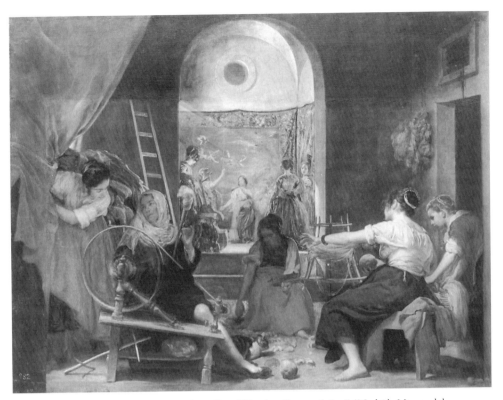

54. Diego Velázquez, *The Fable of Arachne ("Las Hilanderas")*, ca. 1656–58 (Madrid, Museo del Prado).

of pride, provided a prestigious *exemplum* to show the dignity of painting and the power of the *Deus artifex* in Velázquez's picture.

Velázquez's representation of the story of Mars and Venus has been also evaluated in its particular treatment of the narrative that Ovid built in his *Metamorphoses*, IV, 169–89.[62] As an *exemplum* of adultery, the story could be dealt with in an heroic or satiric register. Vulcan, for instance, is frequently mentioned as a sad cuckold in Quevedo's satire, where one finds frequent allusions to the prototypical couple. In a romance written against the power of Cupid, Venus is seen as a prostitute who allows Vulcan to rest while she evaluates Mars's erotic attributes. In another, the poet claims that Venus made him Vulcan, that Mars made him a cuckold.[63] Yet in Quevedo's *Anacreón castellano* Vulcan appears just as the traditional blacksmith, "famoso herrero Vulcano", who makes beautiful golden or silver cups, or the very arrows that Cupid throws at gods and men, which could be construed as an anticipation of Mars's and Venus's story.

For the *Forge of Vulcan* (Fig. 10), Velázquez focused on another section of the narrative, the moment when Apollo descends into Vulcan's forge to announce to him that Venus had cheated on her husband. Thus he mainly depicts Vulcan's pain and the Cyclops's astonishment at hearing the news.

In the *Forge of Vulcan* Ovid's mythological narrative becomes an instrument for examining human reactions, while showing the painter's capacity to express them.

The re-creation of mythological motifs in painting was similar to that at work in literary texts. At times the very thematic focus of a pictorial or poetical composition, it could also become an enlightening source for establishing analogies or for drawing antitheses and semantic oppositions that informed the cherished motif of *coincidentia oppositorum*. Thus Góngora's *Fable of Polyphemus and Galatea* can be seen as an artistic attempt to probe into the nature of *eros* by rewriting a story of gods and cyclops outside and beyond the restrictions imposed by ethical and religious codes in Counter-Reformation Spain. Acis and Galatea's kiss could not have been easily ascribed to a human couple, unless the composition had been set in the genre of satire or other low literary genres.[64] Velázquez's painting of *Venus and Cupid* gave its author the possibility of deploying a female nude, which was probably a not quite acceptable subject for painting in seventeenth-century Spain.[65] More difficult to decode today may be the very Baroque art of allusion to other discourses, mythological, historical, literary, which become then sources of ingenious conceits. The aesthetics of wit was not limited to literature in that century. When seen against the background of what cultivated Spaniards read at the time, Velázquez's paintings seem to cipher the thoughts and beliefs of two generations of poets.

9 Calderón de la Barca

Playwright at Court

Margaret R. Greer

Pedro Calderón de la Barca's career as a dramatist began almost simultaneously with that of Velázquez as court painter. Just months before Velázquez painted his first portrait of Philip IV in 1623, Calderón's play *Amor, honor y poder* (Love, honor, and power) was performed for king and court on 29 June, during the visit of Charles Stuart, Prince of Wales, who was pursuing marriage with the Spanish princess María.[1] The dramatist never had the close relationship to the king that Velázquez enjoyed as painter to the king, but he demonstrated from that early play that he could make his dramatic art speak diplomatically to kings and princes. Calderón's practice of including an explicit or implicit didactic message in his plays afforded a certain protection of them from constant moralist opposition to the theater. But when that message had a clear political relevance, he knew that it was prudent either to sugarcoat the pill by delivering the message through classical gods or great figures of past eras or to blur contemporary identities in such a way that the trajectory of the message from the onstage dramatic world to his privileged palace audience was not overly direct. Instead, he made it visible in a play of mirrors rather like the mirrors Velázquez employed in *Las Meninas* and *Venus and Cupid*. He dramatized the procedure in *Love, Honor, and Power:* when a young nobleman Enrico finds in his garden the king who wants to seduce his sister, he pretends to believe himself kneeling in front of a statue, not the flesh-and-blood king to whom he in fact directs his plea that he control his passions like a true Christian prince. In this case the *onstage* trajectory is too clear; the king slaps the kneeling Enrico and has him imprisoned under a death sentence. Between the stage and the extradramatic palace audience, however, the political significance of the play in the context of matrimonial negotiations between the Princess María and the Prince of Wales was more conveniently veiled, as was the suggestion that Philip IV ought to restrain his own amorous pursuits.[2]

Half a century later, after Velázquez's death and close to his own, Calderón wrote his only extensive aesthetic statement in prose not as a poetics of drama, but in a "Treatise Defending the Nobility of Painting" (1677), a deposition in support of fiscal privileges of the painters' guild of Madrid. In the intervening years, he established himself as the master craftsman of Spanish Golden Age drama in its full range of dramatic genres: (1) three-act *comedias* (dramas, both comic and tragic) for the public theaters; (2) lavish court spectacle plays, operas, and operettas for palace theaters; (3) *autos sacramentales,* one-act allegorical plays performed open-air in the streets of Madrid for the annual Corpus Christi festival; and (4) short burlesque interludes performed with the *autos* or between the acts of *comedias.* Although many of Calderón's plays represented dramatic lessons about the necessity of royal self-restraint of passion before the amorously inclined Philip IV, they did not earn him a royal slap like that delivered to Enrico, much less a death sentence. Rather, Philip IV rewarded his services by making him a Knight of the Military Order of Santiago in 1637, long before he conferred that honor on Velázquez. While we have no direct evidence of personal friendship between the painter and the dramatist, they left abundant evidence of their knowledge and appreciation of each other's art.

Pedro Calderón (1600–81) was born in Madrid to a family of the lower nobility, the third child of Ana María de Henao y Riaño and Diego Calderón de la Barca, who held a relatively lucrative position as Secretary of the Council of Finance.[3] His mother died giving birth to her seventh child when Pedro was ten years old. His father remarried in 1614 but died suddenly the following fall, leaving his five surviving children involved in a lengthy legal dispute with their stepmother over the inheritance. Pedro received an excellent education, beginning with study from 1608 to 1613 in the Jesuit Colegio Imperial, the best school in Madrid. He enrolled in the University of Alcalá in 1614 but left when his apparently despotic father died, stipulating in his will that Pedro should continue his studies toward the priesthood and assume a chaplaincy endowed by his maternal aunt. That will contained other intriguing provisions, including a specification that his eldest son Diego should not marry the person he apparently intended to wed, nor any of his cousins, on pain of disinheritance. It also carried a codicil recognizing as his illegitimate son one Francisco Calderón, heretofore known as Francisco González, whom he had had to abandon for his bad conduct and who was "wandering lost through the world." A. A. Parker suggests on the basis of this will that the recurrent theme of abuse of paternal control in Calderón's dramas might have stemmed from familial experience.[4] Pedro did study canon law at the University of Salamanca between 1615 and 1619[5] but then turned toward a literary career rather than the priesthood. Returning to Madrid, he entered the service of Don Bernardino Fernández de Velasco, Constable of Castile

and Duke of Frías, as his *escudero* (squire). Calderón would have served primarily as a companion to the young Condestable, then only twelve years old (Cotarelo, 1924, 101, Cruickshank 3).

His obligations, like others in similar positions, would have been limited to accompanying the Duke when he appeared in public with an ostentatious display of grandeur, carrying out commissions compatible with his dignity as a gentleman, involving nothing servile or domestic, fencing and riding horseback with his lord whenever he ordered, and certainly, entertaining his lord at table or in his study with verse and narratives. In exchange for those services he would have enjoyed good bed and board, elegant suits of barely used clothing, and a handsome horse to ride, but wages that were low and usually in arrears. (Cotarelo, 1924, 130)

Calderón evidently did not dedicate his energies only to fencing *practice*, however, because in the summer of 1621 one Nicolás de Velaso, son of a servant in house of the Condestable, was killed by the three brothers Diego, Pedro, and José Calderón. Having taken refuge in the German Embassy, they avoided going to prison but were brought to trial and charged with the crime in February 1622. They settled out of court with the victim's father for a payment of 600 ducats plus legal costs (Cotarelo, 1924, 100), and Calderón continued in the Condestable's service.[6] He was thus comfortably installed in Madrid with plenty of leisure time to read and write and the opportunity to continue his education thanks to the excellent library collected by his patron's father, a bibliophile as well as literary patron.

Envisioning a young Calderón given not only to letters but to the sometimes swashbuckling use of arms is a stretch for readers accustomed to the standard (and outdated and partial) image of an ever grave, cerebral, conservative, and supremely Catholic playwright.[7] That is the vision of him transmitted by much twentieth-century commentary on his work and reinforced by the extant portraits or engravings of him, all made late in life when he had indeed become a priest, or after his death. The only likeness of Calderón published during his lifetime (Fig. 55) appeared in the volume of his *Autos sacramentales* published in 1677.[8] An image of such a young Calderón can take on life, however, if we consider the possibility that he might have been the sitter for Velázquez's *Portrait of a Man* (Fig. 56).[9] Given their parallel careers as court artists, Velázquez must certainly have known Calderón better than two other writers, Góngora and Quevedo, whose portraits he did paint. The *Portrait of a Man* and the Quevedo portrait are similarly posed, both wear the white *golilla* collar, and both were taken from the Spanish royal collections by Joseph Bonaparte and found in his coach when the Duke of Wellington defeated the French troops at Victoria in 1813 (Kauffmann 5). The portrait in the Wellington Museum has been variously identified, including suggestions that it represents the Seville artist Alonso Cano, Velázquez himself, Calderón, and José de Nieto, the palace servant shown on the background staircase in *Las Meninas*.[10] Comparing

the engraving of Calderón with the portrait, allowing for decades of difference in age, I see significant similarities in features in the very high forehead, rather small, deep-set eyes, a tendency to hollows under the eyes and pronounced cheekbones, naturally exaggerated by age in the engraving, the aquiline nose, and thin, straight lips. The mustache is very different, but a purportedly autobiographical ballad of Calderón explains it and adds another key detail. The title of the poem attributes it to Calderón in two manuscripts and in another to Carlos de Cepeda, a writer born in Seville in 1640. Cotarelo accepted the poem's attribution to Calderón and used it to flesh out his biography, but Edward M. Wilson demonstrated some years ago that the original was almost certainly written by Cepeda. Wilson (106) also suggests, however, that someone (not Calderón) modified certain biographical or personal traits in the poem to make them fit Calderón. We can presume that he left other traits because they did in fact apply to the

55. Anonymous, *Portrait of Pedro Calderón de la Barca*, 1676 engraving published in the 1677 edition of his *Autos Sacramentales* (Madrid, Biblioteca Nacional).

56. Diego Velázquez, *Portrait of a Man,* 1640s (London, Wellington Museum, courtesy Victoria & Albert Museum Picture Library).

Madrid dramatist as well. The relevant details refer to a high forehead, deep-set eyes, a scar on the left temple and an exaggeratedly curved handle-bar mustache: "I have a "pregnant" (i.e., very high) forehead, but birth (the parting) never arrives; On my left temple I have a certain head split (i.e., scar) that the handiwork of jealousy struck on this point; No one can find my eyes if they don't look carefully for them in their two basins . . .; my mustache, curved as I have trained it, climbs high up from its trunk toward my eyes, and tries to put them out."[11] Aside from the curved mustache, the detail of the scar on the left temple is most significant, because the modifier of Cepeda's poem changed it from a scar on the head caused by a falling brick to a scar on the left temple inflicted by the work of jealousy. Velázquez's portrait shows a light area on the man's left temple that does indeed look like a scar, made by paint thickly applied as with a palette knife. While we are not likely to be able to establish this identification definitively, I find in the portrait the combination of intensity and control that characterizes Calderón's drama, and it can at least help us imagine the young man behind the sword and pen.

The year 1621, when Calderón entered the service of the Condestable in Madrid, was the same year the theater-loving Philip IV ascended the throne. The public theaters (*corrales*) were by this time thriving enterprises, and the plays performed in them were *the* popular genre of the day, equivalent in importance to cinema in the 1930s and 1940s and to television and film today. Secular theater was reborn during the reign of Ferdinand and Isabella, with brief plays crafted by Juan del Encina, performed in the palace of the Duke of Alba. It developed sporadically over the course of the sixteenth century until Lope de Vega Carpio gave it its definitive shape and immense popular appeal in the last two decades of the century and the first quarter of the seventeenth.[12]

The *comedia* as Lope shaped it is a three-act play, mixing comic and tragic elements, noble and plebian characters, and playing them off against each other rather as Velázquez does in the planes of such paintings as *The Fable of Arachne* (Fig. 54) and *Christ in the House of Mary and Martha* (Fig. 19). The plays were performed by professional troupes that included women as well as men, in contrast to the English practice of using boys to play female parts.[13] They are polymetric, with the varieties of verse employed serving the same atmospheric and character-establishing function for the poetically attuned ears of its Spanish audience that background music plays in cinema. Lope, who said that he put the works of classical preceptors under lock and key when writing his *comedias* and tailored them to the tastes of his paying customers, freely violated the unities of time and space in action-packed plots. In such plots, character is defined in movement and in interaction with other members of the dramatic world more than in lengthy monologues of psychological introspection. The charge is often made that *comedia* characters tend to be flat types rather than rounded figures of psychological depth, but this perception reflects a lack of understanding of the difference in theatrical conventions between the *comedia* and classic English or French theater or slice-of-life realism.[14] As the title of Calderón's *Love, Honor, and Power* reflects, the question of upholding a socially defined honor code often provides the dramatic axis of tension. Lope recommended such "honor cases" because he said they were most moving for his public; the extent to which it reflects the reality of social life in early modern Spain and the reasons for its social and theatrical role continue to provide topics for debate.[15]

Lope was a phenomenally prolific writer, said to have written 1,400 plays in his lifetime, which is surely an exaggeration. Yet more than 400 *comedias* that are probably his survive, and dates on the surviving authorial manuscripts indicate he could write a play act in a day. Calderón wrote at a less furious clip but still produced some 120 *comedias* and 80 *autos sacramentales*. This rate of production was a response to voracious public demand for new *comedias* in the *corrales*, where the average run for a play was about four or five days and theater company owners bought and care-

fully guarded new play manuscripts that could pack the house. As a consequence, like the "movies," many works were formula-composed potboilers, but a considerable percentage of artistic jewels emerged nonetheless.

The commanding prestige of Shakespeare in Elizabethan theater was shared three ways in Spain between Lope (1562–1635), Tirso de Molina (1579–1648), and Calderón (1600–81). Tirso was a priest in the Mercedarian order who spent two years as a missionary in Santo Domingo and was the leading figure in a second generation of playwrights. He is best known as the creator of the undying stage figure Don Juan, transported from folklore to the stage in *El burlador de Sevilla*. The vitality of the Don Juan figure, continually reborn from the fires of hell, is the best answer to the charge that the *comedia* is populated by flat types.

The public theaters where the works of Lope, Tirso, Calderón and fellow playwrights were performed displayed surprising parallels to those in England, despite their independent development.[16] With the growth of professional theater companies (starting with traveling Italian troupes), the first permanent public playhouses were opened almost simultaneously in London, Madrid, and other Spanish cities in the decades of the 1570s and 1580s. The standard arrangement was that of an open-air theater with a patio where male spectators stood for the basic entrance price, while those willing and able to pay more for seats occupied hierarchically arranged benches and boxes around the sides, facing the stage, and even on the sides of the stage itself. One important difference in the *corrales* was a *cazuela* (stew pot) for women, with a separate entrance to protect them from harassment on entering and exiting and an *apretador* (squeezer) to pack them in. The theaters also contained a section set apart for the clergy, who were regular spectators at the comedia, despite repeated bans on their attendance. As McKendrick (193) puts it, "The audience represented a good cross section of urban society – nobles, prelates and the wealthy in the boxes, traders, shopkeepers and artisans on the benches and raked seating, manual workers, soldiers, servants, young bucks and those who lived by their wits in the *patio*." The public theaters attracted a similarly broad spectrum of the London population, whereas in Paris, audiences were composed primarily of the aristocracy and bourgeoisie.[17] Patterns of social conduct aside, economic considerations are sufficient to explain the difference, for to stand in the patio about 1600 would have cost laborers about one-fifth of their daily wage in Madrid, or one-twelfth in London, whereas the fifteen-*sous* entrance to the *parterre* in mid-century Paris cost one-half to three-quarters of a worker's daily income.[18]

Court theater developed more slowly than public theater in Spain, primarily because Charles I and Philip II were not interested in theater. Royal patronage of the theater began under Philip III and quickly intensified when Philip IV came to power. He had shown a predilection for the theater even as a child, taking delight in participating in amateur perfor-

mances for the royal family with other young nobles in the palace. His taste for theater fit well with the plans of his *privado* (favorite or prime minister), the Count-Duke of Olivares, to employ theatrical spectacle to enhance the power of the king's image for domestic and foreign consumption. Court spectacle drama had spread from the courts of northern Italy across Europe from the late fifteenth century on, encouraged by humanists' interests in reviving ancient Greek drama and by the rise of absolute monarchs eager to employ spectacle to enhance their prestige and power. Such spectacles combined a poetic text usually based on classical mythology with music, dance, illusionist stage scenery, and elaborate theatrical machinery. The proportions varied according to national and royal preferences, but in other countries the poetic text was generally minimal, and final control over the spectacle rested in the hands of a stage architect such as Iñigo Jones in England. Olivares, fully aware of the image-making power of the court spectacle, had an Italian stage architect, Cosimo Lotti, brought from Italy in 1626. But Calderón insisted from the outset that dramatic coherence should take priority over spectacle. When Cosimo Lotti drew up a long list of the devices to be used in Calderón's first spectacle play, *El mayor encanto, amor* (Love, the Greatest Enchantment), Calderón rejected it, saying: "Although it is most cleverly designed, its scheme is not performable, because it pays more heed to the ingenuity of the machinery than to the pleasure of the performance."[19] He did in fact use a substantial number of Lotti's devices and even added one or two of his own design, well integrated to enhance, not compete with, the dramatic text. Calderón made a dramatized poetics of the court spectacle part of the dramatic prologue to another court spectacle, *The Fortunes of Andromeda and Perseus*. In front of the elaborate stage curtain, three nymphs fly in on blue and silver clouds, bearing the symbols of painting (in the illusionist perspective scenery), music, and poetry. Each explains what her art contributes to the spectacle, and the three clouds then join and fly upward, raising the curtain as they ascend. Just as painting, music, and poetry together constitute the fiesta, so poetry, stage machinery, and music raise the curtain that it may begin.

Calderón ranks as the consummate dramatist of the European court spectacle play not only for his effective synthesis of all its elements but also because he crafted his works polysemically so that the court spectacle play, while effectively transmitting the requisite message of Habsburg glory and power, also included a tactful criticism of specific royal policies.[20] The dramatic proclamation of royal power was contained in the framework of the court fiesta, beginning with an elaborately ceremonial entry of the royal family, which focused the eyes of the assembled public on them. The display of their power was also inherent in the arrangement of the theater, in which the stage constituted one pole of the spectacle, and the royal family, seated on an elevated and well-illuminated platform,

57. Audience arrangement in the Salón Dorado of the Alcázar (courtesy John Varey).

the other pole, so that spectators could always have present both visual poles of the event (Fig. 57). The royal position occupied the ideal point for viewing the perspective scenery, and other spectators were placed in hierarchical order, with the most distinguished closest to the king. What they saw, then, was not simply the play onstage, but the more complex spectacle of watching the king see the drama.[21] The opening *loas* continued the exaltation of the king by linking him with the gods of classical mythology and other icons of royal power. But the central dramatic text then inverted the relation and constructed a story around the very human failings of those gods, failings that also characterized the royal spectators of the event.

Part of the reason why Calderón could maintain a critical position not possible for poets of court spectacles elsewhere in absolutist Europe lies in the strong support he provided for the monarchy in a very different kind of theatrical spectacle, the annual Corpus Christi *autos sacramentales*, performed in the streets of Madrid for all to see. He called these dramas "sermons in verse" and marshaled all the elements of dramatic performance – painted scenery, stage machinery, costume, music, and dance – to help communicate the lessons in Catholic doctrine he crafted in often exquisite dramatic poetry. While England and France in the sixteenth century banned all religious drama, including the English Corpus Christi cycles, that feast came to be celebrated with great popular enthusiasm in Spain, almost as a national rather than a universal observance, as Bruce

Wardropper observes.[22] By the time of Calderón, the performance of the *autos* had come to be the high point of the celebration. The *autos* were performed from mobile carts first for the royal family and palace officials in the Plaza of the Alcázar Palace, then for the various royal councils, for the municipal officials, and for the general populace at various points in the city over the space of several days. For Catholic states, the Corpus Christi celebration offered a symbolic system of particular richness for constituting a sense of community, because its theme was that of society seen as one body. Memorializing Christ's sacrifice and belief in his miraculous presence in the bread and wine at the same time proffered to the individual the means of salvation and, to the community, a powerful metaphor of social coherence centered in his body. In his *autos,* or their prologues, Calderón repeatedly evoked the image of the Spanish monarchy and its crowned city (Madrid) as a unique organism whose diverse members are integrated in their dedication to the Catholic faith. Calderón's command over the form was such that from 1648 to his death in 1681, he was the sole dramatist commissioned to write the two new *autos* for the year. The *auto The New Palace of the Retiro* and the court play *Love, the Greatest Enchantment* were performed just a year apart, in 1634 and 1635, respectively, and both focused on the new Buen Retiro palace, but their explicit and implicit texts regarding the palace, Philip IV, and Olivares were very different. Their comparison demonstrates that the unqualified glorification of the monarch that characterized other European court spectacles is in Calderón restricted to the *auto sacramental*. In the *auto,* performed before a diverse mass audience in the streets of Madrid, Calderón transformed the king into a God on earth in his capacity as defender of the Catholic faith, dramatizing the divine mandate of Philip IV and sanctifying the hierarchical sociopolitical structure that he headed. In his court spectacle, therefore, Calderón could tactfully insert a critical text directed to the king as political leader in which he treats the monarch as a human being subject to very human weaknesses; in *Love, the Greatest Enchantment*, he uses the story of Ulysses and Circe to criticize Olivares's power over Philip IV, showing Ulysses "in retreat *(retiro)*" neglecting his duty and enthralled by the sensual pleasures provided by Circe.[23]

Calderón did not always handle the political demands on a court dramatist so deftly, however. A case in point is *The Siege of Breda*, the play that would inspire Velázquez's *Surrender of Breda* (Fig. 58), both devised to celebrate the surrender of Justin of Nassau, governor of the Dutch stronghold city, to Ambrogio Spinola, the Genoese commander of the Spanish army of Flanders, after a yearlong siege on 5 June 1625. As Gridley McKim-Smith and Marcia Welles point out, this victory of Spanish imperial forces over the Protestant rebels of the United Provinces, "quickly moved from event to myth" as a triumph of universal Catholicism, and the news was rapidly transmitted and repeatedly depicted in art and

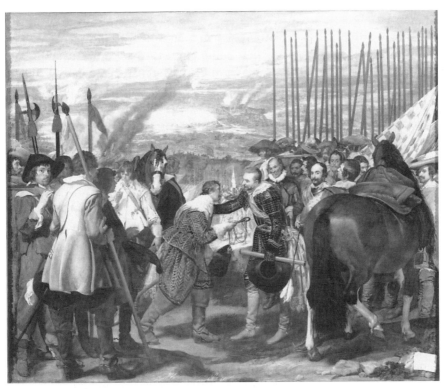

58. Diego Velázquez, *Surrender of Breda,* 1635 (Madrid, Museo del Prado).

letters.[24] Jonathan Brown and J. H. Elliott recount the historical circumstances and the powerful message of clemency and magnanimity in victory transmitted by Velázquez's painting for the Hall of Realms of the Buen Retiro palace.[25] As they and other critics have noted, the key element in that scene – Justin's handing of the keys of the city to Spinola and his gracious reception of them – was a product of Calderón's dramatic imagination rather than historical fact, however truly it rendered the spirit of the occasion. In *The Siege,* Justin brings the keys of power to Spinola, telling him he does so not from fear, for he would prefer the pain of death, but because "fortune . . . turns the proudest and best monarchies to dust." Spinola accepts them, replying, "Justin, I receive them and recognize your valor, for the valor of the defeated lends fame to the victor. And I take this possession in the name of Philip IV, may he long reign, more victorious than ever, and ever blessed."

Aside from providing inspiration for Velázquez, however, Calderón's *Breda* is not likely to draw favor with today's readers. It is more tableau than coherent drama, permeated with ideologically charged declarations of Catholic and Spanish imperial values and glorification of Philip IV. Opening the play for a public-theater audience accustomed to works presented on a nearly bare stage, in which word-pictures create the scene,

"Today. . . . here. . . . here," Calderón paints a series of vignettes of the campaign: troop reviews of the participating allied armies, presented in synecdoche in the person of their commanders; topographic descriptions of Breda's strategic position and formidable defenses, strategic deliberations, glimpses of the human suffering within the besieged city, negotiations for its surrender and the departure of the defeated. The horror of war is neutralized, as Calderón adds an inconclusive romantic motif of a beautiful young Dutch war-widow, Flora, her young son and elderly father, saved by individual magnanimity of the Spanish leaders. From the city walls, Flora describes the troops as fields of colorful flowers or wheat moving rhythmically in the breeze. Part of the purpose of the play, as of the generous terms granted the defeated city, was that of replacing the memory of the cruel treatment of the Dutch by Spanish forces under the Duke of Alba's "Council of Blood" in the 1560s and 1570s with an image of valor and ordered obedience by Spanish troops, and of kind magnanimity toward the enemy by Spanish leaders. Scholars debate whether the play was a command performance in the palace or a public theater presentation and whether it was performed in 1625, shortly after the news reached Madrid, or in 1628–29, when Spinola visited Madrid.[26] While they may not settle the debate, two more scenes in the play point toward a later date. First, in one scene of the play, Spinola, reading and writing under fire, lists other campaigns in Milan, Naples, and Brazil, and declares that it is only just that all the vassals of a king defending the faith and the empire on so many fronts should contribute their financial support. This has the sound of a political advertisement in support of Olivares's planned Union of Arms, by which not just Castile but all the kingdoms of Spain would contribute to the cause of defense. The plan was unveiled in November 1625 and decreed by the king in 1626. Second, Calderón has Spinola explain the fortifications and siege of Breda to a visiting prince of Poland, thus using him as he often does a Jew in his *autos,* as the outsider to whom the glories of Spanish institutions and policies must be explained. This device fits better with the later date, when Olivares was cultivating Polish support for a Spanish Baltic squadron as well as containment of the Protestant Swedes.[27] For one play to satisfy so many political designs was clearly a stretch, and it is no surprise that Calderón excuses the dubious results by having Spinola conclude the play, saying for the author: "And thus concludes *The Siege,* in which he who has written under obligation to so many decrees, cannot show himself any better" (106).

Calderón more generally assigned the concluding plea for audience benevolence to a *gracioso,* a cowardly, flesh-centered commoner who is a foil to the gallant hero and a standard feature of all dramas, comic or tragic, *corral* plays or palace spectacles, and even figures in some *autos.* Through the voices of *graciosos,* Calderón mocked social artifice and played metatheatrically with the conventions and clichés of his own dra-

matic art, including those of the court play and *auto sacramental*. Part of the humor derived from topical allusion to figures and situations well known to his audience but often lost on modern readers.[28]

Velázquez's art can help us recover visual referents for some of the allusions in Calderón's delightful comedy of intrigue, *Casa con dos puertas mala es de guardar* (A house with two doors is difficult to guard), written for performance in 1629 during the customary spring sojourn of the royal family to their estate in Aranjuez, where they were entertained with plays, boating parties, and hunting. The play is an "artful" work in several senses; in self-conscious celebration of literary artifice; in word-paintings of the beauties of the gardens of Aranjuez, floral and feminine; and in its flattering incorporation of the royal couple as both center and frame of the play. The love intrigue revolves around that royal presence, since a young nobleman, Lisardo, has come to Aranjuez, now "the sacred sphere of the fourth Philip . . . the light of the fourth planet."[29] The particular warmth he seeks from that royal sun is a military cross like those that would decorate the chests of Calderón and Velázquez.[30] His friend Don Félix invites him to stay in his house nearby in Ocaña rather than staying in an inn, the "uncomfortable lodging that squires and petitioners suffer in these woods" (vv. 583–86), lines sure to draw a rueful smile from an audience of court followers so housed. Félix has an unmarried sister, Marcela, whom he tries to sequester while Lisardo resides there, but his spirited sister, hiding her identity behind a veil, slips out daily with her maid Silvia to flirt with Lisardo. As is the *comedia* convention, much of the metatheatrical play is generated by the *gracioso*.[31] Given the shaping importance of the royal household, it seems less than a coincidence that the comic figure in this play is named Calabazas, a name Calderón never gave another *gracioso*.[32] We first see him bantering with Silvia, suggesting that the reason she and her mistress wear veils is because "You must both have horribly ugly faces," to which the maid rejoins, "Not as ugly as yours, my fine friend" (5). If the *gracioso*'s name is intended to allude to the jester Velázquez painted, the *comedia* character has more in common with the sprightly figure holding a miniature portrait and a pinwheel questionably attributed to Velázquez (Fig. 59) than with his haunting later portrait (Fig. 60). José López-Rey argues that the earlier image is indeed by Velázquez, suggesting a date of 1628–29. Calabazas is listed as a palace jester from 1630 to his death in 1639, but López-Rey suggests that he might have performed occasionally as palace jester before those dates, and Calderón's adoption of the name in *A House with Two Doors* offers circumstantial support for that conclusion.[33] Calderón pens two wonderfully comic passages for his Calabazas. The first would have been a sure crowd pleaser for a clothes-conscious court, and for servants who customarily received part of their scant wages in the form of hand-me-down clothing. Lisardo promises Calabazas a cape he recently had made, whereupon Calabazas kisses his hand in

59. Diego Velázquez (?), *Calabazas*, ca. 1626–32 (Cleveland Museum of Art, Bequest of Leonard C. Hanna, Jr., 65.15).

gratitude for giving him something already made and improvises a delight-ful dialogue in which he is both a greedy tailor and his abused customer, made to buy too much material, to pose like a clown with his feet together and his arms extended, and to wait too long for a misshapen garment (37–39). *Graciosos* in the *comedia* are traditionally confidants for their masters, but by the last act, Calabazas appears with a bill for back wages to present Lisardo and notice that he plans to seek another master, because, he says:

It isn't right that a master of mine should be so secretive, as if to imply that I can-not keep his secrets. You walk about all on your own; you come and go all on your own, and always without me. It seems, sire, we are as far apart as love and money. Take just one example. If some veiled lady comes to see you, it's "Clear out!" If you're going to visit her, it's "Wait for me; it won't do for you to accompany me."

This can't go on. What grief for the mother who bore me! What use am I to you now? That's why I want to find without delay a more humane master; because, as far as I'm concerned, not [even a Lutheran] could be worse than you. Even a pedantic would-be wit, who's really a nit-wit, couldn't be worse; nor a man with a sound wit and an unsound fortune; nor a busybody with no wit at all, nor a poet who writes plays – even ones presenting masters and men alike as pumpkin-pates; nor a painted fop who talks all la-di-da; nor even the sort – and that's the worst of all – who does his wooing in the palace.[34] (52)

Calderón also incorporates in the third act of *A House with Two Doors* two long ekphrastic passages that woo with flattery the play's royal spectators. One is a description of a boating party by Queen Isabella of Bourbon and her ladies as flowers that rival the floral beauties of the estate. The sun or rose that reigns supreme among them is the queen, of whom Laura says, "may she live infinite ages so that flowers of France may give fruit in Castile" – a reference to the pregnancy of the queen, who would give birth to the prince Baltasar Carlos in November of 1629. The other is Félix's lengthy and elaborate description of a courtly hunting expedition he wit-

60. Diego Velázquez, *Calabazas*, ca. 1639 (Madrid, Museo del Prado).

nesses (vv. 2186–2305). Calderón describes in precious detail all the sights and sounds of the hunt – the king's arrival in a fast coach, the horse he mounts, "a mountainous steed / with eyes of fire, who snorts in eagerness / a cataract of foam," the hooded white gerfalcon that the king's chief hunter places on the king's "invincible hand," the high-soaring flight of the heron, the king's release of the falcon that brings the prey to earth, and the king's horse galloping to retrieve the falcons with a speed rivaling that of the birds themselves.[35] Calderón's description of Philip IV's horse puts in imaginary movement the multiple equestrian portraits Velázquez painted of the king, princes, and Olivares.

Although this word-canvas of Philip at the hunt is the most elaborate in Calderón's dramatic corpus, hunting scenes abound in his plays, particularly those written for palace performance. A hunting scene instantly sets an aristocratic atmosphere, because hunting was the preserve of kings and aristocrats and courtly hunting ceremony underlined the hunter's relative position within the social hierarchy. Philip carries the hawk and lets it fly because that privilege was reserved for the most exalted hunter in the party. Hunting, Velázquez's *La Tela Real* (Fig. 36) and Calderón's play show us, was hardly the lonely confrontation of man and nature that modern hunters praise. When Louis XIV went hunting at Versailles, he was followed by a cortege of chariots, courtiers and musicians, as he supposedly killed more than ten thousand deer in his hunting career.[36] Philip IV was similarly devoted to the hunt, as evidenced by Velázquez's portraits of the king, Prince Baltasar Carlos and the Cardinal-Infante Fernando as hunters.[37] But hunting images served many purposes as well as giving pleasure to the royal huntsman. Calling it an image of war, Calderón's characters praise it as the ideal diversion for kings and noblemen, an exercise that trained them to fulfill their traditional military function. It also served to generate a rich complex of related themes. One of them is the erotic hunt, the hunter's pursuit not only of a boar or heron but also of a feminine object of desire, an elusive prey or one forbidden him by social law. *Love, Honor, and Power* opens with Enrico's caution to his sister not to leave the castle that day, because the king is out hunting there and seeing her beauty may put his pleasure before her honor. In the artful world of *A House with Two Doors*, however, Calderón turns the hunting scene in the opposite direction. Here, the depiction of the king as ideal, invincible hunter, and the queen as a lovely and fertile flower sets the royal couple as a matrimonial model that frames and contains the disorderly conduct of the lesser lovers.[38]

Calderón would make a very different use of the hunting metaphor in a 1642 *auto sacramental*. When a series of rebellions shook Spain in the disastrous year 1640, Calderón was one of a limited number of members of the military orders who answered the call to form a cavalry division from Madrid. He served in the campaign in Cataluña until his release for ill

health in late 1642. Toward the end of October of 1641, he was sent back
from Tarragona to Madrid by the commanding general to give Philip IV an
account of the poor condition of the troops. Calderón stayed in court sev-
eral months and wrote at least one *comedia* and an *auto, The Divine
Hunter,* in which The "Greatest Monarch" (God) sends his son in human
flesh to lead the battle against the demonic beast who has sown civil war
through the realm. Employing a sociopolitically astute metaphor of Christ
as divine hunter, garbed as Velázquez painted his human monarch,
Calderón entered his dramatic argument for Philip IV to take personal
command of the forces in Catalonia, over the resistance of Olivares and
others who preferred to have the king remain in court. Answering Human-
ity's prayers for divine assistance, Christ requests permission to descend to
earth dressed in rough garb "because just the sight of the Prince going out
to observe will end the war." Ending the war proved not so simple, how-
ever. Calderón lost one brother in it, and the war and royal mourning
closed the public theaters from 1644 to 1649. In that dark period, he chose
to become a priest, was ordained in 1651, and took up the endowed family
chaplaincy. He left off writing plays directly for the public theaters but
continued to write the *autos* and plays for palace performances, which
might be opened to a paying audience or transferred in simplified produc-
tions to the *corrales.*

<p align="center">✳ ✳ ✳</p>

From Calderón's first plays to his last, painting and sculpture play a vital
role, marking and mediating human passions and manifesting the kinship
between human artistry and divine creative power. At an instrumental
level, in *The Phantom Lady, Life is a Dream,* and *No hay cosa como callar*
(Keeping silent is best), miniatures such as that held by Calabazas (Fig.
59) evidence a man's attachment to the woman they represent, to the dis-
may of another woman in his life.[39] *Keeping Silent* is a particularly hair-
raising instance, a suspenseful work in which Leonor, a beautiful young
woman, described as "Nature's perfect portrait," having taken refuge from
a fire in an elderly stranger's house, is raped by a man she cannot see in
the dark of night. Her attacker is literally and figuratively a Don Juan who
delights in seducing and then abandoning women but who is also a valiant
soldier, on his way to the front against France. While trying to defend her-
self, she tears from his neck the sash with a conch shell worn by members
of the Order of Santiago. In daylight, she sees that the shell contains a
portrait of another woman, a free-living Marcela said to be unworthy of
portraiture. Covering her dishonor with discreet silence, she uses her inge-
nuity and that portrait to help identify her attacker. The play is at best a
dark comedy, ending not in death or disgrace but a convenient, if loveless,
marriage. That a woman's ingenuity facilitates that outcome is character-

istic of the structure of Spanish Golden Age comedy. When the noble hero finds himself paralyzed between conflicting demands – obligations to God and king, loyalty to king and friend, love of family and a forbidden woman – the happy resolution is regularly provided either by women or by servants, whose marginal position in the power structures allows them – in comedy – a freedom of judgment or action that established ideologies foreclose for the noble male.

At a deeper level, Calderón uses portraiture to dramatize the power and the problems of comprehending and representing the human subject, in paint as in dramatic poetry.[40] The wonderful play *Darlo todo y no dar nada* (Giving Everything and Nothing at All), performed at court in 1651 and 1653, turns the story of the relationship between Alexander the Great, his painter Apelles, and Campaspe into a philosophical examination of power and its limits, of relationships between the sexes, of free will and love, and of the possession, self-possession, and objectification of women.[41] In a contest that recalls the 1627 competiton in which Velázquez won the position of usher of Philip's chamber, three painters compete to paint Alexander, a challenging assignment, since the conqueror has a bad eye.[42] Apelles wins by painting him in profile, neither flattering him by removing his defect, nor offending him by presenting it too openly, but reminding him of his imperfection without the dishonor of its public display. Alexander declares Apelles henceforth his official portraitist, to show the world with "this political example . . . that one must find the way to speak to a King with such care that his voice does not grate nor his silence flatter." That declaration encapsulates Calderón's approach to the obligation of a court playwright, to make drama instructive as well as pleasurable, reminding the king always that the first victory a leader must make is over his own passions. The passion Alexander must conquer is his love for Campaspe, whom his painter also loves. In Calderón's play she is a strong but innocent woman brought up as a shepherdess and huntress in the wilds. Alexander brings her back to court and commissions Apelles to paint her, and the painter, seeking to reproduce her perfect beauty, is driven mad by the conflict between love for her and loyalty to Alexander. Campaspe, who has never seen a portrait, is astounded and dismayed on seeing her image, stammering in ontological doubt: "Am I that one, or am I, I? My tongue stutters clumsily, perhaps because my soul, between the two, trembles doubtingly over where it resides or which it animates, . . . You have this ability? You can give a body a second being? Then, how, how, if you wield such a divine art, do you use it so basely as to create for another owner a copy of the one you say you love?" The "beggar-philosopher" Diogenes humbles Alexander by pointing out that despite his power, he cannot create even a simple flower and persuades him to yield Campaspe to Apelles. But Calderón's Campaspe will not be an object of interchange that solidifies the relationship between two men. When Alexander would give her to

Apelles without her consent, she responds with an eloquent defense of woman's free will, "if he gave you a portrait, you return to him nothing more than a statue, because he who embraces a woman against her will . . . gives everything and gives nothing."

Equally powerful is Calderón's *El pintor de su deshonra* (The Painter of His Own Dishonor), in which the tragic hero is a painter. Don Juan Roca, a studious nobleman and painter by avocation, marries late in life a young beauty, Serafina, who consents to the match only because she believes that her first love, don Alvaro, has drowned. Roca tries to paint her but despairs at his inability to reproduce her unblemished perfection:

> The object of this art . . .
> . . . is to seize
> Those subtlest symmetries, that
> measure, correspondence and
> proportion of features that
> are subtlest in the loveliest; and though
> it has been half the study of my life
> to recognize and represent true beauty,
> I had not dreamt of such perfection
> as yours; nor can I, when before my eyes,
> glass the clear image in my trembling soul;
> and therefore if that face of yours exceed
> imagination, and imagination
> (as it must do) the pencil; then my picture
> can be but the poor shadow of a shade.
> Besides . . .
> 'tis said that fire and light, and air and snow,
> cannot be painted; how much less a face
> where they are so distinct, yet so compounded
> as needs must drive the artist to despair.[43]

His despair turns to jealous fury when don Alvaro reappears and kidnaps Serafina. Don Juan, humbly dressed and working as a painter, goes in search of her. Thus disguised and working for a prince who has also fallen in love with Serafina at first sight, he describes his just-completed painting of Hercules and Deianira. At its center, he paints with such skill Hercules' ferocity as his beautiful Deianira is carried off by the Centaur Nessus "that no one seeing him can then refrain / from saying, 'This man is overcome by jealousy'" (Paterson 173). And in the shadowy distance, painted small according to perspective, he has painted Hercules aflame upon his funeral pyre, illustrating the motto, "So Jealousy in its own flames expires" (Fitzgerald 66). The Prince admires the wit of that composition in two planes, a technique Velázquez put to inspired use in *Landscape with St. Anthony Abbot and St. Paul the Hermit* (Brown, 1986, 96).[44] This three-level art within art makes an ironic commentary on Roca's

indiscriminate revenge, for Hercules, in contrast to Roca, only killed the Centaur, not his innocently abducted wife.[45] The prince chances to find Serafina and takes Don Juan to paint the unidentified beauty in secret. Don Juan shoots both Alvaro and Serafina, leaving a portrait in blood of the beauty he could not paint and whose innocence he will never know. As in two other Calderón tragedies that end in wife murder, there is no moment of anagnorisis for the tragic hero. Culpability for the disaster is diffused across a complex web of characters, all of whom act according to the dictates of the socially imposed honor code. It is left to the audience to recognize the location of the fatal flaw that led to tragedy as they are called upon to second Roca's curse of the "first legislator" who made the "law" of honor that calls for the sacrifice of what one most loves at the altar of social reputation.

Calderón later reworked *The Painter of His Own Dishonor* as an *auto sacramental* in which the first painter is God himself. Calderón tells the story of the creation, fall, and redemption of humankind through an allegory of God as Divine Painter of the universe, who created the world from nothingness, bringing it forth platonistically from his own Idea. As in many other *autos*, Calderón lets the Devil open the action, scheming with his accomplice, Sin, how best to destroy God's design, thus adding dramatic tension to a story with a forgone conclusion. So it is Lucifer who tells Sin how God painted the universal landscape in six days, beginning with a canvas (the blank material base), adding light the first day, tracing out sky, earth, and sea the second, painting in flowers and fruits, plants and trees to adorn it the third day, and finally filling the land with animals on the sixth day.

As Lucifer hides in a tree and Sin curls like a snake at its foot to watch, the Painter comes onstage from his workshop to paint again, this time a portrait in his own image. Wisdom brings his maulstick, Innocence the colors drawn from the earth, and Grace the brushes. God paints the onstage canvas while musicians sing, praising his creation of Sun, Moon, Sky, and Earth in all their glories. The completed portrait falls, revealing Humankind in its place. She puzzles out the nature of her being in dialogue with the Painter, but then Sin throws her a golden apple from Lucifer's tree. Heeding the plebian *gracioso*, her Free Will, she eats of it, falls in Lucifer's arms, and is carried away from Grace. The Painter laments as the offended lover that is his creation has made him the "Painter of his own dishonor," and he looses the flood to wash away the tempera painting into which Lucifer has transformed the portrait he painted with the oil of Grace. Sin has defaced God's living portrait by driving a nail (*es-clavo*) of slavery into her forehead, but the Painter sets again to work to retouch his creation. Divine Love (Christ) hands him three nails as brushes, a sword as maulstick, and blood red alone as color; the blood of his veins in the passion washes away the shadow of Sin. Love twists the sights of the Painter's

weapon to spare penitent Humankind, so that the thunder of his voice wounds only Sin and the Devil. Like Roca, he has painted his beloved first with the colors of nature and then in blood, but with a forgiving love and the wisdom to discern the real offender.

In this beautifully constructed *auto,* richer in detail by far than a summary can indicate, Calderón animates a magnificent apology for the nobility of painting as a human imitation of God's creative power. He later expounded that concept in his 1677 *Treatise in Defense of the Nobility of Painting,* penned to assist Madrid painters in their suit against taxation of their work as a common manual art. In the *auto,* what most angers Lucifer is envy that Christ the Prince should be crowned supreme in all sciences and fields of knowledge, not just Theology and Philosophy, but even the Liberal Arts – Dialectics, Astrology, Architecture, Geometry, Rhetoric, Music, and Poetry – and in the sum of them all, Painting. In the treatise, Calderón spells out the intellectual supremacy of painting and posits its human origins in innocent play: "Some boys came out from swimming and finding themselves naked on the shore, noted how the Sun cast their likeness on the sand; playing mischievously, one began to trace with his finger the profile of another's shadow"; thus, "painting's first workshop was light, its first sketch shadow, its first surface sand, its first brush the boy's finger, and its first artist the youthful exuberance of chance."[46] Velázquez could hardly have found a more persuasive champion for the nobility of his creative art than the artful plays of Pedro Calderón de la Barca.

10 Three Paintings, a Double Lyre, Opera, and Eliche's Venus

Velázquez and Music at the Royal Court in Madrid

Louise K. Stein

While the seventeenth century is accepted as a golden age for Spanish culture, music held a subsidiary place next to theater and the visual arts. The century did not produce a long list of extraordinarily innovative Spanish composers, pages of heated musical debate, tomes of erudite speculative writings on musical theory, or libraries full of beautifully prepared and bound scores – the sort of written legacy that modern scholars accept as evidence of historical investment in other seventeenth-century musical cultures. The musical repertories from seventeenth-century Spain survive largely in manuscript copies on cheap paper and as humble performing parts. Of course, two of the largest collections of music by court composers were lost through natural disasters: in the fire that destroyed the royal library and music archive of the Alcázar palace in 1734, and in the earthquake of 1755 that took with it the great library of King John IV of Portugal. The majority of the surviving musical sources are undated, and printed ones are scarce, limited to a handful of practical or theoretical manuals, especially for organ, guitar, or harp. It would seem that few composers sought to publish their works, printers found little market for the sale of music in Spain during the seventeenth century, and the public was largely illiterate in musical notation (though many amateurs could surely read tablature and *alfabeto*).

The fact that Spanish musicians left behind very few accounts of their lives, performances, or ideas concerning music, is likely a direct result of the musician's place in society, and an important statement about how musicians were viewed and how they perceived themselves. Composers and performers were servants and artisans employed by the court, the Church, or the municipal theaters in the largest cities. Professional composers did not come from the upper reaches of society, and even the best could not rise to that level. The court composers lived as servants of the

crown, with limited social and professional mobility.[1] Professional musi-
cians were unwelcome in the *academias* of the aristocratic intelligentsia,
with few exceptions. Opportunities for individual renown were restricted,
even at court; for example, the names of composers and performers were
only rarely given in printed descriptions of royal entertainments or in the
accounts of court copyists.

Although the court painters fought to assure the status of painting as
a liberal art (and not merely as an artisanal trade), music was accepted as
one, but its creators faced an impossible climb toward the summit of the
contemporary Mount Parnassus. The status of even the most valued of
Spanish musicians was lowered by their need to earn a living by bringing
pleasure to others. When foreign musicians visited the Spanish court in
the entourages of foreign visitors, they invariably provoked the envy of
their Spanish counterparts because of their superior status and remuner-
ation.[2] The invisibility of the Spanish composer is also documented by the
eyewitness accounts of rehearsals and performances. For example, in his
published description of *La selva sin amor* (1627), the first opera ever per-
formed in Spain, the poet and librettist Lope de Vega did not mention the
name of the composer, although he praised Cosimo Lotti as the scenic
designer.[3] In like manner, the letters of Baccio del Bianco sent from the
Madrid court to Florence describe some of the most influential musical
plays given during his time there, along with the antics of their musical
director-composer. Baccio never names this musician, Juan Hidalgo, who
must have been well known to him. Even the music for Pedro Calderón de
la Barca's *Fortunas de Andrómeda y Perseo* (1653), copied by an Italian hand
into the presentation manuscript of the play along with Baccio's drawings
of the stage designs, is given without attribution, though the manuscript
was sent to Vienna, a court where musicians and composers were highly
valued.[4] Later in the century, when the Emperor Leopold I wrote to his
ambassador in Madrid seeking "spanische Musik" (*tonos humanos* and a
score for the opera *Celos aun del aire matan*) for his Spanish wife, he
didn't bother to name any composer in particular.[5] In the later seventeenth
century, copies of theatrical songs by the court composers were not regu-
larly brought into the royal collection, according to a curious *memorial* of
1689, in which a certain Urruela y Arteaga, a chaplain in the royal service,
reveals that he has found a particularly opportune and unique way of serv-
ing Charles II. Urruela seems to have made a specialty of acquiring and
copying theatrical music for the royal collection "as the only one who ded-
icates himself to his majesty's service in this way."[6]

While Philip IV honored the poet-dramatist Calderón and the painter
and decorator Velázquez with induction into the military Order of Santi-
ago, their counterpart and collaborator at court, the harpist and composer
Juan Hidalgo (1614–85), seems never to have dreamed of the like. If any
single composer can be credited with having developed a musical style for

the theater or having influenced the ideas about musical genre held by his nonmusical contemporaries, that honor would go to Juan Hidalgo. A virtuoso harpist, he was consistently responsible for theatrical music at court from around 1644 until his death in 1685, and his music was heard in revival productions into the eighteenth century.[7] We know nothing of Hidalgo's personality, and he did not leave us any personal account of his life, his ideas about music, or his attitude toward musical composition. He was received into the Royal Chapel in 1630 or 1631 as harpist, and beginning in 1644 served as *maestro* and chief composer of the court chamber musicians, composing secular music, theatrical music, and religious songs in the vernacular. He held a secure and well-remunerated position and, by his own accounting, in 1679 had worked for the court for more than forty-seven years. He was the most highly regarded composer in his day; was praised by his musical contemporaries as a genius, valued by his employers, and consistently relied on by Calderón, the leading dramatist of the age. But at no point was he, like Velázquez, sent abroad for further study or to collect music for the king's chamber and chapel, and, though he worked closely with Calderón, he was never specifically praised by him or by any other dramatist.[8]

* * *

The fact that the court painter, Diego Velázquez, included references to music in very few of his paintings fits well this general picture of a culture in which little written attention was paid to music, musicians, and reports of musical performances. If musical scenes are conspicuously few in the works of Velázquez and his Spanish contemporaries, the act of hearing music was of much greater concern to the guardians of public morality and social decorum. We know this principally not through writings on music, but through other kinds of documentation, including texts from the antitheatrical controversy, moralist pamphlets, the texts of novels, poems, and plays, and so forth. Those who criticized songs and dances brought social class and public morality into their commentaries. Popular dances known as *bailes*, such as the *chaconas*, *jácaras*, and *seguidillas*, were dubbed "lascivious," or "venereal" and were prime targets for reformers determined to reduce the moral risks of public performance. For some writers, any music performed publicly that did not sing the praise of God, however veiled the sensuality of the song-texts, could be heard to contain seductive melodies, rich harmonies, and suggestive rhythms that could move the human passions in dangerous ways.[9]

The outcries against public enjoyment of musical eroticism sounded consistently in an era in which visual and poetic eroticism were prominent features of the social life staged by the nobility in their palaces and pleasure houses. The word *erotic* was a Renaissance creation, first used in

European languages in the late sixteenth century.[10] In Spain, as far as is known, *erótico* appeared in print in 1580 in Fernando de Herrera's learned *edición comentada* of the classically inspired poetry of Garcilaso de la Vega, an extensive, high-minded work of literary criticism imbued with all the justification of classical tradition. In his commentary to Garcilaso's first eclogue, Herrera pointed out the ancient derivation of the genre and used the word *erotic* to denote a poetic category. He wrote that "the erotic poets are those who write about matters of love" (*Coronábanse de laurel los poetas heróicos . . . y de mirto los eróticos, que son los que escriben cosas de amor*).[11] The word *erótico* was included in Spanish dictionaries beginning in the second decade of the eighteenth century, where Herrera's phrase is cited.[12] Erotic (*erótico*) pertains to love (*amor*), so that erotic poetry is "love poetry" and the writer who writes about erotic love is "a poet of the lascivious."[13] The word *erotismo* describes a "strong passion of love" and its effects, as in "Conquered by a frenetic eroticism / an illness of love, or love itself. . . ."[14] Early modern Spanish writers and their dictionaries suggest that the erotic existed as an artistic category and an affective realm for poetry (and thus song-texts) and visual art, with its subject matter "de amores" focused on lascivious, carnal, or venereal love. In the dictionary of the learned Spanish royal academy, *venerea* is "what pertains to Venus, or to sensual [sexual?] pleasure" (*lo que pertenece a la Venus, o al deleite sensual*),[15] and in diatribes about the dangers of music, there is the association between dangerously sensual music and *música venerea*.[16] From the late sixteenth century in Spain, the erotic genre, linked closely through "pleasure" or *deleite* with the bucolic, was a legitimate one for high-born poets and men of letters to engage with, because of strong justifications and associations with classical learning and classical mythology.

Though erotic subjects and female nudes were infrequently painted by Spanish artists, paintings of famous mythological scenes decorated the halls and chambers of royal and aristocratic residences, to be enjoyed only by those in the very highest stratum of society.[17] Songs and dances, especially when performed in the theater, offered a unique and broadly available kind of adventure and escape to those listeners cut off from such elite forms of erotic enjoyment. In the contest between the sense of hearing and the sense of sight, hearing allowed the insidious and unguided flood of music and words into the very bodies of the hearers, and its sensual power was inescapable.[18] Songs and dances, tonadas, tonos, bailes, jácaras, chaconas, and seguidillas circulated rapidly through oral transmission to and from all corners of the Hispanic world and were enjoyed by listeners and performers of all social classes.

Music, song, and dance were invested with social significance and could mark or label both hearers and performers. Perhaps the painting of musical scenes could also label the painter? In considering Velázquez's musical depictions, it might not be coincidental that he devoted an entire

painting to a genre scene of common musicians (*Three Musicians*) only early in his career, before he had begun to aspire to the social status of a courtier. The mythological paintings that many scholars associate with Velázquez's later years, painted most likely in the mid-1650s, contain the artist's other depictions of musical instruments (*Mercury and Argus*, and *The Fable of Arachne*).

Three Musicians (Fig. 61) was painted most likely in 1617–18, at roughly the same time as the young Velázquez painted another scene of apparent rustic simplicity, *Three Men at Table*.[19] The painting depicts three common figures in realistic contemporary garb playing musical instruments that are clearly recognizable and appropriate for their time. The musical instruments (two baroque guitars and a violin) are not in any sense otherworldly or fantastical, and the painting presents a plausible musical scene – small ensembles composed of a violin and two guitars were typical in the early seventeenth century and accompanied both singing and dancing. The musicians occupy a space that is most likely a public tavern but that might also be private (a room in a house). The glass of wine on the table and the bread and cheese laid out there are ready to eat but untouched. They seem to anchor the scene's everyday simplicity, though perhaps as well we should imagine that the musicians have been singing for their supper – the boy has stopped strumming long enough to hold a glass aloft, as if toasting the viewer or the audience for the performance. That this is a "performance" for an audience might be suggested by the boy's toast and the monkey caught in movement (perhaps dancing) on the back of the young boy to the viewer's left in the picture. That the two singers have turned to nearly face each other and seem to pause open-mouthed, the taller one as he sings a sustained note long enough to allow his glance at the ceiling, suggests that they have reached a musical cadence or stopping point of importance, perhaps the final cadence or end of their *tono*. The light entering the scene falls primarily on the performers' faces and musical instruments, so that it adds to the effect of the painted scene as performance.

Whether or not Velázquez intended his painting to be wholly about musical performance (and not about a moral or metaphysical issue), he has highlighted the performative aspects of his subject. Though the painting may be about music as an occupation of low social status or may be interpreted as an allegory of the senses and the fleetingness of earthly things (with professional music making depicted as a vain, low occupation),[20] the play of light certainly leaves the only reference to Velázquez's own youthful profession, painting, silent, isolated, and barely real in the background within an out-of-place gilt frame. That Velázquez, like Calderón and so many other contemporaries, recognized the affective power of music is here implicit in the depiction of the two older musicians to the right in the painting. Mouths open, faces turned momentarily away from their public, they seem wholly transported within their song, such that only the boy's toast

61. Diego Velázquez, *Three Musicians*, ca. 1617–18 (Berlin, Staatliche Gemäldegalerie).

reminds us of the listening audience. In seventeenth-century terms, the two singers are "moved" by the affect of their music, and this is the focus of the painting. Here Velázquez has achieved the natural and verisimilar portrayal of the immediacy of musical performance and its affective power.[21]

The power of music in performance is depicted once again in a mythological painting generally dated to 1659, Velázquez's *Mercury and Argus* (Fig. 62). In this painting done for the Hall of Mirrors in the Alcázar palace, the subtle and seemingly casual placement of the simplest of musical instruments brings up the issue of musical performance, which was anyway central to the Ovidian episode depicted. This is from the story of Jupiter and Io (later also known as Isis) in which many-eyed Argus, the ever watchful shepherd of Juno's flock, was enchanted and then lulled to sleep by Mercury's songs, so that the messenger god could steal past him and kidnap Io, a nymph disguised as a cow in Juno's flock, for the sexually insatiable Jupiter. In the Velázquez painting, Argus has just fallen asleep and Mercury has laid down his musical instrument, the shepherd's or Pan pipes (*flautas de Pan, albogues* or *zampoña*), also of mythological extraction.

Though it may at first seem to be a fairly straightforward depiction of this episode, Velázquez's painting contributes in a visual way to a theme

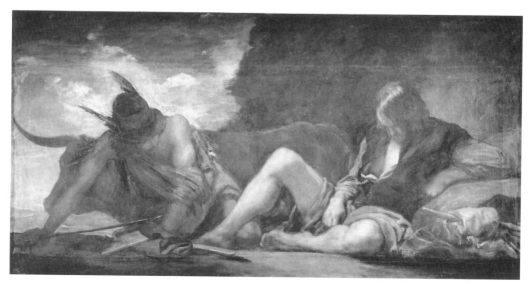

62. Diego Velázquez, *Mercury and Argus,* ca. 1659 (Madrid, Museo del Prado).

that seventeenth-century writers developed variously – the association between beautiful music and evil or corrupt intentions.[22] First of all, the sixteenth-century Spanish mythographer Juan Pérez de Moya's explanation of this myth notes that Argus was "enamoured" of Mercury's performance *(enamorado del tañer y cantar de Mercurio)* and so begged the god, disguised as a goatherd, to stay and entertain him. Pérez de Moya relates that Mercury at first "worked with all his powers and an abundance of sweet songs to put all of Argus' eyes to sleep." When the sweetness of these songs delighted the monster but failed to bring him slumber, the god began to depend on the music of the "newly invented" Pan pipes, whose music rendered Argus "drunk" enough to close all of his eyes in sleep.[23] Another of Velázquez's probable sources, Sánchez Viana's Spanish rendition of Ovid's tale, emphasizes that the music of the *zampoña* leaves the hearers "drunk" *(embebidos)* with its sound as well.[24] In the very sources known to Velázquez, Mercury did not simply sing in some naturally benign mortal way, say, in the style of a common shepherd, but harnessed the power of musical artifice (one of his attributes as a mythical singing deity) to accomplish his deed in preparation for his violent beheading of Argus.

Though we cannot hear Mercury's music in the Velázquez painting, the same reading of Ovid by Pérez de Moya and Sánchez Viana was the inspiration for a musical scene in a contemporary *zarzuela* on the story of Jupiter and Io, performed a little over a decade after Velázquez's death. It may be significant that the dramatist for this production, Juan Vélez de Guevara, admired Velázquez and worked in close proximity to him at court.[25] Vélez de Guevara's *Los celos hacen estrellas,* was performed with music by Juan Hidalgo and others for the birthday of Mariana de Austria

in December 1672.[26] The opening scene of act 2 illustrates Mercury's strategy and the power of music. Mercurio (Mercury) comes onstage disguised as a shepherd, intending to trick Argos (Argus) and kidnap Ysis (Io disguised as a cow amid Juno's flock) for Júpiter. He sings three songs, which constitute the intensity of the scene, as they distract and tame Argos. Within the conventions of the Spanish musical theater, Mercurio exploits the godly attribute of lyrical song, which, as described by Argos "stops birds in flight and rivers in their course," and "robs the soul and holds the senses in suspension, if it doesn't actually imprison them."[27] Singing the first song, "De las luces que en el mar," he stealthily nears Argos to begin his enchantment. The primary strophes of the song, the *coplas,* are happy, shining, intensely and serenely beautiful, with highly ornate poetry. As was standard in Hidalgo's practice, the *coplas* set descriptive texts, and the refrain, or *estribillo,* contains what is directly, subjectively emotional, in this case verging on the lament affect (in contrast with the energetic strophes) although in C major.

When Mercurio sings his third song, "La noche tenebrosa," the elaborate, emotional song has an enchanting effect: its insistent sequences and persuasive lyricism achieve the impossible. Argos closes his glowing eyes and sleeps, only to be violently beheaded by Mercurio. The song-text juxtaposes images of rest, tranquility, and forgetfulness *(olvido)* with images of pathos and violence that foreshadow Argos's violent death in sleep. The musical setting is elaborate in that it is ornamented with melismas and word repetition, unusual and "artificial" characteristics in Hidalgo's usually syllabic, sequential settings of a strophic text. The special dramatic situation inspired Vélez de Guevara to exploit the artifice of an elegant Italianate lyrical form for the song-text, which is written as six stanzas of *liras* (abbacC), each stanza ending with the same eleven-syllable refrain. In the musical setting, the implicit textual refrain is an incorporated musical refrain, emphasized and expanded through the repetition of the word *descanso* (rest). The musical setting is strongly moving, bringing out the affective content of the text, and the composer exploited exceptional musical details to underscore the rhetorical structure and heighten the meaning of the song-text within the dramatic scene. If we consider Hidalgo's music for this scene in light of Pérez de Moya's interpretation of Mercury's performance, then we understand why the first song, "De las luces que en el mar," is both formally simple and less dependent on "artifice" than the third song, "La noche tenebrosa." As Mercurio schemed and labored to enchant and finally to deliver Argos to the realm of sleep, his performance became more elaborate and more overtly constructed, with insistently persuasive musical repetition and other fully loaded affective devices.

Velázquez's *Mercury and Argus* relates to the art of music as practiced by Juan Hidalgo and his contemporaries in other ways as well. In the painting, Velázquez blurred the images in such a way as to create a dream-

like effect, certainly appropriate to his subject matter. One of the striking features of this artist's treatment of this myth and of other mythological subjects is that the characters depicted are natural and verisimilar, so that the painting is grounded in the familiar and the everyday. Argus is a shepherd and Mercury is identified as a god only by his winged hat (which, by the way, Sánchez de Viana noted that he did not wear on this mission). In the same way that Velázquez's painting is grounded in everyday reality rather than in the fantastic, Hidalgo's theatrical songs are grounded in the simple tradition of the strophic song or ballad (though they are newly composed for the theater) and eschew some of the overtly "fantastical" constructivist musical devices that other non-Spanish contemporaries might have employed in such a musically powerful scene of supernatural display.

The realistic depiction of musical instruments that Velázquez took the trouble to create in the *Three Musicians,* with their two guitars and violin, and in *Mercury and Argus* with the perfectly recognizable Pan pipes, links the two paintings with each other and with others by Velázquez's Spanish contemporaries.[28] These depictions are grounded in contemporary musical practice – one has a striking social realism akin to that of *Three Men at Table,* and the other is a mythology in which the unreal becomes real and familiar by virtue of the painter's craft.

In a third painting, the famous *Fable of Arachne* (Fig. 54; earlier known as *The Spinners*), the musical instrument is less clearly drawn and its purpose in the painting is less easily understood.[29] The instrument leaning against a chair to the left, just inside the opening that separates the spinning scene of the foreground from the mythological scene between Arachne and Pallas-Minerva in the background, has been variously identified. In his monumental study published in Germany in 1888, Carl Justi understood the painting as *Las Hilanderas (The Spinners)* and described it as containing two representative scenes: a dimly-lit Plebian scene of working women in the foreground, and the slightly higher, brightly lit aristocratic scene in the background or second plane of the painting. This inner scene, he suggested, could be accepted as a theatrical scene, and the musical instrument leaning against a baroque chair was a *contrabajo,* or double bass, "que insinuaba la música instrumental de los entreactos" (that hinted at the instrumental music played between the acts) of a mythological drama.[30] Although the musical theatricality of the inner, mythological scene is something Justi corrrectly intuited, his identification of the instrument is inaccurate, as is his supposition that instrumental music was only heard between the acts of the play in contemporary performances. Following Justi, Diego Angulo Iñiguez, publishing in 1947–48 his discovery of the painting's true subject (the fable of Arachne), identified the musical instrument as a grand *contrabajo,* again employing the modern terminology that pertains to the lowest-pitched and largest member of the violin family.[31]

The modern double bass, or *contrabajo*, was not in use in Velázquez's day; rather, the largest instrument typically used in the seventeenth century as a low-bass instrument was known as the *violone* in Italian. This was a fretted instrument of the viola da gamba family with a very large range, and whose lowest string was pitched on G'. In Spain this largest instrument of the *vihuelas de arco* was sometimes played to sound below the standard bass instruments and was sometimes called the *violón contrabajo*. The instrument in Velázquez's *Fable of Arachne* seems not much bigger than the chair it is leaning against, so it is unlikely to represent this "contrabass," or G' *violone*, which could be played standing. In any case, the instrument in the painting, as Du Gué Trapier, Tolnay, and Azcárate correctly asserted, most likely belongs to the family of the "leg fiddles" – viols, violas da gamba, and violones – the family of fretted six- or seven-string instruments held between the knees and played with a bow.[32] In 1611, Covarrubias stated clearly the differences between the fretted vihuelas de arco and the unfretted violones or instruments of the violin family.[33]

One interpretation derived from the presence of the musical instrument in the painting is that the painting contains not only the fable of Arachne but an allegory of the liberal arts, with Pallas-Minerva as the goddess of Fine Arts. This interpretation had the advantage of explaining not only the instrument but also the three ladies in modern seventeenth-century dress who seem present to observe the result of the contest between Pallas-Minerva and Arachne. Tolnay identified the lady in contemporary garb standing nearest the musical instrument (to the left of the opening that separates the foreground from the background scene) as its player, the personification of Music as a liberal art. Arachne represents the arts of painting and tapestry (her tapestry in the Velázquez displays a copy of Titian's *Rape of Europa*) and the other two ladies, though they "have no special attributes," are Sculpture (the lady to the extreme right nearest Arachne) and Architecture (with her back turned toward the viewer). In yet another interpretive tradition dating back to Azcárate, the painting is taken as a political allegory in which the musical instrument, given its resemblance to the instrument played by Harmony (Armonia) in Cesare Ripa's *Iconologia*, is understood to be a symbol of political concord, leading to a number of possible but differently framed political allegories.[34]

While the viola da gamba / vihuela de arco is indeed present in many allegories of worldly or monarchical harmony, I have yet to be convinced that one of the proposed moral or political allegories is the right one or that Velázquez indeed meant to depict a simple viol in his painting. Stringed instruments such as lutes, harps, and viols could be carried or played by a variety of emblematic, allegorical, and mythological characters. For example, the viol is the instrument played by the muse Erato in words and image in Francisco Quevedo's *Parnaso Español*, an anthology that included poems for all the poetic genres or categories of the day

(heroic, lyric, amorous, satirical, erotic, etc.). Quevedo's poetry is framed by the extensive commentary of Joseph Antonio González de Salas, a learned *preceptista* and classicist. Each section of the *Parnaso* is presided over by one of the Muses, and six of them are pictured individually in engravings at the head of each section, which were designed by the painter Alonso Cano.[35] Muse number 4, Erato, is described in the *Parnaso* as "she who sings amorous songs and celebrates beauty and the tender feelings of love, particularly those of famous lovers." The engraving after Cano pictures her bowing a viola da gamba while a blindfolded Cupid flies about shooting arrows. Erato is a "temple" for the tender complaints of love, for its sweet laments and generous pain. Her music accompanies Eros and might include decorous laments or songs of erotic longing.[36]

Though it has not been mentioned before in connection with the *Fable of Arachne,* the viola da gamba's association with Erato might be significant. Velázquez may well have known the 1648 edition of the *Parnaso* and Cano's engravings. Further, the scenes woven by Ovid's Arachne into her tapestries during the competition with Minerva depicted the flagrant erotic adventures of the mythological gods, though only that of Titian's *Rape of Europa* can be seen in the Velázquez painting. This work by Titian, along with the others in the Spanish royal collection from his erotic *Poesie,* displayed in the "bóvedas del Tiziano" of the Alcázar,[37] corresponded to the elevated social and intellectual level represented in the background or second plane of the Velázquez *Fable of Arachne*. If the instrument is indeed a viola da gamba and its player is Erato, visiting Arachne's studio as a lady in seventeenth-century dress, then the two other ladies that accompany her might also be Muses or "musas castellanas" present to witness or judge the goddess's competition with the mortal.

The theme of artistic competition between a deity and an arrogant mortal, clearly the focus of this background or second plane in Velázquez's painting, could very well call for the presence of both a musical instrument and the Muses as reminders of another such competition – that between the god Apollo and the satyr Marsyas, recounted in Ovid's *Metamorphoses,* book 6. Among the several stories about Apollo, this episode received the most attention from Spanish painters.[38] Velázquez himself painted at least one now-lost *Apollo and Marsyas,* which hung in the Hall of Mirrors in the Alcázar as a companion to his *Mercury and Argus*.[39] In Spanish interpretations of Ovid, the story of Apollo and Marsyas and that of Minerva and Arachne both warned against the sin of arrogance and lack of obedience to authority, divine or royal. Poor Marsyas, ignorant of the fact that Pallas had forbidden anyone to the play the instrument, retrieved the pipes (probably bagpipes but often taken to be a flute or Pan pipes) invented by the goddess but thrown away because playing them so distorted her face. Marsyas challenged the god Apollo to a musical competition, claiming that the music of these "pipes" was more beautiful and more

powerfully expressive than that of the god's famous lyre. The Muses were called upon to judge the competition. As the winner, Apollo could do whatever he liked to chastise the loser. Though he later repented of his violence, enraged Apollo tied Marsyas to a tree and flayed him alive.

The god Apollo is associated not with a wind instrument but with a stringed instrument identified in classical sources as a lyre. For Julián Gállego, the lyre or *lira,* sometimes in the form of a viola da gamba, appears so frequently in the emblematic literature of Velázquez's day that its presence in his painting must call for an explanation in emblematic terms. As Gállego noted, the *lira,* often transformed into the more familiar Renaissance harp or guitar, and the viol, were often depicted as symbols of moral or political concord and harmony. Gállego cites Alciati, Borja, Baños de Velasco, and Ripa as sources for the emblematic political significance of the "viola" or "lira."[40] Among these, Cesare Ripa's *Iconologia* was one of the books in Velázquez's personal library, though we cannot know for sure which of the illustrated editions was best known to the painter.

In the Rome 1603 illustrated edition of the *Iconologia,* an instrument similar to that in Velázquez's painting is played by Harmony, and the caption explains that she appears in the engraving "as she was depicted in Florence for the Grand Duke Ferdinand . . . a beautiful woman holding a double lyre of fifteen courses of strings; on her head she has a crown with seven jewels . . . her dress is of seven colors, decorated with gold and diverse gems."[41] The word for "jewels," *gioia,* is also that for "joys." The emblem equates the richness of musical harmony with earthly concord and shows a realistic depiction of a relatively new instrument designed to produce a simple bowed chordal accompaniment of the very sort that Renaissance humanists imagined to have been used in ancient performances. This instrument, designated since the mid–sixteenth century with the Italian name *lirone* (double lyre), though sometimes known as the *lyra da gamba,* was neither a simple viol nor an unfretted instrument of the violin family. It was the bass version of the well-known Renaissance *lira da braccio.*[42] Known in Spain as the *lira* or *lira grande,* the instrument was typically fretted, like the viols, and had between nine and fourteen melody strings, with two drone strings off the fingerboard. Covarrubias's 1611 dictionary entry for "Lira" reads: "Instrumento músico. Quál aya sido y de qué forma, acerca de los antiguos, no lo acabamos de averiguar; la que oy se usa es de muchas cuerdas y se tañe con un arquillo largo y haze suave consonancia, hiriendo juntamente tres y cuatro cuerdas, lo que no haze la vigüela de arco."[43]

The *lira grande* was generally taller and wider from side to side than the viola da gamba, and its shoulders were not as sloped, so that it was sometimes shaped similarly to a sort of flattened-out violoncello.[44] When it was bowed, its flat bridge allowed contiguous strings to sound simultaneously (the player could not skip from one course of strings to another), hence its

unique ability to play chords in four- and five-part harmony. The instrument in Velázquez's painting seems perhaps too flat and laterally too wide to be a simple viol (*vihuela de arco* in the Spanish terminology), but it might very well be the *lira grande*. It seems not to have any tuning pegs visible at the sides of its head, and, in instruments of this size played between the knees, only the *lira grande* was sometimes made with frontal rather than lateral tuning pegs (the smaller *lira da braccio* also characteristically had frontally located tuning pegs). It is unlikely that the artist simply forgot to paint in the tuning pegs.

The presence of the *lira grande* in Velázquez's *Fable of Arachne* in a scene about the arrogant artistic claims of a foolish mortal who challenges a deity, might be explained as a reference to the musical competition between Apollo and Marsyas, whose tragic result Velázquez had treated in another painting, now lost. The lirone's illustrious ancestor, the lira da braccio, was typically depicted in the Renaissance as the instrument of Apollo, who played it as his lyre when challenged by Marsyas.[45] On the other hand, the lira might also help to identify its supposed player, the lady in the gold dress of seventeenth-century fashion standing closest to the instrument. Perhaps this figure is Harmony, the daughter of Venus and Mars and thus the niece of Pallas-Minerva. Harmony was married to Cadmus, who was a musician and in turn the brother of Europa and a favorite of Pallas. Given that Europa's kidnapping is depicted in Arachne's tapestry, and Harmony's aunt Pallas-Minerva is a central figure in the scene, she would not be totally out of place here (after all, in some versions of the myth her husband Cadmus was sent off in search of poor Europa), though it seems odd to find her costumed in realistically everyday, nonmythological garb.

My identification of the instrument as a lira and of its player as Harmony (Armonía) is compatible with a number of interpretations. Given the discord of the confrontation between the goddess and Arachne, however, the lira is here silent, and this silence argues against the instrument's being interpreted as a symbol within a complicated allegory of political concord. As Jonathan Brown has written, the musical instrument suggests a continuation of the analogy between Arachne and Titian already established by Velázquez through the depiction of Titian's *Rape of Europa* in Arachne's tapestry. According to Brown, Velázquez's belief in "the nobility and the transcendental value of the art of painting" is the message of this picture. Just as the great Titian painted to music, so did Arachne weave to music, as an "elegant artist" fit to challenge a goddess.[46] Fernando Marías convincingly identifies the three ladies in contemporary garb as the daughters of Meneas who narrate the fable of Arachne from within their own myth in both Ludovico Dolce's Italian edition and Jorge de Bustamente's illustrated Spanish translation of Ovid (book 4), which Velázquez had in his library. Marías's idea of the myth within a myth or "caja china literaria"

is especially attractive, given the questions raised by the lira and its asso-
ciation with Erato, Apollo, and Harmonia in other mythological stories.[47]
His convincing reading of the painting as Velázquez's declaration in favor
of artistic modernity and its superiority over the techniques of the old mas-
ters (both Marías and Brown emphasize the modernity of Velázquez's
achievement with the spinning effect of the wheel in the foreground) also
credits Velázquez as announcing his new manner of interpreting the clas-
sical myths.[48]

If the musical instrument is meant to be the *lira grande* of Velázquez's
day, then another interpretive tradition long associated with this painting
is also reinforced. The musical instrument in the *Fable of Arachne* could
be a reminder or assurance of the famed musical antidote to the spider's
bite, as in the lore associated in the early modern period and in folksong
with the bite of the Tarantula and the dance of the Tarantela. The prob-
lem with this explanation, according to Tolnay and others, is that in the
moment depicted by Velázquez, angry Pallas has yet to transform Arachne
into a spider, and neither the viola da gamba (*vihuela de arco*) or the bass
violin (*violón* or *violón contrabajo*) is among the instruments cited as cre-
ating the clamorous noise of the famous musical antidote. Historians of
art, however, have overlooked the significance of the lira in the musical
cure for the spider bite proposed by the Jesuit musical theorist and poly-
glot scientist Atanasius Kircher, whose monumental treatise on music was
published in Rome in 1650 and dedicated to none other than Philip IV.

Kircher describes and pictures the lira ("Lyra dodecachordae") in the
Musurgia Universalis in the section devoted to the other stringed instru-
ments. For Kircher, as for the French theorist Marin Mersenne, because
of its ability to sound chords and low-lying harmonies, the lira was espe-
cially appropriate for the accompaniment of melancholy songs and
laments, as it easily moved the passions of the listener toward the purga-
tion of such a debilitating affective state.[49] Kircher lists the lira along with
what he designates as "soft" harmonious instruments such as "lutes, gui-
tars, and harpsichords," useful in the musical cure for the spider's bite.
These soft instruments would be appropriate (according to Kircher) only
for treating individuals of the most subtle and "delicate" temperaments.
The loud instruments such as the shawms, drums, trumpets, and horns,
which produce a rough, noisy sound (and are typically mentioned in other
sources) were best for curing the spider's bite in those of melancholy tem-
perament, because the loud noise would actually invigorate their bodies to
expel the poison. Kircher placed his trust first in the loud shawms, drums,
wire-strung citterns, or strummed guitars that were commonly available
(in case of emergency) and easy to play. While the lira is classified here as
a soft instrument, Kircher also clearly grouped it together with other
instruments capable of producing polyphony (and used in the basso con-
tinuo or accompaniment), in opposition to loud melody instruments. His

illustration "Iconismus VIII" (following fol. 486 in chap. 6 of the *Musurgia*) distinguished the lira or "Lyra dodecachordae," from the other stringed instruments, such as the violin ("chelys minor" in his illustration), violoncello ("chelys maioris") or the viol, viola da gamba, or *vihuela de arco* ("chelys hexachordae"). Moreover, in his section on the musical cure for the spider's bite, the low stringed instruments, aside from the *lyra*, are left aside. In an engraving that shows the vigorous music and dancing of the cure, the music is provided by a *lyra da braccio,* the direct ancestor and treble sister of the *lira grande*. There is no doubt that Kircher's testimony reflected far-reaching practices and that he drew his information from ancient and modern sources both speculative and practical, erudite and traditional. Further, given that the book was dedicated to Philip IV and available at court in Madrid, Velázquez might well have known Kircher's theories.[50]

While both *vihuelas de arco* and liras were in use at the Spanish court in Velázquez's years there, the two instruments had rather different functions. The *vihuelas de arco* were a mainstay of the king's chamber music, though they had fallen in status somewhat by the time Velázquez painted his *Fable of Arachne*. Philip IV had played the *vihuelas de arco* in his youth, and, of course, viol playing was part of the musical instruction and enjoyment of European nobility and royalty in his time.[51] Viols were played in consort by professional court musicians as well and were also used for the musical instruction of the royal children, of pages, and of the choirboys in the royal chapel's school. A number of solo songs or *tonos* composed for professional performance at court, however, are scored for voice with a solo *vihuela de arco* as an obbligato instrument, and the lowest instruments in the family of the *vihuelas de arco* were used as well in the *bajo continuo* ensemble that accompanied chamber songs, dancing, and theatrical music.

In the accounts for repairs of musical instruments (stringed instruments including guitars, violones, violins, *vihuelas de arco,* archlutes, and so forth) presented by Manuel de Vega, the luthier, or *guitarerro,* of the Real Capilla, the instrument called *lira grande* is identifed simply as "la lira." From 1648 to 1657 repairs to the lira are noted in Vega's accounts. In 1656 an entirely new lira was built by Vega as ordered by the Capellán Mayor. Vega described this instrument as having "sixteen courses [of strings] with pegs of iron," "the fingerboard of Portuguese ebony . . . with tracery of ivory on the bottom and the front of the case, in imitation of the foreign instruments."[52] Earlier, in 1651, new frets were tied for an older lira and it was fitted with six new tuning pegs made of ebony and ivory, in preparation for use during Lent. Indeed, the Capilla Real seems to have used the lira especially for Lenten services and for the devotional services known as the *cuarenta horas*. That the somewhat nasal sound of the lira

was considered appropriate for penitential Holy Week services and to accompany devotional music at the Spanish court is in line with the associations that the *lirone* had elsewhere with melancholy music and laments. In the years covered by Vega's accounts, the lira was played consistently by Francisco de Valdéz, sometimes as a lone accompaniment instrument and sometimes in a bajo continuo ensemble with archlute (*archilaud*), two harps (*arpas*), and violone (*violón contrabajo*).

<p style="text-align:center">✳ ✳ ✳</p>

It is likely that Velázquez knew something about music: a treatise on music is said to have formed part of his library.[53] In his years at court he knew and perhaps collaborated with musicians of the royal chapel and chamber.[54] In at least one case, his decisions as Philip IV's decorator (*aposentador mayor de palacio* from 1652) almost certainly influenced the course of musical history. Several scholars have described Velázquez's contributions to the preparations for the diplomatic encounters and celebrations of the Franco-Spanish treaty, the Peace of the Pyrennees, and royal marriage of 1659–60.[55] As these events dominated the artistic life of the Spanish court in the months between the armistice of May 1659 and the marriage between María Teresa of Spain and Louis XIV of France in June 1660, Velázquez's musical colleagues were also called upon to plan for and participate in their preparation and accompanying festivities.

In seventeenth-century Europe, dynastic marriages and imperial or royal weddings were increasingly celebrated with the performance of fully sung operas, beginning shortly after the genre's invention in the last years of the sixteenth century. Although we tend to think of the politics of baroque opera as local and specific to particular occasions, there are some themes and characters common to a number of politically inspired operas. In many works performed at the courts of Europe, and in both of the operas produced in Madrid in 1659–60, the presence or power of the goddess Venus brings to the official public recognition of royal weddings and dynastic alliances an erotic element that may have been frankly acknowledged as necessary for dynastic continuance in the seventeenth century.[56] At the least, Venus smiles and lends her suggestive presence to the depiction of earthly political harmony. In keeping with current fashion, operas were composed both for Paris and for Madrid for the 1660 wedding celebrations. On the French side of the Pyrennees, Cardinal Mazarin commissioned Francesco Buti and Francesco Cavalli to put together a festival opera in Italian, and Buti provided the libretto *Ercole amante*, based on book 9 of Ovid's *Metamorphoses*. In this opera, Venus's role is far from merely symbolic, as she helps Hercules to achieve the seduction of Iole. On the Spanish side, Mazarin's plans were probably

well known, for he intended to dazzle Europe with the brilliance of the French celebrations, and made no secret of his plans to produce, among other musical and theatrical works, an opera by the leading Venetian opera composer, Cavalli, who was to have been loaned to Mazarin by the Serene Republic.

Though opera was an unusual genre for the Spanish court's dynastic celebrations (partly sung entertainments were more the rule), it seems likely that, once Mazarin's plans became known to Philip IV and his ministers, the production of fully sung "opera" suddenly became desirable in Madrid. In the frank competition so often noted by observers, the Spaniards could not afford to be outdone. The dramatist Calderón de la Barca brought forth two libretti to be performed in succession, *La púrpura de la rosa* and *Celos aun del aire matan*, and these were set to music by Hidalgo.[57] Because of the great importance of the 1659 negotiations toward the Peace of the Pyrenees, the reception of the French envoy and the official ceremony in which he would request the Infanta's hand were planned with great attention to detail, after consultations with court officials and the Council of State. The marriage proposal would be delivered in a setting that placed the monarch in the proper light. The image of the Spanish king as peacemaker and guardian of moral virtue was amply supported in the broad iconography of the palace, and the attributes of the bride-to-be, María Teresa, were displayed through mythological analogy on the very ceiling of the Hall of Mirrors, where the ceremony was to be staged. Under Velázquez's supervision, the decorations and furniture of the Alcázar, and especially of the Hall of Mirrors, were arranged to project the virtues of the Infanta and the new role of Philip IV as king in the arts of peace and reconciliation.[58] The record of the French delegation's reactions to what they experienced in Madrid not only emphasizes the strong differences in monarchal style between Paris and Madrid (what Jonathan Brown has called the "contrast between French brilliance and Spanish grandeur"), but also contains a note of rivalry: on both sides of the Pyrenees, such displays of court culture were essential to the legitimation of the monarch.[59]

The two Hispanic operas composed in 1659–60 are works of exceptional quality (though the first is only preserved in a recomposed version dating from 1701). Although opera was a foreign genre and merited exceptions to the usual plan of theatrical production, Spanish elegance, not an imported taste, prevailed. In his loa to *La púrpura de la rosa,* Calderón noted the rivalry with France, when he wrote that the opera was to be "all in music; for it is meant to introduce this style, so that other nations will see their refinements rivalled."[60] The two operas relate thematically to a number of paintings connected with the occasion. Their stories (Venus and Adonis for *La púrpura de la rosa* and Cephalus and Procris for *Celos aun del aire*

matan) were prominent among mythological paintings on amorous sub-
jects in the palace decoration of the Alcázar. Tintoretto's *Myth of Venus*
and *Venus and Adonis,* and Velázquez's own *Venus and Adonis* (all three
now lost) hung in the Hall of Mirrors, the very room in which Philip IV
received the Marshall-Duke of Gramont and accepted the marriage pro-
posal.[61] But the more striking comparison is to be made between a pair of
Venetian paintings acquired for Philip IV by Velázquez and the two Span-
ish operas. In the South Gallery of the palace, in one of the king's private
rooms which Gramont's French legation passed through just before enter-
ing the Hall of Mirrors, Veronese's *Venus and Adonis* and its companion
painting *Cephalus and Procris,* were displayed.[62]

It cannot have been purely coincidental that the court produced operas
based on precisely these mythological love stories that so strikingly hung
as a pair in the king's quarters. Following the example of the Veronese
paintings, Calderón's libretti form a unified pair, although Calderón and
Hidalgo interpreted the myths to speak to events at hand. Just as
Veronese's paintings provided a metaphorical warning against the dangers
of the hunt, hunting is equated with the newly despised art of warfare and
with spousal neglect in the operas. The symbolic and emblematic readings
of the myths in other sources known to Calderón, Velázquez, and Hidalgo
underline their appropriateness to the events of 1659–60. The operas, like
the paintings and the emblems that baroque artists drew upon, offered
"advice beneath the surface of some or many figures," a message conveyed
through the "attraction of the senses" to the power of music.[63]

The purpose of mythological stories, according to Pérez de Moya, was
to allow the poet to edify and instruct through "hidden morals" and "wor-
thy doctrine" presented "with some resemblance to reality." In Calderón's
opera texts, the "worthy doctrine" is what connects the operas to the occa-
sions that they commemorated, and their "resemblance to reality" is
demonstrated by the several parallels between the characters on the stage
and those in everyday reality. For example, the mythological marriage
between Pocris and Céfalo in *Celos aun del aire matan* takes place in the
setting of a "salón regio," and, like María Teresa, Pocris marries a "for-
eigner." The Spanish princess María Teresa, like Calderón's initially chaste
nymph, Pocris (his spelling), had been sheltered from men and from
worldly concerns at her father's court in Madrid, such that upon her mar-
riage to Louis XIV she amazed the French court by declaring that "she had
never before spoken to any man except her father and her confessor."
Louis "openly expressed pleasure and surprise at the discovery that his
wife was a virgin."[64]

In *La púrpura de la rosa* Venus is the female protagonist, the erotically
charged goddess who overwhelms the beautiful mortal Adonis and drives
her former lover the warrior god Marte (who is burlesqued) nearly mad

with jealousy. Identified perhaps with the young and idealized Louis XIV as bridegroom, Adonis's youth, superior beauty, and innocence are captured by his high tessitura and overtly lyrical melodic lines. The ever vengeful, blustering Marte sings in an encumbered, syllabic style with many sections in strict binary rhythmic patterns that give his role a sort of *concitato* patter. Likewise, his strident sister Belona, goddess of war and another soprano, is appropriately martial, while Amor sings mostly short catchy songs. Among the comic characters, the sadistic soldier Dragón (literally Dragon but also Dragoon) is a sneering contralto as Marte's sidekick, while the comic rustics Chato and Celfa tend Venus's garden, engage in marital dispute, and comment on the affairs of the high characters, along with Venus's lovely Nymphs, and Desengaño's allegorical companions Temor, Sospecha, Envidia, and Ira (Fear, Suspicion, Envy, and Anger). The latter create a crowd-pleasing scene of supernatural portent when they emerge from a mysterious prison grotto called the Carcel de Celos, where the aged Desengaño is seen enchained in a terrible dungeon. The "advice" offered by this highly entertaining tragedy of exquisite music and mythological analogy is an affirmation of the value of steadfast, conjugal love between a royal Adonis (the amorous hunter whose concordant safety is jeopardized only when he leaves Venus for the dangers of the hunt) and his beautiful and socially superior goddess, the Spanish Venus (whose amorous fulfilment can only occur when she puts aside her pride).

In *Celos aun del aire matan* the goddesses Venus and Diana personify opposed forces. Venus is love, fertility, the "natural" interactions necessary for conjugal contentment, procreation and (in the case of royalty) dynastic survival. Diana has only negative attributes, in spite of the dramatic music composed for her by Juan Hidalgo. Diana sings some of Hidalgo's rare and strikingly affective recitative, though she is overly stern, vengeful, violent, inflexible, and determined to enforce an unnatural chastity upon the nymphs at all costs. Revenge, always a dangerous motive, turns against her and at the opening of act 3 she is shown to us alone in a barren setting, stripped of the instruments of power, her worshipers scattered by fire and panic. Vengeance and chastity, her two salient attributes, are vilified for obvious reasons. The Peace of the Pyrenees was a hard-wrought reconciliation that forced a change in role for the Spanish Habsburgs in European politics, and Philip IV's image was adjusted accordingly to that of peacemaker, after the expensive and fruitless war with France. The infanta's marriage meant that the royal family and its subjects had to embrace a union with a former enemy. Thus Diana's emphasis on vengeance and wrath are placed in a negative light, just as Marte's jealousy, vengeance, and martial instincts are condemned and made light of in *La púrpura de la rosa*. Chastity, however virtuous in itself, was neither prudent nor productive in a royal marriage, so that Diana, once she loses her power, sings ineffectually in an attempt to oppose the love airs incited

by the unseen Venus in *Celos aun del aire matan*. Of course, Pocris loses her chastity as she falls in love with Céfalo, and both relinquish their neglectful pride thanks to the agency of Venus, who gives the nymph Aura the power of love-infusing special song usually reserved for the gods themselves. At the beginning of the opera, just as Diana moves unjustly to punish the nymph for her tryst with Eróstrato, Venus sets Aura free to sing and influence the others with libidinously loaded "venereal" music.

Both pairs of lovers, Venus and Adonis in *La púrpura de la rosa*, and Céfalo and Pocris in *Celos aun del aire matan*, are brought together by Venus and capitulate to the effects of sensual, insistent strophic melodies or *coplas* in triple meter. The transformation of the female protagonists in particular is effected through repetitive and lyrical music, as if the sense of hearing were thought to be especially sensitive in women, making them easy targets for the language of desire and seduction. Touched time and again by Adonis's lyricism, Venus sheds the armour of her deified superiority to love a mortal (inferior France!) in *La púrpura de la rosa*. Her conversion from haughty goddess into love-torn dama is complete when she comes running "naked to the waist with her hair let down" (*desmenelada*), enflamed by the sound of his refrain, in search of the wounded Adonis, only to encounter his death and her own final lament. The transformation of Pocris in *Celos aun del aire matan* is likewise due to her hearing. When Céfalo calls for a breeze to cool him from the ardors of the hunt, the word "aura" is heard as "Laura," fanning Pocris's suspicion. Fatal jealousy pours into Pocris through her ears, when the fury Alecto sings to deceive her with false sweetness, leading her down the path toward her tragic demise. Céfalo, however, can also be blamed for the fatal mistake, since he is charged with neglect (the "olvido" so important to Diana) for spending too much time hunting away from his wife, fascinated by the deceptive voice of the unseen Aura heard in the breeze. The title of the opera, *Celos aun del aire matan*, highlights the importance of this warning against jealousy on the occasion of the royal wedding. Historians have noted that Louis XIV was, from the first, anything but a faithful spouse to his innocent bride, who was forced to adjust to his neglect and the fact that their marriage was "incidental to his sensual life."[65] Moreover, the explanation of the Cephalus and Procris myth given by Pérez de Moya indicates that Calderón's and Hidalgo's audience already knew that the myth contained a moral exhortation against the dangers of unfounded jealousy in marriage.

In the fable of Cephalus and Procris, it will be noted that the dog that Diana gave to Procris signifies the loyalty that the chaste woman should always give to her husband. . . . That Procris dies by the hand of her husband signifies that too little prudence guides us most often to look for that which we would not want to find, and in this way many of us are killed by the spear of too little self control, that is, by the passion that we guard towards ourselves, through having crazily and haughtily believed in gossip.[66]

The operas with all of their scenic and musical apparatus celebrated the political and erotic passions of the royal coupling. Venus, as in other operas and as in the Veronese painting, brings her erotic energy and the beneficent power of love to both of these first extant Hispanic operas, through Calderón's and Hidalgo's elaborately ornate poetics. This is hardly surprising given the importance of procreative activity to the ultimate success of dynastic marriages.

The concordance of themes among paintings and operas, however, was most likely the invention of the patron that Velázquez, Calderón, and Hidalgo all served in one capacity or another in the 1650s and through 1660. This was the flamboyant don Gaspar Méndez de Haro y Guzmán, Marquis de Eliche (also Heliche, Liche), a vigorous patron of the arts and a well-known libertine. The indulged son of the prime minister or *valido*, don Luis Méndez de Haro, the Marquis was a patron of painters and an energetic art collector.[67] As a court minister he knew the royal paintings well (and the king's particular favorites), was deeply involved in the preparations for the visit of the French envoy in 1659, and might have been privy to details of his father's negotiations with Mazarin. As Alcaide del Buen Retiro and as Montero Mayor del Rey, he was the official in charge of the staging of court plays both in Madrid, at the Alcázar and the Buen Retiro, and at the outlying palaces of La Zarzuela and El Pardo. Probably he chose the subjects for the operas of 1660 or worked these out together with Calderón. Eliche may already have produced two of Calderón's mythological plays as semioperas with music by Juan Hidalgo, and he sponsored the first *zarzuelas* on texts by Calderón and other court dramatists.[68] During his tenure as governor of the Retiro, he spared no expense in bringing together the best actress-singers and musicians to perform at the royal theaters, though the singers he engaged were all from the acting companies that regularly performed *comedias* in the public theaters as well.[69]

The musical-theatrical works that Eliche staged for Philip IV had love-inspired conflicts at their center, and some contained flagrantly erotic musical scenes that can be associated as well with erotic paintings. In the surviving music for *La púrpura de la rosa* (Lima, 1701) by Tomás de Torrejón y Velasco, most likely based on that of Hidalgo from 1659 to 1660, the double-choir piece "No puede Amor / hacer mi dicha mayor" encloses the intimate dalliance of Venus and Adonis and dominates the scene in Venus's garden, in which Adonis assumes his traditional pose enjoying the ample luxury of Venus's lap, as in the Veronese painting. This moment from Ovid's tale is regularly depicted with clear erotic intent. Here in the opera, the garden's amorous tranquility has an illicit edge to it, for the musical setting transforms the scene into an enormous *jácara* with solo strophes for the lovers and a choral refrain for the nymphs. Jácaras were

wildly popular with audiences and they usually treated some aspect of the world of *germanía*, the street life of urban ruffians, pimps, and prostitutes. Adonis and Venus here enjoying their illicit affair in pastoral bliss would hardly seem to be the typical *jaque* and *marca*, unless, of course, the composer wanted us to hear them as such. Although Calderón did not disgrace the lovers with lowlife utterance, the music quite clearly lends a sexually explosive and titillating quality to their brief time together, while enforcing an important traditional distinction between moral music and highly sensual and therefore immoral music. This scene, and the fast-driving coplas that Amor initiates to follow it, make audible *La púrpura de la rosa's* erotic appeal.[70]

Though performed before 1655 (the date at which the Marquis de Eliche is usually assumed to have taken up the production of musical theater),[71] Calderón's *Fortunas de Andrómeda y Perseo* (1653) was staged as a semiopera to celebrate the return to good health of Queen Mariana, presumably with music by Hidalgo, and it contains a number of musical scenes essential to the understanding of the plot.[72] In one of these, Morfeo, god of sleep, brings a dream to reveal to the sleeping hero Perseo the circumstances of his conception. In the dream, Perseo sees his mother Danae locked in a chamber in her father's palace and guarded by her *damas*. Danae and her ladies sing a well-known *romance*, "Ya no les pienso pedir" to pass the time and alleviate her loneliness.[73] As they sing the third strophe of their song, a fast, racy new song performed offstage interrrupts them and pieces of gold rain down from above. In their avaricious frenzy to grab the money, the *damas* ignore Danae, allowing Júpiter to enter from above, riding an eagle and disguised as Cupid, to begin his rape of Danae.

The racy song, "El que adora imposibles / llueva oro," thus begins the seduction of Danae through the sense of hearing, seducing the ear first. The text of the song is a *seguidillas*, and the music has a striking rhythm – a bouncy celebration of the flagrant eroticism of the scene. Perhaps this song would have been considered "venereal music" (*música venerea*) by the seventeenth-century critics who objected to the use of the seguidillas and other such dances in the theater. Surely dramatist and composer desired the strong theatrical effect of accompanying Jupiter's rape of Danae with this sort of suggestive music, but perhaps as well this choice of topic was related to the existence of a famously erotic painting of this scene in the royal collection. Titian's *Rape of Danae* (now in the Prado museum) was originally painted for Philip II as part of the erotic *Poesie* that formed part of Philip IV's collection as well.[74]

There is little doubt that Venetian paintings such as Titian's *Rape of Danae*, Veronese's *Venus and Adonis*, Velázquez's *Venus and Cupid* (the *Venus del espejo* or "Rokeby" Venus [Fig. 51]), and others of amorous mythological scenes were appreciated in large part for their eroticism.[75]

This is pointed out in an oft-cited passage from Francisco Pacheco's *Arte de la pintura* (1649) in which he criticized the famous masters who had supplied vividly drawn and colored licentious paintings of women from ancient pagan mythology for the "salons and chambers of the great men and princes of the world."[76] This extract is from the section of his treatise that deals with the manner of depicting the female body, necessary as well for paintings on certain religious subjects. Pacheco, who was Veedor de Pinturas for the Inquisition in Seville, Velázquez's teacher, and later his father-in-law, condemned the practice of providing erotic masterpieces on demand for hungry patrons. In his censure of this activity, he quoted from a poem by the classicist Bartolomé Leonardo de Argensola that specifically mentions the amorous mythological fables of Leda and the swan, the Rape of Europa, and "prodigally lascivious Venus" (*Venus pródigamente deshonesta*).[77] It is likely that a similarly voyeuristic and erotic pleasure was enjoyed by the men who watched as the nearly all-female casts of actress-singers performed in the semioperas and operas, which provided as well the titillation of watching actresses move their bodies in male garb for a number of leading, amorous roles.

Perhaps the most erotic Venus painting of all time, Velázquez's *Venus and Cupid,* itself inspired in part by the painter's study of earlier Venetian *poesie,* belonged to and was most likely painted for the Marquis de Eliche – the very patron who organized the palace musical plays on amorous mythological stories and who constructed the predominantly female casts that sang and danced as deities for the royal enjoyment. The Venus painting was included in an inventory of Eliche's paintings drawn up 1 June 1651 in Madrid. Presumably, Velázquez painted it before he departed for his Italian journey (early 1649 to June 1651). At age twenty-two, Eliche already owned some three hundred paintings. A later inventory of 1677 notes that the Venus not only belonged to Eliche's collection, housed in his Madrid palace known as the Jardín de San Joaquín, but was placed with other paintings of an erotic nature on the ceiling of a gallery (could this room have been the marquis's bedroom?). The other pictures included a depiction of the chaste Susana before the elders, a Danae "with the shower of gold in a landscape naked lying on a red cloth," and a canvas of sleeping Apollo "with the nine Muses around him playing musical instruments."[78]

Though the live model for the Velázquez Venus could not have been the famous actress Damiana, as was once supposed (she became Eliche's mistress years later, in 1658), it is still possible that Velázquez painted as Venus one of the actress-singers that so fascinated the marquis.[79] The dark gray sheets that Venus rests on in the Velázquez painting are striking, and evidently were so in the minds of his contemporaries, who might have associated them with those of an actress who created a scandal by making her

bed with sheets of black taffeta.[80] More important, however, is the fact that this painting and other erotic mythologies help us to understand the ways in which both the personal inclinations of a powerful patron and the political and social requisites of royal occasions intersected in the creation of splendidly unique works of musical drama, such as the Calderón and Hidalgo operas, just as they did in the paintings, musical and nonmusical, produced by Velázquez.

Notes

CHAPTER 1. INTRODUCTION

1. The manuscript for the *Arte* was completed by 24 January 1638 but remained unpublished for another decade. There is a recent edition of Pacheco's work, in Spanish, by Bonaventura Bassegoda i Hugas (Madrid, 1990). Pacheco's writing about Velázquez in particular is translated into English in Enriqueta Harris's *Velázquez* (Oxford, 1982), 191–95.

2. For this and other sources for Velázquez, see *Varia Velazqueña: Homenaje a Velázquez en el III centenario de su muerte, 1660–1960*, 2 vols. (Madrid, 1960). More recently, Julián Gállego has published an edited version of Martínez's *Discursos* (Madrid, 1988).

3. For an English translation, see Nina Ayala Mallory's edition of Palomino's *Lives of the Eminent Spanish Painters and Sculptors* (Cambridge, 1987). The life of Velázquez by Palomino is also translated in Harris's monograph [see note 1 above].

4. Documentary evidence for the history of art at the Habsburg court in Madrid has yielded rich rewards to modern scholars working in four collections: the Archivo de Palacio, Madrid; the Archivo General de Simancas (near Valladolid); the Archivo Histórico de Protocolos, Madrid; and the Archivo Histórico Nacional, Madrid.

5. See chap. 2 of Steven N. Orso's *Velázquez, Los Borrachos, and Painting at the Court of Philip IV* (Cambridge, 1993) and Peter Cherry, "New Documents for Velázquez in the 1620s," *Burlington Magazine* 133 (1991), 108–15.

6. Juan Agustín Ceán Bermúdez, *Diccionario histórico de los más ilustres profesores de las Bellas Artes en España*, 6 vols. (Madrid, 1800).

7. When Antonio Ponz was assembling his many-volume collection of the artistic monuments of Spain, he was not correctly informed about the identity of Ambrogio Spinola, the victorious general for the Spanish forces at Breda in the Netherlands. Describing the dining room in the Royal Palace, he wrote: "De Velazquez hay diferentes cosas; pero la principal es la que, según dicen, representa al Marques de Pescara recibiendo las llaves que le entrega de alguna Ciudad." Antonio Ponz, *Viage de España, en que se da noticia de las*

cosas mas apreciables, y dignas de saberse, que hay en ella, 18 vols. (Madrid, 1772–94), vol. 6, 49.

8. See the *Colección de documentos inéditos para la historia de España* 55 (Madrid, 1870), in which Zarco del Valle publishes documents dating from the time of Velázquez's appointment as *pintor real* in 1623 until the end of his life.

9. Francisco Javier Sánchez Cantón, *Como vivía Velázquez: Inventario descubierto por D. F. Rodríguez Marín, transcripción y estudio por F. J. Sánchez Cantón* (Madrid, 1942).

10. María L. Caturla, "Cartas de pago de los doce cuadros de batallas para el salón de reinos del Buen Retiro, " *Archivo Español de Arte* 33 (1948), 292–304. For an excellent example of how this kind of documentation serves historians and art historians, see Jonathan Brown and John H. Elliott, *A Palace for a King: The Buen Retiro and the Court of Philip IV* (New Haven and London, 1987).

11. Harris, *Velázquez,* 193.

12. Although we may suppose that Velázquez wrote letters home to Spain during his two trips to Italy, and although Pacheco mentions correspondence between Velázquez and the Flemish painter Peter Paul Rubens, only two letters written by Velázquez are known today.

13. William Stirling-Maxwell, *Annals of the Artists of Spain,* 3 vols. (London, 1848), rev. ed. 4 vols. (London, 1891). Stirling-Maxwell's *Velázquez and His Works* (London, 1855) expands slightly on the biography of the artist found in his earlier work but does not include a catalogue of the paintings. The *Annals* was reviewed by the poet Prosper Merimée in the *Revue des deux mondes,* année 18, n.s. 24 (November 1848), and the section on Velázquez was translated and published separately by W. Bürger (nom de plume of Théophile Thoré). It also appeared in a German translation. The French did, during the nineteenth century, publish quite a lot about Velázquez, even going so far in their admiration as to call him "chef de l'Ecole de Madrid Gallo-Espagnole." [See Frédéric Borgella, "Don Diego Rodriguez de Silva y Velasquez," *Revue espagnole, portugaise, brésileinne et hispano-américaine,* a.k.a. *Revue des races latines* 5 [1857], 62–81.) For more about the French appropriation of the painter see Alisa Luxenberg, "Regenerating Velázquez in Spain and France in the 1890s," *Boletín del Museo del Prado* 17, no. 35 (1999), 25–149.

14. Gregorio Cruzada Villaamil, *Anales de la vida y obras de Diego de Silva Velázquez escritos con ayuda de nuevos documentos* (Madrid, 1885).

15. "Velasquez," *Edinburgh Review* 193 (January 1901), 133.

16. Aureliano de Beruete y Moret, *Vélasquez* (Paris, 1898).

17. August L. Mayer, *Velázquez: A Catalogue Raisonné of the Pictures and Drawings* (London, 1936).

18. José López-Rey, *Velázquez: A Catalogue Raisonné of his Work with an Introductory Study* (London, 1963), revised as *Velázquez: The Artist as Maker with a Catalogue Raisonné of his Extant Works* (Lausanne and Paris, 1979), and *Velázquez,* 2 vols. (Cologne, 1996).

19. For a more detailed discussion of the various catalogues of Velázquez's work, see Jonathan Brown's bibliographical essay in *Velázquez: Painter and Courtier* (New Haven and London, 1986), 305–9.

20. "Spanish Art at the New Gallery," *The Daily Telegraph* (14 January 1896).

21. "Velasquez the Courtier," *Blackwood's Edinburgh Magazine* 164 (July–December 1898), 542.

22. Paul Lefort, *Velázquez* (Paris, 1888).

23. Justi's *Velazquez und sein Jahrhundert* was published in Bonn in 1888 and in an English translation by A. H. Keane, with revisions by the author (London, 1889). The definitive edition, in 2 volumes, appeared in Bonn in 1903. It first appeared in Spanish translation, serially, in *España Moderna*, vols. 211–38 (July 1906–October 1908).

24. First edition of only 500 copies. Second edition London 1899; reprinted 1900, 1902, and 1906. The most recent edition (London, 1962) is prefaced by a useful bibliographical essay by Theodore Crombie, "Velázquez Research since Stevenson (1900–1960)."

25. R. A. M. Stevenson, *Velázquez* (London, 1895), 86.

26. Walter Armstrong, *Velázquez: A Study of his Life and Art* (London, 1897), 119.

27. "Velasquez," *Edinburgh Review*, 133.

28. C. J. Holmes, "Velázquez and his Modern Followers," *Dome*, n.s., vol. 3 (1899), 90–95.

29. This connection between Velázquez's critical fortunes and modern art was astutely noted by Juan Antonio Gaya Nuño in his *Bibliografía crítica y antológica* (Madrid, 1963), which remains a fine reference for the literature on the artist to that date. The first such bibliography was published by José Ramón Mélida in a special issue of the *Revista de Archivos, Bibliotecas y Museos* (1899), marking the tercentenary of Velázquez's birth.

30. Mallory, *Lives*, 142–43.

31. Brown, *Velázquez: Painter and Courtier*, 308. See F. J. Sánchez Cantón, "La librería de Velázquez," in *Homenaje a Menéndez Pidal*, vol. 3 (Madrid, 1925), 379–406.

32. José Antonio Maravall, *Velázquez y el espíritu de la modernidad* (Madrid, 1987).

33. For *Los Borrachos*, Orso, *Velázquez*, 1–39, reviews the historiography of the painting as a prelude to the author's advancing his own interpretation of the picture.

34. For a recent study of *Las Hilanderas*, see J. B. Bedaux, "Velázquez's Fable of Arachne (Las Hilanderas): A Continuing Story," *Simiolus* 21 (1992), 296–305.

35. See, for example, the bibliographies in Caroline Kesser, *Las Meninas von Velázquez: Eine Wirkungs- und Rezeptionsgeschichte* (Berlin, 1994); Francisco Calvo Serraller, *Las Meninas de Velázquez* (Alcobendas [Spain], 1995); and Alice Sedgwick Wohl, "Velázquez: Las Meninas," *News from RILA* (*International Repertory of the Literature of Art*), no. 5 (February 1987), 5–10.

36. José Ortega y Gasset, *Velázquez: Sechs Farbige Wiedergaben nach Gemalden aus dem Prado Museum* (Bern, 1943; English edition, Oxford, 1946).

37. Michel Foucault, *Les Mots et les choses* (Paris, 1966). For Foucault's influence, see the bibliographies in publications listed in note 29.

38. *Blackwood's Edinburgh Magazine*, 542–43.

39. It has long been recognized that Velázquez's claims to nobility were extremely difficult for him to justify, though no one has begrudged the king awarding him the Order of Santiago on account of the nobility of his art and his faithful service. However, recently new attention has been brought to bear on this subject by Luis Méndez Rodríguez, "La familia de Velázquez: Una falsa hidalguía," in *Velázquez y Sevilla*, exh. cat. (Monasterio de la Cartuja de Santa María de las Cuevas and Salas del Centro Andaluz de Arte Contemporáneo, 1999), 33–49, and by Kevin Ingram, "Diego Velázquez's Secret History: The

Family Background the Painter was at Pains to Hide in His Application for Entry into the Military Order of Santiago," *Boletín del Museo del Prado* 17, no. 35 (1999), 69–85. The latter author claims that the continued insistence on believing that Velázquez was an *hidalgo* (a gentleman by birth) places "constraints on the interpretation of the work."

40. Jon Manchip White, *Diego Velázquez: Painter and Courtier* (London, 1969), xvi.

41. Ibid., xxi–xxii.

42. *Velázquez y Sevilla,* as in note 33, and *Velázquez in Seville,* exh. cat. (National Gallery of Scotland, Edinburgh, 1996).

43. Among the published results of this kind of research are Gridley McKim-Smith, Greta Anderssen-Bergdoll and Richard Newman, *Examining Velázquez* (New Haven, 1988); Gridley Mc-Kim Smith and Richard Newman, *Cienca e historia del arte: Velázquez en el Prado* (Madrid, 1992); Carmen Garrido Pérez, *Velázquez: Técnica y evolución* (Madrid, 1992); and Jonathan Brown and Carmen Garrido, *Velázquez: The Technique of Genius* (New Haven and London, 1998).

44. As in note 25.

CHAPTER 2. BECOMING AN ARTIST IN SEVENTEENTH-CENTURY SPAIN

1. H. J. Schroeder, *The Canons and Decrees of the Council of Trent* (St. Louis, 1950).

2. Bonaventura Bassegoda i Hugas, "Pacheco y Velázquez," in *Velázquez y Sevilla,* exh. cat. (Seville: Monasterio de la Cartuja de Santa María de las Cuevas, 1999), 124–40 for a worthwhile summary and also the extensive and informative notes of Bassegoda in the 1990 edition of *Arte de la Pintura* (see note 4 below).

3. Jonathan Brown, *Images and Ideas in Seventeenth-Century Spain* (Princeton, 1978), 21–86.

4. Francisco Pacheco, *Arte de la pintura* (Seville, 1649); ed. Bonaventura Bassegoda i Hugas (Madrid, 1990).

5. Gabriele Paleotti, *Discorso intorno alle Imagini sacre e profane* (Bologna, 1582) ed. P. Barocchi, *Trattati d'Arte del Cinquecento,* 3 vols. (Bari, 1960), vol. 2, 119–509.

6. Antonio Acisclo Palomino y Velasco, *El museo pictórico y escala óptica,* 3 vols. (Madrid, 1724); 2nd ed., 3 vols. (Madrid, 1988), vol 3, 306–7.

7. For aspects of artists' education elsewhere in Europe see *Children of Mercury: The Education of Artists in the 16th and 17th Centuries,* exh. cat. (Providence, RI, 1984).

8. Francisco Pacheco, *Libro de descripción de verdaderos retratos, de ilustres y memorables varones* (Madrid, Museo Lázaro Galdiano, Biblioteca del Palacio Real, Biblioteca Nacional). Facsimile edition prepared by José María Asensio, *Francisco Pacheco, sus obras artísticas y literarias: Introducción e Descripción del Libro de Descripción de verdaderos retratos de illustres y memorables varones* [. . .] (Madrid, 1886). Francisco Pacheco, *Libro de descripción de verdaderos retratos de ilustres y memorables varones* (Madrid, 1983), prologue by Diego Angulo.

9. Peter Cherry, "Artistic Training and the Painters' Guild in Seville," *Velázquez in Seville,* exh. cat. (Edinburgh: National Gallery of Scotland, 1996), 67–75.

10. María Carmen Heredía, *Estudio de los contratos de aprendizaje artistíco en Sevilla a comienzos del siglo XVIII* (Seville, 1974).

11. Cherry, "Artistic Training," p. 69.

12. José García Hidalgo, *Principios para estudiar el nobilísimo y real Arte de la Pintura* (Madrid, 1693), ed. Marqués de Lozoya (Madrid, 1965), fols. 8–9.

13. Pacheco, *Arte de la pintura*, 443–444.

14. Jonathan Brown, "Academies of Painting in Seventeenth-Century Spain," *Leids Kunsthistorisch Jaarboek*, 5–6 (1986–87), 177–85.

15. Zahira Véliz, *Artists' Techniques in Golden Age Spain: Six Treatises in Translation* (Cambridge, 1987).

16. María Luísa Caturla, "Documentos en torno a Vicencio Carducho," *Arte Español: Revista de la Sociedad Española de Amigos del Arte* 26 (1968), 177–221.

17. Pacheco, *Arte de la pintura*, 481–82.

18. Pacheco, ibid.

19. Zahira Véliz, "Velázquez's Early Technique," *Velázquez in Seville*, exh. cat. (Edinburgh: National Gallery of Scotland, 1996), 79–84.

20. Pacheco, *Arte de la pintura*, 443 and 527–28.

21. Cherry, "Artistic Training," 74.

22. Lázaro Díaz del Valle, *Origen e yllustración del nobilísimo y real arte de la pintura y dibuxo con un epílogo y nomenclatura de sus más yllustres más insignes y más afamados professores*, eds. F. J. Sánchez Cantón, in *Fuentes literarias para la historia del arte español*, vol. 2 (Madrid, 1933), 323–93; Francisco Calvo Serraller, *Teoría de la pintura del siglo de oro* (Madrid, 1981), 459–78.

23. Gridley McKim-Smith and Richard Newman, *Examining Velázquez* (New Haven and London: 1988); Carmen Garrido Pérez, *Velázquez: Evolución y técnica* (Madrid, 1992).

24. Pacheco, *Arte de la pintura*, 483–88.

25. For a thorough study of the reliance on engraved sources by artists in Andalusia see Benito Navarrete Prieto, *La pintura andaluza del siglo xvii y sus fuentes grabadas* (Madrid, 1999).

26. Pacheco, *Arte de la pintura*, 268–69.

27. Navarrete Prieto, *La pintura andaluza.*

28. Vicente Lleó Cañal, "The Cultivated Elite of Velázquez's Seville," *Velázquez in Seville*, exh. cat. (Edinburgh, National Gallery of Scotland, 1996), 23–27.

29. See, for example, Gridley McKim-Smith, "La técnica sevillana de Velázquez" and also Augustín Bustamente and Fernando Marías, "Entre práctica y teoría: La formación de Velázquez en Sevilla," both in *Velázquez y Sevilla*, exh. cat. (Seville: Monasterio de la Cartuja de Santa María de las Cuevas, 1999), 108–22 and 140–56.

30. Pacheco, *Arte de la pintura*, 526–27.

31. Pacheco, ibid., 521.

32. McKim-Smith and Newman, *Examining Velázquez*, and also Zahira Véliz, "Aspects of Drawing and Painting in Seventeenth-Century Spanish Treatises," *Leids Kunsthistorisch Jaarboek: Looking Through Paintings* (Leiden, 1998), 295–318.

CHAPTER 3. VELÁZQUEZ AND ITALY

This essay was originally read at the symposium "L'Europa e l'arte italiana," held on the occasion of the centennial of the founding of the Kunst-

historisches Institut en Florenz, September 22–27, 1997, and was published in Max Seidel, ed., *L'Europa e l'arte italiano*. Collana del Kunsthistorisches Institute in Florenz (Venice, 2000), 307–19. This version has been slightly revised, and the bibliography has been brought up to date to include articles published in connection with the four hundredth anniversary (1999) of Velázquez's birth.

1. The fundamental article on the 1649–50 trip is Enriqueta Harris, "La misión de Velázquez en Italia," *Archivo Español de Arte* 33 (1960), 109–36. For recently published information, see the following (listed in chronological order): Jennifer Montagu, "Velázquez Marginalia: His Slave Juan de Pareja and His Illegitimate Son Antonio," *Burlington Magazine* 125 (1983), 683–85; José Luis Colomer, "'Dar a Su Magestad algo bueno': Four Letters from Velázquez to Virgilio Malvezzi," *Burlington Magazine* 135 (1993), 67–72; Edward Goldberg, "Diego Velázquez's Visit to Florence in 1650," *Paragone* 45 (1993), 92–96; Enriqueta Harris and José Luis Colomer, "Two Letters from Camillo Massimi to Diego Velázquez," *Burlington Magazine* 136 (1994), 545–48; and Salvador Salort, "La misión de Velázquez y sus agentes en Roma y Venecia: 1649–1653," *Archivo Español de Arte* 72 (1999), 415–68.

2. For the hypothesis of the 1637 trip, see José M. Pita Andrade, "Del Buen Retiro a la Torre de la Parada pasando por Italia?: El posible viaje de 1636," in *Velázquez y el arte de su tiempo*. V Jornadas de Arte, Departamento de Historia del Arte "Diego Velázquez," CSIC (Madrid, 1991), 119–26, and "Velázquez en Italia," in *Reflexiones sobre Velázquez* (Madrid, 1992), 58–62. The hypothesis is refuted by Fernando Marías, "Sobre el número de viajes de Velázquez en Italia," *Archivo Español de Arte* 65 (1992), 218–21.

3. See note 5.

4. Francisco Pacheco, *Arte de la pintura* (Seville, 1649), ed. Bonaventura Bassegoda i Hugas (Madrid, 1990), 206–9.

5. The letters are assembled in *Varia Velazqueña: Homenaje a Velázquez en el III centenario de su muerte, 1660–1960*, vol. 2 (Madrid, 1960), 230–33.

6. See *Varia Velazqueña*, vol. 2, 232–33.

7. For this incident and other details on Barberini's stay in Madrid, see Enriqueta Harris, "Cassiano dal Pozzo on Velázquez," *Burlington Magazine* 112 (1970), 364–73; José Simón Díaz, "El arte en las mansiones nobiliarias madrileñas de 1626," *Goya* 154 (1980), 200–205 and "La estancia del cardenal legado Francesco Barberini en Madrid el ano de 1626," *Anales del Instituto de Estudios Madrileños* XVII (1980), 159–213.

8. Genevieve and Olivier Michel, "Nicolas Poussin et la maison Mannara," *Gazette des Beaux-Arts* 127 (1996), 216, note that this house was rented from 6 January 1630 to 20 April 1631 by "Don Diego pittore," who, they speculate, was Velázquez. While Velázquez left Rome in the autumn of 1630, it is possible that he might have intended to stay longer when he rented the house, if indeed he was the "Don Diego" in question. For speculation on the contact and artistic relations between Poussin and Velázquez, see Véronique Gérard, "Poussin et Velázquez," in *Nicolas Poussin (1594–1665). Actes du colloque organisé au Musée du Louvre par le Service culturel du 19 au 21 octobre 1994*, vol. 1 (Paris, 1996), 395–405.

9. The earlier date is proposed by Enriqueta Harris and John Elliott, "Velázquez and the Queen of Hungary," *Burlington Magazine* 138 (1976), 24–26. The recent attempt to revive the attribution to Velázquez of the so-called "*Quarrel*

at the Spanish Embassy" (Rome, Collezione Pallavicini) seems misguided. I continue to believe that it was executed by one of the *bambocciati*. See the entry by Salvador Salort Pons in the exhibition catalogue *Velázquez a Roma, Velázquez en Roma* (Rome, 1999), 84–85. This exhibition, by the way, is one of the strangest ever devoted to the artist.

10. The final payment to Velázquez for this work was made on 22 July 1629 at just about the time he was preparing to leave for Italy. For the document, see *Varia Velazqueña*, vol. 2, 231.

11. For the recent bibliography on this painting, see José Luis Colomer, "Roma 1630: *La Túnica de José* y el estudio de las 'pasiones," *Reales Sitios* 36 (1999), 39–49, and Fernando Marías, "'La túnica de José': La historia al margen de lo humano," in *Velázquez* (Madrid: Fundación Amigos del Museo del Prado, 1999), 277–96, a searching examination of Velázquez's interpretation of the subject and his response to Italian sources for the painting.

12. See Carmen Garrido Pérez, *Velázquez, técnica y evolución* (Madrid, 1992), 219–33.

13. For a recent survey of the main currents of scholarship on this painting, see Trinidad de Antonio, "La fragua de Vulcano," in *Velázquez* (Madrid: Fundación Amigos del Prado, 1999), 25–41.

14. See Garrido Pérez, *Velázquez* (as in n. 12), 235–45.

15. See ibid., 205–17.

16. The origins of plein-air landscape painting are discussed by Philip Conisbee, "The Early History of Open-Air Painting," in *In the Light of Italy: Corot and Early Open-Air Painting*, exh. cat., Washington, National Gallery (New Haven and London, 1996), 29–46, esp. 29–36.

17. For Pacheco's formulation of the iconography, see Jonathan Brown, *Images and Ideas in Seventeenth-Century Spanish Painting* (Princeton 1978), 70–71.

18. This analysis follows Garrido Pérez, *Velázquez* (as in n. 12), 279–87.

19. For the date and commission, see Jonathan Brown and J. H. Elliott, *A Palace for a King: The Buen Retiro and the Court of Philip IV* (New Haven and London, 1980), 254. Technical information is derived from Garrido Pérez, 1992 (as in n. 11), pp. 419–27.

20. For the problematic date, see Jonathan Brown, *Velázquez: Painter and Courtier* (New Haven and London, 1986), 97–98. The technique is analyzed by Garrido Pérez, *Velázquez* (as in n. 12), 419–27.

21. Two recent articles on Velázquez and his Italian sources trace innumerable borrowings by the artist, both compositions and motifs, from a wide range of Italian and classical sources: Manuela Mena Marqués, "Velázquez e Italia: Las metamorfosis del arte de la pintura, " in *Velázquez: El Papa Inocencio X de la Galería Doria Pamphilij, Roma* (Madrid, 1996), 61–94 (reprinted in *Velázquez a Roma, Velázquez en Roma* (Rome, 1999), 21–33); and Salvador Salort, "Velázquez a Roma," in *Velázquez a Roma, Velázquez en Roma* (Rome, 1999), 43–69.

From reading these articles, one would believe that Velázquez was the most assiduous magpie in the history of art. Mena, in particular, reduces source hunting to absurdity, for example citing Mantegna's *Camera degli sposi* and Ribera's *Holy Family with St. Bruno* (if reversed) as two of the inspirations for *Las Meninas*. The number and variety of the sources cited by these two authors amount to a full complement of the major Italian painters of the sixteenth and seventeenth century, thus confirming the thesis argued above,

that Velázquez's synthesis of Italian art was so thorough as to disguise what he took from whom.

22. For an excellent critical edition, see note 4.

23. The development of painting in Velázquez's Seville is recounted by Jonathan Brown, *The Golden Age of Painting in Spain* (New Haven, 1991), 115–31.

24. For an overview of the Spanish royal collection during the reign of Philip IV, with references to its development in the sixteenth century, see Jonathan Brown, *Kings and Connoisseurs: Collecting Art in Seventeenth-Century Europe* (Princeton, 1995), 95–131.

25. These paintings are discussed by Véronique Gérard, "Philip IV's Early Italian Commissions, " in *Oxford Art Journal* 5 (1982), 9–14.

26. The literature on Crescenzi has proliferated of late, although there is still no systematic study of his important career as a court artist. His significance is further obscured by the tendency of Italian scholars to neglect his Spanish period and of Spanish scholars, his Italian period. For the Italian period, see Luigi Spezzaferro, "Un imprenditore del primo seicento: Giovanni Battista Crescenzi," in *Ricerche di Storia dell'Arte* 26 (1985), 50–73. His work in Spain, especially in the field of architecture, is polemical in the extreme. For an entry into the thick of this discussion and earlier references, see Fernando Marías, "De pintores-arquitectos: Crescenzi y Velázquez en el Alcázar de Madrid," in *Velázquez y el arte de su tiempo* (1991), 81–89.

27. Steven N. Orso, *Velázquez, Los Borrachos, and Painting at the Court of Philip IV* (Cambridge, 1993), 40–96.

28. Jusepe Martínez, *Discursos practicables del noblísimo arte de la pintura*, ed. Julián Gállego (Madrid, 1988), 194.

29. For a brief discussion of the dating problem, see Brown, *Velázquez: Painter and Courtier* (as in n. 17), pp. 67–68.

30. On this point, see Fernando Checa, *Tiziano y la monarquía hispánica: Uso y funciones de la pintura veneciana en España (siglos XVI y XVII)* (Madrid, 1994).

31. The relationship of Velázquez's technique to Venetian painters of the sixteenth century is analyzed by Gridley McKim-Smith, Greta Andersen-Bergdoll, and Richard Newman, *Examining Velázquez* (New Haven, 1988), 34–50, although different conclusions are drawn from the ones presented here.

CHAPTER 4. VELÁZQUEZ AND THE NORTH

1. This passage is taken from Francisco de Holanda's *Roman Dialogues*. A translation of this text can be found in Robert Klein and Henri Zerner, *Italian Art 1500–1600: Sources and documents in the history of art* (Englewood Cliffs, NJ, 1966).

2. For the relationship between Italian and Netherlandish art, see Bernard Aikema and Beverly Louis Brown, eds., *Renaissance Venice and the North: Crosscurrents in the Time of Bellini, Dürer and Titian*, exh. cat. (Venice, Palazzo Grassi, 1999–2000).

3. Quoted from Francisco Calvo Serraller, *Teoría de la pintura española del siglo de oro* (Madrid, 1981), 113.

4. Vicente Carducho, *Diálogos de la pintura*, ed. Francisco Calvo Serraller (Madrid, 1979), 94–95.

5. Francisco Pacheco, *Arte de la pintura*, ed. Francisco J. Sánchez Cantón (Madrid, 1956), 55, 367–68.
6. For Velázquez and his Seville years, see *Velázquez in Seville*, exh. cat. (Edinburgh, National Gallery of Scotland, 1996). For the career of the artist see also Enriqueta Harris, *Velázquez* (Oxford, 1982), and Jonathan Brown, *Velázquez: Painter and Courtier* (New Haven and London, 1986).
7. For Velázquez at court see Brown, *Velázquez*; Steven N. Orso, *Velázquez, Los Borrachos, and Painting at the Court of Philip IV* (Cambridge, 1993); and *Velázquez, Rubens y Van Dyck: Pintores cortesanos del siglo XVII*, exh. cat., ed. Jonathan Brown (Madrid, Museo del Prado, 1999–2000).
8. For the tradition of court portraiture leading up to Velázquez's time, see Lorne Campbell, *Renaissance Portraits* (New Haven and London, 1990), and *Alonso Sánchez Coello y el retrato en la corte de Felipe II*, exh. cat. (Madrid, Museo del Prado, 1990).
9. Linda Seidel, *Jan Van Eyck's Arnolfini Portrait: Stories of an Icon* (New York, 1993), 117–18.
10. For Rubens's Spanish trip and his relationship to Spanish patronage, see Alexander Vergara, *Rubens and His Spanish Patrons* (Cambridge, 1999).
11. See the translation of the biography of Rubens included in Pacheco's book *Arte de la pintura* in Vergara, *Rubens*, app. 1, 189–191.
12. For the technique of Velázquez, see Jonathan Brown and Carmen Garrido, *Velázquez: The Technique of Genius* (New Haven and London, 1998), and Gridley McKim-Smith, Greta Anderssen-Bergdoll, and Richard Newman, *Examining Velázquez* (New Haven, 1988).
13. For this aspect of the career of Velázquez, see Orso, *Velázquez*.
14. Ruth S. Magurn, *The Letters of Peter Paul Rubens* (Cambridge, MA, 1955), 101–2.

CHAPTER 5. "SACRED AND TERRIFYING GAZES"

I would like to thank Fernando Bouza, Roger Chartier, Julio Pardos, Kirsten Schultz, and Gail Duggan for their advice, recommendations, and help.

1. Cf. Fernando Checa and José Miguel Morán, *El Barroco* (Madrid, 1986), 198.
2. Alejandra B. Osorio, *Inventing Lima: The Making of an Early Modern Colonial Capital, 1540–1680* (Ph.D. dissertation, SUNY at Stony Brook, 2001), chap. 4.
3. See F. R. Ankersmit, *History and Tropology: The Rise and Fall of Metaphor* (Berkeley, 1994), 110. See also Louis Marin, *Portrait of the King*, trans. Martha M. Houle (Minneapolis, 1988), 5 and 8.
4. Fernando Bouza's recent observation on the reign of Philip II serves to illuminate the early modern Spanish monarchy in general. According to Bouza, the monarchy made manifest "a true [propagandistic] framework, notable for its dimensions, its richness and, in particular, its surprising capacity . . . to respond to each situation in such a way that fulfilled the needs of the Crown." In Fernando Bouza, *Imagen y propaganda: Capítulos de historia cultural del reinado de Felipe II* (Madrid, 1998), 21. See also, Fernando Checa Cremades, *Felipe II: Mecenas de las Artes* (Madrid, 1992); Antonio Feros, *Kingship and Favoritism in the Spain of Philip III (1598–1621)* (Cambridge, 2000), chap. 4; Jonathan Brown, "Enemies of Flattery: Velázquez' Portraits of Philip IV," *Journal of Interdiscipli-*

nary History 17 (1986), 137–54; Jonathan Brown and John H. Elliott, *A Palace for a King: The Buen Retiro and the Court of Philip IV* (New Haven, 1980); John H. Elliott, *Spain and Its World, 1500–1700* (New Haven, 1989), pt. 3.

5. Tom Conley, "Introduction," in Marin, *Portrait of the King*, xiii.

6. Clifford Geertz, *Negara: The Theatre State in Nineteenth-Century Bali* (Princeton, 1980), 124.

7. Pierre Bourdieu, *Outline of a Theory of Practice*, trans. Richard Nice (Cambridge, 1977), 166.

8. Roger Chartier, *On the Edge of the Cliff: History, Language, and Practices* (Baltimore, 1997), 101. See also Pierre Bourdieu, who has written that "A performative utterance is destined to fail each time that it is not pronounced by a person who has the 'power' to pronounce it." Pierre Bourdieu, *Language and Symbolic Power*, ed. John B. Thompson, trans. Gino Raymond and Matthew Adamson (Cambridge, MA, 1991), 110; and Fernando R. de la Flor, *Emblemas: Lecturas de la imagen simbólica* (Madrid, 1995), 340–41.

9. See Teófanes Egido, *Sátiras Políticas de la España Moderna* (Madrid, 1973); Fernando Bouza, "Servidumbres de la soberana grandeza. Criticar al rey en la corte de Felipe II," in *Imágenes históricas de Felipe II* (Alcalá de Henares, 2000), 141–79; Jean-Marc Pelorson,"La politisation de la satire sous Philippe III et Philippe IV," in *La contestation de la société dans la littérature espagnole du siècle d'or* (Toulouse, 1981); Antonio Feros, "Vicedioses pero humanos: El drama del rey," *Cuadernos de Historia Moderna* 14 (1993), 103–31; Feros, *Kingship and Favoritism*, chaps. 8, 12, and Epilogue; Richard L. Kagan, *Lucrecia's Dreams: Politics and Prophecy in Sixteenth-Century Spain* (Berkeley, 1990); and Ronald Cueto, *Quimeras y sueños: Los profetas y la monarquía católica de Felipe IV* (Valladolid, 1994).

10. David I. Kertzer, *Ritual, Politics and Power* (New Haven, 1994), 39.

11. Janet Coleman, *A History of Political Thought: From the Middle Ages to the Renaissance* (Oxford, 2000), 19; see also Paul Kléber Monod, *The Power of Kings: Monarchy and Religion in Europe, 1589–1715* (New Haven, 1999).

12. Coleman, *A History of Political Thought*, 24.

13. "Sermón que predicó a la Majd. del Rey don Felipe III el doctor Aguilar de Terrones su predicador," in *Sermones funerales en las honras del rey nuestro señor don Felipe II* (Madrid, 1599), fol. 23v.

14. On the palace of the Buen Retiro, see Brown and Elliott, *A Palace for a King*; on the Hall of the Realms, see chap. 6.

15. Hernán Cortés, *Letters from Mexico*, ed. Anthony Pagden (New Haven, 1986), 112.

16. On these theories see Feros, *Kingship and Favoritism*, chap. 1.

17. See John H. Elliott, "The Court of the Spanish Habsburgs: A Peculiar Institution?" in John H. Elliott, *Spain and Its World, 1500–1700* (New Haven, 1989); Fernando Checa Cremades, "Felipe II en el Escorial: La representación del poder real," in *El Escorial: Arte, poder y cultura en la corte de Felipe II* (Madrid, 1989), 17–20; Fernando J. Bouza Alvarez, "La majestad de Felipe II: Construcción del mito real," in *La corte de Felipe II*, ed. José Martínez Millán (Madrid, 1994); and Feros, *Kingship and Favoritism*, chap. 4.

18. Juan Fernández de Medrano, *República mixta* (Madrid, 1602), 32.

19. Diego de Guzmán, *Vida y muerte de doña Margarita de Austria, reina de España* (Madrid, 1617), fols. 229v–230.

20. On the political and institutional consequences of the increasing inaccessibility of the Spanish king, see Feros, *Kingship and Favoritism*, chap. 4.

21. Baltasar Porreño, *Dichos y hechos del rey don Felipe II* [1628], ed. A. González Palencia (Madrid, 1942), 4, 5, 10.

22. Exodus 19:22–24.

23. Porreño, *Dichos y hechos*, 17.

24. In Lope Felix de Vega Carpio, *Obras escogidas*, ed. Fernando Sainz de Robles (Madrid, 1987), vol. 2, 1005–11.

25. *"Deffensa de la poesía": A 17th Century Anonymous Spanish Translation of Philip Sidney's "Defence of Poesie,"* ed. Benito Bracamonte (Chapel Hill, 1977).

26. Juan Pablo Mártir Rizo, *La Poética de Aristóteles traducida del latín* [1623], ed. Margerete Newels (Cologne, 1965).

27. Cf. Luis Cortés Echanove, *Nacimiento y crianza de personas reales en la corte de España, 1556–1886* (Madrid, 1958), 39.

28. Mártir Rizo, *La Poética de Aristóteles*, 44–45.

29. Lope Felix de Vega Carpio, *Valor, fortuna y lealtad (Segunda parte de los Tellos de Meneses)*, in Carpio, *Obras escogidas*, vol. 1, 443.

30. Lope Felix de Vega Carpio, *La Estrella de Sevilla*, in Carpio, *Obras escogidas*, vol. 1, 555.

31. Lope Felix de Vega Carpio, *El Rey Don Pedro en Madrid y el Infanzón de Illescas*, in Carpio, *Obras Escogidas*, vol. 1, 627. On this topic see Feros, "Vicedioses pero humanos."

32. Javier Varela, *La muerte del rey* (Madrid, 1990), 86, and n. 39.

33. Biblioteca Nacional de Madrid, Mss. 11569: "Memorial del pleito contra el Duque de Uceda," fol. 220r. On the justification of the favorite's role and power by claiming that they "represented" the king, see Feros, *Kingship and Favoritism*, chaps. 5 and 6; John H. Elliott, *The Count-Duke of Olivares: The Statesman in an Age of Decline* (New Haven, 1986), chap. 8; and John H. Elliott, *Richelieu and Olivares* (Cambridge, 1984), chap. 2.

34. Stuart Clark, *Thinking with Demons: The Idea of Witchcraft in Early Modern Europe* (Oxford, 1997), 619.

35. Ibid., 604.

36. Joan de Pineda, *La monarquía eclesiástica*, 5 vols. (Barcelona, 1594), vol. 1, 56v. See also Robert Parsons, *A Conference about the Next Succession to the Crown of England* [1592], facs. ed. (New York, 1972), 14.

37. Pineda, *La monarquía eclesiástica*, vol. 1, 57r.

38. Bouza, *Imagen y propaganda*, 139.

39. "Sermón predicado en el funeral por Felipe II," in Fray Alonso de Cabrera, *Sermones del maestro Fray Alonso de Cabrera*, ed. Manuel Mir (Madrid, 1906), 699. On these ideas during the reigns of Philip II and Philip III, see Bouza, *Imagen y propaganda*, chap. 2; and Feros, *Kingship and Favoritism*, chaps. 1, 4, and 6. To compare the situation in the Spanish monarchy with that in other European monarchies, see Clark, *Thinking with Demons*, chaps. 40 and 41.

40. Bartolomé Clavero, *Razón de estado, razón de individuo, razón de historia* (Madrid, 1991), 16, 28.

41. Richard Tuck, *Philosophy and Government, 1572–1651* (Cambridge, 1993), 56.

42. Cicero, *Libro de Marco Tulio Cicero*, trans. Francisco Tamara and Juan Jarava (Salamanca, 1582), bk. 1, chaps. 2–3, fols. 8–13.

43. Francesco Patrizi, *Del reino y de la institución del que ha de reinar* [1470s], trans. Enrique Garcés (Madrid, 1591), bk. 6, chap. 7, fol. 238v.

44. Pedro de Ribadeneira, "Carta para un privado de su Majd. acerca de la desgracia de la armada que fue a Inglaterra, y de lo que acerca de ella se puede considerar para mayor provecho de España," in Fray Pedro de Ribadeneira, *Patris Petri de Ribadeneira, confessiones, epistolae aliaque scripta inedita* [*Monumenta Historica Societatis Iesu*, 60] (Madrid, 1923), 109.

45. Justus Lipsius, *Los seis libros de la política*, trans. Bernardino de Mendoza [1604], ed. Javier Peña Echevarría and Modesto Santos López (Madrid, 1997), bk. 3, chap. 1, p. 71, and chap. 7, p. 26.

46. Tuck, *Philosophy*, 80.

47. Giovanni Botero, *Los diez libros de la razón de estado* [1593] trans. Antonio de Herrera y Tordesillas (Madrid, 1613), bk. 2, chap. 6, fols. 40–44v.

48. See Feros, *Kingship and Favoritism*, chaps. 6–9; Bernardo J. García García, *La pax hispánica: Política exterior del duque de Lerma* (Leuven, 1996); and Paul Allen, *Philip III and the Pax Hispanica, 1598–1621* (New Haven, 2000).

49. Feros, *Kingship and Favoritism*, chaps. 10–11.

50. *Conclusiones políticas del Príncipe y sus virtudes* (Madrid, 1638), fol. 10.

51. Marcos Salmerón, *El príncipe escondido* (Madrid, 1648), 83.

52. On the history and evolution of the representation of the Spanish monarch as defender of religion and religious orthodoxy, see Víctor Mínguez,"La monarquía humillada: Un estudio sobre las imágenes del poder y el poder de las imágenes," *Relaciones* 77 (1999), 123–48.

53. Velázquez's winning drawing depicting the expulsion of the Moriscos is lost; on the expulsion of the Moriscos see Feros, *Kingship and Favoritism*, chap. 9; on the competition and Velazquez's success see Brown and Elliott, *A Palace for a King*, chap. 2.

54. On the Hall of Realms see Brown and Elliott, *A Palace for a King*, chap. 6; and Jonathan Brown, *Velázquez: Painter and Courtier* (New Haven and London, 1986), chap. 4.

55. Brown, "Enemies of Flattery," 137.

56. Ibid., 146.

57. On the continuity of this model of royal portraiture, see Miguel Morán, *La imagen del rey: Felipe V y el arte* (Madrid, 1990), chap. 1.

58. Erasmus, *The Education of a Christian Prince*, ed. Lisa Jardine, trans. Neil M. Cheshire and Michael J. Heath (Cambridge, 1997), 14, 17.

59. Fernando Checa Cremades, *Carlos V y la imagen del héroe en el Renacimiento* (Madrid, 1987), 33–54.

60. On this topic see Fernando J. Bouza Alvarez, "Ardides del arte: Cultura de corte, acción política, y artes visuales en tiempo de Felipe II," in *Felipe II: Un monarca y su época*, exh. cat. (Madrid, Museo del Prado, 1998), 57–81, esp. pp. 58 and 61. See also Miguel Falomir Faus, "Imágenes de poder y evocaciones de la memoria: Usos y funciones del retrato en la corte de Felipe II," in *Felipe II*, exh. cat., 207; and Miguel Falomir Faus, "Imágenes y textos para una monarquía compleja," in *El linaje del emperador* (Madrid, 2000), 61–77.

61. Julián Gállego, *Visión y símbolos en la pintura española del siglo de oro* (Madrid, 1984), 271.

62. Martin Warnke, *The Court Artist: On the Ancestry of the Modern Artist*, trans. David McLintock (Cambridge, 1993), 212, 215.

63. Gállego, *Visión y símbolos*, 270–71.

64. Juan Huarte de San Juan, *Examen de ingenios para las ciencias* [1575], ed. Esteban Torre (Madrid, 1977), 288, 291–93, and 302–8.

65. Fernando Checa Cremades, "Un príncipe del renacimiento: El valor de las imágenes en la corte de Felipe II," in *Felipe II,* exh. cat., 36.

66. See, for example, Warnke, *The Court Artist*, 211. On the continuity of royal portraiture in Spain until 1700, the year when Charles II, the last Spanish Habsburg ruler, died, and the influence of the "Spanish model" during the first years of the reign of Philip V, the first Spanish Bourbon king, see Miguel Morán, *La imagen del rey: Felipe V y el arte* (Madrid, 1990), 11–38.

67. Brown, "Enemies of Flattery," 140–43. A good guide for Velázquez's royal portraits, including information about disagreements among art historians on which of the existing portraits of Philip IV and his relatives were painted by Velázquez, is Miguel Morán Turina and Isabel Sánchez Quevedo, *Velázquez: Catálogo completo* (Madrid, 1999); see esp. portraits, nos. 25, 26, 27 (Olivares), 29 (Olivares), 30 (Olivares), 33, 34 (Don Carlos, Philip's brother), 35, 50, 59, 60 (Queen Isabelle of Bourbon), 62 (Olivares), 65 (Philip III), 65 (Queen Margaret of Austria), 66 (Queen Isabelle of Bourbon), 67, 68 (Prince Baltasar Carlos), 71, 94, 95, and 112.

68. Brown, "Enemies of Flattery," 140.

69. On how the Spanish rulers' subjects "decoded" royal portraits in ways very similar to those expressed by Saavedra y Fajardo, see Falomir Faus, "Imágenes de poder y evocaciones de la memoria," 205, 207.

CHAPTER 6. COURT WOMEN IN THE SPAIN OF VELÁZQUEZ

I would like to thank Gettysburg College and the Grants Advisory Committee for a Research and Professional Grant that enabled me to do much of the research for this essay. I would also like to thank William D. Bowman and Robert R. Garnett for their careful reading of several versions of the text and their very helpful comments.

1. Jonathan Brown and Carmen Garrido, *Velázquez: The Technique of Genius* (New Haven, 1998), 10.

2. For the plan of the Real Alcázar and for an architectural discussion of the palace, see Fernando Checa, *El Real Alcázar de Madrid: Dos siglos de arquitectura y coleccionismo en la corte de los reyes de España* (Madrid, 1994).

3. In his biography of Philip II, Henry Kamen makes a strong case that Philip II had emotional ties to several women, including Isabel Osorio, a lady-in-waiting at his court who never married and who remained on friendly, affectionate terms with the monarch until her death in 1590. Kamen also notes that Philip had affairs with two women in the Netherlands, one of whom bore him a daughter. See Kamen, *Philip of Spain* (New Haven, 1997), 55.

4. See José Deleito y Piñuela, *El rey se divierte* (Madrid, 1988), 18–27.

5. In fact, one hears much more about their offspring, who were often recognized by Spanish kings, than about the mistresses themselves. Charles V made his illegitimate daughter, Margaret of Parma, regent of the Netherlands. Philip II recognized his half-brother, Charles V's illegitimate son Don Juan de Austria, who also served in the Netherlands. Philip IV recognized his son Don Juan de Austria, by his mistress, María Inés de Calderón.

6. John H. Elliott, "The Court of the Spanish Habsburgs: A Peculiar Institution?" in *Spain and Its World, 1500–1700* (New Haven, 1989), 148–54.

7. Geoffrey Parker, *The Grand Strategy of Philip II* (New Haven, 1998), 18–21. For Philip II's court, see M. J. Rodríguez-Salgado, "The Court of Philip II of Spain," in *Princes, Patronage, and the Nobility: The Court at the Beginning of the Modern Age c. 1450–1650*, ed. Ronald G. Asch and Adolf M. Birke (London, 1991), 205–44.

8. The Duke of Lerma did try to separate Philip III from his wife, Margaret of Austria. The *privado* went so far as to warn Margaret that if she did not refrain from discussing political matters with her husband in private, he (Lerma) would see to it that Philip went hunting alone. See Biblioteca Nacional (hereafter BN), Madrid, Ms. 2751, "Historia de Joan Kevenhuller de Aichelberg," 1140–41. For the conflicts between Lerma and Margaret of Austria, see Magdalena S. Sánchez, *The Empress, the Queen, and the Nun: Women and Power at the Court of Philip III of Spain* (Baltimore, 1998), 42–43, 51–52, 87–89, 95–103, 125, 141, 164.

9. In practice, some of these women did indeed pursue agenda that differed from those of the monarch. They sometimes also attempted to sway a king to a particular course. See Magdalena S. Sánchez, *The Empress, the Queen and the Nun*, passim.

10. Margaret of Austria accompanied her husband, Philip III, on some of his trips even when pregnant or soon after childbirth. See Luis Cabrera de Córdoba, *Relaciones de las cosas sucedidas en la corte de España desde 1599 hasta 1614* (Madrid, 1857), 107, 149, 211, 292, 425.

11. Kamen, *Philip of Spain*, 207–8.

12. See, for example, the letter from 28 July 1586 in Fernando J. Bouza Alvarez, *Cartas de Felipe II a sus hijas* (Madrid, 1988), 110–13.

13. Ibid., 94.

14. Ibid., 97.

15. Ibid., 124.

16. Albert served as Viceroy of Portugal from 1583 until 1593, when he returned to the Spanish court. In his biography of Philip II, Henry Kamen claims that Philip loved Albert as a son. See Kamen, *Philip of Spain*, 207.

17. Ibid., 202.

18. José Martínez Millán, "Familial real y grupos políticos: La princesa Doña Juana de Austria (1535–73)," in *La corte de Felipe II*, ed. José Martínez Millán (Madrid, 1994), 104.

19. On Juana de Austria, see José Martínez Millán, "Familial real y grupos políticos," 73–105. Historians such as Henry Kamen have argued that Juana "abstained from any political role after her short regency in 1554–59." See Kamen, *Philip of Spain*, 202. However, José Martínez Millán makes a persuasive case that Juana continued to be involved in Portuguese court politics by requesting offices and favors for her court attendants, servants, and their families. Moreover, Martínez Millán argues that Juana helped remind Philip II of Portugal's importance and thus played a decisive role in keeping Philip focused on that kingdom, eventually resulting in the annexation of Portugal by Spain in 1580. See Martínez Millán, "Familial real y grupos políticos," 100–105.

20. See Magdalena S. Sánchez, "Los vínculos de sangre: La Emperatriz María, Felipe II y las relaciones entre España y Europa Central," in *Felipe II (1527–1598): Europa y la Monarquía Católica*, ed. José Martínez Millán, vol. 1, *El gobierno de la monarquía (Corte y reinos)* (Madrid, 1998), 777–93.

21. This bond was so close that the Duke of Lerma encouraged Philip to move the court to Valladolid so as to remove him from the empress's influence.

22. BN, Madrid, Ms. 2751, "Historia de Joan Kevenhuller de Aichelberg," 1149–50.

23. Jonathan Brown, *Velázquez: Painter and Courtier* (New Haven, 1986), 217–18.

24. For a thorough and fascinating biography of Anne, see Ruth Kleinman, *Anne of Austria: Queen of France* (Columbus, 1985).

25. See Ruth Kleinman, *Anne of Austria*, 18, 40; Martha Hoffman-Strock, "'Carved on Rings and Painted in Pictures': The Education and Formation of the Spanish Royal Family, 1601–1634," (Ph.D. diss., Yale University, 1996), 220–24; and see esp. Ricardo Martorell Téllez-Girón, ed., *Cartas de Felipe III a su hija Ana, Reina de Francia* (Madrid, 1929).

26. At times, early modern royalty was willing to pursue a royal marriage that crossed confessional lines if that marriage would meet their other needs. Thus, the Protestant Elizabeth I of England considered marrying Archduke Karl of Styria, a strong Catholic. Charles I of England was at one point (while still Prince of Wales) considered a good match for María, daughter of Philip III. Eventually, Charles married another Catholic, the French Henrietta Maria. The mixed religions of that marriage ultimately played a critical role in Charles's political crisis in the 1640s.

27. Margaret's mother, Maria of Bavaria, was the daughter of an Austrian Habsburg archduchess. Maria's husband, Archduke Karl of Styria, was also her uncle. On Maria of Bavaria, see Magdalena S. Sánchez, "A Woman's Influence: Archduchess Maria of Bavaria and the Spanish Habsburgs," in *The Lion and the Eagle: Interdisciplinary Essays on German-Spanish Relations over the Centuries*, ed. Conrad Kent, Thomas K. Wolber, and Cameron M. K. Hewitt (New York, 2000), 91–107.

28. On these marriages, see F. Tommy Perrens, *Les mariages espagnols sous le regne de Henri IV et la régence de Marie de Médicis* (Paris, 1869) and Francisco Silvela, *Matrimonios de España y Francia en 1615. Discurso de ingreso en la Real Academia de la Historia* (Madrid, 1901).

29. Maria of Portugal was sixteen years old when she became Philip II's first wife. Isabel of Valois was almost fourteen when she married Philip II. Anne of Austria was fourteen when she married Louis XIII. Henrietta Maria was fifteen when she married Charles I of England. The exceptions were Anna of Austria, Philip II's fourth and final wife who was twenty-one when she married. Truly "ancient" was Mary Tudor, thirty-eight when she became Philip II's second wife. On the wives of Philip II, see Henry Kamen, *Philip of Spain*, 30, 54–55, 57–59, 89–90, 202–8.

30. Jonathan Brown and J. H. Elliott, *A Palace for a King: The Buen Retiro and the Court of Philip IV* (New Haven, 1980), 32.

31. María Jesús Pérez Martín, *Margarita de Austria: Reina de España* (Madrid, 1961), 22.

32. Österreichische Nationalbibliothek, Handschriftensammlung, Ms. 8219, fol. 67v.

33. Joaquín Pérez Villanueva, *Felipe IV y Luisa Enríquez Manrique de Lara, Condesa de Paredes de Nava, Un Epistolario inédito* (Salamanca, 1986), 299.

34. Joaquín Pérez Villanueva, *Felipe IV y Luisa Enríquez Manrique de Lara*, 102. The king reported that his new bride "está bien crecida para su edad, pero bien niña, y en lo poco que le é tratado me parece de linda condición que es lo que más he menester."

35. Joaquín Pérez Villanueva, *Felipe IV y Luisa Enríquez Manrique de Lara*, 299.

36. Margaret of Austria no doubt realized the power that motherhood conferred. As Jorge Sebastián Lozano has shown, Margaret commissioned several portraits that either showed her pregnant or included the likeness of her son and heir to the throne, the future Philip IV. On this subject and on the artistic representation of Margaret of Austria, see Jorge Sebastián Lozano, "Representación femenina y arte áulico en el xvii Español: El caso de Margarita de Austria (1584–1611)," in *V Jornadas Internacionales de Estudios de la Mujer. Noviembre 1997* (Madrid, 1999).

37. For accounts of several of the festivities in Madrid, see José Simón Díaz, *Relaciones de actos públicos celebrados en Madrid (1541–1650)* (Madrid, 1982), 379–90.

38. Andrés de Almansa y Mendoza, *Novedades de esta corte y avisos recibidos de otras partes, 1621–1626* (Madrid, 1886), 346.

39. Letter from Philip IV to Sor María, 15 November 1644, in María de Jesús de Agreda, *Correspondencia con Felipe IV: Religión y razón de estado*, ed. and intro. by Consolación Baranda (Madrid, 1991), 66–69.

40. An exception to this rule was Isabel of Valois, Philip II's third wife, who was able to keep most of her attendants. Henry Kamen argues that Philip loved Isabel so much that he spoiled her, gave in to her demands, and allowed her to spend lavishly. Isabel used her influence with the monarch to try to influence political policy. After her death, Philip resolved to reform the queen's household and not to allow another wife to act like Isabel. See Kamen, *Philip of Spain*, 205.

41. On Lerma's and Olivares's use of patronage and palace offices to solidify their power at the Spanish court, see Antonio Feros, "Lerma y Olivares: La práctica del valimiento en la primera mitad del seiscientos," in *La España del Conde Duque de Olivares*, ed. John Elliott and Angel García Sanz (Valladolid, 1990), 205–16.

42. Luis Fernández Martín, "La Marquesa del Valle: Una vida dramática en la corte de los Austrias," *Hispania* 39, no. 143 (1979), 559–638. For the marquesa's declaration to the judges sent to arrest her, see BN, Madrid, Ms. 18191, "Declaración dada por la Marquesa del Valle," fols. 192r–201v.

43. It may also be that Margaret's mother, Archduchess Maria of Bavaria, who accompanied the queen from Central Europe to Spain, was able to persuade the king as well. Archduchess Maria was a formidable woman, who sincerely believed in the power of queenship and in the creative use of that power. On the archduchess, see Magdalena S. Sánchez, "A Woman's Influence: Archduchess Maria of Bavaria and the Spanish Habsburgs."

44. Magdalena S. Sánchez, *The Empress, the Queen, and the Nun*, 21–22, 50–51, 102–3.

45. On the Junta de Desempeño, see Jean-Marc Pelorson, "Para una reinterpretación de la Junta de Desempeño General (1603–1606) a la luz de la 'visita' de Alonso Ramírez de Prado y de Don Pedro Franqueza, Conde de Villa-longa," *Actas del IV Symposium de Historia de la Administración* (Madrid, 1983), 613–27.

46. On the queen's criticism of the junta, see Archivo Segreto Vaticano, Fondo Borghese, Ser. 2, no. 272, Nunziatura di Spagna 1605–6, fols. 58r–v, 67r–v.

47. The Duke of Lerma was dismissed in 1618. His son, the Duke of Uceda, was dismissed after Philip III's death. Fray Luis de Aliaga was stripped of his

offices and exiled to Aragon. Rodrigo de Calderón was imprisoned and eventually executed for crimes against the state. He was, however, cleared of charges of having poisoned the queen.

48. J. H. Elliott, "Staying in Power: The Count-Duke of Olivares," in *The World of the Favourite*, ed. J. H. Elliott and L. W. B. Brockliss (New Haven, 1999), 118.

49. See J. H. Elliott, *The Count-Duke of Olivares: The Statesman in an Age of Decline* (New Haven, 1986), 135–41.

50 Ibid., 140.

51. Ibid., 314.

52. In fact, historians such as Sir John Elliott have concluded that the constant presence of the Countess of Olivares made it easy for Olivares to know Isabel of Bourbon's every move and effectively silenced her as a political rival. See J. H. Elliott, *The Count-Duke of Olivares*, 640. Isabel had numerous ways of winning the monarch's ear, however – ways that included affection, the bearing of an heir, and a reputation for piety. Her eventual cooperation in Olivares's fall from grace did not happen overnight.

53. Gregorio Marañon, *El Conde-Duque de Olivares: La pasión de mandar* (Madrid, 1977), 339–40.

54. José Deleito y Piñuela, *El rey se divierte*, 14–15.

55. R. A. Stradling, *Philip IV and the Government of Spain 1621–1665* (Cambridge, 1988), 121.

56. Ibid., 121.

57. Quoted in ibid., 100.

58. Magdalena S. Sánchez, *The Empress, the Queen, and the Nun*, 99. On the Countess of Castellar, see Fidel Pérez Mínguez, "La Condesa de Castellar, fundadora del convento 'Las Carboneras,'" *Revista de la Biblioteca, Archivo, y Museo del Ayuntamiento de Madrid* 8, no. 31 (1931), 253–73; 8, no. 32 (1931), 392–418; 9, no. 34 (1932), 150–80; 9, no. 36 (1932), 409–27.

59. See Joaquín Pérez Villanueva, *Felipe IV y Luisa Enríquez Manrique de Lara*, 299. Alessandro Massei, ambassador from Lucca at the Spanish court, described the countess as "one of the most favored and esteemed" of the queen's ladies. See *Relazioni inedite di ambasciatori Lucchesi alla corte di Madrid* (Lucca, 1903), 76.

60. Joaquín Pérez Villanueva, *Felipe IV y Luisa Enríquez Manrique de Lara*, 173 (letter from 13 August 1652), 204 (letter from 8 July 1653).

61. See, for example, the representation of Isabel de Bourbon in the funerary services held in Madrid in 1644. "Relacion de las honras que su Magestad ha hecho a la Reyna nuestra señora doña Isabel de Borbon, que Dios aya, en Madrid jueves, y viernes 17 y 18 deste mes de noviembre de 1644," in José Simón Díaz, ed. *Relaciones de actos públicos celebrados en Madrid (1541–1650)* (Madrid, 1982), 494. Juan Pantoja de la Cruz, in his portrait of Empress María now housed in the convent of the Descalzas Reales in Madrid, depicted her in the garb of a cloistered nun. Isabel Clara Eugenia, governess of the Netherlands from 1598 to 1633, was also depicted in this fashion. See, for example, the frontispiece for François Tristan L'Hermite, *La peinture de la sérénissime princesse Isabella Clair Eugénie, Infante d'Espagne*, reproduced in Luc Duerloo and Werner Thomas, *Albert and Isabelle, 1598–1621* (Louvain, 1998), 294. In that same catalogue, see also Isabel Clara Eugenia's representation in the *Mausolée erigé à la memoire inmortelle de [. . .] Isabelle*, 292.

62. For these expectations of a widow, see Gaspar de Astete, *Tratado del gobierno de la familia y estado de las viudas y donzellas* (Burgos, 1603), 2–3.

63. Fidel Pérez Mínguez, "La Condesa de Castellar, 8, no. 32 (1931), 414–15.

64. She retired to the monastery of Valle de Utande en Alcarria. See José Deleito y Piñuela, *El rey se divierte* (Madrid, 1988), 26–27.

65. R. A. Stradling writes that from their first known meeting in July 1643 until the king's death in 1665, Sor María "was to be the king's most influential adviser." See *Philip IV and the Government of Spain*, 124. On Sor María, see Francisco Silvela, *Cartas de la Venerable Sor María de Agreda y del Señor Rey Don Felipe IV*, 2 vols. (Madrid, 1885–86); Clark A. Colahan, *The Visions of Sor María de Agreda: Writing, Knowledge and Power* (Tucson, 1994); Thomas D. Kendrick, *Mary of Agreda: The Life and Legend of a Spanish Nun* (London, 1967).

66. Clark Colahan, "María de Jesús de Agreda: The Sweetheart of the Holy Office," in *Women and the Inquisition: Spain and the New World*, ed. Mary E. Giles (Baltimore, 1999), 155–70.

67. María de Jesús de Agreda, *Correspondencia con Felipe IV*, 59, n. 19.

68. Ibid., 52, 53, 55, 247–52.

69. Ibid., 60, n. 22.

70. For examples of her insistence on peace and her request for information about battles, see her letter to Philip IV from 25 October 1643, María de Jesús de Agreda, *Correspondencia con Felipe IV*, 66.

71. For veiled and overt references to the Countess of Olivares and Philip IV's style of governance, see Philip IV's letter to Sor María of 4 October 1643, in María de Jesús de Agreda, *Correspondencia con Felipe IV*, 57–58, and Sor María's letter from 13 October 1643, in María de Jesús de Agreda, *Correspondencia con Felipe IV*, 62–63.

72. This is at least the opinion of Consolación Baranda. See María de Jesús de Agreda, *Correspondencia con Felipe IV*, 44–45.

73. Ibid., 45.

74. Stradling, *Philip IV and the Government of Spain*, 275.

75. Ibid., 124.

76. Ibid., 273.

77. In this respect, Sor María's relationship with Philip IV is reminiscent of Saint Teresa of Avila's relationship with many priests and with her confessors, who told the nun of their sinful ways and asked for her spiritual guidance and prayer. See *The Life of Saint Teresa of Avila by Herself*, trans. J. M. Cohen (New York, 1957).

78. See, for example, Ventura Ginarte González, *El Duque de Lerma: Protector de la reforma trinitaria* (Madrid, 1982).

79. Gregorio Marañon, *El Conde-Duque de Olivares*, 339.

80. Andrés de Almansa y Mendoza, "Carta Decimatercera: Sucesos desta corte desde 15 de agosto hasta fin de octubre," in *Novedades de esta corte y avisos recibidos*, 222. She was also depicted as a virtuous, saintly queen in art. See Jorge Sebastián Lozano, "Representación femenina y arte áulico en el xvii Español."

81. For Margaret of Austria's testament, see Real Academia de la Historia, Colección Salazar y Castro, M63.

82. Amedeo Pellegrini, ed., *Relazioni inedite di ambasciatori Lucchese alla corte*

di Madrid (sec. XV–XVII) (Lucca, 1903), 66. Arnolfini's report is from 26 January 1644.

83. Andrés de Almansa y Mendoza, *Novedades de esta corte,* 231. This entry is dated Madrid, 31 October 1623.

84. Andrés de Almansa y Mendoza, *Novedades de esta corte,* 243–44. This entry is dated Madrid, 31 October 1623. Isabel's devout practices were so similar to those of Habsburg women (both in Spain and in Central Europe) that one could argue that she acquired these practices from having lived from the age of twelve at the Spanish court. Alternately, these practices might have been the norm for any early modern Catholic queen, regardless of nationality.

85. Steven N. Orso, "Praising the Queen: The Decorations at the Royal Exequies for Isabella of Bourbon," *Art Bulletin* 72 (March 1990), 63.

86. Report of Pietro Guinigi and Claudio Bonvisi, extraordinary ambassadors at the Spanish court, in Amedeo Pellegrini, ed., *Relazioni inedite,* 84. The report is dated 18 November 1666.

87. Report of Lorenzo Cenami, in Amedeo Pellegrini, ed., *Relazioni inedite,* 89. The report is dated 12 July 1674. On the relationship between Mariana and her confessor, see JoEllen M. Campbell, "Women and Factionalism in the Court of Charles II of Spain," in *Spanish Women in the Golden Age: Images and Realities,* ed. Magdalena S. Sánchez and Alain Saint-Saëns (Westport, CT, 1996), 112–17.

88. "Relazione di Ottaviano Bon," 21 December 1602, in Nicolò Barozzi and Guglielmo Berchet, *Relazioni degli state europei: Lette al senato dagli ambasciatori veneti nel secolo decimosettimo,* serie I: Spagna, vol. 1 (Venice, 1856), 247.

89. Diego de Guzman, *Reina católica: Vida y Muerte de Doña Margarita de Austria, Reina de España* (Madrid, 1617), fol. 116v.

90. Jerónimo de Florencia, "Sermón que predicó a la Magestad del Rey Don Felipe III en las honras que Su Magestad hizo a la sereníssima Reyna D. Margarita su muger, que es en gloria, en San Gerónimo el Real de Madrid a 18 de noviembre de 1611" (Madrid, 1611), fols. 17r–v.

91. BN, Madrid, Ms. 20260 30, fols. 124r–v.

92. As Steven Orso has shown, in the temporary decorations created by the church of San Jerónimo for Isabel's exequies, the queen was depicted as an active sovereign and praised for her effective governance of the realm in 1642–44, when Philip IV was in Aragon. On the other hand, the funerary decorations in honor of the queens of other Habsburg rulers primarily emphasized those queens' passivity. Orso argues convincingly that Philip IV wanted to use this forceful image of Isabel to encourage Spaniards to support the war against France. See Orso, "Praising the Queen," 61–64.

93. Elliott, *The Count-Duke of Olivares,* 631, 642; Stradling, *Philip IV and the Government of Spain,* 120–21; Gregorio Marañon, *El Conde-Duque de Olivares,* 426–46.

94. Elliott, *The Count-Duke of Olivares,* 642; Gregorio Marañon, *El Conde-Duque de Olivares,* 442–43.

95. Gregorio Marañon, *El Conde-Duque de Olivares,* 428, 433–34.

96. A complete picture of the court world in which Velázquez moved would ideally include an examination of the households of influential aristocrats and of women of lower social status. It would also consider the role of women in

patronage networks, particularly those involved in art patronage. Research to produce such a complete picture of all the women at the Spanish court in the age of Velázquez still remains to be done, however.

CHAPTER 7. SPANISH RELIGIOUS LIFE IN THE AGE OF VELÁZQUEZ

1. One of best surveys of the church at this time remains Antonio Domínguez Ortiz, *La sociedad española en el siglo XVII: El estamento eclesiástico* (Madrid, 1970; reprint, Granada, 1992). Also very useful is the *Historia de la Iglesia en España*, vol. 4: *La Iglesia en la España de los siglos XVI y XVII*, dir. Ricardo García-Villoslada (Madrid, 1979).

2. *La Iglesia en la España*, 18–19. Also, Joan Bada Elías, "Iglesia y sociedad en el antiguo régimen: El clero secular," in *Iglesia y sociedad en el Antiguo Régimen* (Las Palmas, Spain, 1994), vol. 1, 81–92.

3. Several recent studies are available in English: Henry Kamen, *The Phoenix and the Flame: Catalonia and the Counter Reformation* (New Haven, 1993); Sara T. Nalle, *God in La Mancha: Religious Reform and the People of Cuenca, 1500–1650* (Baltimore, 1992); Allyson Polska, *Regulating the People: The Catholic Reformation in Seventeenth-Century Spain* (Leiden, 1998); and A. D. Wright, *Catholicism and Spanish Society under the Reign of Philip II, 1555–1598, and Philip III, 1598–1621* (Lewiston, 1991).

4. Three contemporary descriptions of the lavish celebrations may be found in *Relaciones de actos públicos celebrados en Madrid (1541–1650)*, ed. José Simón Díaz (Madrid, 1982), 163–78.

5. Nalle, *God in La Mancha*, chaps. 3 and 4; Jean-Pierre Dedieu, "'Christianisation' en Nouvelle Castille: Catéchisme, communion, messe et confirmation dans l'archevêché de Tolède," *Mélanges de la Casa de Velázquez* 15 (1979), 261–94. A mixed portrait appears of the late seventeenth-century clergy in Ramón Sánchez González, "Mentalidad y conducta social del clero rural en la diócesis de Toledo (siglo XVII)," in *Iglesia y sociedad en el Antiguo Régimen* (Las Palmas, Spain, 1994), vol. 1, 187–95.

6. Polska, *Regulating the People*; Josué Fonseca Montes, *El clero en Cantabria en la Edad Moderna* (Santander, 1996). A depressing picture of the clergy in the city of Córdoba emerges in José Cobos Ruiz de Adana, *El clero en el siglo XVII: Estudio de una visita secreta a la ciudad de Córdoba* (Córdoba, 1976).

7. *La Iglesia en la España*, 73–88.

8. José Deleito y Piñuelo, *El Rey se divierte* (Madrid, 1988), 13–28.

9. The relationship has been studied at length: for a synopsis and bibliography, see Ricardo García-Villoslada, "Sor María de Agreda y Felipe IV: Un epistolario en su tiempo," *La Iglesia en la España*, 361–417. On Sor María, see Clark A. Colahan, *The Visions of Sor María de Agreda: Writing, Knowledge, and Power* (Tucson, 1994).

10. Juliet Glass, "The Royal Chapel of the Alcázar: Religion and Politics at the Habsburg Court." Ph.D. thesis in progress, directed by Richard L. Kagan, at the Johns Hopkins University.

11. For a general survey, see *La Iglesia en la España*, 455–60, and Angel Uribe, "La Inmaculada en la literatura franciscano-española," in *Archivo Ibero-Americano* (Madrid, 1954).

12. The artwork produced at this time to celebrate the cult has been studied by Suzanne L. Stratton, *The Immaculate Conception in Spanish art* (Cambridge and New York, 1994).

13. On the fate of Teresa's body, see Carlos M. N. Eire, *From Madrid to Purgatory: The Art and Craft of Dying in Sixteenth-Century Spain* (New York, 1995), 425–45.

14. Francisco de Quevedo, "Memorial por el patronato de Santiago," *Obras Completas*, 2 vols. (Madrid, 1932), vol. 1, 504. An example of the controversy fought in the local press is Fernando Mera Caruajal, *Informacion en derecho. Por el Vnico y Singvlar Patronato del glorioso Apostol Santiago Zebedeo, Patron y Capitan general de las Españas. Con la Sagrada Religión de Carmelitas Descalços. Sobre el nvevo compatronato destos Reynos, que pretende para la gloriosa Virgen Santa Teresa de Jesús* (Cuenca, 1628).

15. See the meticulous, comparative description of the auto-da-fé in Francisco Bethencourt, *La Inquisición en la época moderna: España, Portugal, Italia, siglos XV–XIX*, trans. from the Portuguese by Federico Palomo (Madrid, 1997), 281–366. Also, Consuelo Maqueda Abreu, *El auto de fe* (Madrid, 1992). An analysis in English is Maureen Flynn, "Mimesis of the Last Judgement: The Spanish Auto de Fe," *Sixteenth Century Journal* 22 (1991): 281–97.

16. The Tribunal de Corte's foundation, and its relationship to the Supreme Council of the Inquisition and Tribunal of Toledo is far from clear-cut. See *Historia de la Inquisición en España y América* (Madrid, 1984), 1036–37.

17. The 1632 auto is documented as *Relacion del Auto de la Fe, que se celebro en Madrid, Domingo a quatro de Iulio de MDCXXII* in *Relaciones de actos públicos*, 414–34. The 1680 auto is studied in Jesús M. Vegazo Palacios, *El Auto General de Fe de 1680* (Málaga, 1995).

18. Spaniards were not always so approving of the Inquisition's activities; before 1550 criticism was often voiced (and prosecuted). Such dissent does not appear in trials from the seventeenth century.

19. Ignacio Javier de Miguel Gallo, *Teatro y parateatro en las fiestas religiosas y civiles de Burgos (1550–1752): Estudio y documentos* (Burgos, 1994), 48–49. On the mad marching in Corpus Christi, see Sara T. Nalle, *Mad for God: Bartolomé Sánchez, the Secret Messiah of Cardenete* (Charlottesville, VA, 2001). Also, Vicente Lleó Cañal, *La fiesta del Corpus Christi en Sevilla en los siglos XVI y XVII* (Seville, 1975).

20. The basic reference is Bruce Wardropper, *Introducción al teatro religioso del Siglo de Oro: Evolución del auto sacramental antes de Calderón* (Madrid, 1953).

21. See Pedro Calderón de la Barca, *Triunfar muriendo*, ed. I. Arellano, B. Oteiza, and M. C. Pinillos, with a study by C. Bandera (Pamplona, 1996).

22. This description in part draws on Gwendolyn Barnes-Karol's article, "Religious Oratory in a Culture of Control," in Anne J. Cruz and Mary Elizabeth Perry, *Culture and Control in Counter-Reformation Spain* (Minneapolis, 1992), 51–77, and Félix Herrero Salgado, *La oratoria sagrada en los siglos XVI y XVII* (Madrid, 1996). See also Hilary Dansey Smith, *Preaching in the Spanish golden age: A study of some preachers of the reign of Philip III* (Oxford, 1978).

23. Susan Verdi Webster, *Art and Ritual in Golden-Age Spain: Sevillian Confraternities and the Processional Sculpture of Holy Week* (Princeton, 1998).

24. On confraternities, see Maureen Flynn, *Sacred Charity: Confraternities and Social Welfare in Spain, 1400–1700* (Ithaca, 1989), and John Patrick Donnelly

and Michael W. Maher, eds., *Confraternities and Catholic Reform in Italy, France, and Spain* (Kirksville, MO, 1999).

25. Trends are remarkably similar for Toledo, Cuenca, and Madrid (the latter study ends, unfortunately, in 1600). On Toledo, see Fernando Martínez Gil, *Muerte y sociedad en la España de los Austrias* (Madrid, 1993), 528; Nalle, *God in La Mancha*, 185–93; Eire, *From Madrid to Purgatory*, 126.

26. Martínez Gil, *Muerte y sociedad en la España de los Asturias*, 314.

27. Between 1594 and 1646, the city of Burgos lost 78 percent of its *vecinos* (heads of household); Cuenca, 74 percent; Valladolid, 63 percent; Toledo, 54 percent; and Salamanca, 41 percent (Jean-Paul Le Flem et al., *La frustración de un imperio (1476–1714)* [Barcelona, 1982]), 96.

28. Nalle, *God in La Mancha*, 193–99.

29. William A. Christian, Jr., *Local Religion in Sixteenth-Century Spain* (Princeton, 1981).

30. Polska, *Regulating the People*, 86–87; Sara T. Nalle, "A Saint for All Seasons: Cuenca and the Cult of San Julián," in Anne J. Cruz and Mary Elizabeth Perry, *Culture and Control in Counter-Reformation Spain* (Minneapolis, 1992), 25–50.

31. Virtually all conversions were to Islam and occurred among sailors and soldiers who fell into Berber hands. See Bartolomé Bennassar, *Los cristianos de Alá: La fascinante aventura de los renegados*, trans. from the French to Spanish by José Luis Gil Aristu (Madrid, 1989).

32. The rhythms of the Inquisition's activity are analyzed in Jean-Pierre Dedieu, "Les quatre temps de l'Inquisition," in Bartolomé Bennassar, ed., *L'Inquisition Espagnole, XVe–XIXe siècle* (Paris, 1979), 15–42.

33. Henry Kamen, *The Spanish Inquisition: A Historical Revision* (New Haven, 1977), 214–28; Anwar G. Chejne, *Islam and the West: The Moriscos, a Cultural and Social History* (Albany, 1983); James Casey, *The Kingdom of Valencia in the Seventeenth Century* (Cambridge and New York, 1979).

34. Kamen, *The Spanish Inquisition*, 249–54.

35. Yvette Cardaillac-Hermosilla, *Magie en Espagne: Morisques et vieux chrétiens aux XVIe et XVIIe siècles* (Zaghouan, 1996).

36. Sebastián Cirac Estopañán, *Los procesos de hechicerías en la Inquisición de Castilla la Nueva* (Madrid, 1942), 70–71, based on AHN Inq. Toledo. Leg. 514, exp. 6,708.

37. Bethencourt, *La Inquisición en la época moderna*, 234.

38. For a survey, Julio Caro Baroja's *Vidas mágicas e Inquisición*, 2 vols. (Madrid, 1967) is still good. More recently, see also Juan Villarín, *La hechicería en Madrid: Brujas, maleficios, encantamientos y sugestiones de la Villa y Corte* (Madrid, 1993) and Francisco Fajardo Spínola, *Hechicería y brujería en Canarias en la Edad Moderna* (Las Palmas, 1992).

39. William Monter, *Frontiers of Heresy: The Spanish Inquisition from the Basque Lands to Sicily* (Cambridge and New York, 1990), 270–75; *Historia de la Inquisición en España y América*, 913–18; Gustav Henningsen, *The Witches' Advocate (Basque Witchcraft and the Spanish Inquisition)* (Reno, 1980).

40. Mary Elizabeth Perry, *Gender and Disorder in Early Modern Seville* (Princeton, 1990), 97–117.

41. Le Flem et al., *La frustración de un imperio (1476–1714)*, 248–49; Henry Charles Lea, *A History of the Inquisition in Spain*, 4 vols. (New York, 1966 edition),

vol. 4, 171. Lea writes, "Carlos was industriously stripped and anointed and purged and prayed over, but to no purpose save to terrify and exhaust him."

CHAPTER 8. VELÁZQUEZ AND TWO POETS OF THE BAROQUE

1. Ernest Robert Curtius, *European Literature and the Latin Middle Ages* (New York, 1953), 559 (*Excursus* XXIII, "Calderón's Theory of Art and the Artes Liberales").
2. As Vicente Carducho does in his *Diálogos de la pintura*; see F. Calvo Serraller, *Teoría de la pintura del Siglo de Oro* (Madrid, 1981). López Pinciano relates both arts in his dialogue, *Philosophia antigua poética* (1596) (Madrid, 1973), vol. 1, 197 and ff.
3. E. R. Curtius, "Calderón's Theory," 563, already showed that the *index pictorius* to Calderón's work is very extensive.
4. Jonathan Brown translates Pacheco's words in *Velázquez: Painter and Courtier* (New Haven and London, 1986), 44. See now the latest edition of F. Pacheco's *Arte de la pintura*, ed. Bonaventura Bassegoda i Hugas (Madrid, 1990), 203–4.
5. Emilio Orozco Díaz, *El barroquismo de Velázquez* (Madrid and Mexico City, 1965), 88 and ff., states their acquaintanceship as a fact; Pablo Jauralde Pou, *Francisco de Quevedo (1580–1645)* (Madrid, 1998), 17, also says that Quevedo and Velázquez knew each other.
6. Velázquez painted the portrait at his father-in-law's request; cf. *Arte de la pintura*, 203: "Hizo, a instancia mía, un retrato de Don Luis de Góngora, que fue muy celebrado en Madrid." It is now newly reproduced in the catalogue of the Seville exhibit for the Year of Velázquez (1999): *Velázquez y Sevilla. 1599–1999.* (Seville, 1999), 214–15.
7. See the recently published life of Quevedo by Jauralde, *Francisco de Quevedo*, 899–924.
8. Jonathan Bown does not include this portrait among Velázquez's authentic paintings. Spanish scholars, however, take for granted that Velázquez and Quevedo knew each other by relying on the portrait, which had been identified as Velázquez's by Antonio Palomino, *El museo pictórico y escala óptica* (1715–24) (Madrid, 1724), vol. 2, 333: "Otro retrato hizo Velázquez de don Francisco de Quevedo [. . . .] Pintóle con los anteojos puestos como acostumbraba de ordinario traer . . . [Velázquez painted another portrait, that of Francisco de Quevedo. . . . He painted him with his eyeglasses on, as he usually wore them . . .]"; E. Orozco, P. Jauralde, and L. López Grigera accept Palomino's attribution.
9. For a detailed presentation of Madrid in the work of Quevedo see Pablo Jauralde Pou, "El Madrid de Quevedo," *Edad de Oro*, 17 (1998), 59–96.
10. See among many others his sonnet 79, entitled "It describes the miserable life in palaces and the habits of the powerful that receive favors in them," the satirical sonnet 572, "Farewell to ambition and the court," or the *romance* 711, "Retired from the Court, he answers the letter of a physician," in Francisco de Quevedo, *Poesía original*, ed. J. M. Blecua (Barcelona, 1968) [all translations of Spanish texts are mine].
11. See Luis de Góngora, *Fábula de Polifemo y Galatea* and *Soledades* in *Obras completas*, ed. J. and I. Millé y Giménez (Madrid, 1951).

12. In *Obras completas*, cf. numbers 275 ("Llegué a Valladolid . . ." [I arrived in Valladolid]), 276 ("Jura Pisuerga . . ." [The river Pisuerga swears . . .]), 277 ("¡Oh qué malquisto con Esgueva quedo" [Oh, how the river Esgueva dislikes me]), 278 ("¿Vos sois Valladolid? ¿Vos sois el valle" [Are you Valladolid? Are you the valley . . .]), 279 ("Valladolid, de lágrimas sois valle," [Valladolid, you are the valley of tears]), or the *letrilla* 120 ("¿Qué lleva el señor Esgueva?" [What does Mr. Esgueva carry?]). Quevedo answered with poems such as his *décimas* 826 ("Ya que coplas componéis" [Since you write poems]), or 827 ("En lo sucio que has cantado" [You have sung such dirty things]) in *Poesía original*, 1162–66.

13. Pedro Espinosa, *Flores de poetas ilustres* (Valladolid, 1605); the anthology was compiled before 1603.

14. On Góngora's experiences in the city, and the compositions that include references to it, see Antonio Carreira, "Góngora y Madrid," *Edad de Oro*, 17 (1998), 19–30. For Góngora as a courtier, his panegyric poem to the Duke of Lerma, and other compositions of the Madrid years, see Robert Jammes, *Etudes sur l'oeuvre poétique de don Luis de Góngora y Argote* (Bordeaux, 1967), 307–49.

15. Cf., for instance, the sonnet attributed to Góngora in *Obras completas*, 17, "A don Francisco de Quevedo": "Anacreonte español, no hay quien os tope" [Spanish Anacreon, nobody who meets you], and Quevedo's sonnet 829: "Yo te untaré mis obras con tocino" [I will spread my works with pork fat]. In 1609 Quevedo translated into Spanish the Greek *anacreonta*, a collection of poems attributed in the Renaissance to Anacreon of Teos; Góngora is accused of not eating pork, thus of being of Jewish origin.

16. The first two, "The Gongorist Latin-Speaking Woman" and his *Aguja*, "Compass to navigate Gongorist Poetry," were published in 1631 in his *Libro de todas las cosas y otras muchas más*, "A Book of All Things and Many More." The *Discurso* "A Discourse of All Devils" was published in 1627; *Fortuna*, "The Fortune in her Wits and the Hour of All," dated 1636 in one manuscript, appeared posthumously.

17. For the latest re-creation of their enmity, see Pablo Jauralde, *Francisco de Quevedo*, 899 and ff.; for a different opinion, Antonio Carreira, "Quevedo en la redoma: Análisis de un fenómeno criptopoético," in Lía Schwartz and Antonio Carreira, eds., *Quevedo a nueva luz: Escritura y política* (Málaga, 1997). Carreira follows Robert Jammes, who has even questioned the authorship of some satires against Góngora, traditionally transmitted as written by Quevedo; cf. R. Jammes's edition of Góngora's *Soledades* (Madrid, 1994), 676 and ff.

18. 'In order to perfume the house and to *degongorize* it of such thick mist, he burned as if they were aromatic substances poems by Garcilaso"; cf. *silva* 841 ("Alguacil del Parnaso, Gongorilla' [Constable of Parnassus, little Góngora]), ll. 130–33, p. 1184, and, for the details of Góngora's eviction, James O. Crosby, *En torno a la poesía de Quevedo* (Madrid, 1967), 137.

19. Luis de Góngora, *Obras completas*, 981 (letter 61): " Grandes mudanzas se esperan; yo iré dando cuenta de ellas."

20. Francisco de Quevedo, *Grandes anales de quince días*, in *Obras completas*, ed. de L. Astrana Marín (Madrid, 1932), vol. 1, 471–99. For an analysis of some sections thereof, see John H. Elliott, "Quevedo and the Count-Duke of Olivares», in *Quevedo in Perspective*, ed. J. Iffland (Newark, DE, 1982), 227–50

and *The Count-Duke of Olivares: The Statesman in an Age of Decline* (New Haven, 1986), 3.

21. Cf. Francisco de Quevedo, *Política de Dios, Govierno de Christo*, ed. James O. Crosby (Madrid, 1966); his *Epístola satírica y censoria contra las costumbres presentes de los castellanos, escrita a don Gaspar de Guzmán, Conde de Olivares, en su valimiento*, a satiric epistle in tercets, is number 146 in *Poesía original*, 140–47; the version transmitted in the Harvard ms. is dated 1625. His play *Cómo ha de ser el privado* ['How Should the Favorite Be'] has been dated ca. 1628; published in vol. 4 of Francisco de Quevedo, *Obra poética*, ed. J. M. Blecua (Madrid, 1981).

22. Cf. Luis de Góngora, *Obras completas*, 984 (letter 62): "Ayer, segundo día de Pascua, estando yo con el señor Conde de Olivares, a las doce y media, lo llamó S.M. y habiendo despachado no sé qué negocios brevemente con el Conde de Benavente, estando el del Infantado y Velada también para negociar, dijo el Rey en voz más alta que suele: 'Conde de Olivares, cubríos'. Hízolo el Conde y volviéndose luego a descubrir, hechas tres reverencias, besó la mano de S.M. Diéronle todos el parabién, los que allí estaban con S.M. Luego salió un ayuda de cámara dando la nueva a los que habíamos quedado en su aposento, que fue de mucho contento para todos, porque el Conde merece el aplauso con que se oyó."

23. See Robert Jammes, *Etudes*, 357.

24. Cf. Francisco de Quevedo, *Epistolario*, ed. de L. Astrana Marín, Madrid, 1946, 113–15.

25. Cf. Bonaventura Bassegoda, "Pacheco y Velázquez," in *Veláquez y Sevilla: Estudios* (Seville, 1999), 138.

26. Jauralde remembers what is but L. Astrana's plausible conjecture in his *Francisco de Quevedo*, 894; see Francisco Pacheco, *Libro de verdaderos retratos*, facs. ed. (Seville, 1983).

27. *Arte de la pintura*, 77, where he refers to Plato's *Republic* and Aristotle's *Politics* as sources.

28. Vicente Carducho wrote his well-known *Diálogos de la pintura* in 1633 (2nd ed., Madrid, 1865, pp. 144 and ff.). Baltasar Gracián's famous treatise on Baroque aesthetics, *Agudeza y arte de ingenio* (Madrid, 1969), is a codification of the devices used for the production of wit. For a comprehensive review of the topic, see Emilio Orozco Díaz, *Temas del Barroco: De poesía y pintura* (Granada, 1947); Emilie Bergmann, *Art Inscribed: Essays on Ekphrasis in Spanish Golden Age Poetry* (Cambridge, 1979); Aurora Egido, *La página y el lienzo: Sobre las relaciones entre poesía y pintura en el barroco* (Zaragoza, 1989), 10, who often refers to Francisco Calvo Serraller, *Teoría de la pintura del Siglo de Oro* (Madrid, 1981), as well as Pierre Civil, "Retrato y poder en el teatro de principios del siglo XVII: *Las grandezas de Alejandro* de Lope de Vega," in *Représentation, écriture et pouvoir en Espagne à l'époque de Philippe III (1598–1621)* (Paris, 1999), 71–86.

29. See Emilio Orozco Díaz, *El barroquismo de Velázquez* (Madrid, 1965), 88.

30. See Luis de Góngora, *Obras completas*, sonnet 291, composed in 1607: "Oh tú, cualquiera que entras, peregrino, / si mudo admiras, admirado para / en esta bien por sus cristales clara, / y clara más por su pincel divino /" [Oh, pilgrim, whoever you are who enters this (gallery), if you, mute, admire, stop in admiration / in this clear [gallery] for its crystals, /but more illustrious, for its

divine brush.] On the motif of the *Deus artifex,* cf. A. Egido, *La página y el lienzo,* 10, and Emilie Bergmann, *Art Inscribed,* 17 and ff.

31. See his description of the city of Granada, in the poem written in 1586: 'and its room of fruits, / fresh, colorful and remarkable / an insult to the brushes / of Apelles and Timanthes, / in which the ficticious [fruits] / imitate so well the natural ones, / that they mock all men, / and deceive all birds.'; Góngora, *Obras completas,* romance 22, ll. 37–44.

32. For the anecdote about Parrhasius, see Pliny, *Naturalis Historia,* XXXV, 36, 65–66. Pliny's work was very well known in the seventeenth century through a *polianthea* like Pero Mexía's *Silva de varia lección* 91550–1551. It is also known, however, that Velázquez had in his library three copies of the *Naturalis Historia;* see Agustín Bustamante y Fernando Marías, "Entre práctica y teoría: la formación de Velázquez en Sevilla," in *Velázquez y Sevilla: Estudios,* 148.

33. Cf. sonnet 220, "Al retrato del rey Nuestro Señor hecho de rasgos y lazos con pluma, por Pedro Morante" [To the Portrait of the king, our lord, sketched with a pen by Pedro Morante, ll. 1–3: 'With his pen's rare cunningness and generous of lines, the unique Morante defeats the brushes of Apelles and Timanthes'.

34. Sonnet 332, written in 1614–15, ll. 1–4: "Esta en forma elegante, oh peregrino / de pórfido luciente dura llave / el pincel niega al mundo más suave, / que dio espíritu a leño, vida a lino." [This in elegant form, oh pilgrim, hard key of shining porphyry, deprives the world of the softest brush, which conferred spirit and life to wood and canvas].

35. *Romance* 74, composed in 1618, ll. 41–44: 'In the meantime, let the unshapely scratches of the brushes of a goose tell us its two beatiful drawings.'

36. 'Brave pen, if eloquent brush', in sonnet 81, *Obras completas,* 553. Juan de Jáuregui (1583–1641), born in Seville, probably participated in Pacheco's academy; as poet and painter, Jáuregui embodied the assimilation of literature and painting that was characteristic of its times. For his *Orfeo,* cf. Juan de Jáuregui, *Poesía,* ed. Juan Matas Caballero (Madrid, 1993), 425–516.

37. See Gabriel Bocángel, *La lira de las Musas,* ed. Trevor Dadson (Madrid, 1985), 369, sonnet 137.

38. Emilio Orozco, "Poema y cuadro," in *Paisaje y sentimiento de la Naturaleza en la poesía española* (Madrid, 1974), 113 and ff.

39. The numbers correspond to Blecua's edition of *Poesía original,* where these *ekphrastic* poems have been ordered according to a thematic grid. The portrait of Osuna that Quevedo described has not been included among Guido Reni's (1575–1642) authentic paintings; cf. J. O. Crosby, *En torno a la poesía de Quevedo,* 115–116, although he could have met the Viceroy of Sicily and of Naples between 1610 and 1620. Pedro Díaz de Morante (1565–1633) was a famous calligrapher, who drew the portrait of the king celebrated by Quevedo; cf. *Poesía original,* 266–67.

40. Cf. *Al pincel,* ll. 17–18: "Por ti, por tus conciertos / comunican los vivos con los muertos;" [Thanks to you, thanks to your arrangements, the living communicate with the dead]. This *topos,* which can be traced back to Seneca, is often applied in Quevedo's poetry to the act of reading, as in his sonnet 131: "Retirado en la paz de estos desiertos / con pocos, pero doctos libros juntos, / vivo en conversación con los difuntos / y escucho con mis ojos a los muertos."

[Retired in these peaceful deserts with a few but wise books together, I live talking to the deceased and I listen to the dead with my eyes.]

41. Some of the *exempla* cited by Quevedo to confirm the power of the brush have been built in imitation of parallel ones in Rémy Belleau's poem *Le pinceau,* included in his *Petites inventions:* "A qui mieux doy ie presenter / Ce Pinceau que ie veux chanter . . .", in *Oeuvres* (Paris, 1867), vol. 1, 73–75. Quevedo had carefully read Belleau's translation of the Greek *Anacreonta* and was familiar with his work. Eugenio Asensio was the first in establishing Quevedo's source; cf. "Un Quevedo incógnito: Las «Silvas»," *Edad de Oro,* vol. 2 (1983), 45–48.

42. See M. A. Candelas, "La silva 'El pincel' de Quevedo: La teoría pictórica y la alabanza de pintores al servicio del dogma contrarreformista," *Bulletin Hispanique,* 98 (1966), 85–95.

43. On Quevedo's description of Velázquez's "impressionistic" technique of brush strokes that, when seen at a distance, conferred reality to his paintings, cf. Emilio Orozco Díaz, "Lo visual y lo pictórico en el arte de Quevedo," *Homenaje a Quevedo* (Salamanca, 1982), 430–31.

44. The lines on Velázquez's painting can be read in the critical edition of J. M. Blecua, *Obra poética* (Madrid, 1969), vol. 1, 403–4, where the editor reproduces them in the critical apparatus: "y por ti el gran Velázquez ha podido, / diestro, cuanto ingenioso, / ansí animar lo hermoso,/ ansí dar a lo mórbido sentido, / con las manchas distantes, / que son verdad en él, no semejantes, / si los afectos pinta . . . / . . . / Y si en copia aparente / retrata algún semblante, y ya viviente / no le puede dejar lo colorido, / que tanto quedó parecido, / que se niega pintado, y al reflejo / te atribuye, que imita en el espejo." [Thanks to you (brush), the great Velázquez, skillful and ingenious, was able to confer life to beauty, to confer life to painted bodies by means of his brush strokes, which make them "true" and not only similar, if he paints the emotions . . . / . . . / And if in apparent imitation, he portrays a face, and already alive he cannot accept the combination of colors that makes it so similar that it does not look painted, he attibutes it to the reflection that he imitates in the mirror.] These lines also appear in eighteenth-century editions of Quevedo, like *Las tres últimas musas castellanas* (Madrid, 1772). On the complex transmission of this *ekphrastic* poem, or *silva,* see L. López Grigera, "La silva 'El pincel' de Quevedo," *Homenaje al Instituto de Filología* (Buenos Aires, 1975), 221–42, and now also M. A. Candelas, *Las silvas de Quevedo* (Vigo, 1997).

45. See J. Brown, *Velázquez,* 182. *Venus and Cupid* is dated before November 1648.

46. Sonnet 307; in ll. 9–11, the poet-painter sums up his impossible task: 'I learned the impossible in my sketch, but your mirror, reflecting you thanks to your own light, made sure its success.'

47. The passage is quoted by A. Bustamante and F. Marías, *Velázquez: Estudios,* 142; see also p. 148, for some mythographical sources. About Palomino's claim that Giovanni Battista della Porta was an author that Velázquez perused to study questions of physiognomy, it is important to remember that he was also a source for Quevedo's satirical portraits, for instance, those that show similarities between humans and animals, as in the *romance* 725, ll. 27–30, where a mother and a daughter are said to be like an angel and a donkey at the same time (*ángel* y *sardesco*).

48. For a qualified reappraisal of the differences between Pacheco's background and interest in literature, and Velázquez's, see *Velázquez: Estudios*, 137.

49. See Peter Cherry, "Los bodegones de Velázquez y la verdadera imitación del natural," *Velázquez y Sevilla* (Seville, 1999), 77–91, and the first chapter of *Lazarillo de Tormes*, in *Two Spanish Picaresque Novels* (Harmondsworth, 1969), 34: "As the blind man groped for the money in his purse I took the sausage and swiftly put the turnip in its place in the pan."

50. Marcia L. Welles, *Arachne's Tapestry: The Transformation of Myth in Seventeenth Century Spain* (San Antonio, 1986), 139, analyzes Pérez de Moya's *Philosophia secreta*'s generalizations on the devastating power of wine; see also J. Brown, *Velázquez*, 66–67.

51. Cf. *Poesía original*, poem 697.

52. Francisco de Quevedo's Picaresque story had had a vast readership while still in manuscript, when Velázquez arrived to Madrid; see Francisco de Quevedo, *La vida del Buscón*, ed. de Fernando Cabo (Barcelona, 1993).

53. The first edition of Quevedo's satires was published in 1627 in Barcelona, with the title *Sueños y discursos*. See now the edition by James O. Crosby, *Sueños y discursos* (Madrid, 1993).

54. *Lucian*, trans. by A. M. Harmon (London-Cambridge, 1969), vol. 4, 71–110.

55. *Velázquez*, 162.

56. See *Poesía original*, romance 745: "Visita de Alejandro a Diógenes, filósofo cínico."

57. See Aurora Egido, "La página y el lienzo," 14, for a discussion of the treatise and its importance.

58. See, for instance, Baltasar Gracián, *Agudeza y arte de ingenio* (Madrid, 1969), vol. 2, chap. 58, p. 217.

59. Marcia L. Welles, *Arachne's Tapestry*, 137, analyzes the different translations and conjectures which sources were those used by Velázquez, including the series of "moralized" Ovids that can be traced back to French translations. See also J. Pérez de Moya, *Philosofía secreta de la gentilidad* (Madrid, 1995).

60. Cf. Góngora, *Soledades*, I, ll. 838–43: "de Aracnes otras la arrogancia vana / modestas acusando en blancas telas, / no los hurtos de amor, no las cautelas / de Júpiter compulsen: que, aun en lino, / ni a la pluvia luciente de oro fino, / ni al blanco cisne creo." [Others should weave white cloths, without embroidering them, condemning with their modesty the vain arrogance of Arachne; and they should not transfer to them (or imitate in their embroidery) Jupiter's love thefts nor his tricks and deceptions, because even on cloth I do not trust the shining rain of fine gold nor the white swan, that is, Jupiter's metamorphoses to conquer Danae and Leda] (my translation is based on R. Jammes's interpretation of the passage in his annotated edition of *Soledades* [Madrid, 1994], 367–69).

61. For a detailed analysis of the painting, see Brown, *Velázquez*, 252–54, and Welles, *Arachne's Tapestry*, 149–55, as well as Julián Gállego, *Velázquez* (Barcelona, 1983), 138 and ff.

62. See Brown, *Velázquez*, 74 and Welles, *Arachne's Tapestry*, 140–43.

63. Cf. *romance* 709, ll. 21–24: "La madre, buena señora, / que al pobre herrero descansa, / pues a los armados toma / la medida de las armas" [The mother, a good lady that allows the poor blacksmith to rest, because she measures the weapons of those that wear armor . . .]. With the same irony, based on erotic puns Quevedo makes a masculine voice say in *romance* 680, ll. 103–4:

"Menguó mi luna en mi esfera / y mi sol vino a eclipsarse, / Venus me dejó Vulcano, / cornudo me dejó Marte." [My moon decreased in my sphere, my sun was eclipsed, Venus made me Vulcan, Mars made me a cuckold.]

64. Cfr. *Polifemo*, ll. 329 and ff.: "No a las palomas concedió Cupido / juntar de sus dos picos los rubíes, / cuando al clavel el joven atrevido / las dos hojas le chupa carmesíes."

65. See Brown, *Velázquez,* 182.

CHAPTER 9. CALDERÓN DE LA BARCA

1. See D. W. Cruickshank, "*Amor, honor y poder* and the Prince of Wales, 1623), forthcoming in *Bulletin of* Hispanic Studies, 77 (2000), 75–99.

2. Ibid.

3. The only comprehensive biography of Calderón is that of Emilio Cotarelo y Mori, *Ensayo sobre la vida y obras de D. Pedro Calderón de la Barca* (Madrid, 1924), from which most of this biographical data is drawn.

4. "The Father-Son Conflict in the Drama of Calderón," *Forum for Modern Language Studies,* 2 (1966), 99–113.

5. He did not receive the Bachelor of Canon Law, however. See E. M. Wilson, "Escribió Calderón el romance *Curiosísima Señora?*" *Anuario de Letras: Revista de la Facultad de Filosofía y Letras, Mexico,* 2 (1962), 103.

6. Apparently, at least to the end of 1635. From 1637 to 1640, he served another powerful – and unruly – young nobleman, the Duke of Infantado, don Rodrigo de Sandoval y Hurtado de Mendoza, grandson of the Duke of Lerma, *privado* of Philip III (Cotarelo, *Ensayo,* 178–82).

7. "Partial" in two senses: one, that it is partially true, and partial in that it is affected by the uses made of Calderón by Franco supporters and the reaction to that use by subsequent generations.

8. Pedro de Arce (1643–80), court painter for Charles II, also painted a portrait of the elderly Calderón, a copy of which exists in the Biblioteca Nacional. See Cotarelo, *Ensayo,* 353–59 and José Valverde Madrid, "Iconografía de Calderón de la Barca," *Goya* 161–62 (1981), 322–23.

9. Don Cruickshank first drew this possibility to my attention. P. M. Bardi says the sitter has been identified as Calderón de la Barca, Alonso Cano (on the basis of supposed initials "AC" on the canvas, which do not in fact exist), and Philip II's secretary Antonio Pérez, who died in 1611 and is therefore impossible (*La obra pictórica completa de Velázquez* [Barcelona, 1969]). C. M. Kauffmann's *Catalogue of Paintings in the Wellington Museum* (London, 1982), 141–42, rejects identifications as Alonso Cano, Calderón, or Velázquez without giving his source for the Calderón identification.

10. The Nieto identification by Enriqueta Harris, "Velázquez's Apsley House Portrait: An Identification," *Burlington Magazine* 120 (1978), 304, is the one most generally accepted at present.

11. "Preñada tengo la frente / sin llegar el parto nunca / Sobre la sien izquierda tengo / cierta descalabradura / que al encaje de unos celos / vino pegada esta punta / No me hallan los ojos todos / si atentos no me los buscan, / que allá en dos cuencas . . . / A ellos suben los bigotes / desde el tronco hasta la altura / cuervos los he criado, / y sacarmelos procuran." The verses, with spelling modernized, are taken from Wilson's transcription in "¿Escribió Calderón el romance *Curiosísima señora?*" 99–118. Some details in the poem do not quite

fit Calderón, as Wilson points out: i.e., the date of the subject's ordination as a priest, having received the title of *bachiller* in Salamanca, winning money in a poetic competition (Calderón's prizes were not in coin), which family member stipulated that he should become a priest. They were, however, close enough to pass in this sort of comic autobiography.

12. The best history of Spanish theatre of the period at present is that of Melveena McKendrick, *Theatre in Spain, 1490–1700* (Cambridge, 1989).

13. For comparative studies of the *comedia* and Elizabethan theatre, including theater configurations, see Louse and Peter Fothergill-Payne, *Parallel Lives: Spanish and English Drama, 1580–1680* (Lewisburg, PA, 1991), and Margaret R. Greer, "A Tale of Three Cities: The Place of the Theatre in Early Modern Madrid, London, and Paris," *Bulletin of Hispanic Studies* 77 (2000), 391–419.

14. A classic essay on those conventions is that of A. A. Parker, "The Spanish Drama of the Golden Age: A Method of Analysis and Interpretation," in Eric Bentley, *The Great Playwrights: Twenty-five Plays with Commentaries by Critics and Scholars Chosen and Introduced by . . .* (New York, 1970), vol. 1, 679–707; for a thoughtful update, see Richard J. Pym, "Tragedy and the Construct Self: Considering the Subject in Spain's Seventeenth-Century *Comedia*," *Bulletin of Hispanic Studies* 75 (1998), 273–92.

15. The most searching study is that of Claude Chauchadis, *Honneur, morale et société dans l'Espagne de Philippe II* (Paris, 1984); see also C. A. Jones, "Spanish Honour as Historical Phenomenon, Convention and Artistic Motive," *Hispanic Review* 33 (1965), 32–39; Pym, *Tragedy,* and Greer, "Woman and the Tragic Family of Man in Juan de la Cueva's *Los siete Infantes de Lara*," *Hispania* 82 (1999), 472–80.

16. See the excellent study of Walter Cohen, *Drama of a Nation: Public Theater in Renaissance England and Spain* (Ithaca, 1985).

17. See Alfred Harbage, *Shakespeare's Audience* (New York, 1941), and John Lough, *Paris Theatre Audiences in the Seventeenth and Eighteenth Centuries* (London, 1957).

18. McKendrick, *Theater in Spain,* 193; Virginia Scott, *The Commedia dell'Arte in Paris, 1644–97* (Charlottesville, VA, 1990), 97–98.

19. Calderón's response was published by L. Rouanet, "Un autographe inédit de Calderón," *Revue Hispanique* 6 (1899), 196–200.

20. See Margaret R. Greer, *The Play of Power: Mythological Court Dramas of Calderón de la Barca* (Princeton, 1991).

21. Stephen Orgel pointed out this element of court spectacles in relation to the court masques in England; see *The Illusion of Power: Political Theatre in the English Renaissance* (Berkeley, 1975), 9.

22. *Introducción al teatro religioso del Siglo de Oro: La evolución del auto sacramental: 1500–1648* (Madrid, 1953), 35. For a description of the celebration, see Margaret R. Greer, "Embodying Faith: The Auto Program of 1670," in *The Theater of Calderón: Body and Soul,* ed. Manuel Delgado (Lewisburg, PA, 1997), 133–53.

23. See Margaret R. Greer, "Bodies of Power in Calderón: *El nuevo palacio del Retiro* and *El mayor encanto, amor*," in *Conflicts of Discourse, Spanish Literature of the Golden Age,* ed. Peter Evans (Manchester, 1990), 145–65.

24. "Topographical Tropes: The Mapping of Breda in Calderón, Callot, and Velázquez," *Indiana Journal of Hispanic Literatures* 1 (1992), 186.

25. *A Palace for a King: The Buen Retiro and the Court of Philip IV* (New Haven, 1980), 178–84.

26. See Shirley Whitaker, "The First Performance of Calderón's *El sitio de Bredá*," *Renaissance Quarterly* 31 (1978), 515–31; and Simon Vosters, "Again the First Performance of Calderón's *El sitio de Bredá*," *Revista Canadiense de Estudios Hispánicos* 6 (1981), 117–34.

27. See J. H. Elliott, *The Count-Duke of Olivares: The Statesman in an Age of Decline* (New Haven, 1986), 231–33, 270–72, 332–33.

28. For example, Cruickshank suggests that the *gracioso* named Tosco (Coarse or Uncouth) in *Love, Honor, and Power* was influenced by the coarse and bawdy humor of the jester Archy who was part of the Prince of Wales' group in Madrid. See Cruickshank, *Amor, honor y poder*.

29. *Three Plays by Calderón, Casa con dos puertas mala es de guardar, La vida es sueño, La cena del Rey Baltasar*. ed. George Tyler Northup (Boston, 1926), verses 1052–54. Other published editions in Spanish omit the hunting scene cited below. They probably derive from subsequent performances in the *corrales* that omitted that lengthy passage to speed the action. The Muir and Mackenzie translation cited later includes it as an appendix.

30. Lisandro also adds kudos for the king's ministers (i.e., Olivares), the Hercules who helps the royal Atlas carry the weight of government (vv. 570–80), an unqualified flattery that Calderón would not accord the royal favorite in later works.

31. For example, as Lisardo and Félix start to trade stories of their troubles, Calabazas asks the other lackey if he has anything good for breakfast while their masters indulge in "two enormous speeches" (8), poking fun at the stock convention of long introductory narratives by *comedia* heroes and heroines.

32. See Richard W. Tyler and Sergio D. Elizondo, *The Characters, Plots and Settings of Calderón's Comedias* (Lincoln, NB, 1981), 18–19.

33. See Jonathan Brown, *Velázquez: Painter and Courtier* (New Haven, 1986), 270–71, and José Moreno Villa, *Locos, enanos, negros y niños palaciegos* (Mexico City, 1939), 85–87.

34. I have added the "Lutheran" omitted in Muir and Mackenzie's translation. Because "luterano" rhymed with "culterano" [euphuistic, gongorine style], the word could suggest both religious and poetic heresy.

35. *Three Comedies by Pedro Calderón de la Barca*, trans. by Kenneth Muir and Anne L. Mackenzie, (Lexington, KY, 1985), 68–70.

36. Matt Cartmill, *A View to Death in the Morning* (Cambridge, MA, 1993), 59–66.

37. See Brown, *Velázquez*, 129–38.

38. See John Varey's analysis in "*Casa con dos puertas*: Hacia una definición del enfoque calderoniano de lo cómico," in *Cosmovisión y escenografía: El teatro español en el Siglo de Oro* (Madrid, 1987), 189–202.

39. See Margaret R. Greer, "The (Self)Representation of Control in *La dama duende*," in *The Golden Age* Comedia: *Text, Theory, and Performance*, eds. Charles Ganelin and Howard Mancing (West Lafayette, IN, 1994), 87–106.

40. Laura Bass gives an in-depth treatment of how several Golden Age dramatists raise this issue through the use of portraits in her dissertation "The Portrait in the Play: Subjectivity and Representation on the Seventeenth-Century Spanish Stage" (Princeton, 2000). For a study of Calderón's use of the portrait motif

in his auto version of *El pintor de su deshonra*, see Laura Bass's article "A sue imagen y semejanza: La Naturaleza Humana como retrato de Dios en *El pintor de su deshonra*, in *Pedro Calderón de la Barca, El pintor de su deshonra. Edición conmemorativa del IV centenario del nacimiento del autor* (Madrid, 2000), 57–78.

41. See the comparative study of the versions of Pliny, John Lyly, Lope de Vega and Calderón by Melveena McKendrick, "El libre albedrío y la reificación de la mujer: La imagen pintada en *Darlo todo y no dar nada*," in *Texto e imagen en Calderón: Undécimo Coloquio Anglogermano sobre Calderón*, ed. Manfred Tietz (Stuttgart, 1998), 158–70.

42. See Emily Umberger's superb article, "Velázquez and Naturalism II: Interpreting *Las Meninas*," *Res* 28 (Autumn 1995), 103. Also Robert Ter Horst, "The Second Self: Painting and Sculpture in the Plays of Calderón," in *Calderón de la Barca at the Tercentenary: Comparative Views*, ed. Wendel M. Aycock and Sydney P. Cravens (Lubbock, TX, 1982), 175–95.

43. The 1865 translation of Edward Fitzgerald, in *Eight Dramas of Calderón, Foreword by Margaret R. Greer* (Urbana, 2000), slightly modified by reference to that of A. K. G. Paterson's rendition in his bilingual edition, *The Painter of His Dishonour* (Warminster, 1991), 83.

44. Calderón too plays on two planes, tragedy and comedy, as he gives major importance to Don Juan's comic storytelling lackey.

45. See Susan L. Fischer, "Art-within-Art: The Significance of the Hercules Painting in *El Pintor de su deshonra*": *Critical perspectives on Calderón de la Barca* (Lincoln, NB, 1981), 69–79.

46. The Spanish text with commentary was published by Ernst Robert Curtius in "Calderón's 'Traktat über die Malerei'," *Romanische Forschungen* 50 (1936), 89–137; part of the translation is taken from his chapter "Calderón's Theory of Art and the *Artes Liberales*," in Curtius, ed., *European Literature and the Latin Middle Ages* (New York, 1953), 561.

CHAPTER 10. THREE PAINTINGS, A DOUBLE LYRE, OPERA, AND ELICHE'S VENUS

1. During the early seventeenth century certain of the court composers were clearly locally famous, to judge by the citation of their names in works by the courtier poets. The royal chapelmaster who retired in 1634, Mateo Romero, known by his nickname "el maestro Capitán," was actually a Fleming (Mathieu Rosemarin) and perhaps because he was not Spanish he rose to the position of registrar of the Order of the Golden Fleece in 1621; see Stein, *Songs of Mortals, Dialogues of the Gods: Music and Theatre in Seventeenth-Century Spain* (Oxford, 1993), 93–95.

2. For example, Joseph Alfonso Guerra y Villegas, one of the Royal Chapel's scribes, notes the many cash payments awarded the French musicians who accompanied Marie-Louise de Orléans when she traveled to Madrid as the bride of Carlos II in 1679, in "Relación de la Jornada que se hizo . . . en las reales entregas de la Reyna . . ." (B.N.M. MS 7862); see Stein, *Songs of Mortals*, 326–29.

3. See Lope's dedication of *La selva sin amor* in Lope Félix de Vega Carpio, *Laurel de Apolo, con otras rimas* (Madrid, 1630) [B.N.M., R-177], fol. 103; also in

Obras de Lope de Vega, 13, ed. Marcelino Menéndez y Pelayo (Madrid, 1965), BAE 188, 187–98

4. Baccio's letters are transcribed in Mina Bacci, "Lettere inedite di Baccio del Bianco," *Paragone* 14 (1963), 68–77; the music for *Fortunas de Andrómeda y Perseo* is preserved in Cambridge, Harvard University, Houghton Library, MS Typ 258H, fols. 105v–150r; facs. ed. Rafael Maestre (Almagro, 1994); see the study in Stein, *Songs of Mortals*, 144–69.

5. Letters published in "Privatbriefe Kaiser Leopold I an den Grafen F. E. Pötting: 1662–1673," ed. Alfred Francis Pribram and Moriz Landwehr von Pragenau, Fontes rerum austriacarum: Abteilung II, *Diplomataria et acta*, vol. 56, pp. 276, 293, 295, 300, 312, 354; extracted in J. E. Varey and N. D. Shergold, "Introducción," to Juan Vélez de Guevara, *Los celos hacen estrellas* (London, 1970), cv–cvi.

6. See Stein, *Songs of Mortals*, 299–300; the theatrical songs in the so-called "Guerra Manuscript" copied around 1680 (MS 265 in the manuscript library of the University of Santiago de Compostela) indicate that Urruela y Arteaga's claims to uniquity were overstated; on this source see Alvaro Torrente and Pablo-L. Rodríguez, "The 'Guerra Manuscript' (c. 1680) and the Rise of Solo Song in Spain," *Journal of the Royal Musical Association* 123 (1998), 147–89.

7. On the use of Hidalgo's music in the eighteenth-century theater in Madrid, see Louise K. Stein, "El 'manuscrito novena': Sus textos, su contexto histórico-musical y el músico Joseph Peyró," *Revista de Musicología* 3 (1980), 197–234.

8. See Stein, *Songs of Mortals*, chap. 7 and passim.

9. Concerning seventeenth-century musical eroticism in Madrid, see Stein, "Eros, Erato," 654–77; and Louise K. Stein, "'Al seducir el oído . . . ,' delicias y convenciones del teatro musical cortesano," *El teatro cortesano en la España de los Austrias*, ed. José María Díez Borque, *Cuadernos de Teatro Clásico* 10 (Madrid, 1998), 169–89.

10. I am indebted to Dr. Rose Pruiksma for sharing with me her as yet unpublished seminar paper on the vocabulary of early modern eroticism.

11. *Obras de Garcilaso de la Vega con anotaciones de Fernando de Herrera* (Seville, 1580); see Antonio Gallego Morell, *Garcilaso de la Vega y sus comentaristas, obras completas del poeta acompañadas de los textos íntegros de los comentarios de el Brocense, Fernando de Herrera, Tamayo de Vargas y Azara* (Granada, 1966), 458.

12. "*Erotico, ca*; adj. Cosa amatória y perteneciente à las passiones y afectos de amór. Es voz Griega. Lat. Amatorias, a, um. f. herr. Sob. la Egl. I. de Garcil. Coronabanse de laurel los Poetas heróicos, como se puede vér en Horacio y Estacio, y de Myrtho los Eroticos, que son los que escriben cosas de amór." Real Academia Española, *Diccionario de la lengua castellana, en que se explica el verdadero sentido de las voces, su naturaleza y calidad, con las phrases o modos de hablar, los proverbios o refranes, y otras cosas convenientes al uso de la lengua* (Madrid, 1726–39), vol. 3 (1732), 544.

13. Sebastián de Covarrubias Orozco, *Tesoro de la lengua castellana o española* (Madrid, 1611), ed. Felipe C. R. Maldonado (Madrid, 1995); "*Amor*. Latine amor . . . por no amontonar aqui tanto como esta dicho de amor, y escrito por diversos autores, de que se pudiera hazer un volumen entero. Amores, siempre se toma en mala parte por los amores lascivos, que son los que tratan los enamorados" (86); "*Amores*. De ordinario son los lascivos" (86); "*Lascivia*. No

es muy usado este termino en lengua Española, vale luxuria, incontinencia del animo, inclinación y propensión a las cosas venereas, blandas, y regaladas, alegres, y chocarreseas en esta materia. Lascivo. El que esta afecto de tal pasión ó el incitamento della. Poeta lascivo, el que escrive amores" (702); *Diccionario de la lengua* castellana, vol. 1 (1726), 273; "*Amores*. En nuestra lengua se toma por los amores profanos y lascivos, que son los que tratan los enamorados. Lat. Amatoriae blanditiae."

14. *Diccionario de la lengua castellana*, vol. 3, 544–45; "*Erotismo*. s. m. pasión fuerte de amor . . . Vencido de un frenetico erotismo / enfermedad de amor, o el amor mismo."

15. *Diccionario de la lengua castellana*, vol. 6, 444–5; "*Venereo, rea*. adj. Lo que pertenece a la Venus, o al deleite sensual. Es del Latino *Venereus*. Lag. Diosc. lib.6. Prefac. Tengo por burla lo que hallo escrito en algunos doctores Arabes, que cierta doncella muy acabada y hermosa fue mantenida desde niña con el Napelo, para cautamente atosigar algunos reyes, y príncipes, que despues con ella tuviessen conversación *venerea* . . . Comunmente continencia se toma por abstinencia del acto *venereo*."

16. Emilio Cotarelo y Mori, *Bibliografía de las controversias sobre la licitud del teatro en España* (Madrid, 1904); see esp. (125) the extracts from the Jesuit Padre Ignacio Camargo, whose *Discurso theológico sobre los theatros y comedias de este siglo* (Salamanca, 1689) contains very clear statements about music.

17. See Alfonso E. Pérez Sánchez, *Pintura barroca en España 1600–1750* (Madrid, 1992), 51–55, and the excellent study by Rosa López Torrijos, *La mitología en la pintura española del Siglo de Oro* (Madrid, 1985).

18. Padre Igancio Camargo acknowledged the connection between well-crafted music and affective power as "music's enchantment," (*el encanto de la música*), and described the erotic impact of performances by actress-singers, whose enchantingly beautiful music was among the artifices that "spread the crude fire of lasciviousness" (*arrojando el fuego torpe de la lascivia*) that transformed the public theaters, or *patios*, into a "center of sensual delight" (*centro de las delicias sensuales*); see Stein, "Eros, Erato" and "Al seducir el oído," and Cotarelo y Mori, *Bibliografía*, 123–27.

19. For the chronology of the paintings considered in this essay I have relied on Miguel Morán Turina and Isabel Sánchez Quevedo, *Velázquez: Catálogo Completo* (Madrid, 1999); José López-Rey, *Velázquez: Painter of Painters*, 2 vols. (Cologne, 1996); and Jonathan Brown, *Velázquez: Painter and Courtier* (New Haven and London, 1986), as well as other sources cited in these notes.

20. My ingenious colleague Pepe Rey has explained the painting as a meditation on the vanity and fleetingness of mundane pleasure; see his very tempting explication in his "Divagaciones en torno a Velázquez y la música," *Scherzo* 133 (April 1999), 133–38.

21. Concerning the paintings in "un tono naturalista" that Velázquez completed in Seville, see the superb essay by Alfonso E. Pérez Sánchez, "Velázquez y su arte," in the exhibition catalogue *Velázquez* (Madrid, 1990), 26–27.

22. On this point see Jack Sage, "Calderón y la música teatral," *Bulletin Hispanique* 58 (1956), 275–300; Sage, "The Function of Music in the Theater of Calderón," in J. E. Varey, ed., *Critical Studies of Calderón's Comedias* (London, 1973), 209–27; and Louise K. Stein, "La plática de los dioses: Music and the Calderonian Court Play, with a Transcription of the Songs from *La estatua*

de Prometeo," chap. 2 in Pedro Calderón de la Barca, *La estatua de Prometeo,* a critical edition by Margaret Rich Greer (Kassel, 1986), 13–92.

23. Juan Pérez de Moya, *Philosofía secreta* (Madrid, 1585), ed. Carlos Clavería (Madrid, 1995), 415–16.

24. Pedro Sánchez Viana, *Las transformaciones de Ovidio* (Valladolid, 1589). fols. 8r–10r, excerpted in Juan Vélez de Guevara, *Los celos hacen estrellas,* ed. J. E. Varey and N. D. Shergold (London, 1970), 135–42.

25. Vélez de Guevara's sonnet "Pincel que a lo atrevido y a lo fuerte / les robas la verdad, tan bien fingida" praises one of Velázquez's paintings (transcribed in Guillermo Diaz-Plaja, "Velázquez y la poesía," *Varia Velazqueña,* 2 vols. (Madrid, 1960) vol. 2, 619); Juan Vélez de Guevara inherited his father Luis's position as Ugier de cámara in 1642 [BNM MS 14018/19] (though by this time Velázquez was Ayuda de Guardarropa) and contributed a loa to the January 1658 festivities that celebrated the birth of Prince Philip Prosper, festivities organized by the Marquis de Eliche and in which the intervention of Diego Velázquez, aposentador, was important (see J. E. Varey, "Velázquez y Heliche en los festejos madrileños de 1657–1658," *Boletín de la Real Academia de la Historia* 169 (1972), 408); and María Jesús Muñoz González, "Nuevos datos sobre los oficios y puestos de Velázquez en la casa real," *Archivo Español de Arte* 288 (1999), 546–49.

26. For the date of performance, see the introduction to *Los celos hacen estrellas,* ed. Varey and Shergold, xliv–lxxi, and the appendix with transcriptions prepared by Jack Sage; on the music of this zarzuela, see Stein, *Songs of Mortals,* 288–96, and Stein, "Las convenciones del teatro musical y la herencia de Juan Hidalgo," *Bances Candamo y el teatro musical de su tiempo (1662–1704),* ed. José Antonio Gómez (Oviedo, 1995), 204–6.

27. In *Los celos hacen estrellas,* ed. Varey and Shergold, lines 16–20: "Voz más que humana es sin duda / ésta que obliga sonora / a que no buelen las aves, / y a que las fuentes no corran," and 147–50: "no sé qué tiene tu voz / cantando, que el alma roba, / y suspende los sentidos, / si es que no los aprisiona."

28. See, for example, the verisimilar depiction of musical instruments in Juan de Roelas, *Adoration of the Name of Jesus / Circumcision,* 1604–5 (Seville, Capilla Universitaria); Francisco de Zurbarán, *Adoration of the Shepherds,* 1638 (Grenoble, Museum of Grenoble); Francisco de Zurbarán, *Temptation of Saint Jerome,* 1638 (Guadalupe, Real Monasterio de Nuestra Señora); and Juan de Valdés Leal, *Temptation of Saint Jerome,* 1657 (Seville, Museo de Bellas Artes).

29. Although the date of this painting is uncertain (some scholars suggest that it was painted around 1648, before Velázquez's second trip to Italy, while others date it a decade later) there is little doubt that it belonged to Don Pedro de Arce, an art collector and colleague of Velázquez's as aposentador de palacio, for it was listed in an inventory of his collection taken in 1664, as revealed in María Teresa Caturla, "El coleccionista madrileño don Pedro de Arce," *Archivo Español de Arte* 1948, 292–304.

30. Carl Justi, *Velázquez y su siglo,* trans. Jesús Espino Nuño (Madrid, 1999), 650–56.

31. Diego Angulo Iñiguez, *Velázquez: Cómo compuso sus principales cuadros y otros escritos sobre el pintor* (Seville, 1947; reprint Madrid: Ediciones Istmo, 1999) 112–18; and Angulo Iñiquez, "Las Hilanderas," *Archivo Español de Arte* 21 (1948), 1–19.

32. Elizabeth Du Gué Trapier, *Velázquez* (New York, 1948), 350; Charles de Tolnay, "Velázquez' *Las hilanderas* and *Las meninas* (an interpretation)," *Gazette des Beaux-Arts* 35 (1949), 21–38; and José María de Azcárate, "La alegoría en *Las hilanderas*," *Varia Velazqueña* vol. 1, 344–51.

33. Covarrubias, *Tesoro*, 966, 968.

34. Azcárate, "La alegoría en *Las hilanderas*," and Santiago Sebastián, "Nueva lectura de 'Las Hilanderas,' la emblemática como clave de su interpretación," *Revista Fragmentos* 1 (1984), 45–51.

35. On the engravings of the Muses, see López Torrijos, *La mitología*, 306–7.

36. Citations are extracted from Francisco Quevedo y Villegas, *El parnaso español, monte en dos cumbres dividido con las nueve musas castellanas* (Madrid, 1648), an edition with commentary by Joseph Antonio González de Salas [BNM R-4418]. According to López Torrijos, *La mitología*, 307, the drawings for the remaining three Muses (Euterpe, Calliope, and Urania) by another artist were later used as the basis for engravings in *Las últimas tres musas castellanas* in 1670.

37. Brown, *Velázquez*, 244, and see Steven N. Orso, *Philip IV and the Decoration of the Alcázar Palace* (Princeton, 1986), 30.

38. Spanish paintings on this story are studied in López Torrijos, *La mitología*, 298–302.

39. Orso, *Philip IV*, 73, 83, 86–87, 104; the Apollo and Marsyas was described as "Apolo desollando a un sátiro" in palace inventories of 1666, 1686, and 1700, according to Bernardino de Pantorba, "Notas sobre cuadros de Velázquez perdidos," *Varia Velazqueña* vol. 1, 394.

40. Julián Gállego, *Visión y símbolos en la pintura española del siglo de oro*, 3rd ed. (Madrid, 1991), 263–66.

41. I have consulted the Rome, 1603 edition of the *Iconologia*, which was the first illustrated edition; concerning Ripa and his influence on Velázquez and Calderón, see Cesare Ripa, *Iconologia* (Siena 1613), trans. Juan Barja et al., 2 vols. (Madrid, 1996) vol. 1, 21–24.

42. On the lirone, see Howard Mayer Brown, "Lirone," *The New Grove Dictionary of Music and Musicians*, ed. Stanley Sadie (London, 1980), vol. 11, 23–24; Erin Headley, "Lirone," in *The New Grove Dictionary of Musical Instruments*, vol. 2, 528–30; Annette Otterstedt, "Lira," *Die Musik in Geschichte und Gegenwart*, 2nd ed. (Kassel, 1996), vol. 5, 1348–61.

43. Covarrubias, *Tesoro*, 717.

44. See esp. the shape of the lirone depicted in Michael Praetorius, *Syntagma musicum* 2 (Wolfenbüttel, 1619), facs. ed. (Kassel, 1958), 26, 49, and the lirone that illustrates the emblem for "Poesia" in the 1618 edition of Ripa's *Iconologia*, reproduced in Emanuel Winternitz, *Musical Instruments and their Symbolism in Western Art*, 2nd ed. (New Haven and London, 1979), 92. As other illustrations reproduced in Winternitz indicate (esp. plate 31), the lirone took on various shapes; that depicted in Marin Mersenne, *Harmonie Universelle* (Paris, 1636), bk. 4, 280, differs from what is pictured in Ripa and Praetorius; see the facsimile, ed. François Lesure (Paris, 1963).

45. Winternitz, *Musical Instruments*, 86–98 and 150–65; Howard Mayer Brown, "Psyche's Lament: Some Music for the Medici Wedding in 1565," in *Words and Music: The Scholar's View*, ed. Laurence Berman (Cambridge, MA, 1971), 1–21.

46. Brown, *Velázquez*, 252–53.

47. Marías does not bring the musical instrument into his interpretation, but see Fernando Marías, *Velázquez: Pintor y criado del rey* (Madrid, 1999) 206–12.

48. Ibid., 212.

49. Athanasius Kircher, *Musurgia Universalis* (Rome, 1650), vol. 1, lib. 6, "De musica instrumentali," fols. 486–87; see also the facsimile reprint, ed. Ulf Scharlau (Hildesheim and New York, 1970); according to Mersenne, *Harmonie Universelle*, 180, the "lyre" was best suited to music in "le mode triste et languissant."

50. Kircher, 486–87; see the exhaustive study in Luis Robledo, "Poesía y música de la tarántula," *Poesía* 5–6 (1979–80), 224–32, which draws information as well from Kircher's *De arte magnetica* (Rome, 1641; Cologne, 1643) and *Phonurgia nova* (Kempten, 1673); Robledo (230) reproduces the engraving from Kircher with the lyra da braccio. Concerning the likely influence of the *Musurgia universalis* on practical music making at Philip IV's court, see Stein, *Songs of Mortals*, 240–41.

51. The famous Bolognese lute and theorbo player Filippo Piccinini, who became one of Philip IV's favorites among the chamber musicians (he served from 1613 to his retirement in 1636), was viol teacher to "sus altezas" the princes in 1620; see BNM MS 14040/3, and BNM MS 14069/221, fol. 16. A glimpse of Philip IV as amateur musician and of informal music making at court is provided by a letter from Averardo Medici to Andrea Cioli in Florence, dated 1 July 1627: "il Re si diletta della musica et n'intende tanto che sa comporre di contrappunto et suona franco il basso del violone; et ogni sera si trattengono Sua Maestà e gli Infanti suoi fratelli un'hora con un concerto di viole, che tuttiatre suonano, et con loro il maestro di cappella et un Italiano musico di camera della Maestà Sua che si chiama Filippo Piccinini" (Shirley B. Whitaker, "Florentine Opera Comes to Spain: Lope de Vega's *La selva sin amor*," *Journal of Hispanic Philology* 9 [1984], 63). These informed observations of Averardo Medici were perhaps the source for the strikingly similar comments of Vincenzo Giustiniani in his "Discorso sopra la musica de' suoi tempi," written in Rome in 1628, ed. Angelo Solerti, *L'origini del melodramma* (Torino, 1903), 111–12.

52. "Memoria del gasto que tuvo una lira que hizo Manuel Vega, guitarrero de la Real Capilla de S.M. de orden del Sr Capellan mayor este año de 1656." "Lleva la dicha lira diez y seis ordenes con clavijas de hierro, los puntos y plantilla y el cordel de la dicha lira de ebano de Portugal con masillas de perfiles de ebano y marfil guarnecido el suelo y la tapa a imitacion de las estrangeras, que vale de materiales y mano 800 rs." BNM MS 14046/155 [Barbieri copy of the original document].

53. "Lipo Galio, de Arte musica" is listed in the inventory of Velázquez's library, along with treatises on architecture and cartography; see F. J. Sánchez Cantón, "La librería de Velázquez," *Homenaje ofrecido a Menéndez Pidal*, 3 vols. (Madrid, 1925), vol. 3, 391.

54. Velázquez served as Ugier de cámara with the famous composer Juan Blas de Castro (d. 1631) [BNM MS 14018/19, fol. 13], who was also a friend of Lope de Vega (Luis Robledo, *Juan Blas de Castro: Vida y obra musical* (Zaragoza, 1989)). Velázquez also knew the castrato singer and chronicler, Lázaro Díaz del Valle, who served in the royal chapel (see Francisco J. Sánchez Cantón, *Fuentes literarias para la historia del arte español* vol. 2 (Madrid, 1933), 326; and *Varia Velazqueña*, vol. 2, 59–62 and 387; and Matilde López Serrano,

"Reflejo velazqueño en el arte del libro Español de su tiempo," *Varia Velazqueña,* vol. 1, 511) and whose otherwise unreliable history of the royal chapel praises Juan Hidalgo. The English composer and virtuoso viol player Henry Butler, one of Philip IV's chamber musicians, is mentioned with another supposed musician, the Roman harpist Bartolomé Jovenardi, who was principally a spy and economic adviser to Philip IV, in a document of 1637 concerning clothing (see *Varia Velazqueña,* vol. 2, 243). As aposentador de palacio he would most likely have known the músicos de cámara, who were often called to perform for the king in his private quarters, as well as others among the court musicians.

55. See esp., José María Azcárate, "Noticias sobre Velázquez en la Corte," *Archivo Español de Arte* 33 (1960), 357–85; Orso, *Philip IV,* passim, and Brown, *Velázquez,* 244–52.

56. In the Jacopo Peri and Ottavio Rinuccini *Euridice* (1600) that honored the marriage of Maria de' Medici to Henri IV of France, Venus as the "immortal guide" leads the mythical hero Orfeo to Hades and encourages him to "display his noble song" and endeavor with his "soft lament" to move Pluto to release Euridice. In Marco Da Gagliano's *La Dafne,* commissioned for the wedding of Francesco Gonzaga of Mantua in 1607 and performed in 1608, an openly flirtatious Venus warns Apollo that his pride will not protect him from the sting of Cupid's dart, and she encourages Amore to ensnare the proud god so that he is left "servile and subjected to our reign. In a clear case of operatic eroticism mirroring the royal pleasure, the role of Venus in John Blow's *Venus and Adonis* (ca. 1683) was played and sung by none other than King Charles II's mistress, although it was not for a wedding but celebrated instead the legitimacy of the sovereign's amorous extramarital adventure for the English court. Opposite to Blow's erotic miniature, the grandiose Antonio Cesti–Sbarra festa teatrale *Il pomo d'oro,* performed in the Vienna Hoftheater auf der Cortina in July of 1668 to celebrate the wedding of Leopold I and the Infanta Margarita of Spain, also includes Venus prominently in its elaborate interpretation of the myth of the Judgment of Paris. *Il pomo d'oro* was thus created for another daughter of Philip IV, though emperor Leopold was originally to have married María Teresa of Spain, who was instead married off to Louis XIV.

57. The operas, their texts, music, and politics, are treated in detail in Stein, *Songs of Mortals,* chap. 5; Louise K. Stein, "Opera and the Spanish Political Agenda," Acta Musicologica 63 (1991), 126–67; and in the introduction to Louise K. Stein, ed., Tomás de Torrejón y Velasco and Juan Hidalgo, *La púrpura de la rosa* (Madrid, 1999).

58. Orso, *Philip IV,* 76–107.

59. Brown, *Velázquez,* 249.

60. ". . . que ha de ser / toda música; que intenta / introducir este estilo / porque otras naciones vean / competidos sus primores," from the first printed edition of the text in *Tercera parte de comedias de don Pedro Calderón . . .* (Madrid, 1664), fol. 206v; see also Pedro Calderón de la Barca, *Obras,* ed. Juan Eugenio Hartzenbusch, 4 vols. (Madrid, 1850–52; reprint, 1944–45), Biblioteca de Autores Españoles 9, 676.

61. Orso, *Philip IV,* 76–87, 100–104.

62. Velázquez had purchased these paintings in Venice in 1652; Gramont's formal

entry took place in October 1659; see Brown, *Velázquez*, 208; on the South Gallery and the visit of Gramont, see Orso, *Philip IV*, 36–40 and 144–53.

63. "Fábula dicen a una habla fingida, con que se representa una imagen de alguna cosa . . . toda fábula se funda en un razonamiento de cosas fingidas y aparentes, inventadas por los Poetas y sabios, para debajo de una honesta recreación de apacibles cuentos, dichos con alguna semejanza de verdad, inducir a los lectores a muchas veces leer y saber su escondida moralidad y provechosa doctrina." Pérez de Moya (bk. 1, ch. 1), 65.

64. W. H. Lewis, *The Splendid Century: Life in the France of Louis XIV* [1954] (reprint New York, 1978), 16–17.

65. For further analysis of the relationship of the operas to historical fact, see Stein, *Songs of Mortals*, 222–27. Concerning the marriage of Louis and María Teresa, see Ragnhild Hatton, "Louis XIV: At the court of the Sun King," in A. G. Dickens (ed.), *The Courts of Europe, Politics, Patronage and Royalty 1400–1800* (London, 1977), 235, and Olivier Bernier, *Louis XIV: a Royal Life* (New York, 1987), 105–8. Bernier notes (107) that the queen made known her unhappiness about Louis's affair with Henriette of England shortly after they were installed at court in France. Jules Lair, in *Louise de la Vallière et la jeunesse de Louis XIV, d'après des documents inédits* (Paris, 1881), indicates that María Teresa confided her jealousy to the Queen Mother in the summer of 1661 and that by the end of July 1661 Louise de la Vallière was quite openly Louis XIV's mistress. Madame de Motteville noted that the queen knew that La Vallière "was the cause of her suffering," and that it "became impossible to conceal her misfortune from her" (*Memoirs of Madame de Motteville*, trans. Katharine Prescott Wormeley, 3 vols. (Boston, 1902), iii, 282). María Teresa's suffering, caused by neglect and isolation, increased during the last months of her pregnancy, before the birth of a dauphin in November 1661. (Lair, 48–68). See also, Gilette Ziegler, *At the Court of Versailles: Eye-Witness Reports from the Reign of Louis XIV*, trans. Simon Watson Taylor (New York, 1966), 45–47.

66. "En la fábula de Céfalo y Procris, se notará que el perro que Diana dió a Procris significa la lealtad que la mujer casta debe tener siempre a su marido. . . . Que Procris muera a manos de su marido, significa que la poca prudencia nos guía las más veces a buscar lo que no querríamos hallar, y así quedamos muchos de nosotros muertos del dardo de la poca continencia, esto es, de la pasión que encerramos en nosotros mismos, por haber loca y desvanecidamente creído a palabras ajenas." (Ibid., 564)

67. The standard biography is Gregorio de Andrés, *El Marqués de Liche, bibliófilo y coleccionista de arte* (Madrid, 1975); Eliche's significant activities as patron and collector of painting and sculpture in Italy (as Marquis del Carpio) are summarized in Francis Haskell, *Patrons and Painters: A Study in the Relations between Italian Art and Society in the Age of the Baroque*, revised and enlarged edition (New Haven and London, 1980), 190–92. The most detailed study to date of his activity as a collector in Spain is included in Marcus Burke, *Collections of Paintings in Madrid 1601–1755*, 2 vols. (Los Angeles, 1997), vol. 1, 156–78. Among the many articles about his relationship to Velázquez, see José Manuel Pita Andrade, "Los cuadros de Velázquez y Mazo que poseyó el séptimo marqués del Carpio," *Archivo Español de Arte* 99 (1952), 223–36; Enriqueta Harris, "El Marqués del Carpio y sus cuadros de

Velázquez," *Archivo Español de Arte* 30 (1957), 136–39; Varey, "Velázquez y Heliche," 407–22; and Rosa López Torrijos, "Coleccionismo en la época de Velázquez: El marqués de Heliche," *Velázquez y el arte de su tiempo* (Madrid, 1991), 27–36.

68. Two plays by Calderón, *La fiera, el rayo y la piedra* (1652) and *Fortunas de Andrómeda y Perseo* (1653) were the first to be staged as mythological semi-operas; although it is possible that Eliche was involved, Barrionuevo does not mention Eliche in connection with the big palace productions until 1655; see Jerónimo de Barrionuevo, *Avisos*, 2 vols., ed. A. Paz y Meliá, Biblioteca de Autores Españoles 222 (reprint Madrid, 1968–69), 107, 222. In 1657 Eliche produced *El golfo de las sirenas*, and the first zarzuela, Calderón's *El laurel de Apolo*; see Stein, *Songs of Mortals*, chap. 4 on the semioperas, and chap. 6 on the zarzuelas.

69. The Marquis de Eliche's interest in procuring fine actress-singers for Madrid is documented beginning in 1657 when he required the Andrade sisters (Ana, Feliciana, and Micaela) to travel from Toledo to Madrid to be incorporated into the company of Diego Osorio; *Genealogía, origen y noticias de los comediantes de España* [B.N.M., MS 12917 and MS 12918], ed. N. D. Shergold and J. E. Varey (London, 1985), 419–20; and Cristóbal Pérez Pastor, *Documentos para la biografía de D. Pedro Calderón de la Barca* (Madrid, 1905), 248.

70. See Stein, ed., *La púrpura de la rosa*, p. xxvi of the introductory essay, and the score beginning at p. 112.

71. An unpublished letter suggests that Eliche was involved in the production of spectacle plays as early as 1650. The letter, to the Duke of Veragua from Juan Alonso Verdugo de Albornoz in Madrid, dated 18 January 1650, mentions Eliche's responsibility for a "comedia de apariencias que se ha de hacer que dicen costará 20 mil ducados" (Madrid, Biblioteca de la Casa de Alba, Palacio de Liria, Caja 102–11, 7242).

72. See the detailed account in Stein, *Songs of Mortals*, 144–69.

73. The music for this song in 1653 was a recomposed version of the setting by Juan Blas de Castro from ca. 1620–25; ibid., 159–61.

74. Titian's fame as a specialist in erotic painting is especially relevant because he was commissioned by Philip II of Spain to paint a series of erotic paintings on mythological subjects; though these were once hidden behind a curtain in a special room in the monastery-palace at El Escorial, they were displayed in Philip IV's Alcázar. On Titian as erotic specialist and for an especially insightful look at erotic paintings in the Renaissance, see Mary Pardo, "Artifice as Seduction in Titian," in *Sexuality and Gender in Early Modern Europe,* ed. James Grantham Turner (Cambridge, 1993), 55–89.

75. On the Velázquez *Venus*, Francis Haskell has written, "la Venus del espejo ha tenido una reputación extraña: quienes la conocieron más de cerca – el marqués del Carpio, los Alba, Godoy, Morritt – estaban convencidos (y sin duda encantados) de que era indecente y sólo apta para ser vista por unos pocos escogidos; y hay que admitir que, en el contexto de sus épocas, tales supuestos eran razonables." Francis Haskell, "La *Venus del espejo*," in *Velázquez* (Barcelona: Galaxia Gutenberg, Amigos del Museo del Prado, 1999), 235; likewise Fernando Marías, in *Velázquez: Pintor y criado del rey* (Madrid, 1999), 169–73, comments on the overt sensuality of the *Venus del espejo* and suggests a number of sources for its erotic imagery.

76. Pacheco's text reads: "que se han extremado con la licenciosa expresión de

tanta diversidad de fábulas; y hecho estudio particular de ellas, con tanta viveza o lascivia, en debuxo y colorido; cuyos cuadros (como vemos) ocupan los salones y camarines de los grandes señores y príncipes del mundo. Y los tales artificios alcanzan no sólo grandes premios, pero mayor fama y nombre. . . ." Francisco Pacheco, *Arte de la pintura,* ed. Bonaventura Bassegoda i Hugas (Madrid, 1990), 376; this passage is explained and extracted in Jonathan Brown, *Images and Ideas in Seventeenth-Century Spanish Painting* (Princeton, 1978), 72.

77. Pacheco, *Arte de la pintura,* 376.
78. Duncan Bull and Enriqueta Harris, "The companion of Velázquez's Rokeby Venus and a source for Goya's Naked Maja," *Burlington Magazine* 128 (1986), 643–44; see also Brown, *Velázquez,* 181–83, on this painting and the tastes of the Marquis de Eliche.
79. Jerónimo de Barrionuevo relates gossip about the Marquis and Damiana in his *aviso* of 26 June 1658; see *Avisos.* Gregorio de Andrés, *El Marquís de Liche,* makes reference to this Damiana and the Venus del Espejo in his biography; on Eliche as playboy see Andrés, 10–14.
80. This is the association suggested long ago by Felipe Picatoste, in *Estudios sobre la grandeza y decadencia de España,* 3 vols. (Madrid, 1887), vol. 3: "El siglo XVII," 121; see also López-Rey, *Velázquez: Painter of Painters,* vol. 1, 156, 238 n. 153.

Selected References

This bibliography includes the most useful works cited in the essays in this volume. The literature about Diego de Velázquez is far too abundant for a complete bibliography to even be attempted here. The reader is instead referred to the most recent catalogue raisonné, monographs, and exhibition catalogues for further sources.

Agreda, María de Jesús de. *Correspondencia con Felipe IV: Religión y razón de estado,* ed. and intro. by Consolación Baranda (Madrid, 1991).

Allen, Paul. *Philip III and the Pax Hispanica, 1598–1621* (New Haven, 2000).

Angulo Iñiguez, Diego. *Velázquez: Cómo compuso sus principales cuadros y otros escritos sobre el pintor* (Seville, 1947; reprint Madrid, 1999).

Armstrong, Walter. *Velázquez: A Study of his Life and Art* (London, 1897).

Aycock, Wendel M., and Sydney P. Cravens, eds. *Calderón de la Barca at the Tercentenary: Comparative Views* (Lubbock, TX, 1982).

Bardi, P. M. *La obra pictórica de Velázquez* (Barcelona, 1969).

Berman, Laurence, ed. *Words and Music: The Scholar's View* (Cambridge, MA, 1971).

Beruete y Moret, Aureliano de. *Vélasquez* (Paris, 1898).

Bethencourt, Francisco. *La Inquisición en la época moderna: España, Portugal, Italia, siglos XV–XIX,* trans. from the Portuguese by Federico Palomo (Madrid, 1997).

Bourdieu, Pierre. *Outline of a Theory of Practice,* trans. Richard Nice (Cambridge, 1977).

Language and Symbolic Power, ed. John B. Thompson, trans. Gino Raymond and Matthew Adamson (Cambridge, MA, 1991).

Bouza, Fernando, *Imagen y propaganda: Capítulos de historia cultural del reinado de Felipe II* (Madrid, 1998).

Bouza Alvarez, Fernando J. *Cartas de Felipe II a sus hijas* (Madrid, 1988).

Brown, Jonathan. *Images and Ideas in Seventeenth-Century Spanish Painting* (Princeton, 1978).

"Academies of Painting in Seventeenth-Century Spain," *Leids Kunsthistorisch Jaarboek* 5–6 (1986–87), 177–85.

Velázquez: Painter and Courtier (New Haven and London, 1986).

"Enemies of Flattery: Velázquez' Portraits of Philip IV," *Journal of Interdisciplinary History* 17 (1986), 137–54.

Brown, Jonathan, and Carmen Garrido. *Velázquez: The Technique of Genius* (New Haven and London, 1998).

Brown, Jonathan, and John H. Elliott, *A Palace for a King: The Buen Retiro and the Court of Philip IV* (New Haven and London, 1980).

Burke, Marcus. *Collections of Paintings in Madrid 1601–1755*, 2 vols. (Los Angeles, 1997).

Calderón de la Barca, Pedro. *La estatua de Promoteo*, ed. Margaret Rich Greer (Kassel, 1986).

Carducho, Vicente. *Diálogos de la pintura*, ed. Francisco Calvo Serraller (Madrid, 1979).

Caro Baroja, Julio. *Vidas mágicas e Inquisición*, 2 vols. (Madrid, 1967).

Caturla, María Luisa. "Documentos en torno a Vicencio Carducho," *Arte Español: Revista de la Sociedad Española de Amigos del Arte* 26 (1968), 177–221.

"Cartas de pago de los doce cuadros de batallas para el salón de reinos del Buen Retiro," *Archivo Español de Arte* 33 (1948), 292–304.

Ceán Bermúdez, Juan Agustín. *Diccionario histórico de los más ilustres profesores de las Bellas Artes en España*, 6 vols. (Madrid, 1800).

Chartier, Roger. *On the Edge of the Cliff: History, Language, and Practices* (Baltimore, 1997).

Chauchadis, Claude. *Honneur, morale et société dans l'Espagne de Philippe II* (Paris, 1984).

Checa Cremades, Fernando. *Carlos V y la imagen del héroe en el Renacimiento* (Madrid, 1987).

Felipe II: Mecenas de las artes (Madrid, 1992).

Cherry, Peter. "New Documents for Velázquez in the 1620s," *Burlington Magazine* 133 (1991), 108–15.

Children of Mercury: The Education of Artists in the 16th and 17th Centuries, exh. cat. (Providence, RI, 1984).

Clark, Stuart. *Thinking with Demons: The Idea of Witchcraft in Early Modern Europe* (Oxford, 1997).

Clavero, Bartolomé. *Razón de estado, razón de individuo, razón de historia* (Madrid, 1991).

Cohen, Walter. *Drama of a Nation: Public Theater in Renaissance England and Spain* (Ithaca, 1985).

Colahan, Clark A. *The Visions of Sor María de Agreda: Writing, Knowledge and Power* (Tucson, 1994).

Colomer, José Luis. "'Dar a Su Magestad algo bueno': Four Letters from Velázquez to Virgilio Malvezzi," *Burlington Magazine* 135 (1993), 67–72.

"Roma 1630: 'La Túnica de José' y el estudio de las 'pasiones,'" *Reales Sitios* 36 (1999), 39–49.

Cosmovisión y escenografía: El teatro español en el Siglo de Oro (Madrid, 1987).

Cotarelo y Mori, Emilio. *Bibliografía de las controversias sobre la licitud del teatro en España* (Madrid, 1904).

Ensayo sobre la vida y obras de D. Pedro Calderón de la Barca (Madrid, 1924).

Cruickshank, D. W. "*Amor, honor y poder* and the Prince of Wales (1623)," *Bulletin of Hispanic Studies* 77 (2000).

Cruz, Anne J., and Mary Elizabeth Perry, eds. *Culture and Control in Counter-Reformation Spain* (Minneapolis, 1992).

Cruzada Villaamil, Gregorio. *Anales de la vida y obras de Diego de Silva Velázquez escritos con ayuda de nuevos documentos* (Madrid, 1885).

Cueto, Ronald. *Quimeras y sueños: Los profetas y la monarquía católica de Felipe IV* (Valladolid, 1994).

Curtius, Ernst Robert. "Calderón's Theory of Art and the *Artes Liberales*," in Curtius, ed., *European Literature and the Latin Middle Ages* (New York, 1953).

Deleito y Piñuela, José. *El rey se divierte* (Madrid, 1988).

Delgado, Manuel, ed. *The Theater of Calderón: Body and Soul* (Lewisburg, PA, 1997).

Díaz del Valle, Lázaro. *Origen e yllustración del nobilísimo y real arte de la pintura y dibuxo con un epílogo y nomenclatura de sus más yllustres más insignes y más afamados professores*, ed. F. J. Sánchez Cantón, in *Fuentes literarias para la historia del arte español*, vol. 2 (Madrid, 1933). See also Francisco Calvo Serraller, *Teoría de la pintura del Siglo de Oro* (Madrid, 1981).

Domínguez Ortiz, Antonio. *La sociedad española en el siglo XVII: El estamento eclesiástico* (Madrid, 1970; reprinted Granada, 1992).

Du Gué Trapier, Elizabeth. *Velázquez* (New York, 1948).

El Escorial: Arte, poder y cultura en la corte de Felipe II, exh. cat. (El Escorial, 1986).

Elliott, John H. *Richelieu and Olivares* (Cambridge, 1984).

 Spain and Its World, 1500–1700 (New Haven, 1989).

 The Count-Duke of Olivares: The Statesman in an Age of Decline (New Haven, 1986).

Elliott, John H., and Angel García Sanz, eds. *La España del Conde Duque de Olivares* (Valladolid, 1990).

Evans, Peter, ed. *Conflicts of Discourse: Spanish Literature of the Golden Age* (Manchester, 1990).

Felipe II: Un monarca y su época, exh. cat. (Madrid, Museo del Prado, 1998–99).

Fernández Martín, Luis. "La Marquesa del Valle: Una vida dramática en la corte de los Austrias," *Hispania* 39, no. 143 (1979), 559–638.

Feros, Antonio. "Vicedioses pero humanos: El drama del rey," *Cuadernos de Historia Moderna* 14 (1993), 103–31.

 Kingship and Favoritism in the Spain of Philip III (1598–1621) (Cambridge, 2000).

Fischer, Susan L. "Art-within-Art: The Significance of the Hercules Painting in *El pintor de su deshonra*": *Critical Perspectives on Calderón de la Barca* (Lincoln, NB, 1981), 69–79.

Flor, Fernando R. de la. *Emblemas: Lecturas de la imagen simbólica* (Madrid, 1995).

Flynn, Maureen. "Mimesis of the Last Judgment: The Spanish Auto de Fe," *Sixteenth Century Journal* 22 (1991), 281–97.

Gállego, Julián, *Visión y símbolos en la pintura española del siglo de oro* (Madrid, 1984).

Ganelin, Charles and Howard Mancing, eds. *The Golden Age Comedia: Text, Theory, and Performance* (West Lafayette, IN, 1994).

García Hidalgo, José. *Principios para estudiar el nobilísimo y real arte de la pintura*, 1693, ed. Marqués de Lozoya (Madrid, 1965).

García García, Bernardo J. *La pax hispánica: Política exterior del duque de Lerma* (Leuven, 1996).

Garrido Pérez, Carmen. *Velázquez: Técnica y evolución* (Madrid, 1992).

Goldberg, Edward. "Diego Velázquez's Visit to Florence in 1650," *Paragone* 45 (1993), 92–96.

Gómez, José Antonio, ed. *Bances Candamo y el teatro musical de su tiempo (1662–1704)* (Oviedo, 1995).

Greer, Margaret R. *The Play of Power: Mythological Court Dramas of Calderón de la Barca* (Princeton, 1991).

 "Woman and the Tragic Family of Man in Juan de la Cueva's *Los siete Infantes de Lara*," *Hispania* 82 (1999), 472–80.

"A Tale of Three Cities: The Place of the Theatre in Early Modern Madrid, London, and Paris," *Bulletin of Hispanic Studies* 77 (2000), 391–419.

Harris, Enriqueta. "La misión de Velázquez en Italia," *Archivo Español de Arte* 33 (1960), 109–36.

"Cassiano dal Pozzo on Velázquez," *Burlington Magazine* 112 (1970), 364–73.

Velázquez (Oxford, 1982).

"Velázquez's Apsley House Portrait: An Identification," *Burlington Magazine* 120 (1978), 304.

Harris, Enriqueta, and José Luis Colomer, "Two Letters from Camillo Massimi to Diego Velázquez," *Burlington Magazine* 136 (1994), 545–48.

Heredía, M. Carmen. *Estudio de los contratos de aprendizaje artístico en Sevilla a comienzos del siglo XVIII* (Seville, 1974).

Herrero Salgado, Félix. *La oratoria sagrada en los siglos XVI y XVII* (Madrid, 1996).

Historia de la Iglesia en España. Vol. 6: *La Iglesia en la España de los siglos XVII y XVIII*, dir. Ricardo García-Villoslada (Madrid, 1979).

Hoffman-Strock, Martha. "'Carved on Rings and Painted in Pictures': The Education and Formation of the Spanish Royal Family, 1601–1634" (Ph.D. diss., Yale University, 1996).

Iglesia y sociedad en el antiguo régimen: El clero secular (Las Palmas, 1994).

Jones, C. A. "Spanish Honour as Historical Phenomenon, Convention and Artistic Motive," *Hispanic Review* 33 (1965), 32–39.

Justi, Carl. *Velazquez und sein Jahrhundert* (Bonn, 1888).

Velázquez y su siglo. Trans. Jesús Espino Nuño (Madrid, 1999).

Kamen, Henry, *The Phoenix and the Flame: Catalonia and the Counter Reformation* (New Haven, 1993).

Philip of Spain (New Haven, 1997).

Kauffmann, C. M. *Catalogue of Paintings in the Wellington Museum* (London, 1982).

Kendrick, Thomas D. *Mary of Agreda: The Life and Legend of a Spanish Nun* (London, 1967).

Kent, Conrad, Thomas K. Wolber, and Cameron M. K. Hewitt, eds. *The Lion and the Eagle: Interdisciplinary Essays on German-Spanish Relations over the Centuries* (New York, 2000).

Lefort, Paul. *Velázquez*. (Paris, 1888).

Lleó Cañal, Vicente. *La fiesta del Corpus Christi en Sevilla en los siglos XVI y XVII* (Seville, 1975).

López-Rey, José. *Velázquez: A Catalogue Raisonné of his Work with an Introductory Study* (London, 1936).

Velázquez: The Artist as Maker with a Catalogue Raisonné of His Extant Works (Lausanne and Paris, 1979).

Velázquez, 2 vols. (Cologne, 1996).

López Torrijos, Rosa. *La mitología en la pintura española del Siglo de Oro* (Madrid, 1985).

Luxenberg, Alisa. "Regenerating Velázquez in Spain and France in the 1890s," *Boletín del Museo del Prado* 17, no. 35 (1999), 125–49.

Maqueda Abreu, Consuelo. *El auto de fe* (Madrid, 1992).

Maravall, José Antonio. *Velázquez y el espíritu de la modernidad* (Madrid, 1987).

Marías, Fernando. "Sobre el número de viajes de Velázquez en Italia," *Archivo Español de Arte* 65 (1992), 218–21.

Velázquez: Pintor y criado del rey (Madrid, 1999).

Martínez, Jusepe. *Discursos practicables del nobilíssimo arte de la pintura*. In *Varia Velazqueña*, vol. 2 (Madrid, 1960), and Julián Gállego, ed. (Madrid, 1988).

Martínez Millán, José, ed. *La corte de Felipe II* (Madrid, 1994).

Felipe II (1527–1598): Europa y la Monarquía Católica, 4 vols in 5 (Madrid, 1998).

Martorell Téllez-Girón, Ricardo. *Cartas de Felipe III a su hija Ana, Reina de Francia* (Madrid, 1929).

Mayer, Auguste L. *Velázquez: A Catalogue Raisonné of the Pictures and Drawings* (London, 1936).

McKendrick, Melveena, *Theatre in Spain, 1490–1700* (Cambridge, 1989).

McKim-Smith, Gridley, and Marcia Welles. "Topographical Tropes: The Mapping of Breda in Calderón, Callot, and Velázquez," *Indiana Journal of Hispanic Literatures* 1 (1992), 66–85.

McKim-Smith, Gridley, Greta Anderssen-Bergdoll, and Richard Newman, *Examining Velázquez* (New Haven, 1988).

McKim-Smith, Gridley, and Richard Newman. *Ciencia e historia del arte: Velázquez en el Prado* (Madrid, 1992).

Mínguez, Víctor. "La monarquía humillada: Un estudio sobre las imágenes del poder y el poder de las imágenes," *Relaciones* 77 (1999), 123–48.

Montagu, Jennifer. "Velázquez Marginalia: His Slave Juan de Pareja and His Illegitimate Son Antonio," *Burlington Magazine* 125 (1983), 683–85.

Morán Turina, Miguel, and Isabel Sánchez Quevedo. *Velázquez: Catálogo completo* (Madrid, 1999).

Morán, Miguel. *La imagen del rey: Felipe V y el arte* (Madrid, 1990).

Moreno Villa, José. *Locos, enanos, negros y niños palaciegos* (Mexico City, 1939).

Muñoz González, María Jesús. "Nuevos datos sobre los oficios y puestos de Velázquez en la casa real," *Archivo Español de Arte* 27 (1999), 546–49.

Nalle, Sara T. *God in La Mancha: Religious Reform and the People of Cuenca, 1500–1650* (Baltimore, 1992).

Mad for God: Bartolomé Sánchez, the Secret Messiah of Cardenete (Charlottesville, VA, 2001).

Navarrete Prieto, Benito. *La pintura andaluza del siglo xvii y sus fuentes grabados* (Madrid, 1999).

Northup, George Tyler, ed. *Three Plays by Calderón: Casa con dos puertas mala es de guardar, La vida es sueño, La cena del Rey Baltasar* (Boston, 1926).

Orso, Steven N. *Philip IV and the Decoration of the Alcázar Palace* (Princeton, 1986).

"Praising the Queen: The Decorations at the Royal Exequies for Isabella of Bourbon," *Art Bulletin* 72 (March 1990), 51–73.

Velázquez, Los Borrachos, and Painting at the Court of Philip IV (Cambridge, 1993).

Ortega y Gasset, José. *Sechs Farbige Wiedergaben nach Gemalden aus dem Prado Museum* (Bern 1943; English edition, Oxford, 1946).

Pacheco, Francisco. *Libro de descripción de verdaderos retratos, de ilustres y memorables varones,* facsimile ed. prepared by José María Asencio (Madrid, 1886); also edition with prologue by Diego Angulo Iñiguez (Madrid, 1983).

Arte de la pintura, ed. Bonaventura Bassegoda i Hugas (Madrid, 1990).

Palomino, Antonio. *Lives of the Eminent Spanish Painters and Sculptors,* trans. Nina Ayala Mallory (Cambridge, 1987).

Palomino y Velasco, Antonio Acisclo. *El museo pictórico y escala óptica,* 3 vols., 1715–24 (Madrid, 1988).

Parker, A. A. "The Spanish Drama of the Golden Age: A Method of Analysis and Interpretation," in Eric Bentley, ed., *The Great Playwrights: Twenty-five Plays with Commentaries by Critics and Scholars Introduced by . . .* (New York, 1970), vol. 1, 679–707.

Pérez Martín, María Jesús. *Margarita de Austria, Reina de España* (Madrid, 1961).

Pérez Sánchez, Alfonso E. *Pintura barroca en España 1600–1750* (Madrid, 1992).

Pérez Villanueva, Joaquín. *Felipe IV y Luisa Enríquez Manrique de Lara, Condesa de Paredes de Nava, un epistolario inédito* (Salamanca, 1986).

Perrens, F. Tommy. *Les Mariages espagnols sous le regne de Henri IV et la régence de Marie de Médicis* (Paris, 1869).

Perry, Mary Elizabeth. *Gender and Disorder in Early Modern Seville* (Princeton, 1990).

Polska, Allyson. *Regulating the People: The Catholic Reformation in Seventeenth-Century Spain* (Leiden, 1998).

Ponz, Antonio. *Viage de España, en que se da noticia de las cosas mas apreciables, y dignas de saberse, que hay en ella*, 18 vols. (Madrid, 1772–94).

Pym, Richard J. "Tragedy and the Construct Self: Considering the Subject in Spain's Seventeenth-Century *Comedia*," *Bulletin of Hispanic Studies* 75 (1998), 273–92.

Rey, Pepe. "Divagaciones en torno a Velázquez y la música," *Scherzo* 133 (April 1999), 133–38.

Sage, Jack. "Calderón y la música teatral," *Bulletin Hispanique* 58 (1956), 275–300.

Salort, Salvador. "La misión de Velázquez y sus agentes en Roma y Venecia: 1649–1653," *Archivo Español de Arte* 72 (1999), 415–68.

Sánchez Cantón, Francisco Javier. *Fuentes literarias para la historia del arte español*, 3 vols. (Madrid, 1925).

 Como vivía Velázquez: Inventario descubierto por D. F. Rodríguez Marín, transcripción y estudio por F. J. Sánchez Cantón (Madrid, 1942).

Sánchez, Magdalena S. *The Empress, the Queen, and the Nun: Women and Power at the Court of Philip III of Spain* (Baltimore, 1998).

Sánchez, Magdalena S., and Alain Saint-Saëns, eds. *Spanish Women in the Golden Age: Images and Realities* (Westport, CT, 1996).

Sebastián, Santiago. "Nueva lectura de 'Las Hilanderas', la emblemática como clave de su interpretación," *Revista Fragmentos* 1 (1984), 45–51.

Sebastián Lozano, Jorge. "Representación femenina y arte áulico en el xvii español: El caso de Margarita de Austria (1584–1611)", in *V Jornadas Internacionales de Estudios de la Mujer . . . noviembre 1997* (Madrid, 1999).

Silvela, Francisco. *Cartas de la Venerable Sor María de Agreda y del Señor Rey Don Felipe IV*, 2 vols. (Madrid, 1885–86).

 Matrimonios de España y Francia en 1615 (Madrid: Discurso de Ingreso en la Real Academia de la Historia, 1901).

Stein, Louise K. "Opera and the Spanish Political Agenda," *Acta Musicologia* 63 (1991), 126–67.

 Songs of Mortals, Dialogues of the Gods: Music and Theatre in Seventeenth-Century Spain (Oxford, 1993).

 "'Al seducir el oído . . . ,' delicias y convenciones del teatro musical cortesano," *El teatro cortesano en la España de los Austrias,* ed. José María Díez Borque, *Cuadernos de Teatro Clásico* 10 (Madrid, 1998), 169–89.

 "Eros, Erato, Terpsichore and the Hearing of Music in Early Modern Spain," *Music Quarterly* 82 (1998), 654–77.

Stirling-Maxwell, William. *Velázquez and His Works* (London, 1855).

 Annals of the Artist of Spain, 3 vols. (London, 1848); rev. ed. 4 vols. (London, 1891).

Stradling, R. A. *Philip IV and the Government of Spain 1621–1665* (Cambridge, 1988).

Stratton, Suzanne L. *The Immaculate Conception in Spanish Art* (Cambridge, 1994).

Thompson, I. A. A. *Crown and Cortes* (Aldershot, 1993).

Three Comedies by Pedro Calderón de la Barca, trans. Kenneth Muir and Anne L. Mackenzie (Lexington, KY, 1985).

Tietz, Manfred, ed. *Texto e imagen en Calderón: Undécimo Coloquio Anglogermano sobre Calderón* (Stuttgart, 1998).

Tolnay, Charles de. "Velázquez' *Las hilanderas* and *Las meninas* (an interpretation)," *Gazette des Beaux-Arts* 35 (1949), 21–38.

Tuck, Richard. *Philosophy and Government, 1572–1651* (Cambridge, 1993).

Tyler, Richard W., and Sergio D. Elizondo. *The Characters, Plots and Settings of Calderón's Comedias* (Lincoln, NE, 1981).

Umberger, Emily. "Velázquez and Naturalism II: Interpreting *Las Meninas*," *Res* 28 (Autumn 1995), 94–117.

Valverde Madrid, José. "Iconografía de Calderón de la Barca," *Goya* 161–62 (1981), 322–23.

Varela, Javier. *La muerte del rey* (Madrid, 1990).

Varey, J. E. "Velázquez y Heliche en los festejos madrileños de 1657–1658," *Boletín de la Real Academia de la Historia* 169 (1972), 407–22.

Varia Velazqueña: Homenaje a Velázquez en el III centenario de su muerte, 1660–1960, 2 vols. (Madrid, 1960).

Vegazo Palacios, Jesús M. *El Auto General de Fe de 1680* (Málaga, 1995).

Velázquez (Barcelona: Amigos del Museo del Prado, 1999).

Velázquez (Madrid, Fundación Amigos del Museo del Prado, 1999).

Velázquez a Roma: Velázquez en Roma (Rome, 1999).

Velázquez in Seville, exh. cat. (Edinburgh, National Gallery of Scotland, 1996).

Velázquez, Rubens y Van Dyck: Pintores cortesanos del siglo XVII, exh. cat. (Madrid, Museo del Prado, 1999–2000).

Velázquez y el arte de su tiempo. V Jornadas de Arte, Departamento de Historia del Arte "Diego Velázquez," CSIC (Madrid, 1991).

Velázquez y Sevilla, exh. cat. (Seville, Monasterio de la Cartuja de Santa María de las Cuevas/Salas del Centro Andaluz de Arte Contemporáneo, 1999).

Véliz, Zahira. *Artists' Techniques in Golden Age Spain: Six Treatises in Translation* (Cambridge, 1987).

"Aspects of Drawing and Painting in Seventeenth-Century Spanish Treatises," *Leids Kunsthistorisch Jaarboek: Looking Through Paintings* (Leiden, 1998), 295–318.

Vergara, Alexander. *Rubens and his Spanish Patrons* (Cambridge, 1999).

Vosters, Simon. "Again the First Performance of Calderón's *El sitio de Bredá*," *Revista Canadiense de Estudios Hispánicos* 6 (1981), 117–34.

Wardropper, Bruce. *Introducción al teatro religioso del Siglo de Oro: Evolución del auto sacramental antes de Calderón* (Madrid, 1953).

Introducción al teatro religioso del Siglo de Oro: La evolución del auto sacramental (Madrid, 1953).

Warnke, Martin. *The Court Artist: On the Ancestry of the Modern Artist*, trans. David McLintock (Cambridge, 1993).

Webster, Susan Verdi. *Art and Ritual in Golden-Age Spain: Sevillian Confraternities and the Processional Sculpture of Holy Week* (Princeton, 1998).

Whitaker, Shirley. "The First Performance of Calderón's *El sitio de Bredá*," *Renaissance Quarterly* 31 (1978), 515–31.

Winternitz, Emanuel. *Musical Instruments and their Symbolism in Western Art* (New Haven and London, 1979).

Women and the Inquisition: Spain and the New World, ed. Mary E. Giles (Baltimore, 1999).